Psychoanalytic Perspectives on Art

Psychoanalytic Perspectives on Art

P P A

Editor Mary Mathews Gedo

The Analytic Press
1988

Distributed by
Lawrence Erlbaum Associates, Publishers
Hillsdale, New Jersey London

The Analytic Press

Distributed solely by

Lawrence Erlbaum Associates, Inc., Publishers
365 Broadway
Hillsdale, New Jersey, 07642

Library of Congress Cataloging-in-Publication Data

Psychoanalytic perspectives on art.

Includes bibliographies.
1. Psychoanalysis and art—Periodicals. I. Gedo,
Mary Mathews. II. PPA.
N72.P74.P78 1985 701'.05 85-9212
ISBN 0-88163-030-6 (v. 1)
 058-6 (v. II)
 078-0 (v.III)

Printed in the United States of America
10 9 8 7 6 5 4 3 2 1

Contents of Volume III

About the Authors

Andrew Abarbanel is a psychiatrist in private practice in Los Altos, California. In addition to his medical degree, he also holds a Ph.D. in physics from Stanford University. His research interests center on the psychological aspects of the creative process. He is currently completing psychological studies of Mark Twain and Albert Einstein.

K. Porter Aichele is Director of Planned Giving at Bryn Mawr College, where she took her Ph.D. in art history in 1976. She has published on Paul Klee and on the American Arts and Crafts Movement, and is currently working on essays about Klee and Pablo Picasso.

Leon E. A. Berman practices psychoanalysis in Birmingham, Michigan. He is an Associate Professor of Psychiatry at Wayne State University College of Medicine and a faculty member of the Michigan Psychoanalytic Institute. He has published widely on psychoanalytic topics and has also written interdisciplinary essays about librettist W. S. Gilbert.

Catherine C. Bock is Professor of Art History, Theory, and Criticism at the School of the Art Institute of Chicago. She is the author of *Henri Matisse and Neo-Impressionism, 1898–1908* (1981) and is currently working on the relationship of nationalism to the interpretation of modern art in Europe around World War I. She is also preparing an anthology of Matisse criticism entitled *Perspectives on Matisse: French Art Criticism from 1905–55.*

Mihaly Csikszentmihalyi is the Chairman and Professor in the Department of Behavioral Sciences (Human Development) at the University of Chicago. He has served as Visiting Professor at various Canadian and European universities and is a Fellow of the National Academy of Education and the National Academy of Leisure Sciences. He has published over 100 articles in professional journals and is the author of five books, including *Forms of Flow,* written with Isabella Csikszentmihalyi and currently in press. He is also an exhibited painter and has published short stories in the *New Yorker.*

Aaron Esman, Professor of Clinical Psychiatry at Cornell University Medical College and Past President of the New York Psychoanalytic Society, has written extensively on the arts, as well as on topics of child and adolescent psychiatry. His books include *The Psychology of Adolescence* (1975) and *The Psychiatric Treatment of Adolescents* (1983).

Frank Galuszka is Associate Professor at the Philadelphia College of Art. His paintings have been featured in numerous one-man and group shows in America and Europe.

Milly Heyd is Associate Professor of art history at the Hebrew Univeristy of Jerusalem. Her book, *Aubrey Beardsley: Symbol, Mask, and Self-Irony,* appeared in 1986. She has published articles on Andy Warhol and on the relationship of text and illustration in the work of Salvador Dali and on Jewish printed books of the 17th and 18th centuries and their connections to Christian sources. She is currently working on a monograph devoted to the art of Giorgio de Chirico.

G. H. Huntley is Professor Emeritus at Northwestern University. His monograph on Andrea Sansovino (1935) remains the authoritative text on the artist. Dr. Huntley has also lectured and published widely on the oeuvre of Giorgio Vasari and on 19th-century French art, particularly problems of style.

Donald Kuspit, Professor of Art History and Philosophy at the State University of New York at Stony Brook, was awarded the Frank Jewett Mather award for Distinction in Art Criticism in 1982. He is a member of the staff of *Artforum,* a regular contributor to many international art publications, and the editor of *Art Criticism.* He has published over 400 essays and seven books, most recently, *The New Subjectivism: Art of the Eighties.*

John A. Phillips teaches philosophy and religious studies at Springfield College in Massachusetts. He is the author of *Christ in the Theology of Dietrich Bonhoeffer* (1968) and *Eve: The History of an Idea* (1984). His essay "Eve and Psychoanalysis" appeared in the *American Journal of Psychoanalysis* (Jan. 1986).

Avigdor W. G. Posèq is Professor of Art History at the Hebrew University of Jerusalem. His publications include books on Renaissance format and perspective, and he has also written on contemporary and Jewish art. A painter as well as an art historian, he has exhibited in one-man and group shows and has designed sets for Israeli theater and film productions.

Stephen L. Post is a Training/Supervising Analyst at the St. Louis Psychoanalytic Institute, Associate Clinical Professor of Psychiatry at St. Louis University Medical School, and Past President of the St. Louis Psychoanalytic Society. He is a Consulting Editor for *Psychoanalytic Inquiry*.

Nancy Scott is an Associate Professor in the Department of Fine Arts at Brandeis University. She is the author of *Vincenzo Veli, 1820–91* (1979) and of the exhibition catalogue *Charles Gleyre* (1980). She has published essays on 19th-century sculpture and on the art of Christo and is currently working on a publication devoted to the correspondence of Georgia O'Keeffe.

Leonard Shengold is a faculty member and Training Analyst at the Psychoanalytic Institute of New York University Medical School. He has served as Director of that Institute and has held important administrative posts in the American and International Psychoanalytic Associations. He is a member of the editorial boards of *American Imago* and the *Psychoanalytic Quarterly*. He has published essays on all aspects of psychoanalysis, including applied analysis. His book, *The Halo in the Sky,* appeared in 1987.

Charlotte Stokes is Associate Professor of Art History at Oakland University, Rochester, Michigan. She has published essays on Max Ernst and on Salvador Dali and is currently completing a monograph about Ernst's collages.

Laurie Wilson, Director and Professor in the Art Therapy Program at New York University, is both an art historian and a psychoanalyst in training at the NYU Psychoanalytic Institute. Her monograph, *Louise Nevelson, Iconography and Sources,* appeared in 1981. She is currently working on a publication about Alberto Giocometti.

Introduction

Volume III of *Psychoanalytic Perspectives on Art* features a long special section on Proto-Surrealist and Surrealist art, bracketed by a brief segment on Renaissance art and a longer group of miscellaneous essays on aspects of Modern Art. The book ends with dual reviews of James Lord's biography of the sculptor Giacometti, an artist who played a prominent role in the early Surrealist movement.

The volume opens with Avigdor W. G. Posèq's article, "The Affinity between the Comic and the Sublime in Pictorial Imagery." Posèq demonstrates the close link aligning the development of caricature to that of the High Renaissance and Baroque styles, providing examples from both genres in the work of Leonardo, Michelangelo, Bernini, and the Carracci. Posèq not only correlates his findings with Freud's discoveries about humor, he even demonstrates that Freud himself unwittingly created a caricature in the sketches he drew to accompany his essay on Michelangelo's *Moses,* which transformed the expression on the prophet's face into an angry snarl.

John A. Phillips explores the multiple artistic, psychosexual, and theological implications of Eve's far-from-idle hand in "Michelangelo's Eve in the Sistine *Temptation.*" The theologian's startling findings demonstrate not only that Michelangelo possessed a subtle knowledge of the language of gesture, but that he utilized his weighted depiction of Eve's right hand to link together the entire program of the Sistine ceiling and its underlying theological message.

"What Vasari Meant to Raphael," written by my beloved professor of Renaissance art, G. Haydn Huntley, effectively answers the question that has puzzled so many historians of the Renaissance: Why did Giorgio Vasari's treatment of Raphael and his significance differ so widely in the first edition of his *Lives,* published in 1550, and the second, brought out in 1568? As Huntley shows, Vasari, ever keen to political advantage and eager to please Michelangelo, downplayed the achievements of his hated rival, Raphael, in the first edition of the lives, written before the great sculptor's death. By 1568, Michelangelo was gone, along with the political benefits he could bestow, and Vasari could more openly reveal his identification with, and admiration for, his fellow Umbrian, Raphael, an artist whose genial personality, organizing skills, and political savvy were much more commensurate with those of Vasari himself. Though Huntley does not address such problems directly, his essay raises all sorts of fascinating questions about the role of idealization in artistic creation. For Vasari's admiration of Raphael (by then dead for nearly 70 years) serves as the historic prototype for similar idealizations by later artists of great masters of the past. The idealized roles that both Raphael and Vasari played with their studio assistants, as well as the reciprocal effects on these masters of the esteem in which their employees held them, constitute yet other interesting unresolved questions. The lack of biographical and historical data may make such problems virtually insoluble, but they remain no less central to our complete comprehension of the psychology of the artist for all that.

The special section devoted to Surrealist art begins with three essays that examine various aspects of the art and psyche of that quintessential Proto-Surrealist, Giorgio de Chirico, whose early paintings were the foundation upon which Surrealism was erected. In "The Mystery and Melancholy of Nineteenth Century Sculpture in de Chirico's *Pittura Metafisica,*" Nancy Scott ingeniously explores the multiple psychological, political, and artistic meanings symbolized in de Chirico's repeated use of images derived from statues of 19th-century Italian Risorgimento heroes in his important metaphysical paintings. She demonstrates that these statues should be understood as images both of de Chirico's father and of his fatherland. According to Scott's argument, it was de Chirico's attempt to integrate and sublimate the internalized image of his powerful father that precipitated the end of his metaphysical period. As she points out, in the series of pictures devoted to the theme of the prodigal son that de Chirico painted at the close of this phase, the statues of the heroes descend from their pedestals to embrace their mannequin-sons, just as the artist himself would soon embrace the classicism that symbolized his return to outmoded 19th-century standards.

Milly Heyd also discusses de Chirico's relationship to his father in her linked essays about the artist, "The Girl with the Hoop" and *The Greetings of a Distant Friend.* She identifies the genesis of the artist's ambivalence toward his remote and awesome parent in

early childhood experiences vividly recounted in the artist's later autobiographical writings. Heyd's primary focus, however, is on the artist's siblings, his sister, Adele, four years his senior, and his younger brother, Andrea, who later adopted the name Alberto Savinio. In the first essay, she discusses de Chirico's persistent guilt and mourning over the death of his sister during his early childhood, which profoundly imprinted his later art and life. Heyd convincingly connects the recurring image of the girl with the hoop and the carnival wagon, both major features of the key painting *The Mystery and Melancholy of a Street,* with the artist's memories of his sister and the experience of witnessing her funeral cortege. The second essay addrsses the issue of de Chirico's deep and abiding rivalry toward his brother, Andrea, who was born soon after the sister's death and evidently symbolized this lost child to his mother. Although Heyd's interpretation of the impact of these relationships and events on de Chirico's life makes full use of psychoanalytic insights, she enriches her interpretations and reinforces her conclusions with excerpts from the artist's autobiographies and quotations from literary sources, especially philosophers, like Nietzsche and Weininger, whom the artist credited with deeply influencing the development of his metaphysical pictures.

The following two essays, "Sisters and Birds: Meaningful Symbols in the Work of Max Ernst," by Charlotte Stokes, and "The Role of the Primal Scene in the Artistic Works of Max Ernst," by Leon Berman, represent an unique phenomenon in *PPA* history. They illustrate the happy results of an informal, interdisciplinary collaboration conducted between art historian Stokes and pyschoanalyst Berman. Dr. Berman agreed in advance to write an article in response to Stokes' essay on "Sisters and Birds," and during the evolution of the two essays, the collaborators—who live in two nearby Michigan cities—conferred informally, primarily by telephone and letter. In the opinion of the editor, such collaborations represent one of the most effective ways for art historians who have not experienced a personal analysis or undertaken special analytic training to use a psychoanalytic method, and we hope that the success of this collaborative effort will encourage other art historians to follow Stokes's practice.

Stokes's essay skillfully ties together multiple themes, showing how Ernst used his knowledge of psychoanalytic theory, derived from reading Freud, to develop a kind of free-associative technique that he employed to create his collages, frottages, and other works that unite seemingly disparate elements into an integrated entity. Stokes also demonstrates how Ernst's relationship to his many sisters—his four surviving sisters, as well as the two little girls who died within five months of one another in 1896, when the future artist was in his sixth year—deeply impregnated his art. That, in his adult work, Ernst often represented himself as Loplop, "the bird superior," has been widely recognized. But most Ernst scholars have ignored the fact that, in a brief autobiographical essay, the artist clearly associated his bird imagery with reminis-

cences of his sisters. Stokes corrects this omission to show that many of Ernst's works, especially his two collage novels featuring youthful heroines, evolved out of his close, but inevitably ambivalent, relationship to his sisters, living and dead.

Leon E. A. Berman's related essay capitalizes on his clinical experience; he offers compelling suggestions concerning the nature of Ernst's oedipal conflicts, especially his memories of the primal scene (the scene of parental intercourse), which recur again and again in the artist's work and writings. It is the powerful, repetitious character of these associations, Berman suggests, that convinces us that this material derived from Ernst's submerged memories, rather than from his psychoanalytic sophistication.

Leonard Shengold's contribution, "A Psychoanalytic Perspective on Sister Symbolism in the Art of Ernst and de Chirico," presents yet another psychoanalytic view of Ernst, as well as offering a seasoned professional's evaluation of de Chirico's psychology. Shengold suggests the kinds of material these seminal artists might have brought to their analyses had they entered treatment. The analyst's disclaimer that "since pathology rather than health gets elucidiated [in an analysis], it is probable that little insight about the artist's creativity would have emerged from his treatment that would differentiate his analytic associations from those of anyone else . . ." may surprise those art historians who consider psychoanalysts naively all too ready to believe that they can directly translate their clinical insights into artistic equivalents. Shengold's essay goes on to evaluate the differing methodologies of Heyd and Stokes as well as the contrasting characters of Ernst's and de Chirico's personalities—and mental health.

"A Note on Magritte's Use of the Shroud," by Andrew Abarbanel, suggests that the painting, *Person Meditating on Madness* (1928), which shows a young man staring at a blank canvas or table top, symbolically depicts René Magritte arriving at the artistic solution to the terrible dilemma caused by his mother's suicide during the future artist's early adolescence.

The final two articles in this section, written respectively by psychoanalyst Stephen L. Post and art critic Donald Kuspit, deal not with specific artists and works but with the historic relationship between Surrealism and psychoanalysis and its implications for the latter. Post's essay, "Surrealism, Psychoanalysis, and Centrality of Metaphor," addresses such perennial problems as the role of the dream and the unconscious in Surrealist creativity, providing new and surprising conclusions to these questions. His closing suggestion that psychoanalysis could learn from Surrealism "that subjectivity is intrinsic to experiential validity as well as vitality; that empathy . . . is usefully extensible to inanimate objects, [and] that irrationality does make sense, not just within the individual, but in the objective physical world" is one that the discipline might seriously consider.

Kuspit reexamines many of the same questions from the art historical viewpoint in his essay, "Surrealism's re-Vision of Psychoanalysis." His conclusions, however, are quite congruent with those of Post. Kuspit, too, proposes that the artistic movement

may expose limitations in psychoanalytic thinking and practice, and he ends by urging psychoanalysis—and psychoanalysts—to employ the discipline more freely and energetically in the ever-lasting war mankind must wage against its own "miserablism."

Many scientific writers of the 19th century posited a causal relationship between creativity and madness. The essay "The Dangers of Originality: Creativity and the Artistic Process," by Mihaly Csikszentmahalyi, which introduces the section of this volume devoted to Modern Art, reconsiders this question, Csikszentmahalyi reviews evidence based on his detailed studies and follow-up interviews conducted more than twenty years later with a group of artists who were students at the School of the Art Institute of Chicago when the study began. His provocative findings have many ramifications for scholars interested in the personalized sources of creativity, and one eagerly awaits the full discussion of his conclusions, to be presented in a volume now in process.

In "Cézanne's Bathers: A Psychoanalytic View,"Aaron Esman considers once again the French master's lifelong obsession with this motif. Through his analytic insights, Esman illuminates the nature of this struggle but emphasizes that the creative mechanisms through which Cézanne transformed his "ubiquitous and fairly banal conflicts" into works of magnificent originality remain obscure.[1]

Catherine C. Bock's study, "Henry Matisse's Self-Portaits: Presentation and Representation," compares and contrasts his self-images in various media with photographs of the artist taken at different stages in his career. She suggests that, although Matisse used his self-portaits as an aid to self-discovery and realization, he manipulated photographic images of his countenance to emphasize his bourgeois respectability and professionalism as an artist. In her moving concluding section, Bock demonstrates that, in the final portraits, these two strains fuse, resulting in images of "apotheosis and radiant self-sufficiency."

K. Porter Aichele's essay, "Self-Confrontation in the Early Works of the Vienna School," examines self-portraits created by six artists grouped together as the Vienna School of Fantastic Realists. Their work seems especially pertinent for consideration in this volume of *PPA,* since they were interested both in Surrealist techniques of automatism and in psychoanalytic theories of the unconscious and used their self-images in the service of self-revelations fruitfully explored by Aichele in this essay.

The final article in this section, Avigdor W. G. Posèq"s "Tumarkin and the Feminine Archetype" focuses on a single work, the remarkable statue of that biblical femme fatale, Salomé, created by the contemporary Israeli sculptor, Igael Tumarkin. Posèq skillfully traces the art historical and religious antecedents of this statue. But he also sensitively probes the personal psychological ramifications of the work and its root in a childhood trauma involving maternal deception that deeply impregnated Tumarkin's mature artistic creations.

The volume closes with a review of the controversial Giacometti

biography by James Lord. In keeping with *PPA* practice, we offer dual essays about this book, by artist Frank Galuszka and art-historian, clinician—and sculptor—Laurie Wilson. Galuszka responded to the book with a poetic recapitulation of Giacometti's professional career, while Wilson reacted more strongly to the genetically significant biographical data revealed by this study. However, both reviewers agreed completely in assessing the biography as a flawed work, too colored by the author's unresolved positive transference to his subject to provide the definitive treatment of Giacometti, the artist and the man, that the author obviously intended to write.

Notes

1. John E. Gedo's portrait of Cézanne's psychology, spelled out in his essay, "Paul Cézanne: Symbiosis, Masochism, and the Struggle for Perception," appeared in Volume II of *PPA* (1987). His conclusions generally seems congruent with those of Esman, who wrote his article before Gedo's appeared. The consistency of these two interpretations suggests not only that both analysts perceive Cézanne's psychology in a similar light, but that they use strikingly similar psychoanalytic principles and methods in their applied analytic work.

Psychoanalytic Perspectives on Art

Section One **Renaissance Topics**

Avigdor W. G.
Posèq, Ph.D.

An Affinity Between the Comic and the Sublime in Pictorial Imagery

At the end of Plato's *Symposium,* Socrates forces the other partici-
pants to admit that the abilities necessary for a writer of tragedy
and comedy are the same and that the true artist in tragedy is also
an artist in comedy. This statement raises some interesting points.
Humorous moments enlivening the sublime mode of tragic plays
easily come to mind, but it is difficult to recall comedies that
include tragic incidents. The history of drama shows that the
authors often tend to specialize in only one of these literary
genres. Pictorial art, however, provides instructive illustrations of
Plato's assertion, showing that, at least in some cases, the sublime
and the comic modes were both practiced by the same artist. Even
more thought-provoking is the fact that the two kinds of imagery
actually share certain structural features, resulting in a remarkable
affinity of their visual effect.[1]

The similarity of the ludicrous and the exalted may usefully be
explored in the work of Mannerist and Baroque artists who used
the sublime mode in their monumental commissions but in their
freer moments drew comic sketches which are among the pioneer-
ing attempts at caricature. The contrast is especially striking in the
work of Gian-Lorenzo Bernini. The sublime pathos of his figures
is exemplified by his best-known statuary group, the ecstatic Saint
Teresa being pierced by the angelic lance (fig. 1; Hibbard, 1965,
pp. 136–38). His sketch of Cardinal Scipione Borghese (fig. 3)
shows that the sculptor was equally proficient in the burlesque
(Harris, 1977, p. vii, n. 14; Harris, 1975, pp. 158–60). Since the
affinity between the comic and the sublime can be better studied

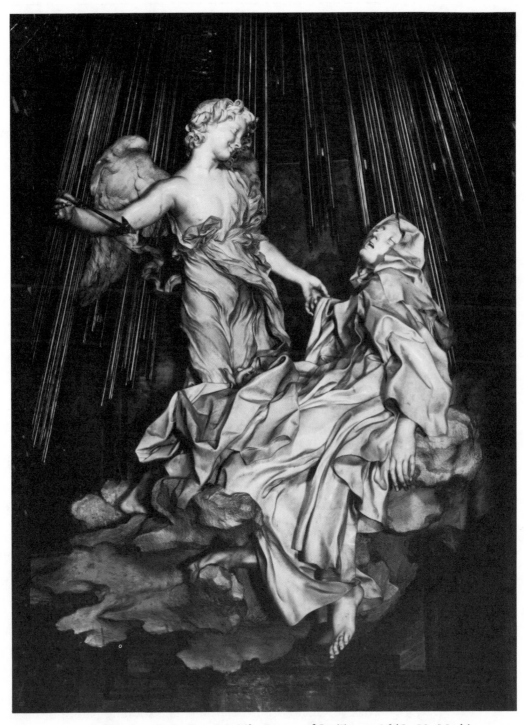

Fig. 1. G. L. Bernini, *The Ecstasy of St. Teresa,* 1645–52. Marble.
Rome, S. Maria della Vittoria, Cornaro Chapel. Photo: Alinari/Art
Resource, New York.

5

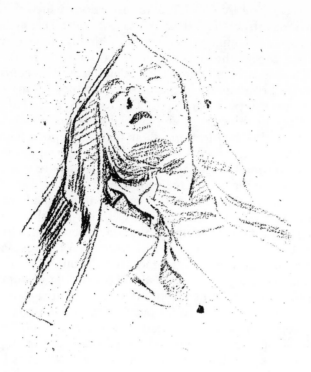

Fig. 2. G. L. Bernini, A study for the head of St. Teresa, 1647. Red chalk. Stadtbibliothek, Leipzig.

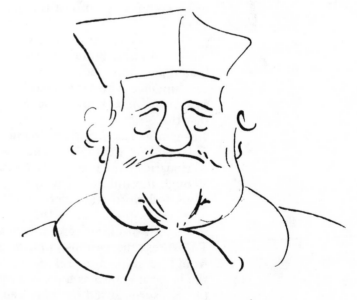

Fig. 3. G. L. Bernini, Caricature of Cardinal Scipione Borghese, c. 1650. Pen and ink. Biblioteca Corsini, Rome.

in works of the same medium, we shall compare the Cardinal Borghese drawing with a preparatory sketch for the figure of Saint Teresa (fig. 2). Formal analysis of these drawings shows that in spite of the differences in their expressive intent, the witty physiognomical sketch and the foreshortened head of the rapturous saint share a determinate structural pattern. Apart from the

conciseness which reduces both faces to a few strokes, both heads are characterized by considerable distortions which transform their proportional effect. The deformation of Saint Teresa's uplifted face involves the enlargement of her chin and throat, which seem blown out of size; her nose, seen from below, is reduced in length so that it assumes an almost triangular shape. The contraction is even more pronounced in the forehead, which seems forcefully pushed into the pictorial depth. The cardinal's head also appears to have been subjected to an external squeeze, which, modifying the shape of the features and their reciprocal position, creates an inner pressure that seems to push the face out of its contour. In the first drawing the distortion contributes to the exalted effect, while in the other it is perceived as ridiculous.

The most striking features of graphic humor and caricature, here exemplified by the sketch of Cardinal Borghese, may perhaps be elucidated with the help of Sigmund Freud's investigation of humor. In his study of the verbal structure of jokes, Freud (1905),[2] calls attention to the fact that although the meaning of jokes may be grasped quite easily, the wording is sometimes perplexing—the phrases are often arbitrarily abridged and may even skip the most significant parts of the message (pp. 168–69). This observation was anticipated by the German philosopher Theodor Lipps. In his essay on comedy and humor, Lipps declared that "a joke says what it has to say, not in few words but always in *too* few words, that is, in words that are insufficient by strict logic, or by common modes of thought and speech" (in Freud, 1905, p. 13).

The comic effect of conciseness may occasionally be seen in one-word puns. Freud illustrates this by Heinrich Heine's celebrated anecdote about a comic character who boasted of his close acquaintance with Baron Rothschild, who, he claimed, treated him as a *famillionär*. Looking at this curious expression, Freud inferred that the obscure term arose out of the witty amalgamation of two German words: *familiar* ("familiar") and *millionär* ("millionaire"). The result is a completely new word, not listed in standard dictionaries, which conveys a variety of amusing connotations. Though the linkage of words is a characteristic of German, whimsical word combinations also occur in other languages. Freud gives an example noting the composite term *alcoholidays* alluding to English drinking sprees during Christmas (1905, pp. 19–22). To express the various implications of such an abbreviation, one would be obliged to use many words, and so the economy of the single term comes as a pleasurable surprise. Freud suggests that the pleasure caused by jokes can be explained as a release of inner tension, resulting from the sudden comprehension of that which was initially unintelligible (1905, pp. 95-96). This mental effect may be compared to the satisfaction that some people achieve from the solution of riddles, the breaking of secret codes, or simply discovering the meaning of conventional symbols and signs. All of these involve flashlike insights, which are somewhat akin to the grasping of pictorial imagery.

Verbal puns have an obvious affinity with pictorial puns and witty portrait sketches. Freud saw in cartoons a sublimated form of aggression against persons who lay claim to authority and who are therefore commonly regarded as "sublime." (1905, pp. 200–201). The replacement of the exalted by the ridiculous is in fact experienced as comic, but Freud's concept of caricature is too restricted, since distorted physiognomic portraits are sometimes appreciated even by their subjects. Cartoons of unknown individuals may also be amusing, though they are usually less effective, since the degree of distortion cannot be properly evaluated. The artistic deformation may be so subtle that it passes unnoticed, or the caricature may be taken for an accurate depiction of reality.

Although the appreciation of physiognomic caricatures presupposes a familiarity with the subject, this may only involve a knowledge of their official portraits or, nowadays, more simply of photographs. Incidentally, neither the subject nor his photograph need be physically present and may in fact be superfluous. Cartoons are often more effective when juxtaposed with one's remembered image of the depicted person or, in the case of caricatures of obscure individuals, with the general notion of what a normal person looks like. The comic effect of graphic humor, however, depends upon the special quality it shares with verbal puns, namely, the severe conciseness which, as we saw in Bernini's sketch of Cardinal Borghese, may reduce an entire personality to a few graphic strokes. A sudden discovery of familiar features in the seemingly arbitrary signs comes as a surprise, sitrring a pleasurable release which may be expressed by a smile or laughter.

The universal appeal of physiognomic cartoons suggests that more may be involved than a simple deciphering of the portrayed person's identity. In other words, the distortions that distinguish caricatures from regular portraits may have additional implications. Henri Bergson observed that the comic effect of cartoons often implies an imaginary activation of the image, so that the essentially static design is perceived as if it was infused with movement (1956, pp. 74–79). He argued that this is due to the fact that a caricature is seen not as a factual depiction of reality, but rather as the result of an imaginary twist, which is reenacted in the viewer's mind. This contention may be supported by reference to similar phenomena occurring in other contexts. For example, a driver passing a road accident perceives the wrecked car as a result of a physical collision, rather than as an inert object, and in looking at the wounded he reenacts their injuries in his mind. The emotional reaction depends in both cases on the circumstances since open wounds on an anatomic model or a wreck displayed as a legal exhibit fail to arouse a similar response. To some degree this is also true of artistic representations, which are always more effective when perceived in their context. Bergson suggested that when one is familiar with the subject's face, the artistic distortion of his features is perceived as a grimace. This may be illustrated by one of the sketches that Freud himself drew for his article on

Michelangelo's *Moses* (1914, pp. 226–27; figs. 1–4). Since the drawing is immediately recognized as a representation of the familiar statue, Freud's exaggeration of *Moses'* features is perceived as a grisly snarl. This impression can probably be explained as a result of a mental oscillation between the distorted image and one's memory image of what the statue really looks like.

The efficacy of artistic distortion may be better appreciated by comparing the effect of Bernini's sketch of Cardinal Borghese with his marble bust of this ecclesiastic (figs. 3 and 4); Though the official portrait is remarkable for its vigor, the few lines and dots that make up the caricature convey a much stronger suggestion of animation. This effect was no doubt experienced more vividly by those who cherished a visual memory of the cardinal's face, but it can also be appreciated by those who are familiar only with the bust. Faces of the famous are not only better remembered from their cartoons than from their realistic portraits, but the real person sometimes appears as a weaker version of his caricature.[3]

The energizing impact of distortion is by no means limited to physiognomical portraits. It can also be experienced when looking at other kinds of imagery far removed from the realm of graphic humor. The effect is most notable in perspective representations of the human figure, technically called "anatomical foreshortenings." The term implies that the image shows an apparent reduction of proportions corresponding to the visual phenomenon that occurs when the human body is seen from a subjective point of view or when the body is situated in a position other than that in which it is normally observed (Arnheim, 1969, p. 99 and passim; Posèq, 1982, p. 64). Figures seen in such circumstances are subject to optical distortions that cause an irregular shrinking of their dimensions. The seeming alteration of proportions may be represented in painting—Mantegna's *Lamentation over the Dead Christ* is probably the best-known example of this kind (fig. 5).

Although the optical effects of distortion, including the apparent contraction of anatomical proportions, are an integral part of the visual experience of reality, they are seldom consciously noticed. The multitude of impressions one may have of a single object are mentally condensed into a synthetic memory image, which embodies the typical aspects by which the object can be identified. Perhaps because the visual impressions are so variable, extreme foreshortenings are not only excluded from the mental image but are usually also avoided in pictorial representations.[4] Even Mantegna, who was no doubt eager to astonish by the novelty of his composition, slightly modified the deformation of Christ's body for aesthetic purposes. The amendment may be seen if one compares the painting with a photograph of a living model in a similar pose (fig. 6).

The striking effect of visual distortions documented by modern photographs was formerly seen only in pictorial representations that deliberately ignored the conventional figure schemes. Looking at such images, one is often amazed at how much they differ from one's mental image of the human body. When photography was

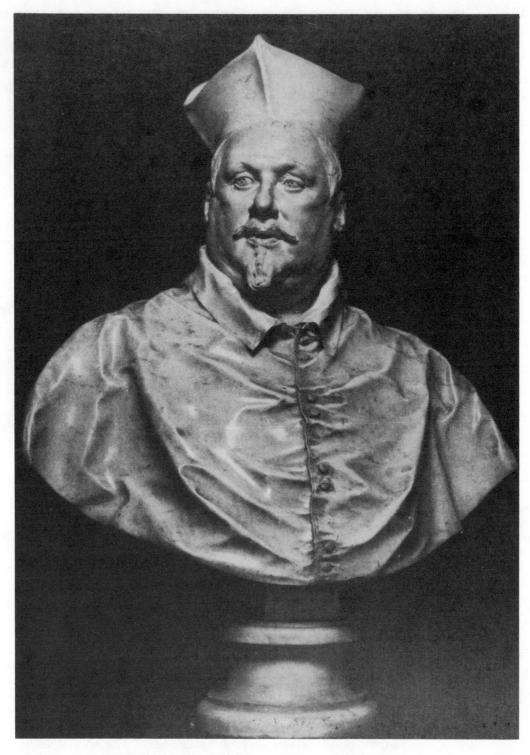

Fig. 4. G. L. Bernini, Bust of *Cardinal Scipione Borghese,* 1632.
Marble. Galleria Borghese, Rome.

10

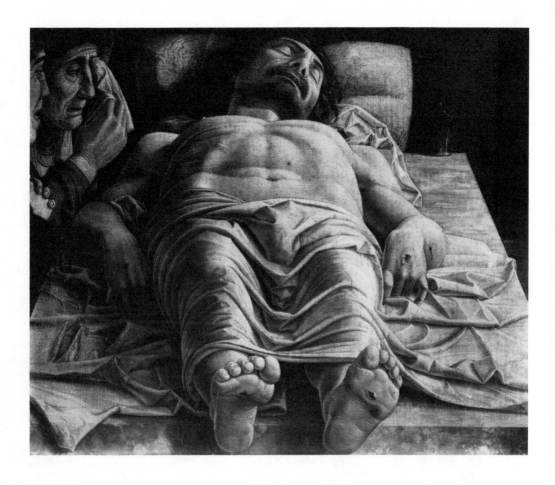

Fig. 5. Andrea Mantegna, *Lamentation over the Dead Christ,* 1480–90. Oil on canvas. Milan, Galleria di Brera. Photo: Alinaria/Art Resource, New York.

not available for comparison, such paintings were even more difficult to understand. This may be one of the reasons why artists usually preferred to show only slighter degrees of deformation so that the viewer would be able to relate the foreshortened representation to his memory image and to reconstruct mentally the figure's true shape. The seemingly arbitrary pictorial pattern is then transformed into a spatial representation that seems closer to actual experience than a conventional figure formula. Even more significant is the fact that the mental process of decoding, involving an oscillation between the initially obscure representation and the memory image, injects the figures shown in foreshortening with especial vigor. The seeming compression of proportions enhances the haptic effect of the figure so that it seems either powerfully drawn into the imaginary space or, vice versa, pushed out of the picture, into the spectator's realm.[5] In Mantegna's *Dead Christ* both effects occur simultaneously. The special immediacy of such figures is essentially independent of their gestures, but in figures shown in motion the expressive impact of contraction is even more strongly felt by the spectator.

11

Because the depictions of body foreshortenings require a subtle combination of the knowledge of anatomy and the laws of scientific perspective, their expressive potential came to be appreciated only in the Renaissance. The ambiguity of the seemingly misshapen but optically correct images fascinated both painters and theoreticians (in Barocchi 1960–62, 1:148–49). One of the pioneers of this method of representation was Piero della Francesca, who illustrated his book on pictorial perspective with a complex graphic system for the design of a foreshortened head (in Fasola, 1942, 1:173–74). The application of perspective to figural compositions was later investigated and illustrated by Albrecht Dürer (Panofsky, 1943, pp. 202, 267, figs. 312, 322; Strauss, 1972, figs. 95–107), and by Leonardo da Vinci, whose procedures were eventually transcribed in the (so-called) *Codex Huygens.* (Panofsky, 1940, *passim*). Leonardo made little use of this method in his own painting, but figures shown *dal sotto in sú* ("from below upwards") were much favored by his contemporaries (Maclehose, 1960, pp. 145–46).

Fig. 6. L. Smith, Live model in the pose of Mantegna's *Dead Christ,* 1977. Photograph. Reproduced from R. Smith (1974).

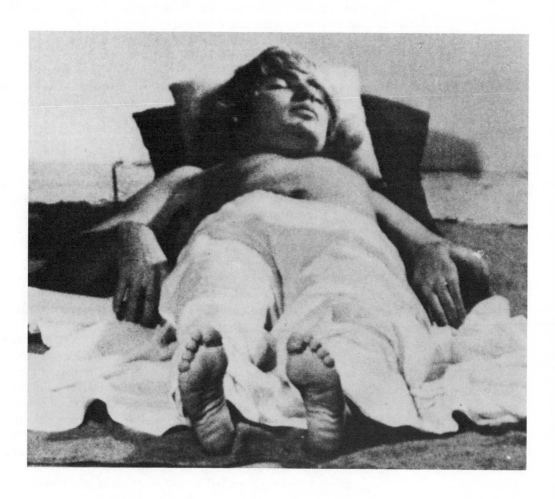

12

Fig. 7. Michelangelo, *The Last Judgment,* (detail: the flayed skin of St. Bartholomew with the supposed self-portrait of Michelangelo), 1536–48. Fresco, Sistine Chapel, Rome.

Among those who most brilliantly exploited the effect of foreshortening was Michelangelo, whose perfect control of this type of representation may be illustrated by the figure of the Divine Creator in the Sistine Chapel, where the correlation of God's violent gesture with the sharp contraction of his body conveys a formidable impression of physical energy (De Tolnay, 1949, p. 137, fig. 50). The expressiveness of such figures dazzled contemporaries, who described them as "terrible." Though originally restricted to the pictorial rendering of foreshortenings, the Italian term *terribilità* was later adopted by the critics as a tribute to the exalted mode of Michelangelo's work.[6] The term is also appropriate to the figure of the martyred Saint Bartholomew, who was flayed alive and is shown in the *Last Judgment* with his own skin draped over his arm (fig. 7). The folds of the flayed skin form a distorted self-portrait of the artist, which may be defined as a tragi-comic caricature. The intensity of the deformation embodied in this image may be appreciated by comparing the fresco with a bronze head of Michelangelo done by one of his followers (D'Ancona, 1963, p. 261, fig. 274).

The development of the sublime style closely parallels the contemporary evolution of pictorial satire. Here, too, one should recall Leonardo's pioneering contribution in his "grotesque" studies of strongly deformed physiognomic types (Johnson, 1942, pp. 141–45, and 1943, p. 192; Heydenreich, 1954, p. 102; Clark, 1961, p. 70). These studies may have inspired Albrecht Dürer, who invented an intricate graphic system for the classification of facial distortions (Panofsky, 1943, pp. 268–70, fig. 321; Strauss, 1972, figs. 116–20). Even Michelangelo took an occasional respite from his work on the Sistine vault to draw a mocking sketch of himself, engaged in his titanic task (fig. 8). The special pungency of this sketch is derived from the ironic manner in which the artist alludes to the "terrible" effect of his imagery; the figure which he is painting may be identified as the aforementioned image of the

13

Fig. 8. Michelangelo, Caricature of himself painting on the Sistine vault, 1510. Pen and ink. Archivio di Stato, Florence. Reproduced from Posèq (1978).

Creator. The appreciation of the graphic pun requires a familiarity with its subject, which in this particular case is a sublime work of art, whose expressive *terribilità* depends on anatomical foreshortening.

The comic pictorial genre came into its own only later, when the drawing of humorous portrait sketches was adopted as a playful hobby by members of the Carracci workshop (Kris and Gombrich, 1952, pp. 189–90 and passim). The artistic reputation of this school was mainly due to the sublime mode of their monumental frescoes, typified by a lavish deployment of sharply foreshortened nudes. Comparison of a study for a figure which Annibale Carracci painted in the Palazzo Farnese in Rome (Martin, 1965, p. 265, fig. 215) with two caricatures drawn by a member of his school (Kris and Gombrich, 1952, figs. 62–63), illustrates the expressive range of these painters.

The concomittance of the sublime and the comic also occurs in the work of other contemporary artists, such as Bernini, to whom many surviving 17th-century caricatures were formerly ascribed. Bernini was, of course, familiar with the depiction of anatomical

foreshortening and frequently employed it in preparatory drawings for his sculptures (fig. 2). The association of foreshortening with the sublime mode was so deeply rooted that statues were even set in elevated positions so that the *dal sotto in sú* optical contraction might contribute to their pathos (fig. 1).

Both pictorial depictions of foreshortening and caricatures were considered daring deviations from the conventional ideal of beauty, which was codified in the Renaissance schemes of anatomic proportions. The innovation attracted the sophisticated who admired the expressive potential of artistic deformations and enjoyed the special demand that such images make upon the viewer's capacity for perception. In modern terms one may say that they found that both types of imagery stimulated a spontaneous expenditure of mental energies which are projected upon the pictorial representation.

The application of Freud's theory of psychic release to the perception of artistic distortions may be supported by some behaviorist experiments in the apprehension of images of objects shown in an atypical position. Practical demonstrations consisting of perspective drawings of simple objects shown in various degrees of foreshortening showed that when there was only a slight degree of distortion the object was easily and swiftly identified, whereas the recognition of sharply foreshortened objects took longer, and there was a direct relation between the length of time required for recognition and the degree of perspective deformation (Shepard and Metzler, 1971, pp. 701–3; Cooper and Shepard, 1984, pp. 114–20). The lengthening of the mental process implies that the recognition of a sharply foreshortened object presented an initial difficulty, which was overcome by additional mental effort. Reporting the results of their investigation the psychologists suggested that the identification of the imagery involved "a mental rotation of the depicted object from the atypical to a more familiar position, which was not unlike a rotation of a real object in space." One may thus assume that once the object is turned around in one's mind, and the initially obscure image is identified as a depiction of a familiar object, a release of inner tension is experienced. The behaviorist experiments may also be valid for the human body; one may even argue that in looking at the foreshortened body of Mantegna's Christ, the viewer mentally makes the necessary adjustment. The mental process may be understood as a reversal of the procedure of perspective foreshortening illustrated in the *Codex Huygens*. The imaginary rotation of the foreshortened figure may also render a strong sensation of release, and the simultaneity of the viewer's experience of the surplus energy with his perception of the deformed figure makes it seem activated by an inner energy. The seeming animation of distorted physiognomical portraits was, as we have already said, also explained by a similar process.

The curious coincidence and incongruity between Italian artists' pursuit of the sublime and their causal excursions into the comic

may seem less arbitrary when we consider that the structural affinity shared by the two genres results in an analogy of their perceptual effect. In both cases the conciseness and the seeming compression of the figures cause a preliminary difficulty in deciphering, but the mental energies spent on sorting out such distortions endow the images with an immediacy that is rarely equalled by other types of representation. Though these artistic aberrations are no longer a novelty, the special challenge they impose upon the visual perception still persists. The preliminary obstacle in the comprehension of the imagery attracts the viewer's curiosity, activating his imagination. While the visual data are mentally rearranged, and the missing details are filled in from the viewer's own stock of memory images, he is subtly drawn into an active participation. The implicit fusion of the external visual stimuli with the viewer's surplus energy strongly enhances the figures' effect. The aesthetic effect of caricature and anatomic foreshortenings are sometimes so closely akin that when taken out of their context the pictures may be easily misunderstood; a comic sketch may be taken for a highly expressive tragic figure, while a foreshortened human body may be perceived as ridiculous rather than sublime. One may, therefore, assume that the context in which such images are presented conditions the viewer's perception of their mode.

Notes

This essay originated as a lecture delivered to the plenary session of *The Fourth International Congress on Humor* (Tel-Aviv, June 10–15, 1984) cf. Abstracts, n.p.

1 The similarity of the comic and sublime was noted by Kris 1952, pp. 187–88.

2 For the relevance of this passage to the study of cartoons see Kris 1952, pp. 174 ff.

3 For instance, Daumier's famous caricature of King Louis-Phillippe as a *poire* (pear), a slang term for fathead, conditioned the perception of the Roi Bourgeois by his subjects, and even today he is always remembered from Daumier's cartoon. (See the later variations on Daumier's model by Phillipon, reproduced in Kris, 1952, fig. 75, n.p.)

4 On the special perception effect of such foreshortenings and on the artist's reluctance to depict them, see Räthe 1938.

5 The expressive effects of foreshortening were admired by G. Vasari, *Le Vite* 1:177; cf. Maclehose 1907, p. 216.

6 For various interpretations of the meaning of *terribilità*, see Dolce, 1960–62, 1:49; Blunt, 1966, p. 154; Białostocki, 1967, 1:222–25; Summers, 1981, pp. 234–41, 522; Posèq, 1983, pp. 80–103.

References

Ancona, d', P. (1963). *Michelangelo*. Milan: Bramante, 1964.

Arnheim, R. (1956). *Art and Visual Perception*. London: Faber & Faber, 1969.

Bergson, H. (1956). "Laughter." In Sypher, 1956, pp. 61–190.

Białostocki, J. (1967). "Terribilità." *Stil und Uberlieferung in der Kunst des Abendlandes, Akten des 21, Internationalen Congeresses für Kunstgeschichte in Bonn 1964,* 3 vols. Berlin: Mann.

Blunt, A. (1962). *Artistic Theory in Italy, 1450–1600*. Oxford: Clarendon Press, 1966.

Clark, K. (1939). *Leonardo da Vinci*. Harmondsworth: Penguin, 1961.

Cooper, L. A., & Shepard, R. N. (1984). "Turning Something over in the Mind." *Scientific American,* 251, 6:114–20.

Dolce, L. (1960–62). "Dialogo della pittura." In P. Barocchi, ed., *Trattati d'arte del Cinquecento,* 1, pp. 140–206. Bari: Laterza.

Fasola-Nicco, G., ed. (1962). *Piero della Francesca, De' Prospectiva Pingendi*. Florence: Sansoni.

Freud, S. (1905). *Jokes and Their Relation to the Unconscious. Standard Edition,* 8.

———— (1914). "The Moses of Michelangelo." *S.E.,* 13:211–36.

Harris, A. Sutherland. (1977). *Selected Drawings of Gian Lorenzo Bernini*. New York: Dover.

————. (1975). "Angelo de Rossi, Bernini, and the Art of Caricature," *Master Drawings,* 13:158–60.

Heydenreich, L. H. (1954). *Leonardo da Vinci*. New York & Basel:

Hibbard, H. (1965). *Bernini*. Harmondsworth: Penguin.

Johnson, M. (1942). "Leonardo's Fantastic Drawings." *Burlington Magazine,* 80:141–45; 81:192–95.

Kris, E. (1952). "The Psychology of Caricature." *Psychoanalytic Explorations in Art,* pp. 173–88. New York: International Universities Press, 1962.

Kris, E. & Gombrich, E. (1952). "Principles of Caricature." In *Psychoanalytic Explorations in Art,* pp. 189–203. New York: International Universities Press, 1962.

Maclehose, L. S. (1907). *Vasari on Technique*. New York: Dover, 1960.

Martin, J. R. (1965). *The Farnese Gallery*. Princeton, NJ: Princeton University Press.

Panofsky, E. (1940). *The Codex Huyghens and Leonardo da Vinci's Art Theory*. Nendeln, Lichtenstein: Kraus reprint ed., 1968.

————. (1943). *The Life and Art of Albrecht Dürer*. Princeton, NJ: Princeton University Press, 1971.

Posèq, A. W. G. (1978). *Format in Painting*. Tel Aviv: Gomé, Tcherikover.

————. (1982). *Perspectiva* (in Hebrew). Tel Aviv: Gomé, Tcherikover.

————. (1983). "The 'Terribilissimà arte' of Foreshortening in the Mannerist Theory of Art." In *Norms and Variations: Essays in Honor of Moshe Barasch,* pp. 80–103. Jerusalem: Magnes.

Räthe, K. (1938). *Die Ausdruckfunktionen extrem verkurtzer Figuren*. Nendeln, Lichtenstein: Kraus reprint ed., 1968.

Shepard, R. N., & Metzler, J. (1971). "Mental Rotating of Three Dimensional Objects." *Science,* 171:701–3.

17 Smith, R. (1974). "Natural versus Scientific Vision: The Foreshortened Figure in the Renaissance." *Gazette des Beaux-Arts,* ser. 6, 84:239–48.

Strauss, W. L. (1972). *Albrecht Dürer: The Human Figure; The Complete Dresden Sketchbook.* New York: Dover.

Summers, D. (1981). *Michelangelo and the Language of Art.* Princeton, NJ: Princeton University Press.

Sypher, W., ed. (1956). *Comedy.* Garden City, NY: Doubleday.

Tolnay, C. de. (1960). *Michelangelo,* vol. 5, *The Final Period.* Princeton, NJ: Princeton University Press, 1971.

————. (1945). *Michelangelo,* vol. 2, *The Sistine Chapel.* Princeton, NJ: Princeton University Press, 1949.

John A. Phillips,
Ph.D.

Michelangelo's Eve in the Sistine *Temptation*

The history of the creation and fall of mankind is depicted on the vault of the Sistine Chapel in a series of three scenes, the *Creation of Adam,* the *Creation of Eve,* and a third scene consisting of the *Temptation and Fall* and *Expulsion from Paradise* (fig. 1). This

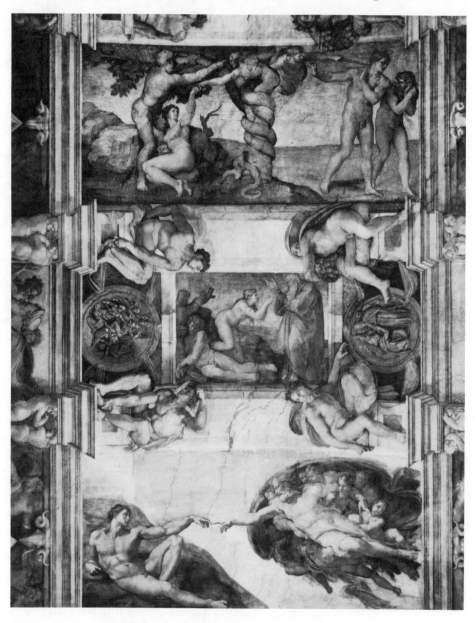

Fig. 1. Michelangelo, Central section of the Sistine Ceiling: *The Temptation and Expulsion, The Creation of Eve,* and *The Creation of Adam,* 1510–11. Fresco. Sistine Chapel, Vatican, Rome. Photo: Marburg/Art Resource, New York.

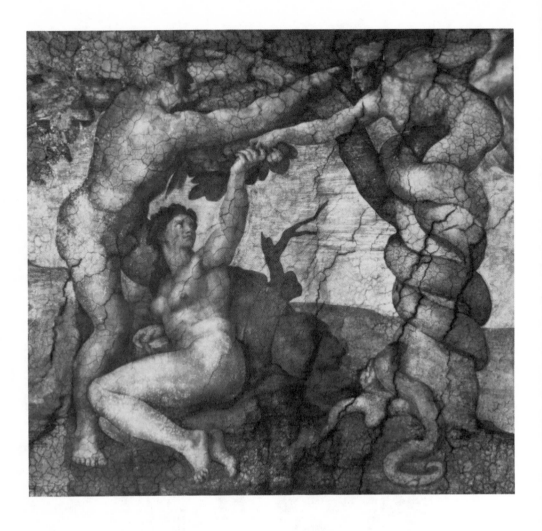

Fig. 2. Detail of fig. 1, *The Temptation and Fall.*

triad—functionally, though not technically, a triptych—is placed in the center of the ceiling, so that the *Creation of Eve* (not, as is often supposed, the *Creation of Adam*) serves as the midpoint of Michelangelo's collossal conception. I propose to examine in detail the character and activity of Eve in the temptation half of *The Temptation and Expulsion* panel (fig. 2) as a way of understanding why her creation should serve as the focus of the entire history and as the centerpiece of the three panels. Along the way, I will indicate a possible direction for inquiry into the theological dimension of the Sistine Chapel ceiling.

The Woman-Headed Serpent

On one side of the *Temptation and Expulsion,* Eve reaches for the forbidden fruit at the urging of a serpent with the head and torso of a female human, (fig. 2) presenting us with our first problem: Why partly human? And why female?

The serpent's human head, a detail about which Genesis itself tells us nothing, was by Michelangelo's time conventional in

Western art. Because the marvelous animal could talk, early commentators, and then artists, gave it a human visage. But why female? Jewish rabbinical tradition had generally portrayed the serpent as a masculine seducer, since he was either the foil of Sammael or Sammael himself in disguise, and the story was increasingly supposed to have to do with the onset of sexual activity or awareness which passed from the serpent to Eve, who either had an innate desire for him or developed one. Some early representations of the temptation followed the Jewish tradition and depicted the serpent as male. But other factors, particularly in the Christian tradition, led to the eventual depiction of the serpent more often as female.

In the first place, the Latin Vulgate Bible had rendered the snake as *serpens,* a word in the feminine gender. The early Church Fathers, influenced spiritually by the monastic ideal of celibacy and intellectually by pagan stories such as that of Pandora, assumed the woman's guilt for the Fall and tended to regard the Garden of Eden story as final proof of the conspiratorial and seductive nature of women. In an influential essay written almost seventy years ago, J. K. Bonnell (1917, pp. 255 ff.) argued that the visual representation of this tendency began with the mystery plays in the 14th century, where the need for the serpent to speak lines required an actor dressed to the waist or neck in a snake costume. Painters and sculptors thereafter depicted the scene as it came to be imagined popularly, including the human-headed serpent. Although iconographical evidence shows that in fact the visual portrayal of a partially human snake began earlier than the 14th century (Kirschbaum, 1968, p. 59), there is no reason to believe that dramatic presentations of the Fall could not have helped to establish this as a tradition. Although males played the role on stage, it required a youth with long, "angelic" hair to establish his identity as a divine being; although fallen, Satan was still an angel. The two characters on stage who seemed to have most in common were thus Eve and the apparently female serpent.

The influential commentary of the church historian Peter Comestor, who died in 1173, held that "Satan chose a certain kind of serpent . . . having a virginal face, because like things applaud like" (Migne, 1844, vol. 198, col. 1072). The *Chester Play* (1328) put this decision into the script itself, as Satan determined "a mayden face, her kinde will I take" (Bonnell, 1917, p. 282). Satan appears as a woman in order to be "like" Eve, which is not far from the notion that Eve is somehow "like" the serpent with the woman's head. Eve the seduced is, after all, Eve the seducer at the same time. To subvert Adam, the perfect being, Eve will require the superhuman knowledge promised by the snake. Necessarily she becomes Satan's ally in the plot to overthrow Adam. Thus pagan tales of demonic or amoral women, rabbinical legends about Lilith and Sammael, and early Christian apologetical assumptions about the dangers of the female sex are brought to the service of the exegesis of a text which by itself is already highly suggestive,

given Eve's domination of the events and the sequence of the fall from grace: first she, then he.

In fact, the notion that Eve and Satan were in collusion against Adam has a theological and ideological as well as artistic history—all three of which had combined dramatically during the period framed by Michelangelo's birth and death (1475–1564). It is astonishing to note how many remarkable temptation scenes were painted within that religiously and politically troubled time: by Michenangelo, Raphael, Bosch, Cranach, Dürer, Gossart, and that Eve specialist, Hans Baldung Grien. Why this sudden outpouring of artistic renditions of Eden? Certainly it was a popular subject with patrons, perhaps because it provided opportunities to realize religiously acceptable depictions of the naked human form, interest in which characterized the Renaissance. But we have also to account for the following coincidences:

1. During this period, the traditions concerning Pandora, illuminated in Dora and Erwin Panofsky's *Pandora's Box,* merged artistically with traditions concerning Eve, adding to Jewish and Christian testimony (through Erasmus among others) the evidence from pagan literature that the first woman was indeed at fault for the fall of mankind and that all her sex was similarly untrustworthy.

2. During this same period, the first of what would be thirty editions of the *Malleus Maleficarum* made its appearance. This notorious theological and legal manual for the identification and eradication of witches, published in 1486 with the approval of the theology faculty of the University of Cologne and the sponsorship of Innocent VIII, the pope of Michelangelo's childhood, rested its case on a highly tendentious characterization of Eve, arguing that the first woman was an ally, and all women were potentially allies, of Satan against men. In words strikingly similar in style and content to Hesiod's characterization of Pandora, the *Malleus* summed up women as "beautiful to look upon, contaminating to the touch, and deadly to keep" (Kramer and Sprenger, 1948, p. 46).

3. It is difficult to know how much weight should be given to an occurrence which certainly affected the popular understanding of the sexual lesson of the Fall. The return of Columbus's sailors from the New World was followed by an epidemic in Italy, and then throughout Europe, of a new disease, the cause and course of which were described in 1530 by the physician and poet Girolamo Fracastoro, who gave it the name "syphilis." The relationship between sin, sex, and death had never been so clear to the human imagination, and the heretical equation of reproduction with damnation must never have seemed so tempting a theological theme.

4. And indeed, the identification of sexual intercourse with the fall from grace, which was never far from popular imagination, did become a serious theological position. In 1529 in Antwerp and

again in 1532 in Cologne—where the *Malleus* had found formal support—Heinrich Cornelius Agrippa published *De originale peccato,* a radical modification of the Augustinian tradition concerning the role of Eve in the Fall which perfectly suited negative suspicions about the nature of women and human sexuality.[1]

After some hesitation in his earlier writings, Augustine had come to recognize that the allegorical interpretation of the Fall that originated with Philo of Alexandria and established itself in Christian theology through the writings of Origen, Clement of Alexandria, and Ambrose was no longer tenable because it made Eve somewhat less than fully human. In the older view, Adam, as Reason, participated fully in the transcendant reality, while Eve, Sense, shared in the divine world only through her relationship to her husband. The serpent, as Pleasure, successfully seduced Sense into an attachment to the physical world, and the game was up. Thus fallen, Eve was empowered to seduce Reason to turn also from heavenly things toward the corporeal.

The older view suited the belief that it was Christ, as the Second Adam, who reversed the action of the drama. The incarnated *Logos* redeems the fallen woman by disregarding her womanliness, "elevating her to male completeness" (Ambrose; Migne, 1887, vol. 15, col. 1938) and removing the source of her sexuality, so that "she will be called man" (Jerome; Migne, 1884, vol. 26, col. 567). It was this curious use of the notion of Atonement that provided a theoretical basis for the monastic ethic of virginity (Bugge, 1975, p. 12). But Augustine correctly recognized that the theory provided Manichaeism and Gnosticism with the rationale for their elaborate mythologies and ritual and moral practices which supposedly "restored" women to their lost status as human beings, thus inviting heresy along with its patent misogyny.

Augustine therefore esablished Eve's full humanity in *De trinitate,* allegorizing her this time as *scientia,* the "lower reason," which is bound to Adam's *sapientia* or "higher reason," which was to govern her and secure her allegiance to the transcendent, the *spiritualia* and *invisibilia* (Migne, 1886, vol. 42, cols. 819 ff.).

The "real" Fall is thereby shifted from Eve's attraction to the fruit (which it is the legitimate function of *scientia* to investigate) or the disobedient eating of the fruit (at most, a venial sin), to Adam's acceptance of the fruit from her hand. With this act, he surrenders his governance over her and enslaves the couple to the world of the flesh, *corporalia.* Thereafter, the evil they would not do is what they do, and their sexuality, formerly under the control of the will, is enthralled by concupiscence.

Agrippa followed the general outlines of Augustine's theory, as it had been further developed by Hugh of St. Victor (Migne, 1880, vol. 176, cols. 314–18) and Bonaventure (Bonaventure, 1967). But confusing result with cause, he gave it as his opinion that it was the first sexual act that was the actual occasion of the Fall and that the serpent, described suggestively by Augustine as "that creeping, slippery thing," was in reality the male sexual organ activated by Eve. The guilt for the Fall, formally attached to

Adam by Augustine and required by Church doctrine because of the orthodox, Pauline notion of Christ as the Second Adam who must overcome the sin of the First, passes to Eve. Augustinianism notwithstanding, popular understanding of the Fall had always remained, and continues to remain, closer to the suspicions of the early Church Fathers.

Certainly Agrippa's position was never authorized by the Church. Nor is there any evidence whatever that Michelangelo was even familiar with Agrippa's or congenial views of the Fall. What the appearance of *De originale peccato* demonstrates is the tenaciousness of the older view and its appeal, especially during this period, to visual artists.[2]

Fico and *Fica*

However Michelangelo may have been influenced by traditional or contemporary theological thinking regarding the Fall, the Eve of his Sistine temptation shares with many other depictions a clear, apparently natural affinity with the woman-headed serpent. *She* is the one who reaches toward and relates directly to the snake. While her left hand receives the fruit, mimicked by a lifeless tree suggesting death, the standing Adam makes an obvious countermovement. We assume, and Michelangelo's commentators confirm, that he is also reaching for the forbidden fruit. But the evidence—the fruit itself—is lacking. Perhaps Michelangelo's intention was rather that Adam is reaching in haste for the leaves with which he and his wife will cover themselves— an idea which is artistically (and, as we shall see, psychologically and theologically) more coherent, despite the fact that in the expulsion scene, Adam and Eve are still naked.

On the question of the identity of the fruit, Genesis is, once again, silent. Western tradition has identified it as an apple, probably because of the belief from antiquity that the apple was both a divine and an aphrodisiac food and because of the accidental similarity in Latin between "apple" (*mālum*) and "evil" (*malum*).[3] Artistic interpreters of the story were apparently free to follow other traditions, especially that of the Greek Fathers, for whom the fruit was a fig. Certainly Michelangelo has depicted the leaves of a fig tree, and we must suppose the fruit to be the same.

Now, for a Florentine of the Renaissance the sexual overtones and connotations of "fig" (*fico*) were endless. Vulgar custom used the word *fica* to refer to the female genital, and a coarse expression for sexual intercourse was the assonantal *ficcare,* "to put into," "thrust," or "shove." The question must arise whether Michelangelo intended us to make any of these associations in understanding his portrayal of Eve.

Some years ago, the art historian Leo Steinberg taught a graduate seminar on Michelangelo at Hunter College and, in keeping with his insistence on developing in his students an absolutely insatiable curiosity about detail, asked a single question for the final essay: Eve is obviously reaching for the fruit with her

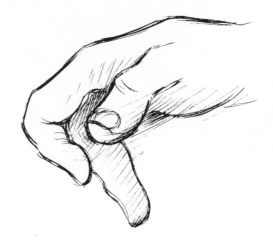

Fig. 3. William Conger. Detail of the right hand of Eve from *The Temptation and Fall.* Pen and ink on board. Sketch courtesy the artist.

left hand; what is she doing with the right, the "idle" hand? The responses from his students were collected and published, with commentary from their teacher, in 1976 (Steinberg, 1975/76). The artistic problem is that the positioning of Eve's fingers is highly unusual (fig. 3) and, it would appear (since Michelangelo was perfectly capable of painting human hands), deliberately contorted. She seems to be pointing to her pudenda, but she does not point, as she naturally would, with her index finger. I would say that this can only be deliberate on the part of the artist. The solution proposed by Steinberg's students—scandalous when one considers the subject, artist, and location of the painting—is that Michelangelo intended at least the suggestion of an obscene gesture.

I must leave to Steinberg's colleagues the decision whether the appropriate response to this proposal ought to be silence, amusement, or contempt and to psychohistorians the delightful problem of what use can be made of this information. As a student and teacher of religion, let me offer further evidence that this was exactly what Michelangelo intended and that it provides an important clue to the theological understanding of this scene and its sisters in the center of the ceiling. Consider first that *fico* or *fica,* "fig," had in Renaissance Tuscany yet another meaning. It was the name for that obscene, vigorous gesture of contempt one Italian might make to another, apparently by placing the thumb between the other fingers and flicking it against the upper teeth. Shakespeare referred to it half a dozen times in the plays, usually as "the Spanish fig," and its most memorable appearance in the plays is as the insult passed from Capulet to Montague in *Romeo and Juliet.*[4]

We have the evidence that Michelangelo himself knew the gesture and its meaning well enough. On an odd page of drawings—really "doodles"—he has made a sketch of an antaomically correct *fica* (fig. 4). These sketches, probably unrelated and drawn at different periods in his career, have been subjected to sensational interpretations based upon the identification of the various heads and the relationship between the drawings. I have no wish

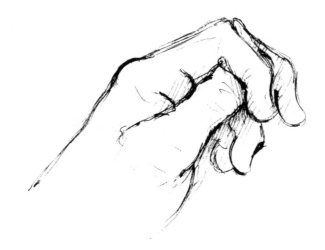

Fig. 4. William Conger, Enlarged detail of Michelangelo's representation of the *fica*, from a sheet of sketches in the Archivio Buonarroti, Florence. Pen and ink on board. Sketch courtesy the artist.

to theorize about the sketches. One matter is beyond dispute: From the hand of Michelangelo, we have an easily identifiable obscene gesture.

We also have an important precedent in the use of the *fica* as a theological and artistic subject. Michelangelo's beloved Dante has included in the *Inferno* (cantos 24–25) an encounter between the poet and several thieves, including one Vanni Fucci, whose historical counterpart was involved in a robbery of the sacred vessels from the church of San Jacopo in Pistoia, a traditional rival of Florence. Dante pictures him bound and rebound by snakes, that eternally prevent him from eternally attempting an extreme form of blasphemy, "making *le fiche* ["the figs"] toward God" with both hands (Singleton, 1970, 2:428–29).

According to Villani's chronical of Florence, when the Florentines captured a Pistoiese stronghold in 1228, they found a tower with two marble arms which made *le fiche* toward Florence (Celestino, 1880, chap. 4, p. 64), and in the same century, in Prato, a statute stipulated fines or whippings for "whoever has made the *fiche* or has shown his buttocks toward the image of God or the Virgin" (Tommaséo, 1865, p. 337). For Dante, Fucci functions not simply as a thief in the usual sense, but as one who has robbed divinity of its due respect—"the most presumptuous against God of all the spirits he has seen in hell" (Singleton, 1970, 2:429). He represents the depth of depravity possible for a human being. That is, his sin is the original sin of Adam and Eve.

But if we have a suitable precedent for Michelangelo's theological use of an obscene gesture, we do not have the precise gesture itself. Eve's hand does not form *la fica* as Dante and Michelangelo knew it; perhaps once especially identified with northern Italy but now recognized throughout the Mediterranean, the anatomy of "the fig" is quite specific (Morris et al, 1979, pp. 148–55). It is meant to mock female genitalia, the thumb substituting for the erect clitoris. The universal and probably more ancient *digitus obscenus* (which seems to have been particularly associated with Roman culture) is more obviously phallic and

representative of male sexual aggression. But Eve is not making this gesture either. There is, however, a less familiar hand communication for copulation which does fit, although we cannot say whether or how widely it was known in Michelangelo's Italy. It is now rarely used or understood because it has become or was confused with a widely used sign for good luck or for invalidating a statement: crossing the fingers (Morris et al, 1979, pp. 18–19). In the original, obscene usages, the forefinger was placed on top of the middle finger (and sometimes rubbed rhythmically). It appears to have been the least aggressive and most seductive of the three gestures. In the same 1979 study, one northern Italian subject explained that the middle finger placed over the forefinger means that the male wishes to be in the superior position; reversed, that the female would be on top. This latter gesture is the one Eve makes with her right hand.

Her gesture also points unmistakably to her genital. Far from "idle," then, Eve's right hand is a vital link in the chain of what Elizabeth Katsivelos called "a spiraling force of cognition" which courses through her body (Steinberg, 1975/76, p. 131). It moves from the forbidden *fico* through her left hand and arm, then down into the right arm ending in an obscene gesture of seduction, which, in turn, directs our attention to what is the real forbidden fruit, Eve's *fica*.

Eve's Posture

Obscene gesture or not, the thematic logic of Michelangelo's conception of the original sin is persuasive: *fico, fica.* And this brings us at least to the real question: Why is Eve's genital, the woman's genital, the "real" forbidden fruit? Here we must venture into that murkiest of forests, Michelangelo's psychology and religious sensibility. One's footing is bound to be insecure.

Once again, our best evidence must be what we see. As Charles de Tolnay has observed, Eve "is seated with bent legs in a pose considered from antiquity as an erotic position, [her] voluptuous body outlined with rhythmic contours" (1945, 2:31). If, as Steinberg once said about Michelangelo's work, anatomy is theology, we are bound to ask the question de Tolnay does not: What is the theology of such a pose and positioning? I propose that any observation of her posture and her positioning vis-à-vis Adam must conclude that it is sexually provocative—as deliberately contorted as the fingers of her right hand.

While Adam moves vigorously toward the tree, to seize either fruit or leaves, Eve's attitude is fundamentally languid. Only her head and torso turn as her arm reaches toward the serpent. But if one rotates her head and torso back to what would have been their original positions, it appears as though the serpent has either just interrupted or is about to preside over oral sexual activity.[5] Supposing as I have that Michelangelo's *Temptation* should be regarded as one of those highly charged sexual interpretations of the Fall that appear to have dominated artistic, intellectual, and

popular understanding of the original sin during his lifetime, I have nevertheless been unable to locate any artistic precedent for a conception which is *quite* so original.

Let us venture further. The dead tree in the background, which mimics Eve's reach toward the Tree of Knowledge, adds an element to Michelangelo's interpretation that is bound to excite the curiosity of any who remembers the classic Gnostic cycle of existence in this corrupted world: Sin, curse, sexual activity, and the potential for reproduction, which means the potential for death—all these elements are certainly present in Michelangelo's depiction of the Fall. But for Gnosticism, it is of course re-productive, genital sex that locks us into the nightmare of history. Most of the Church Fathers acknowledged sexual activity in paradise *prior* to the Fall; some asserted, contrary to the biblical command that the couple were given before the Fall that they were to "be fruitful and multiply," that such activity was the innocent, and above all, nonreproductive, sex play of children. The Fall is a fall into reproductive sex and therefore into birth and death—the endless, inescapable, and cursed cycle of *eros* and *thanatos,* which, according to Liebert (1983), were Michelangelo's fundamental themes.

It is, of course, possible that Michelangelo has depicted a moment *before* the actual Fall, with Adam and Eve interrupted at innocent play. Anciently, some Gnostic groups appear to have practiced free, noncoital sex in the hope that emulating the activity of Adam and Eve prior to the Fall would return them to paradise; the eschaton was imagined as a return to the prelapsarian state of mankind, when human sexuality was for the purpose of play, not reproduction. Such practices seem to have survived among groups called, collectively and vaguely, "Adamites," within the Bogomil movement, which brought the Cathars to France as the Albigensians and to Italy as the Patarines—who established one of their largest churches in Florence and survived at least until the death of Dante. We know practically nothing about the Adamites, but such sexual practices were notorious enough to have characterized the entire Catharist heresy, known for its Bulgarian origins, as *bolgres* or *bougres,* loaned from French into English as "buggers."

But is is more likely that Michelangelo understood that sexual activity was *about* to commence and that he identified it not with the play of angels, but with the primal sin of humans.[6] Oral sex appears to be Michelangelo's original sin, and we should bear in mind that comparative mythologists have always insisted that eating and copulation are inseparable themes of the Genesis account. Adam and Eve presume ultimately against God through greed and insult, like Dante's thief. In the expulsion half of the scene (fig. 5), which is otherwise quoted from the convention represented by della Quercia and Masaccio, Eve's glance backward registers not the traditional grief or contrition, but anger and defiance. The Eve of the expulsion does not resemble the Eve of the temptation, but the serpent.

Fig. 5. Detail of fig.
1, *The Expulsion.*

**Eve and the The-
ology of the
Ceiling**

However Michelangelo may have regarded the original sin, the
gesture of Eve's right hand and the play on the identity of the
forbidden fruit provide vital clues to the interpretation of the
triptych as a whole. In the most famous panel of the three, God
startles Adam into life with the reach of his right arm. And once
again, we must be certain that the right knows what the left is
doing. Beneath the left arm of God are the figures of a woman
and a child on whom God's finger falls (fig. 6). The woman,
Steinberg surmises, is Eve:

> Crouched in the posture of the familiar *Venus accroupi,* she
> eyes God's latest invention with the keenest interest and
> reacts with a left-handed gesture, gripping the heavy paternal
> arm that weighs on her shoulder.
> And there is more, for being all-woman, she relates as well
> to the child. God's far-reaching arm, yoking her huddled
> form, comes to rest on a powerful putto reclined in Adamic
> pose, a child overscaled for his infant years and gravely
> serious—the only person within these biblical histories in eye
> contact with the beholder. Michelangelo surely meant him to
> represent the Second Adam, so that the span of God's arms
> becomes coextensive with the redemptive history of the race.

Fig. 6. Detail of fig. 1, section from *The Creation of Adam* showing Eve (?) beneath the left arm of God.

And the Child's intimate nestling near to the woman's limbs makes him the son of Eve, son of the First Eve as of the Second. For the First is the type of the other: as theologians used to point out, the "Ave" by which Mary is hailed is but "Eva" reversed. (Steinberg, 1980*b*, pp. 437–39)

The First Eve is the Second Eve as well, and the creation of the First Adam directs our attention to the advent of the Second, the Christ. Each Old Testament scene on the Sistine ceiling must be read, according to the older exegetical method, typologically as an event in the New, including the panel at the center of the ceiling that serves as its axis: the *Creation of Eve.*

Here, Eve emerges from the side of the sleeping Adam at the beckoning of God. The thickness of her body suggests her role as the mother of humanity, and her obedient and prayerful attitude represents the relationship to God appropriate for unfallen humanity. The panel is iconographically unexceptional, standing in the tradition of three-figured creations of Eve, which, by Michelangelo's time, was already at least four centuries old and

included renditions by Wiligelmo, Maitani, and the relief Michelangelo knew very well, by Jacopo della Quercia. Reading the panel typologically, the Church is the Second Eve born from the side of the Second Adam, the dead Christ. And it is this reading, and the location of the panel in the chapel, that interest us.

Howard Hibbard, in the text most widely used to introduce Michelangelo to students, reminds us that the chapel choir screen separating the sanctuary from the laity was, at the beginning of the 16th century, situated directly beneath the triptych, so that *The Temptation and Expulsion* would have been the final painting on the laity side and *The Creation of Eve* the first in the sanctuary (Hibbard, 1974, pp. 113–15). One therefore passed into the saving community by moving from beneath one panel to the other. On the one side, symbolically, was unbelief, unregenerated man, the Old Covenant, on the other, faith, the community of the redeemed, the New Covenant.

Juxtaposed on either side of the *Creation of Eve* are two prophecies of the virgin birth of Christ. The prophet Ezekiel points to his book, perhaps, as Hibbard believes, to that passage believed to be messianic and Mariological at that time: The gate of the sanctuary is shut and may be opened by no man, but only by the Lord God of Israel (Ezek. 44:1–3)—meaning allegorically not only the gateway to the door between belief and unbelief, but the womb of the Virgin. On the other side, the Cumaean Sibyl reads, in Hibbard's opinion, her prediction from the Fourth Eclogue of Vergil, verses 4–10:

> We have reached the last Era in Sibylline Song. Time has conceived, and the great sequence of the Ages starts afresh. Justice, the Virgin, comes back to dwell with us, and the rule of Saturn is restored. The Firstborn of the New Age is already on his way from high heaven down to earth.
>
> With him, the Iron Race shall end and Golden Man inherit all the world. Smile on the Baby's birth, Immaculate Lucina: your own Apollo is enthroned at last. (Hibbard, 1974, p. 115)

As several of Steinberg's students surmised, the gesture of Eve's right hand is, although a gesture of depravity, not *simply* that; Michelangelo's details are never anything simply. This is not *la fica,* though it is meant to suggest it. This indicative gesture must also carry us from that tragically fallen world on the one side of the choir screen to the community of the redeemed on the other. She points not merely to the genital through which all are born, sin, and die, *eros* and *thanatos* eternally recurring, but also to *spes,* the hope for mankind, the gateway of the Second Eve through which will pass the Second Adam, bringing salvation. "For behold, a virgin shall conceive and bear a son, and his name shall be called Emmanuel, which means, God with us."

Notes

1 Agrippa, *Opera* (Hildesheim and New York: Georg Ohms, n.d.). For this reference, the discussion of Augustinian and Agrippan views of the Fall, and references to Augustine and St. Hugh of Victor, which appear below, I am much indebted to A. Kent Hieatt (1980).

2 The identification of the original sin with sexual awareness or activity was quite explicit in the work of Hans Baldung Grien and Jan Gossart. See the discussion of Hieatt, 1983, pp. 290–304.

3 The Vulgate rendition of Song of Songs 8:5 (*sub arbore malo*) was probably instrumental in making the identification between the apple and evil ("under the apple tree" = "under the evil tree") as well as reinforcing the connection between sexual intercourse and the original sin (*ibi corrupta est mater tua, ibi violata,* "where your mother was corrupted, violated").

4 As "fig," "figo," or "fico," it is found often in an oath uttered by Pistol in *Henry V,* iii, 6, 62, and iv, 1, 60; *Henry VI,* part II, ii, 3, 67. See also *Henry IV,* part II, v, 3, 115, and *Merry Wives of Windsor,* i, 3, 33. In *Romeo and Juliet,* i, 1, 38–46, it appears as an actual gesture.

5 I have located at least one additional occupant of the limb on which I have taken my position. Robert S. Liebert (1983, p. 258) writes: "We must note that the most traditionally feminine sensual painted figure in all of Michelangelo's art—Eve in the Sistine Chapel ceiling *Temptation*— is placed, while plucking the forbidden fruit, in a position that can hardly fail to suggest fellatio."

6 Leo Steinberg (1980*a*) discusses Michelangelo's depiction of the Prince of Demons in the lower right-hand corner of the altar wall. In this work of his old age, the artist paints this satanic figure in the act of copulation with a serpent.

References

Bonaventure, S. (1967). *Breviloquium.* Part 3, *La Corruption du Péché.* Paris: Editions Franciscaines.

Bonnell, J. K. (1917). "The Serpent with a Human Head in Art and in Mystery Play." *American Journal of Archaeology,* 21:255 ff.

Bugge, J. (1975). *Virginitas: An Essay in the History of a Medieval Ideal.* The Hague: Martinus Nijhoff.

Celestino D., ed. (1880). *La Cronica de Giovanni Villani.* Turin: Libreria Salesiana.

Hartt, F. (1970). *Michelangelo Drawings.* New York: Abrams.

Hibbard, H. (1974). *Michelangelo.* New York: Harper & Row.

Hieatt, A. K. (1980). "Eve and Reason in a Tradition of Allegorical Interpretation of the Fall." *Journal of the Warburg and Courtauld Institutes,* 43:221–26.

———. (1983). "Hans Baldung Grien's *Ottawa Eve* and Its Context." *Art Bulletin,* 65, no. 2 (June): 290–304.

33 Kirschbaum, E. (1968). *Lexikon der Christliche Ikonographie.* Freiburg: Herder.

Kramer, H. & Sprenger, J. (1948). *Malleus Maleficarum.* Trans. M. Summers. London: Hogarth Press.

Liebert, R. S. (1983). *Michelangelo: A Psychoanalytic Study of His Life and Images.* New Haven, CT: Yale University Press.

Migne, J. P. (1844). *Patrologiae Cursus Completus.* 221 vols. Paris: Garnier Fratres.

Morris, D. et al. (1979). *Gestures.* New York: Stein & Day.

Panofsky, D., & Panofsky, E. (1962). *Pandora's Box: Changing Aspects of a Mythological Symbol.* New York: Pantheon.

Steinberg, L. (1975/76). "Eve's Idle Hand." *Art Journal,* 35, no. 2 (Winter):129–33.

_____. (1980*a*). "A Corner of the Last Judgment." *Daedalus,* 109, no. 2 (spring): 207–73.

_____. (1980*b*). "The Line of Fate in Michelangelo's Painting." *Critical Inquiry,* 6, no. 3 (spring): 437–39.

Singleton, C. S., ed. (1970). *The Divine Comedy: Inferno,* by Dante Alighieri. Princeton, NJ: Princeton University Press.

Tommaséo, N., ed. (1865). *Commedia Divina* by Dante Alighieri. Milan: Francesco Pagnoni.

Tolnay, C. de (1945). *Michelangelo.* Princeton, NJ: Princeton University Press.

G. Haydn
Huntley, Ph.D.

What Raphael Meant to Vasari

Giorgio Vasari was a painter and an architect. Today he is honored as an art historian, the first great art historian. Though twice knighted by popes, Vasari was an opportunist, one who could deal from the bottom of the deck when the occasion demanded, but in Italy of the cinquecento his morality was never questioned, except perhaps, by that outstanding moralist, Benvenuto Cellini, who both despised Giorgio and envied his success.

Successful Vasari was. He amassed a fortune which brought his descendants a principality. He became an intimate of popes and princes and the esteemed friend of the learned men and the great artists of his time. Of course, a comparative lack of moral virtue was not enough by itself to account for the little Aretine's rise to fortune and immortal fame. It helped: he toadied to ignoble princes, he flattered unprincipled nobles, and he not only tolerated the waywardness of impious prelates, he sought them out as friends and advisers. In other words, his morality was of the cinquecento; it was elastic. From his writing it is clear that he thought of himself as a paragon of virtue, and if you agree that moral standards are relative to time and place, perhaps you will not dissent.

Morality enters into a discussion of Vasari's treatment of Raphael. Vasari knew the difference between a dead ally and a live one. The first edition of his *Lives,* published in 1550, was a panegyric to Michelangelo, and it paid off royally. The second edition of the *Lives* was published in 1568, four years after the great artist's death. Scholars have often remarked that Vasari

augmented his tribute to Raphael in the later edition. Generally this observation was made when noting that the second edition was so enlarged and extended that it lacks the organic unity of the first; it no longer builds up to the climax, the perfection of the divine Michelangelo, whom he praised to the heavens in the first edition.

> O, happy age! O, blessed artists who have been able to refresh your darkened eyes at the fount of such light, and see all that was difficult made clear by a master so marvelous! His labors have removed the bandages from your eyes and he has separated the true from the false which clouded your minds. Thank Heaven, then, and try to imitate Michelangelo in all things!

Vasari in the second edition qualified this paean significantly by inserting the following in the "Life of Michelangelo":

> Suffice it to say that the purpose of this remarkable man was none other than to paint the most perfect and well-proportioned composition of the human body in the most various attitudes, and to show the emotions and passions of the soul, displaying his superiority to all artists, his great style, his nudes, and his knowledge of the difficulties of design. He has thus facilitated art in its principle object, the human body, and in seeking this end alone he has neglected charming coloring, fancies, new ideas with details and elegances which many other painters do not entirely neglect, perhaps not without reason.

This deviation from the *perfetta regola* of Michelangelo's example should be followed by Vasari's (second edition) advice that:

> everyone should be content to do the things for which he has a natural bent, and ought not to endeavor out of emulation to do what does not come to him naturally, in order that he may not labor in vain, frequently with shame and loss. Besides this, he should rest content and not try to surpass those who have worked miracles in art through great natural ability and the especial favor of God.

When his first edition was published Giorgio was already angling for the position of court painter to Duke Cosimo. In 1554 he obtained this appointment, in part certainly because of the success of his book. During the remainder of his life Vasari was both rich and famous. He no longer needed to hitch his wagon to the star of Michelangelo. His formula for success had worked, he could now afford to think things out at leisure and express himself freely without apprehension of the effect on his success. In the later edition of his *Lives,* for example, he significantly increased the praise of Leonardo and Titian, but most important of all his reevaluations was the elevation of Raphael to the plane of

Michelangelo. Vasari had already extolled him highly both as a man and as an artist in the 1550 edition when he said:

> But more than all the others, the most graceful Raphael of Urbino, studying the works of both old and modern masters, took the best from each of them. Out of this harvest he enriched the art of painting with that complete perfection which the figures of Apelles and Zeuxis anciently possessed, and even more, if I dare say so. Nature herself was vanquished by his color, and his invention seemed easily achieved and just right, as anyone may judge who has seen his works, which are like writings. . . .

Actually the early version of the life of Raphael is already so remarkably sympathetic to him both as a man and as an artist, so understanding of Raphael's problems, and so full of praise for his felicitous solutions, that one may detect a strong bond of sympathy between the biographer and his subject. Only in the second edition, however, did he dare express the full extent of this sympathy as in the following condensed quotation about Raphael, where what we really find seems to be Vasari talking about Vasari.

> [Raphael] studied the nude, comparing the muscles of dead men with those of the living . . . becoming excellent in these parts as a great master should. But seeing that he could not in this respect attain to the perfection of Michelangelo, and being a man of good judgment, he reflected that painting does not consist of representing nude figures alone, but that it has a larger scope, and that there were many excellent painters who could express their ideas with ease, originality and good judgment. . . . One could, he thought, enrich his works with a variety of perspective, building and landscapes, a light and delicate treatment of the draperies, sometimes causing the figure to be lost in the darkness, and sometimes coming into clear light, making living and beautiful heads of women, children, youths and old men, endowing them with appropriate movement and vigor. He also reflected upon the importance of the flight of horses in battle, the courage of the soldiers, the knowledge of all sorts of animals, and above all, the method of drawing portraits of men to make them appear lifelike and easily recognized, with a number of other things, such as draperies, shoes, helmets, armor, women's headdresses, hair, beards, vases, trees, caves, rain, lightning, fine weather, night, moonlight, bright sun and other necessities of present-day painting. Reflecting upon these things, Raphael made up his mind that, if he could not equal Michaelangelo in some respects, he would do it in others and perhaps even surpass him. . . . If other artists had done this instead of studying and imitating Michelangelo only, . . . they would not have striven in vain. . . .

Both as men and as artists Vasari and Raphael had a great deal in common, and one might note that these qualities and achieve-

ments were not held in common with Michelangelo. First of all, neither Vasari nor Raphael was a Florentine. Second, both had intimate ties from their early careers, from their late teens, with the Umbrian upper valley of the Tiber—Raphael with Perugia and Vasari with Borgo San Sepolcro.

Undoubtedly one of the strongest ties that Vasari felt with Raphael was his convinction that Raphael was slow to develop just as he himself was. When Vasari went to Camaldoli to arrange for what developed into his first extensive commission, he reported that the venerable monks were "taken aback by my youth." He was already 26. The work he did at Camaldoli during the following year may well be described as "hesitant, dry and weakly composed," the very terms Vasari used to describe the kind of painting that Raphael was doing when he arrived in Florence toward the end of 1504. Raphael was twenty-one.

In the prefaces to the three parts of his *Lives* Vasari stated clearly that *disegno,* which means both drawing and design, is to be acquired by the imitation of great numbers of the best works, both ancient and modern, and by combining the best features from them. In other words one learns *disegno* by an eclectic process. For Vasari and for Tuscan artists in general, *disegno* was the foundation of the arts, "the very soul which conceives and nourishes every part of the intelligence." Vasari traced its divine origin back to the Garden of Eden when God molded Adam from a lump of clay.

The command of drawing and the ability to design were of special and peculiar importance to Raphael and Vasari because they were both masters who ran shops on a grand scale. They designed, and their helpers did the work, at least a great deal of it (fig. 1, Vasari, drawing for *The Taking of Vico Pisano*).

The ability to make and keep friends, to get along with people, had its effect on them as artists. They knew how to make others work for them. Vasari's friends, from his early days, were forever finding him commissions, often more than he could handle, and the same was true for Raphael. Fortunately, their assistants were many and so loyal that they would work their hearts out to please their masters, to finish a work on schedule. The love he elicited from his assistants was a quality of Raphael that Vasari took up and he did it *con brio,* as the following quotation testifies:

And from all his rare gifts one stood out so eminently that it amazes me: that Heaven endowed him with a power unusual amongst painters, which is that the artists working with Raphael, not only the humble ones but those who aspired to be great (and our art produces a myriad of these), lived united and in harmony, they stopped quarreling when they saw him and all base and vile thoughts fled from their minds. This kind of harmony was never seen at any other time, and it arose because they were conquered by his courtesy and tact and still more by his good nature, so full of gentleness and love that even the animals honored him, not to speak of

39

Fig. 1. Giorgio Vasari, drawing for *The Taking of Vico Pisano*, Pen and Ink on blue paper. Uffizi Gallery, Florence.

Fig. 2. Raphael, *The Triumph of Galatea,* c. 1512. Fresco. Villa Farnesina, Rome. Photo: Giraudon, Art Resource, New York.

men. . . . He always kept a great number employed, and he helped them and taught them with as much affection as if they had been his own sons. For this reason he never went to court but that from the moment he left his house, he would have with him fifty painters, all valiant and good, keeping him company to honor him.

In short, he did not live like a painter, but like a prince. For this reason, O Art of Painting, thou mayest consider thyself most fortunate for having an artist who by his genius and character has raised thee above the heavens!

Vasari also had his faithful little army, and like Raphael, he knew how to use it. Both men, unlike Michelangelo, could work with others; they carried out their paintings almost the way an architect builds a building.

Admittedly, Vasari was not another Raphael, in fact it is somewhat strange that Giorgio ever became a painter. Nature endowed him liberally as a researcher, as an organizer, as an administrator; she had given him remarkable facility to articulate in speech and in writing, but he was not a natural born painter. Eventually he learned to draw well, but he was unbelievably slow in doing so. One sometimes wonders why he did not heed Michelangelo's advice to devote himself to architecture.

In the year 1548 when Vasari, aged 37, was finishing his first *Lives,* he was by no means a very important figure in the world of art. He had had some big commissions from the point of view of square yardage, but the pay was so poor, or the time allowed so short that the work was hastily executed and won him little fame. Vasari lamented this latter handicap in his life of Pierino del Vaga as follows:

> It pleases princes to have work done rapidly. Also while it may profit the assistants who are carrying it out, they never have that love for the things of others that one has for his own. And regardless of how well drawn the cartoons are, the results will not be up to the work of the artist's own hand. The latter seeing his design being ruined, gives up in desperation and lets the work go on as it may. Thus all who thirst for honor must do their work alone. I can attest to the proof of this, for after devoting great care to the cartoons of the hall of the Cancelleria in the Palazzo di San Giorgio at Rome, since the work had to be entirely completed in one hundred days, many painters were set to color it. And they deviated

Fig. 3. Giorgio Vasari and C. Gerhardi, *The Allegory of Water,*
1555. Fresco. Palazzo Vecchio, Florence. Photo: the author.

so far from the lines and quality of the cartoons, that I resolved and I have maintained my resolution from then on, to let no one put his hand to my work. Hence an intelligent man who wishes to obtain the full honor due him, will execute his works entirely by himself.

Astonishingly enough, Vasari repeated this passage in the second edition though it was common knowledge that a great part of his own extensive murals in the Palazzo Vecchio and most of his other commissions were executed by assistants. Indeed, he himself tells us this. To understand this variance between Vasari's preaching and his practice one must turn to Vasari's own "Life," which, of course, is in the second edition only. There after telling us that it would have been better to have worked in the Cancelleria for a hundred months and to have done it all by himself, he specified what he meant by "all by himself." It was to give the finish to everything after the preparatory work of his assistants had been done from his drawings. He did not, however, always adhere to this procedure. There were instances, according to his own testimony, when he permitted Cristoforo Gherardi to finish paintings completely; and, to judge from stylistic variances, the prepatory work of his assistants must have carried far indeed in many of Vasari's late commissions. A readily available example of this is the *Madonna of the Rosary* in Santa Maria Novella, Florence. In this large altarpiece, the colors, the way the paint is applied and even the facial types clearly indicate the handiwork of Francesco Morandini, called Il Poppi.

The period between the two editions of the *Lives* was dominated by Vasari's charge to transform the old city hall, the Palazzo Vecchio, into a modern and sumptuous palace for a reigning prince. His mind was filled with these problems and their solutions to such an extent that it could not but effect a certain change in his evaluations, in his judgments of the works of others. It is true that in looking back through the previous career of Vasari, one sees signs that decorative painting was his goal from the beginning of his service under the Medici in 1532. After the murder of his dear patron, the Duke Alessandro, Vasari resolved "to follow art alone and not the favor of courts," realizing his mistake for having based his hopes "on men and the weathercocks of this world," so he tells us. Nevertheless it is not difficult to detect his heightened enthusiasm whenever he describes his decorative projects of the next few years, especially those in Bologna and Venice. Thus if by nature and interest he was already in tune with the spirit of Raphael, that attunement, virtually by necessity, became pronounced after 1555.

Echoes of his praise of Raphael's accomplishments are frequent in Vasari's practice. In fact there are so many in the Palazzo Vecchio and in the Vatican, that only a few of the most obvious will be pointed out.

Vasari paid tribute to Raphael's *Triumph of Galatea* (fig. 2) in his second edition by adding the phrase, "*dipinto con dolcissima* Vasari's model for the main scene in the *Coronation of Charles V,*

43

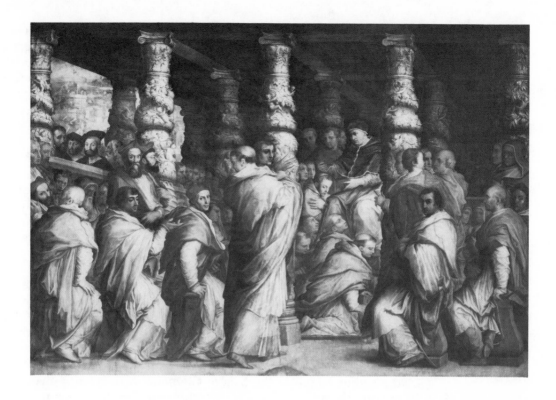

Fig. 4. Giorgio Vasari, *Leo X with the College of Cardinals,* 1560.
Fresco. Palazzo Vecchio, Florence. Photo: Art Resource, New York.

Fig. 5. Raphael, cartoon for the tapestry, *Healing the Lame Man at
the Beautiful Gate,* c. 1515–16. Gouache on paper. Victoria and
Albert Museum, London. Photo: Marburg/Art Resource, New York.

maniera," which must be given in the original language because the obvious translation, "painted in the sweetest manner," conveys little of what Vasari meant. This praise helped to repay the debt he owed Raphael for the success of the *Allegory of Water* (fig. 3) painted in the first room he decorated for Duke Cosimo.

Vasari employed a certain measure of manneristic subtlety to extol Raphael in *Leo X with the College of Cardinals,* (fig. 4) a fresco from 1560 in the Palazzo Vecchio. Here he actually portrayed Leonardo and Michelangelo but did not portray Raphael (perhaps because he was not a Florentine); nevertheless, the entire work is a panegyric to the great Urbinate. Not only did Giorgio borrow the dominant motif of the twisted columns from Raphael's tapestry design for *The Healing of the Lame Man at the Beautiful Gate of the Temple* (fig 5), he also made two of the six portraits he took from Raphael the most striking of the entire assembly of forty-four. These are the likenesses of the cardinals Dovizi and de' Rossi, the two central seated figures in the front row. In the *Ragionamenti* Vasari relates that he borrowed the Dovizi portrait by Raphael to work from; and that he took the Cardinal de' Rossi from Raphael's *Leo X and Two Cardinals,* which was then (the Pitti Palace version) in the ducal collection.

The Coronation of Charlemagne in the Stanza del Incendio was the ceiling fresco in the Sala di Clemente VII. And to give Vasari his due the adaptation is remarkably effective for a picture in its impossible setting (on the ceiling).

Fig. 6. Giorgio Vasari, *Gregory XI Returns from Avignon,* 1573. Sala Regia, Vatican, Rome. Photo: Art Resource, New York.

Finally, one of the latest and most obvious of Raphael's gifts to Giorgio is in the Sala Regia of the Vatican, *Gregory XI Returns from Avignon* (fig. 6), which Vasari painted for Pius V in 1573. The source was the *Meeting of St. Leo and Attila,* of which Vasari remarked, "Raphael shows Sts. Peter and Paul flying with swords in hand as they come to defend the Church. Although the history of Leo III does not speak of this, Raphael had the bright idea to show it thus. This kind of embellishment often occurs in painting as in poetry, however it must not detract from the main theme."

The above cited instances of Raphael's influence on Vasari are readily demonstrable. More significant in proving the durable and profound influence are the hundreds, literally hundreds, of less conspicuous borrowings of compositional devices, of gestures of all sorts and of decorative features. But such a demonstration would exceed the scope of this paper.

In conclusion, let us once again quote Vasari on Raphael. "Nature herself was vanquished by his colors, and his invention was easy and just, as anyone may judge if he has seen his works, which are like writings, showing us the sites and the buildings and the ways and habits of native and foreign people just as he desired."

"Raphael's very silence is speech."

Notes

This paper was presented at a 1970 meeting of The Renaissance-Baroque Workshop, an interdepartmental forum of the University of Chicago. It appears here as originally delivered.

Special Section | **Proto Surrealism and Surrealism**

Nancy J. Scott, Ph.D.

The Mystery and Melancholy of Nineteenth Century Sculpture in De Chirico's *Pittura Metafisica*

Giorgio de Chirico first painted a piazza populated only by a statue and two shadowy figures in 1910, while he was in Florence. (*The Enigma of an Autumn Afternoon,* fig. 1). Soon thereafter, in the summer of 1911, he and his mother moved to Paris where they remained, together with his brother, until 1915. In Paris, de Chirico continued to paint piazzas that increasingly reflected Italy through the sculptures, which are clearly identifiable as Italian monuments. Indeed, the Piazza d'Italia series flourished throughout the painter's Parisian period. This part of his *pittura metafisica* represents the crucial conjunction of de Chirico's real experience of things he has seen and places he has inhabited with his imagined and dreamlike transformations of those same places and things. Without doubt, it is this conjunction of the real and the imaginary, the product of the years when de Chirico lived in Paris and dreamed of Italy, that gives the *pittura metafisica* its haunting power. The aim of this article is to aid our understanding of that power, first of all, by suggesting several hitherto overlooked sources for de Chirico's Piazza d'Italia series—in particular the actual nineteenth century works that stand behind de Chirico's sculptural inventions—and, second, by tracing the transformations of those sources in the paintings.

What follows takes as its starting point a radical, but essential, move away from the traditional view that Turin and, very secondarily, Florence are the Italian cities most important to the painter's inventions. In point of fact, prior to his sojourn in Paris, de Chirico, who was born in Greece to Italian parents, lived in

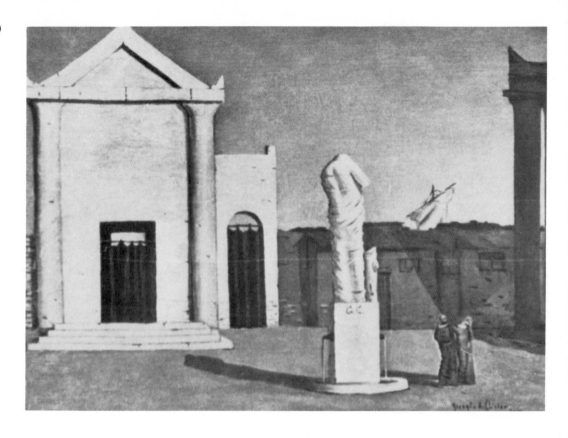

Fig. 1. Giorgio de Chirico, *The Enigma of an Autumn Afternoon,* 1910. Oil on canvas. Whereabouts unknown. Reproduced from J. T. Soby (1955).

Italy for only two years, from 1909 to 1911, and these two years were spent first in Milan and then in Florence. The city of Milan, which was de Chirico's first residence in Italy, has received virtually no attention in the de Chirico literature even though, as will be shown below, there is a strong presence of Milan, both of its statuary and its public spaces, in certain of the metaphysical paintings.[1] This neglect of Milan began with de Chirico himself. He referred to Turin in his *Memorie della mia vita* (1945, pp. 80–81, 94, 101) in several key contexts, to Florence once in another key document on the "revelation of the enigma," and to Milan quite negligibly (p. 89; Soby, 1955, p. 251). Notably, in the *Memorie* (p. 81), he described Turin as the place one could best observe Nietzsche's *Stimmung,* the profound poetry and mystery of which the painter equated with the long shadows and clear late afternoon light of autumn. Scholars have followed this and other leads and have concentrated on Turin as the city to comb for the real-world counterparts of de Chirico's inventions (Soby, 1955, pp. 49–50, 70).[2] While the incongruities of the objects placed within de Chirico's pictorial compositions have often been noted as central to the disquieting poetry of his proto-Surrealist imagery, the inconsistencies of what de Chirico wrote and said about

sources and places important to his work have not been given the same scrutiny for "poetic" invention.

In fact, we have de Chirico's word for it that his first trip to Turin was made in the extreme heat of July 1911 to see an exhibition and that illness forced him and his mother to go on to Paris after just two days (1945, p. 94).[3] Thus, at least in 1911, the painter obviously did not visit Turin during the long-shadowed days of autumn. Furthermore, he did not return to Turin during his metaphysical period, when all but one of the works considered here were completed. De Chirico was drafted into the Italian army after the outbreak of World War I and was sent directly from Paris to Florence and from there to Ferrara (Soby, 1955, p. 107).

Certainly, there can be no doubt that de Chirico was powerfully drawn to Turin—if more in his imagination than in reality— because of the city's connections with Nietzsche, which will be explored in more detail below. And there is the strong probability that even his extremely brief stay in Turin may have provided the painter with a fund of visual memories and, perhaps more important, with resonant associations that intensify the symbols chosen from that city. The 19th-century Mole Antonelliana, for example, which clearly dominates Turin's skyline in early 20th-century photographs of the city, as it still does, seems a logical source for the tricolonnaded structure in de Chirico's "tower" pictures, such as *The Nostalgia of the Infinite* (fig. 2, 1913–14), or *The Great Tower,* 1913.[4] So, too, the equestrian monument first seen in *The Red Tower* (1913) is most definitely the Torinese *Monument to Carlo Alberto* (1861) of Marochetti (figs. 4 and 5), to be discussed below.

With regard to the vast architectural spaces that have often been given a Torinese source, and which become a necessary subtopic here, it is my contention that de Chirico could have been impressed by arcaded structures in many Italian cities (see note 19) and that the inspiration for piazzas of a vast scale came from a visit the painter made to Versailles, much closer to his actual city of residence while he created the Piazza d'Italia series.

Furthermore, in contrast to his two-day stay in Turin, de Chirico lived in Milan for a year. In his *Memorie* (p. 89), the painter dismissed his one-year residence in Milan by saying that there he merely "painted Böcklinesque canvasses." Here I propose new source material in Milan for de Chirico's pictorial use of sculptures. The shift in focus to Milan and the consequent investigation of the Milanese sculptures de Chirico used as sources inevitably leads to an examination of the meaning of those sources, both in their original contexts and in those new ones de Chirico provided. This second line of inquiry opens up an astonishing range of de Chirico's associations—psychological, political, and pictorial. To a large extent, the psychological associations are focussed upon a single 19th-century frock-coated statue that de Chirico introduced into his desolate piazzas, a figure which I believe should be understood as de Chirico's image of his father

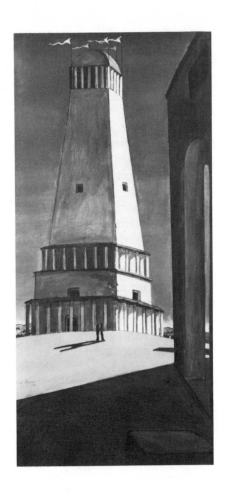

Fig. 2. Giorgio de Chirico, *The Nostalgia of the Infinite,* 1913–14? (dated on painting 1911). Oil on canvas. The Museum of Modern Art, New York. Purchase.

and, on another level, of his fatherland. The political associations stem from an interpretation of statesmen sublimated in the design of the statue. Finally, the pictorial associations center on Milan's Brera, where de Chirico saw Raphael's *Marriage of the Virgin* (fig. 18), and where, in the courtyard, he could also have seen the statuary that sparked the creation of the frock-coated figure.

The frock-coated statue makes its first appearance in 1913, and by 1914 it has come to dominate the piazzas painted by de Chirico.[5] As early as 1910, de Chirico placed a sculpture in the center of a piazza, its back turned to the spectator, in *The Enigma of an Autumn Afternoon* (fig. 1). This is the first painting in which de Chirico uses a 19th-century sculpture though its transformation renders its source (which the painter said was *Dante* in the Piazza Santa Croce) unrecognizable. Sculptural monuments are generally the only presence in de Chirico's vast spaces apart from a much smaller pair of figures which, by 1913–15, were reduced to blackened silhouettes. The painter populated his compositions throughout the Parisian period with works of sculpture either from the Greek period or the 19th century. The Greek motifs have been reasonably well identified. For example, a derivation of the recumbent classical figure at the Vatican, long known as

Ariadne, dominates major works of the year 1913.[6] Moreover, in 1913, a 19th-century equestrian monument makes its first appearance in *The Red Tower*. By 1914, Ariadne has ceded her place in the lonely piazza to the figure of the frock-coated 19th-century statue.

It is by tracing the frock-coated statue through the chronological grouping of de Chirico's paintings, as proposed by Soby, that its identity as a father figure emerges so clearly. De Chirico's father died in Greece when the painter was 17 years old and, up to now, his image has seemed oddly absent from de Chirico's oeuvre—though his spirit is constantly evoked through the many trains on distant horizons. The reasons for identifying the isolated stone figure in the piazza with de Chirico's father and thereby solving the problem of this curious lacuna in the painter's work, will unfold below, confirmed by de Chirico himself in the works depicting the return of the prodigal son (c.f. fig. 19), which he began in 1917 just as his *pittura metafisica* period was drawing to a close. In these works the statue steps down from his pedestal to embrace the mannequin, which, I argue, is an image of de Chirico himself. Thus, the son is reconciled to the father, whom he perceived as distant, reticent, and embodying those 19th-century values that were at odds with the creative impulses underlying the *pittura metafisica.* Simultaneously, there is increased evidence in the works of de Chirico's admiration of Raphael. Indeed, by 1919 de Chirico was thoroughly disengaged from the paintings of his youth, which he would later vehemently condemn, and had embraced the outmoded academic classicism that is in itself a return to 19th-century standards.

The identification of the correct sources for the frock-coated statue is, then, not simply an arcane point of art historical interest. It is not enough to know, as Maurizio Fagiolo dell'Arco (1982, p. 33) has suggested, that de Chirico uses types of monuments to suggest in a general manner, if an encoded one, the "epic times" of the Italian Risorgimento.[7] The examination of the frock-coated sculpture, which appears in at least five major paintings of 1914 and 1915, and the location of its source not in Turin, but in Milan lead to the unlocking of the far more personal side of de Chirico's iconography through the period of the *pittura metafisica,* that is, to his imagery of the father. This father image is situated in a dreamlike locale (Gordon Onslow-Ford coined the phrase "Chirico City"). It may be characterized by motifs as diverse as palm trees and distant locomotives, red-brick smokestacks and arcaded facades stretching to distant horizons of unearthly yellow and green or blue tones. This place was created in Paris, made up of memories from the wanderings of de Chirico's dislocated Italian family: living first in Greece, then returning to their homeland to see Venice and Milan, then to Munich, returning a second time to Italy, where they lived in both Milan and Florence, then to Paris, and finally to Italy again, to Ferrara with the advent of the First World War.

Before turning to my major subject, the proposed source for

the frock-coated figure and its meaning, two preliminary subjects claim our attention: first, the hitherto unrecognized role of de Chirico's actual city of residence, Paris, and its environs, in sparking the creation of Chirico City and, second, a reevaluation of Turin's importance in the Piazza d'Italia series.

Versailles as Source for the Piazza D'Italia Series

De Chirico's presence in Paris during the genesis of these paintings must be taken into account. Why was it that in the city of Paris de Chirico began to dream of an Italy of vast squares populated only by statues? His longing for a homeland and consequent sense of identification in Italy may be a psychological explanation. Yet something he saw or experienced in Paris might have triggered the creation of the enormous, desolate spaces that have become de Chirico's trademark. One quickly rejects a number of possible sites: Fremiet's *Jeanne d'Arc* in the Place des Pyramides is in too constricted a place; the Place de la Concorde and that surrounding the Arc de Triomphe are certainly vast, but far too busy with traffic and filled with architectural sculpture to correspond precisely to de Chirico's vision; the Tuileries exhibits a number of pieces of 19th-century sculpture, but its trees and grassy squares inhibit the feeling of scale and monumental distance that the painter captured.

The anwer, it seems, may be found in de Chirico's own manuscript of 1913, where so many telling clues are hiding in plain view:

> One bright winter morning I found myself in the courtyard of the palace of Versailles. Everything looked at me with a strange and questioning glance. I saw then that every angle of the palace, every column, every window had a soul that was an enigma. I looked about me at the stone heroes, motionless under the bright sky, under the cold rays of the winter sun shining *without love* like a profound song. . . . Then I experienced all the mystery that drives men to create certain things. (Soby, 1955, p. 247)

The location de Chirico describes would have offered him a view of the vast scale of the square in front of the palace. With its three axially symmetrical roads and few trees or buildings nearby to lessen the impression of grandeur, the entrance to Versailles would have certainly far surpassed any other of de Chirico's experiences of an enormous, little-populated public space, whether in Paris or in Italy.

The description coincides in several telling ways with the painter's well-known "revelation of the enigma" of 1912, which has often been cited as a rare insight into his working method.

> . . . let me recount how I had the revelation of a picture that I will show this year at the Salon d'Automne, entitled *Enigma of an Autumn Afternoon.* One clear autumnal afternoon I was

sitting on a bench in the middle of the Piazza Santa Croce in Florence. It was of course not the first time I had seen this square. I had just come out of a long and painful intestinal illness, and I was in a nearly morbid state of sensitivity. The whole world, down to the marble of the buildings and the fountains, seemed to me to be convalescent. In the square rises a statue of Dante draped in a long cloak, holding his works clasped against his body, his laurel-crowned head bent thoughtfully earthward. The statue is in white marble, but time has given it a gray cast, very agreeable to the eye. The autumn sun, warm and unloving, lit the statue and the church facade. Then I had the strange impression that I was looking at all these things for the first time, and the composition of my picture came to my mind's eye. Now each time I look at this painting I again see that moment. Nevertheless, the moment is an enigma to me, for it is inexplicable. And I like also to call the work which sprang from it an enigma. (Soby, 1955, p. 251)[8]

The first parallel between the two accounts is the anthropo-morphizing of architecture. In the Versailles passage, things looked at the painter. The various aspects of architecture, "every angle of the palace, every column," and most notably the window, "had a soul." In the Florence experience in the Piazza Santa Croce, even the "marble of the buildings and the fountains seemed to me to be convalescent," as was the painter. Then, in both, the sun is shining but is either "unloving" or "without love" (which de Chirico emphasizes in italics in his description of Versailles). The Florentine experience is seen in an autumn sun, that at Versailles "under the cold rays of the winter sun." Finally, the presence of the statues at Versailles is strongly felt, and they are noted as "stone heroes." The Florence passage, of course, turns on the marble figure of Dante in the center of the Piazza Santa Croce.

Notably from the Florence revelation, we learn that each element of a specific, closely observed scene has etched itself in the painter's mind and simultaneously been transformed into something else entirely. Thus, for example, in *The Enigma of an Autumn Afternoon,* de Chirico transforms Enrico Pazzi's *Dante* (1865) so that he becomes a quasi-Greek evocation. Although the figure has another source in Böcklin's *Odysseus and Calypso,* this is the first 19th-century sculpture known as a source for de Chirico. The Renaissance facade of Santa Croce has become a small Greek temple, and with the same logic of the unconscious, the city around the piazza has also disappeared.

It is thus plausible to take the Versailles passage as another example of de Chirico's "revelation of the enigma" and to hy-pothesize pictorial composition and motifs transformed from the experience, just as in the Piazza Santa Croce. The date of the manuscript concerning Versailles, June 15, 1913, coincides with important stylistic changes in de Chirico's work.[9] Paintings follow-

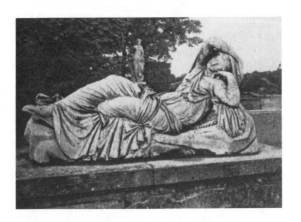

Fig. 3. Cornelius
Van Cleve, copy
after Roman *Ariadne,*
18th century. Garden
of Versailles.

ing the very early *Enigma of an Autumn Afternoon* will begin to
leave behind its boxlike spatial construction and arcades will
emphasize the pushing back of the central motif against the
horizon as well as the vertiginous foreground tilting of planes (as
seen in *The Nostalgia of the Infinite* or *The Red Tower,* for
example). This chronological coincidence points to the experience
at Versailles as a crucial, if sublimated, source for the creation of
Chirico City. Indeed what better real-world perspective lesson
could there be for the deepening of space than the ordered allées
and axial paths of Versailles stretching away to seeming infinity?
Moreover, as Soby sees it, the use of a deeper perspective in
1913 parallels the appearance of *Ariadne* in the piazza. The
Vatican sculpture, which exists in several other Roman copies that
de Chirico could have seen either in Rome or Florence (Soby,
1955, p. 52), is also to be found at Versailles in an 18th-century
copy by Van Cleve, placed near the Orangerie (fig. 3).

The use of the abandoned figure, such an evocative symbol for
de Chirico's own state of mind as he took up residence in yet
another foreign country, may have been prompted by finding
Ariadne once again. De Chirico mentions the sculptures at Ver-
sailles only as "stone heroes." Certainly this image does not
correspond to the courtyard in front of the palace, where he
locates his experience. He surely must have seen the marble
statues, placed in rhythmic progression on either side of the Tapis
Vert stretching out behind the garden facade. Is it merely coinci-
dence that his own "stone hero" in paintings from the next year,
1914, will so often be associated with the vast spaces of elongated
perspectives? The emphasis on a deeper space is markedly exagge-
rated in *The Mystery and Melancholy of a Street* or *The Enigma of a
Day,* both works of 1914, as opposed to the earlier painting *The
Red Tower* (fig. 4, 1913), where deep space is first used. The front
of the palace at Versailles, in contrast, contains only a single
sculpture, the bronze equestrian monument of Louis XIV. Curi-
ously, an equestrian monument will recur in de Chirico's paintings
from 1913 to 1917, beginning with *The Red Tower.* However, this
major monument, which stands in the square where Nietzsche
once lived, has long been correctly identified as the one in Turin.

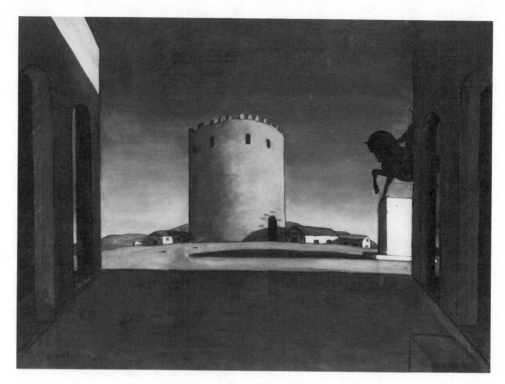

Fig. 4. Giorgio de Chirico, *The Red Tower,* 1913. Oil on Canvas.
The Peggy Guggenheim Collection, Venice. S. R. Guggenheim
Foundation, New York. Photo: Robert E. Mates.

The Carlo Alberto Monument: Risorgimento Heroes, Turin, and Nietzsche

The earliest unaltered depiction of a 19th-century monument is in *The Red Tower,* where an equestrian monument appears as a shadowed silhouette. It is the only presence in the deserted piazza other than the architecture itself. In *The Red Tower* the equestrian monument clearly refers to Turin and to the Risorgimento. The monument is identifiable as one dedicated to Carlo Alberto, who was king of the Sardinian Empire up to 1849; it was sculpted by Carlo Marochetti and inaugurated in 1861, in Turin (fig. 5). It was so identified by James Thrall Soby's pioneering de Chirico catalogue of 1955 (p. 49). De Chirico himself had broadly hinted at the source in his *Memorie della mia vita* (p. 101), when he compared the background monument to those "dedicated to the soldiers and heroes of the Risorgimento so ubiquitous in Italy and especially common in Turin."[10]

Above all, de Chirico was predisposed to evoke Turin and its 19th-century symbolism in his painting because, for him, Turin was Friedrich Nietzsche's place. Nietzsche was de Chirico's great hero. The artist has noted that while in his twenties studying art in Munich he was introduced to the works of Nietzsche (de Chirico, 1945, pp. 80–81).[11] In Turin, too, we know that de Chirico felt one could best observe Nietzsche's *Stimmung* (which he translated as *atmosfera* or mood), what he called the philosopher's greatest

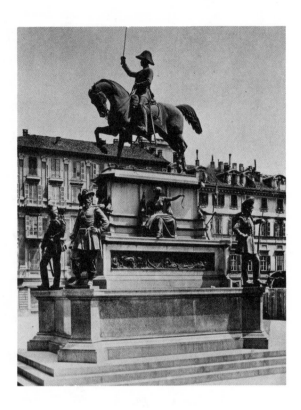

Fig. 5. Carlo Marochetti, *Monument to Carlo Alberto,* 1861. Piazza Carlo Alberto, Turin.

discovery. The long shadows and clear late afternoon light that de Chirico identifies as this Nietzschean sensation, "a strange and profound poetry, infinitely mysterious and solitary," is integral to his imagery of Italian piazzas (de Chirico, 1945, p. 81).[12]

Turin was Nietzsche's favorite Italian city and the place where the philosopher went mad. As the story goes, upon seeing a horse flailed in the Piazza Carlo Alberto in January 1889, Nietzsche fell upon it, embracing it.[13] This incident marked the onset of his irreversible mental breakdown.

We have seen that the Carlo Alberto equestrian form of *The Red Tower* may be taken to symbolize the Risorgimento. Might it not also suggest de Chirico's awareness of the exact location of Nietzsche's seizure and of the horse that occasioned his collapse? To push the hypothesis even further, might not de Chirico's own hallucinatory illness-induced perceptions of a place have found a sympathetic parallel in Nietzsche's genius tragically combined with madness? Thereafter, incidentally, it was widely known that Nietzsche in his insane state believed himself to be the reincarnation of Vittorio Emanuele, king of an Italy newly unified by the Risorgimento. In Nietzsche's often quoted letter to Jakob Burckhardt, written just a few days after the incident, the philosopher recounted that he lived opposite the "Palazzo Carignano (in which I was born as Vittorio Emanuele)" (Middleton, 1969, pp. 346–48).[14] And, of course, Carlo Alberto was the father of Vittorio Emanuele. The father-son relationship was such a significant one for de Chirico, as indeed it had been for Nietzsche, that such a

connection seems more than coincidental in unraveling new meanings attached to the painter's use of the Carlo Alberto monument.

One can rather quickly see how interlocked and, in the Freudian sense, overdetermined the symbols and images of de Chirico's use of a single sculpture are.

The Frock-Coated Figure

After 1913, in the paintings of the vast desolate piazza, dense with Nietzschean *Stimmung,* the very long shadow of a lone figure, extending his arm, intrudes. In *The Mystery and Melancholy of a Street* (1914), the shadow is the harbinger of the frock-coated marble sculpture, de Chirico's own "stone hero," soon to dominate the piazza.

The hidden frock-coated figure or the "Victorian statue" as Soby has called him (1955, p. 72),[15] is a particularly difficult sculpture to identify because it is such a common type. There are more than enough frock-coated Risorgimento heroes atop pedestals to choose from in Italy, in attempting to trace de Chirico's source. He appears here as a threatening shadow; in other paintings he is seen only from the back or side. In 1919, the painter in an article in *Valori plastici* cited Schopenhauer on the importance of placing statues of famous men on low plinths "as they do in Italy, where some marble men seem to be on a level with the passersby and seem to walk beside them" (de Chirico, quoted by Soby, 1955, p. 35). Not only does the statue enter slyly, first with its shadow, then by facing into the space much as we the spectators face the canvas (see especially fig. 10, *The Serenity of the Scholar,* and fig. 14, *The Joy of Return*), but the statue is from the first more real than the people. The overpowering menace of the statue's shadow in the same composition with the little girl rolling her hoop, herself a blackened silhouette, has often been noted (Soby, 1955, pp. 72–74).

Soby proposed a Torinese statue, a bronze monument to Giovanni Battista Bottero by Odoardo Tabacchi as the source for the marble figure who reappears in full light in *The Enigma of a Day* (fig. 6) (Soby, 1955, pp. 59 and 70).[16] For reasons I have not been able to trace, Soby believed Bottero was a philosopher and thus a particularly appropriate choice for de Chirico's metaphysical turn of mind. In fact, however, Bottero was a political writer and founder of the *Gazzetta del Popolo,* a copy of which he extends in his right hand.[17] The statue still stands today in the street where the newspaper's offices are. The bronze work was completed in 1899 and probably still looked reasonably new when de Chirico could have seen it just twelve years later, in 1911. That the Bottero monument is bronze and the statue in *The Enigma of a Day* is obviously marble is not an insignificant difference. From his 1912 discussion of *The Enigma of an Autumn Afternoon* we know that de Chirico especially appreciated the gray tone acquired by marble out of doors. Finally, in de Chirico's painting, it is the right hand, not the left, that is extended in a gesture that is

60

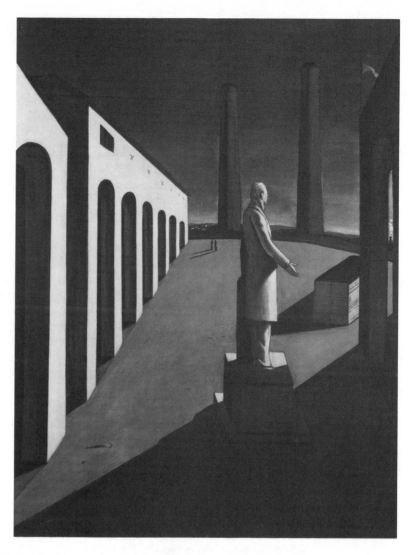

Fig. 6. Giorgio de Chirico, *The Enigma of a Day,* 1914. Oil on canvas. The Museum of Modern Art, New York. James Thrall Soby Bequest.

willfully ambiguous. The Bottero statue, though clearly a close precedent from Turin's 19th-century monuments, no longer seems the most persuasive source for de Chirico's marble man.

In seeking out de Chirico's sources, one must as always look for a melding of elements, disjunctive images, and locales that would have found resonance in the painter's self-described "great sensitivity," and our search leads us to look anew in Milan, the other great city of the Risorgimento. The Brera cortile, ringed by six 19th-century marble statues, with Canova's *Napoleon* at its center, offers the possibility of further sources for de Chirico's painting (fig. 7). Moreover, a text written between 1911 and 1915, titled *The Statue's Desire,* indicates that de Chirico seems to have had one of his hallucinatory visions of just such a place. He describes "The statue of the conqueror in the square, his head bare and bald. Everywhere the sun rules. Everywhere the shadows console" (Soby, 1955, p. 253).[18] Though Napoleon is not bald, the figure standing opposite him in the shadowed arcade is.

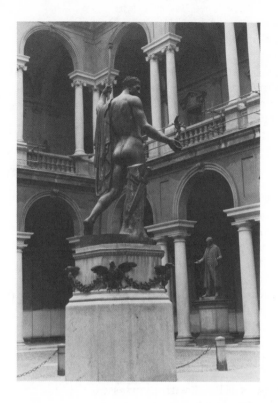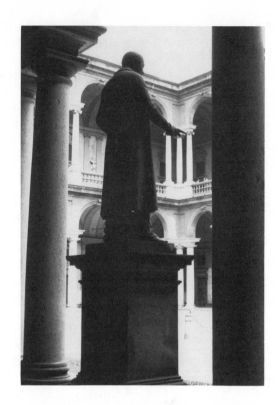

Fig. 7. Antonio
Canova, *Napoleon I,*
1809 (left fore-
ground). Vincenzo
Vela, *Gabrio Piola*
(right background,
under arch), 1857.
Brera Courtyard,
Milan.

Fig. 8. Vincenzo
Vela, rear view of
statue of *Gabrio Pi-
ola,* 1857. Courtyard
of the Pinocoteca
Brera, Milan.

The recognizable Napoleon does not dominate the Italian
piazza paintings of 1914; indeed, he would be far too obvious a
form for the workings of de Chirico's enigma. Instead, what de
Chirico re-creates is the modest unassuming portrait of a mathe-
matician standing opposite Napoleon in the Brera cortile who
echoes with his empty right hand the great gesture with which
Napoleon possesses Victory atop the world (fig. 8). Another
passage from *The Statue's Desire* alludes to just this sort of visual
dialogue between the two sculptures: "And now the sun has
stopped, high in the center of the sky. And in everlasting
happiness the statue *immerses its soul in the contemplation of its
shadow*" (ibid., author's italics).

The statue of the mathematician may have been seen rather
quickly by de Chirico as he walked through the Brera courtyard.
Nonetheless, the form could have been an evocative one, recalling
the several layers of de Chirico's Brera memories without detail-
ing them. That sort of powerful associative image could very well
lodge in the painter's visual memory. We shall see if, in fact,
Napoleon disappears entirely.

The figure of this mathematician, Gabrio Piola, is an archetypal
bourgeois citizen, explaining a point of calculus. An equation is
inscribed on the tablet he holds in his left hand. He was sculpted
in 1857 by Vincenzo Vela and represents the beginning of the
realist mid-century tendency to reject the neoclassical toga and
rhetorical manner (Scott, 1979, pp. 277–79). His explanatory
gesture corresponds to the vague open gesture of de Chirico's

statue; his long frock coat resembles the latter's. Both figures are rather bald. The *Piola* is closely linked with the arcade[19] and, too, with its "shadows that console." One might even postulate that the brick smokestacks (associated by Soby with towers at Viterbo) represent another Brera memory, that of the columns framing the Piola statue, and the others around the courtyard.

Two differences are apparent: the statue of *The Enigma of a Day* wears wire-rimmed glasses, and a supporting post is visible on his left side. Such a tree-trunk post supporting Napoleon's scabbard is part of the Canova bronze. The Vela marble, however, has no such device.

Vela's *Piola* then is not the single source for de Chirico's statue, though it is arguably the center of his visual associations. Napoleon and perhaps others form part of the evocative reverberation of de Chirico's emotional associations as he paints again and again the mysterious marble man. A sentence from the second part of the 1913 manuscript, "The Feeling of Prehistory," gives one further clue of the painter's direct observtion of the Piola: "In public squares shadows lengthen their mathematical enigma" (Soby, 1955, p. 247).

The presence of the eyeglasses has caused some scholars to hypothesize that Cavour, prime minister of the first United Kingdom of Italy under Vittorio Emanuele, is the source for de Chirico's image. A drawing of a head with eyeglasses, titled *L'enigme cavourien* on the sheet, further supports this notion (Fagiolo, 1982, p. 33).[20] Even more telling is a caricature that Fagiolo has recently reproduced as de Chirico's sketch for *La Ghirba,* published by Ardegno Soffici in 1918. It shows a statue in an arcaded piazza, significantly facing forward, so that we see his eyeglasses and the pedestal's inscription. The low plinth bears the legend "A CAMILLO CAVOUR / LA PATRIA." Apart from de Chirico's signature and the word *Erudizione,* the bottom of the sheet contains a brief exchange. It presumably indicates what the two grotesque heads to the lower right are saying: "Whose monument is this? It's the nation's" (Fagiolo, 1980, p. 63).

Only one specific Cavour monument can be considered as a possible source. The Cavour monument in Milan is quite close to the stance and gesture of de Chirico's statue though Cavour does not wear the eyeglasses habitually identified with him, nor is its setting an arcaded one (fig. 9). The sculptor of the standing figure is the same Odoardo Tabacchi of the Bottero monument in Turin.

The sole Torinese monument to Cavour was executed by the Florentine sculptor Giovanni Duprè, who had to use a toga to cover Cavour's paunch and was much denounced because the neoclassical motif and rhetorical gesture were all wrong for the well-known, rumpled statesman. This clearly shows that Milan, not Turin, would have been de Chirico's source if indeed he had used a Cavour monument.

The Piola source remains as the most convincing visual prototype for the statue in *The Enigma of a Day,* but the enigma, too, remains. Did de Chirico intend the statue to be seen simply as

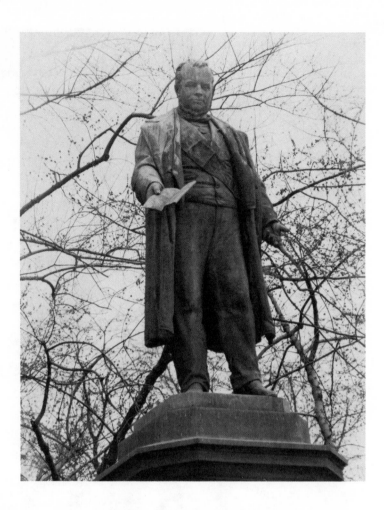

Fig. 9. Odoardo Tabacchi and Antonio Tantardini, *Monument to Cavour,* 1865. Public Gardens, Milan.

Cavour each time he appears? Could there be another identity or symbolism attached to this bourgeois commemorated in stone? Other paintings in which the figure recurs must be examined for further clues.

The Serenity of the Scholar, another major work of 1914, depicts the statue once again, now seen squarely from behind, with his right hand resting firmly on a fluted column (fig. 10). The monument to Pietro Verri across the Brera cortile from the statue of Piola uses precisely this gesture, and one thus sees the melding of visual memories that may have constituted de Chirico's building up of the engima. The eyeglasses, though enlarged and painted blue green, may again recall Cavour.

The schematized black cylinders and puff of smoke visible on the higher horizon line represent the locomotives de Chirico used in the distant ground of many of his paintings. In fact, a tiny train is visible in *The Enigma of a Day* through the arch to the far right. It suggests the image of voyage recurrent in de Chirico, first evidenced in *The Enigma of an Autumn Afternoon* (with its sculpture's sources both significantly voyagers—Odysseus and Dante), and his constant juxtaposition of themes of departure and return.

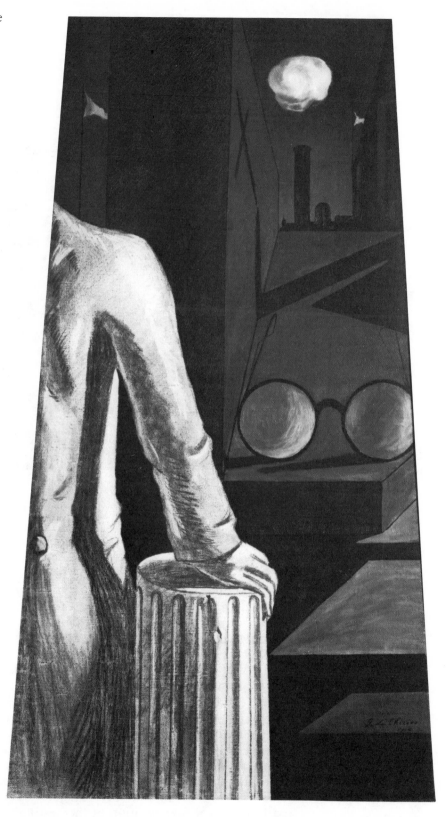

The train has also been interpreted as one of the more obvious symbols of de Chirico's father, for Evariste de Chirico was an engineer involved in the planning of Thessaly's network of railroad lines. The locomotive of these two examples leads us to another symbolic identification for the statue figure and one which has never been thoroughly considered. The statue can be seen as an image of de Chirico's father, a figure otherwise oddly absent from his paintings. Is it conceivable that the painter's father might have been transformed into a marble monument?

In his *Memorie,* the painter describes his father very near the beginning:

> My father was a man of the 19th century; he was an engineer and also an old-fashioned gentleman; brave, loyal, hardworking, intelligent and good. . . . Like many of his contemporaries, he had many skills; he was a first-class engineer, had a beautiful handwriting, he drew well, he had a fine ear for music, he was an acute and ironic observer, he hated injustice, loved animals, he treated the wealthy and powerful haughtily but always came to the defense of the weak and poor. . . . This means that my father, like many men of that time, was the exact opposite of most men of today, who lack a sense of direction and any character. (p. 11–12)[21]

De Chirico introduces his father by relating how the elder de Chirico gave him his first drawing lesson. He elevates his memory of his father's skills in comparison to others "full of stupidity" who today would never have any idea how to teach a child tricks of drawing.[22] The diatribe then reaches a fever pitch as de Chirico accuses today's fathers of producing horrors such as Matisse. The de Chirico of later years was, of course, irrational on the topic of modern painting and once equated it with Nazism (Soby, 1955, p. 16).

Given de Chirico's predilection for multiple layers of meaning, it is not impossible that the statue, drawn from sources in Milan, although linked with Cavour and the Risorgimento and closely associated in its initial context with Napoleon, may also be interpreted throughout the 1914–15 paintings as an ideal image of de Chirico's father. In fact, the association of the sculpture with *La Patria,* literally "the Fatherland," in the 1918 caricature provides a linguistic link between de Chirico's associations on both personal and public levels. For both his father and his fatherland must have represented to the painter a rich cultural heritage that was now sadly out of reach. It is altogether plausible that both Cavour and Napoleon stand behind the painter's invention of a father figure of awesome powers.

The identification of the statue as the father is further suggested by examining other paintings and drawings in which the marble frock-coated figure appears. One of these, *La Joie,* a drawing of 1913, the year before the major paintings of this motif begin, shows the statue with a scroll in his hand standing alongside

the base of a tower. He is not at all the spatially dominating figure of *The Serenity of the Scholar,* nor is he the menacing shadow of *The Mystery and Melancholy of a Street,* but it is in the childlike draftsmanship of this improvisatory sketch that de Chirico bluntly connects images that will be the purposefully obscured enigma of the paintings. The firing cannon recalls de Chirico's description in his *Memorie* (pp. 27–33) of an old cannon aboard a warship anchored at Volos, where his family lived in Greece, during the Turkish war.[23] Again sails are visible on the distant horizon. The miniature train crosses the foreground, much as it crossed exactly through the center of Volos,[24] and the statue, appearing even more like a father figure in this context of toylike machines, stands on his pedestal. The work's title, *La Joie,* indicates the painter's great pleasure in uniting this episodic scene of the child's fondest memories.

The constant use of the statue's profile or back view (in *La Joie, The Enigma of a Day, The Serenity of a Scholar,* and, as we will see, in fig. 19, *The Joy of Return,* and in fig. 21, *The Double Dream of Spring*) renders the father figure ever more remote and inaccessible, as in fact, de Chirico testifies was the case with his own father: "Despite a deep mutual affection, the relationship between my father and myself was somewhat distant and cold. A certain reticence prevented us from indulging in the demonstrative behavior of the middle classes" (p. 66).

Although the locomotives and train stations have frequently been read as symbols of the father, it is surprising that only the painting *The Child's Brain* (1914; fig. 11) has been seen as an image, if a fantasy portrait, of de Chirico's father (Rubin, 1982, p. 68). That the pale, half-nude, mustachioed figure of that painting should be equated with de Chirico's elegant, learned, gentlemanly father of the *Memorie* is an argument based primarily, it would seem, on an intuitive leap from the painting's title and on an erotic-sexual deciphering of the symbols within the painting. Robert Melville, while stressing that de Chirico's eroticism is as "subtle and innocent as Watteau's," first advanced the theory that the painting is "a jealous and malicious image of the father" and that the "scorn poured upon the father is the measure of the child's frustration" (Melville, 1940, p. 8). Soby accepted Melville's interpretation, notably the symbol of the book as mother, and thus described the truncated torso, against which are set book and marker, as "the father's desire and the mother's acquiescence" (Soby, 1955, pp. 74–75). The fact that by about 1921, Max Ernst had adapted the image for his own father iconography in *Pieta,* or *La revolution de nuit,* has only increased the "unanimous" acceptance of this painting as *the* image of de Chirico's father. *The Child's Brain* does reveal the naked torso of the figure, which might be taken as an image of the father, representing both literally and psychologically a flabby fallen idol, in juxtaposition to the ideal "stone hero" seen only from behind, on a pedestal in other paintings. One could accept the two expressions of the father as a necessary duality of de Chirico's recreation of what

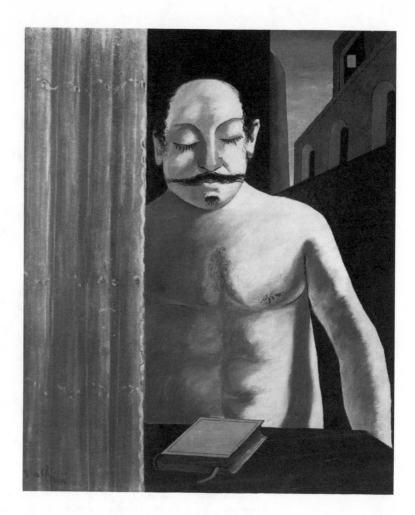

Fig. 11. Giorgio de Chirico, *The Child's Brain,* 1914. Oil on canvas. Moderna Museet, Stockholm.

must have been a troubled and intense relationship. Yet it seems hard to believe that de Chirico himself consciously thought of *The Child's Brain* as his father as he painted it. It is important to reassert his innocence, which Melville attempted to highlight, or his unconscious motivation because so many of de Chirico's interpreters emphasize the erotic readings of the towers, cannons, arches, artichokes, gloves, and the like, to an extent that other layers of meaning go unexplored. Moreover, if *The Child's Brain* is a fantasy portrait of Evariste de Chirico, it must be remembered that it bears not the slightest resemblance to his father (Soby, 1955, p. 17, fig. 2). The man looks rather more like an athlete or wrestler gone to pot, with the long mustaches of Vittorio Emanuele II (fig. 12).[25] Could there then be political imagery (Italy's inertia?) mixed once again with the painter's unconscious thoughts on his father?

On the other hand, the painting's iconography—not so clearly decipherable to me—may well represent the brute force and uncomprehending, unconscious cruelty of the child, latent in man (suggested by the work's title), and thus shown in the form of a man with closed eyes. Some sort of Nietzschean "loam and clay"

Fig. 12. Anony-
mous. Photograph of
Vittorio Emanuele II,
c. 1865. Museo Vela,
Ligornetto,
Switzerland.

may be the painter's notion, as yet unshaped by marble to the
level of a heroic man, an *Ubermensch* literally, who can preside
over the rest of humanity from his pedestal as does de Chirico's
"stone hero." In any case, if one accepts the statue as the father, it
seems *The Child's Brain* merits further investigation. And, most
clearly of all, the statue supplies the otherwise missing imagery of
de Chirico's father, whose figure is oddly absent in the painter's
work which does include portraits of his mother and brother and
several self-portraits.

Associations between the frock-coated statue and the equestrian
monument continue in *The Departure of the Poet,* where the
equestrian form casts a shadow quite similar to that of the single
statue, and then in de Chirico's still life series of 1914. One of
these, *Still Life: Turin, Spring* (Soby, 1955, p. 197), combines
disjunctively an artichoke, a book, and an egg presented on a
slanting plane with the black silhouette of the equestrian monu-
ment to Carlo Alberto (previously depicted in *The Red Tower*) on
the horizon line. The pedestal of the equestrian monument,
however, reads "NUELE II TORINO." This reveals that de Chirico
misremembered the monument and confounded the imagery of
the son with that of the father (Schmied, 1980, p. 68; Schmied
believed the monument was that of Vittorio Emanuele). The
frock-coated figure does not appear here, but the statue's pointing
gesture may be recalled in the white board with black hand, its
index finger extended. The hand also recalls signboards of Paris,

one of which de Chirico remembered above a shop, and is perhaps a more obvious source.[26] This is another of those proto–Pop Art elements, an example of disquieting, disjunctive objects, enlarged and isolated in de Chirico's painting as were Cavour's glasses.

It is, however, the didactic quality of the statue's explanatory gesture and of a monument's function in general that reverberates in the use of the pointing hand. This is quite close to Piola's gesture, repeated in the two Tabacchi statues we have seen, and common to many a 19th-century figure imparting his great notion or indicating his shining moment in history. Moreover, the didactic associations of statue as cultural icon may be so easily related to the father as a civilizing force within the more personal context of family that one cannot imagine the connection escaped de Chirico, who so admired his father's cultivation and learning as *un'uomo dell'ottocento*. Another author, however, has recently seen evidence of a new classicism and a relation to Raphael in this sign (Baldacci, 1983, pp. 27–28). Whatever the multilayered evocations of the pointing hand, the bland signboard overlaps the equestrian monument and highlights its presence—recalling Turin, Risorgimento, Nietzsche's madness. At the same time, the hand functions as a mysterious, flat sign seen on the surface just as the objects: book, egg, or artichoke.

The marble statue reappears in *Joy of the Return* (1915, fig. 13) seen as always from behind and here only from the shoulders up.[27] De Chirico's association of an arcaded context with the statue is here most aggressively stated. This image nonetheless most closely recalls the reality of de Chirico's point of departure—the statues in the shadowed arcade surrounding the Brera cortile. Here, too, the linking of the train with the statue continues; the two motifs are physically closer to each other than in any other of the compositions with both. The painting's title, *Joy of the Return,* focuses on the comforts of a reunion, and one cannot but speculate that the anxiety and dislocation of previous years were giving way to a rapprochement with the idealized father.

The Frock-Coated Statue and the Mannequin

In two works of 1914, the statue is cross-fertilized with mannequin figures, which began to fascinate de Chirico at this time, and results in another variation. The marble statue becomes a sewn and stitched version of its former self. In one of these works (*I'll be there . . . The Glass Dog*; Soby, 1955, p. 202), this is a schematic line drawing in white on a blackboard within the painting. In *The Nostalgia of the Poet* (fig. 14), the figure gains color and substance as he shares space with the bizarre classical head sporting sunglasses (the blind poet as Homer?), which appears in other paintings of 1914, notably the *Portrait of Guillaume Apollinaire.*

The classical head has elsewhere been identified as that of the *Apollo Belvedere* (Soby, 1955, p. 75), a resemblance that is clearer

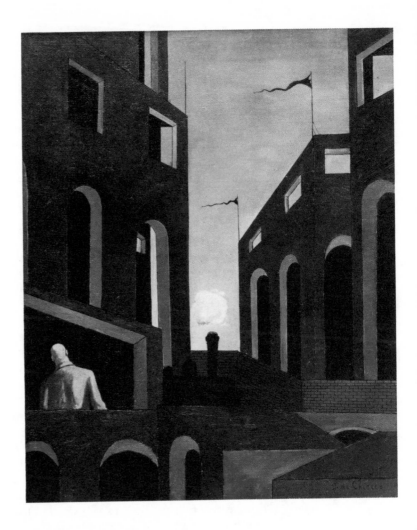

Fig. 13. Giorgio de Chirico, *The Joy of Return,* 1915. Oil on canvas. Collection of Mr. and Mrs. James Alsdorf, Chicago.

in a painting such as *The Song of Love,* where the sculpture retains its original full head of hair. The bald classical head, however, reveals—if one focuses on its somewhat menacing profile of nose and mouth and covers the sunglasses and forehead—its other connection. For here the *Napoleon* reappears. Even the viewpoint from slightly below the chin and mouth reminds one of the conqueror's lofty height on his pedestal. Antonio Canova's dependence on the *Apollo Belvedere* for the gesture and stance of his *Napoleon* is well known. This is "The statue of the conqueror in the square, his head bare and bald," of which de Chirico speaks in his manuscript *The Statue's Desire.* "Everywhere the sun rules. Everywhere the shadows console," the painter further tells us. So, of course, the statue wears sunglasses!

The Dream of the Poet, then, contains one association of Piola and Napoleon, both admittedly much transformed, that confirms de Chirico's heretofore unacknowledged source material at the Brera in Milan (see fig. 11). The father figure, which in this painting is not only moving toward the background literally but has lost his "stone hero" identity, is only to be replaced and reinforced by a greater one, the bald conqueror, Napoleon.

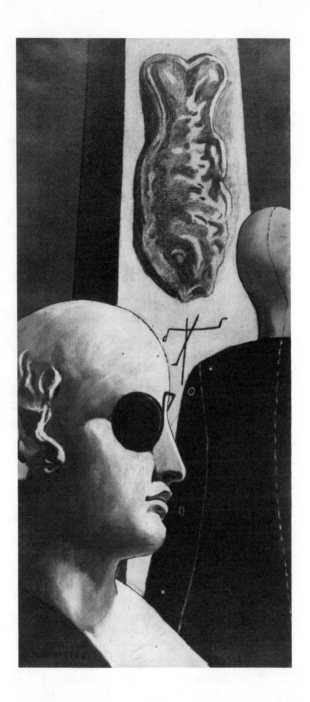

Fig. 14. Giorgio de Chirico, *The Nostalgia of the Poet,* 1914. Oil on canvas. The Peggy Guggenheim Collection, Venice. S. R. Guggenheim Foundation, New York. Photo: Robert E. Mates.

I show this metamorphosis of stone statue into a tailor's dummy because it is amplified in the next year, 1915, when in *The Double Dream of Spring* (fig. 15), mannequin and statue separate and become independent entities. On either side of an easel containing a schematic drawing within the painting, the newly separated pair may suggest a context for identifying the mannequin, a crucial component in de Chirico's later iconography. The previously metamorphosed image (the statue as mannequin) of *The Nostalgia of the Poet* may be interpreted as one in which the mannequin has tried on the clothing of the father (also Cavour) and in so doing

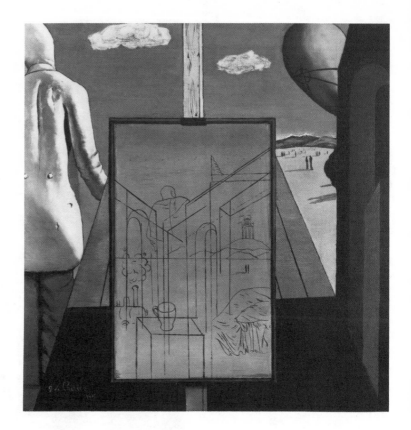

Fig. 15. Giorgio de Chirico, *The Double Dream of Spring,* 1915. Oil on canvas. The Museum of Modern Art, New York. Gift of James Thrall Soby.

assumed for himself a part of the figure's power, as he basks in the reflected glory of the sun-drenched conqueror. Could it be that the mannequin is the painter's alter ego?

The sketchy perspectives and designs on the easel of *The Double Dream of Spring,* first recall the composition of *The Joy of Return* with its converging arcade, train, and sculptural figure. Other images are generally a recapitulation of motifs from the previous two years (Soby, 1955, p. 106). Coexisting with the angled facades is a distant horizon line. Atop its mountains rises the colonnaded tower of *The Nostalgia of the Infinite,* pennants flying. The draped legs of the Ariadne figure intrude at the right side. One entirely new motif, a cup drawn carefully in a three-dimensional scheme atop a cube, prefigures the solidity and precision of what Soby calls a "companion piece" to *The Double Dream of Spring, The Seer,* also of 1915 (fig. 16).

Significantly, the easel painting's arcade perspectives with a statue depicted among them is repeated on a blackboard along with the mannequin in *The Seer,* as if to imply a new sense of order, restraint, and control over which the figure presides. The mannequin in the latter work sits atop the cube, now wood-grained, and this faceless figure turns toward a blackboard on an easel containing lines and angles plotting the diminution of an arcaded wall. A great shadow of a statue on a pedestal intrudes at right. A wooden planked flooring (similar to that behind the easel

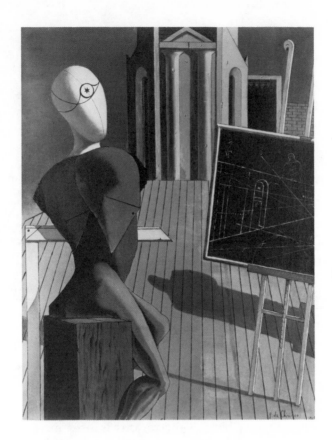

Fig. 16. Giorgio de Chirico, *The Seer,* 1915. Oil on canvas. The Museum of Modern Art, New York. James Thrall Soby Bequest.

in *The Double Dream of Spring*) supports this tableau and recedes sharply back to a small classical edifice.

The separation of the statue–father figure and mannequin, taken together with the painting-within-a-painting motif of *The Double Dream of Spring,* shows an important shift—both psychological and pictorial—beginning in de Chirico's art. It is a new adjustment in the artist's delicate balance between the ideal (his marble man) and the real (the artist's perceptions). This might be called a new awareness on the painter's part of the hauntingly disjunctive spatial arrangements of his style. It is as if de Chirico had stepped outside of himself and begun to realize what he has been up to in his paintings. The figures even convey such dualities. The statue, now in a shortened, more modern coat, continues to stare off into the distant plain and is surrounded by blue sky. He represents the hallucinating visions, the romantic imagination perhaps, that have given rise to the *pittura metafisica.* The mannequin, who appears to turn toward the easel painting, looms up from a distant background containing the familiar pair of black silhouettes. He appears the more analytic personality now— the one who examines the real world and renders it a substantial form on his easel.

What is the source of these changes? Why does the painter suddenly seem to awake from his unconscious pouring forth of images and look at himself more sharply? In a word—if ever a

Fig. 17. Raphael,
*The Marriage of the
Virgin,* 1504. Oil on
panel. Pinocoteca
Brera, Milan.

single word can explain de Chirico—the source of these changes
is Raphael.

Raphael and Milan

Two new places have been proposed here as the sites of de
Chirico's mysterious transformations from real-world observations
to the metaphysical enigma of his paintings: Versailles and the
courtyard of Milan's Brera. The Versailles experience is clearly
documented by the painter. That de Chirico was actually once at
the Brera is documented by his exaltation of Raphael's painting,
The Marriage of the Virgin in the Brera's Pinacoteca (fig. 17). Only
two other names, that of Nietzsche, his great hero, and that of
Phidias, occupy a similar place of honor in the Paris manuscript,
"Meditations of a Painter—What the Painting of the Future Might
Be," of 1912 (Soby, 1955, p. 251).

This is the same 1912 manuscript in which de Chirico discusses
the enigma experienced in the Piazza Santa Croce. The paragraph
on the "revelation of the enigma" is followed by that on Raphael.
He focuses upon "revelation" in Raphael, Phidias, and Nietzsche.
He states that Raphael, when painting the sky and temple of *The
Marriage of the Virgin,* "knew this sensation [of revelation]." In
this sense, he compares Raphael to Nietzsche, who, de Chirico
quotes, was "surprised by Zarathustra." It is clear that Raphael has
received de Chirico's close attention and occupies his highest
pantheon.

Ironically, de Chirico's nonsensical perspective systems from
1913–14 on turn the Renaissance order on its ear. Raphael
upholds the standard of this perfect world. The point of much of
de Chirico's compositional design during his Paris period has been
to follow the modernist impulse set forth by Picasso and Braque.

The blackboard diagram in *The Seer* (fig. 16) is an example of de Chirico's faking of "scientifically" planned orthogonals and vanishing point.

At the same time, his particular admiration for Raphael's temple and sky may be recalled in de Chirico's invented stone facade precisely at the center of *The Seer.* It sits on a horizon line rather high in the picture plane. Approximately one-third of the painting's space is above the horizon; this proportion is similar to that of the Raphael. The temple of *The Seer* could be said to depart from de Chirico's earlier manner and to bespeak the influence of Raphael for several reasons: first, it does not sit flatly nor does it recede precipitously as other of his architectural motifs do; second, it is centered, and its arched buttresses recede along correct orthogonals; and third, the right side is lit while the left is in shadow just as in the Raphael. Moreover, the tilted planking of de Chirico's work may additionally be seen as a buckling, forward-pushing imitation of the logically paced recession into deep space of the paving stones in Raphael's painting. The curve downward of the steps from the temple to the horizon is imitated in the curve to the left background of de Chirico's wooden fake flooring and thus, ironically, heightens its artificiality. Finally, the diminutive figures that recede logically into deep space recall de Chirico's own tiny silhouettes that recur in his paintings from 1912 on.

Moreover, the references to Raphael may not end with only the flattening of the carefully constructed perspective of *The Marriage of the Virgin* and the reconstruction of its temple. The use of square block, black slate and measuring implements by the mannequin recall the tools of the classical world, as demonstrated in Raphael's ideal recreation, *The School of Athens.* By not too great a leap, de Chirico's mannequin can be said to perch atop Michelangelo's writing block (which may explain the unusually muscular leg) and to contemplate Euclid's slate. The title of the painting, *The Seer,* may even confirm de Chirico's essay that "What the Painting of the Future Might Be" is no less than himself, a prophet, synthesizing Raphael, Nietzsche, and Phidias.

Images of 19th-century sculpture and Turin persist alongside the new motifs drawn from Raphael, echoing the painting seen in Milan's Brera. The Dante figure of *The Enigma of an Autumn Afternoon* is represented in schematic white lines on the blackboard. The word "Torino" is visible to the far right (the Nietzschean reference), and the 19th-century statue, now standing outside the picture plane, its gesturing arm subsumed in the silhouette, once more casts its long shadow. Or has the classical toga of Phidias now covered the frock coat?

As for the importance of the father, it can be inferred that he has been integrated into the growing dominance of the mannequin. The latter has set up shop, with some of the tools of an engineer's trade (de Chirico's own father's profession), a measuring tool behind him and plans before. The new order demands the restraint of a new classicism, and while the equipoise of new and

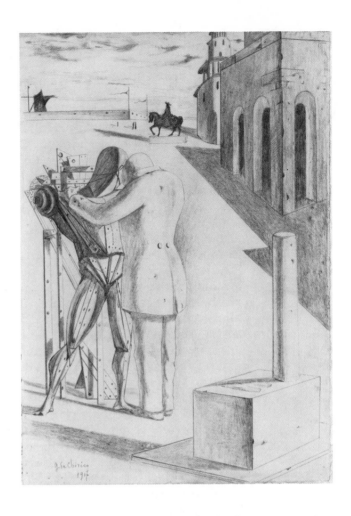

Fig. 18. Giorgio de
Chirico, *The Return
of the Prodigal,* 1917.
Pencil and gouache.
Private collection.

old results in the masterful strangeness of *The Seer,* the classicizing
tendency that de Chirico now has absorbed (just as he has
incorporated his father figure) soon overwhelmed the hallucinato-
ry poetry of his early work. The strong influence of Raphael
prefigures the classicism that overtook de Chirico's style after
1917.

In a drawing of 1917, *The Return of the Prodigal* (fig. 18), where
the enigma lessens its most mysterious force, the statue *steps down*
from his pedestal and embraces the mannequin. Their identities as
father and son are thus confirmed in this image from the last year
of the metaphysical period, and, as a kind of seconding gesture,
the Carlo Alberto equestrian monument, fully visible for the first
time in the same composition with the frock-coated statue, ap-
pears in the distant ground. The reverberations of both Turin and
Milan are apparent here. Nietzsche's city is recalled by a bit of the
transformed Mole Antonelliana tower visible next to the eques-
trian monument; Carlo Alberto's commemorative image thus
stands next to the monument of his son, Vittorio Emanuele. The
second pairing of father and son in the foreground reflects instead

Milan, the city where de Chirico discovered at the Brera the frock-coated statue, the *Napoleon* of Canova, and Raphael's *Marriage of the Virgin*. This drawing sums up, then, the political and psychological associations of the father embracing the errant son. The prodigal returns to his own statue father and to his "patria," to the native land from which he has journeyed.

That the theme of the prodigal son was an obsessive one for de Chirico can be confirmed by the number of times he painted the motif. There are at least four versions of the son's return and embrace by the father between 1917 and 1924. In addition, de Chirico's Surrealist novel *Hebdomeros* (1929) possesses only one "fairly straightforward passage," according to its translator Margaret Crosland (1964, p. 7), which is the description of the return of the son of Monsieur Lecourt. The father is described as "that old man with the severe profile," and elsewhere as smiling "sadly beneath his white moustache," and as "the white-haired old man holding out his arms in forgiveness" (1964, pp. 84–85). In contrast, the son, said to have left his father's house "five years ago . . . to travel the world," is scarcely described at all. The son is featureless, as Crosland points out (pp. 7–8), much like the mannequin of de Chirico's paintings.[28]

Clearly the image of *Hebdomeros* refers back to his paintings. But does it refer to the painter's life? It may be of some passing interest that the prodigal son's five years away from his father's house parallel the number of years the painter spent in Paris, from 1911 to 1915, creating the bulk of the *pittura metafisica* that he would later condemn.

The young de Chirico, who has suffered years of dislocation and abandonment, reminds us in the year 1917 of his continuing identification with Ariadne. In a drawing, *Solitude,* the mannequin reclines in a pose that exactly replicates the pose of *Ariadne* (Sloane, 1958, p. 14, fig. 20). De Chirico confirms his empathy for Ariadne's plight, abandoned on Naxos by Thesus after she had helped to save him from the labyrinth. As the motifs of statue, mannequin, and Ariadne are so closely linked in the 1917 drawings, the replacement of Ariadne by the frock-coated figure from 1913 to 1914 seems, in retrospect, a more logical association than previously thought. The artist dwells first on his despair at being abandoned by his father's death in Greece through his identification with Ariadne, then proceeds to reconstruct an ideal "stone hero" in Italy, reclaiming both father and fatherland (*patria*).

When the father, a gentleman of the 19th century, and a standard-bearer of old-fashioned mores, who taught his son to draw, embraces the son in the 1917 drawing, is it not because the painter has at last left behind his prodigal ways? Is it not even more revelatory that the same theme is repeated in a stiffly Raphaelesque mode in the year 1919 (fig. 19),[29] the same year de Chirico proclaimed himself *Pictor Classicus,* and turned his back on the style of his fantastically creative youth?

De Chirico is quite a rare example of an early 20th-century

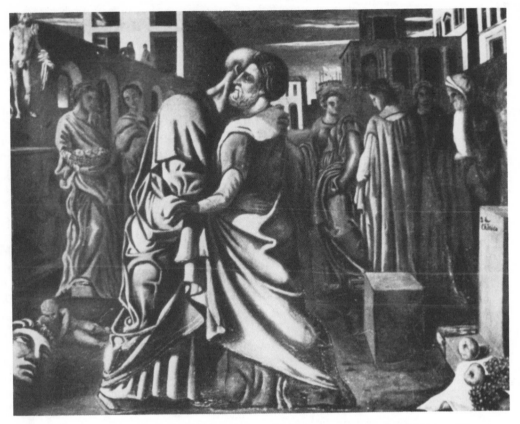

Fig. 19. Giorgio de Chirico, *The Return of the Prodigal*, 1919. Oil
on canvas. Present whereabouts unknown. Reproduced from J. T.
Soby (1955).

modernist whose powerful sense of symbol and iconography is
tied to the 19th century and yet enriches his vanguard pictorial
vocabulary. It is no coincidence, then, that de Chirico seized upon
sculpture as the embodiment of so many motifs close to his heart.
Through the use of sculpture, the painter could approach the
remote nobility of those Risorgimento heroes of the past as well
as that of his own father. The investigation of sculpture in de
Chirico helps the contemporary viewer to find further confirma-
tion of major themes of the *pittura metafisca,* specifically those of
abandonment and reconciliation, departure and return, and the
obsessional imagery of his father. Moreover, de Chirico's use of
sculpture and its iconography provides an important link between
the classicism he aspired to and alluded to in his early works and
that which he achieved, in his embrace of "Old Master" tech-
niques and traditional themes, after 1918. Ironically, perhaps
tragically for his painting, the son's return to the father's 19th-
century embrace closed the door on the most inventive period of
his career.

Notes

1 My research on the sculptor Vincenzo Vela (1820–91) some years ago led me to photograph 19th-century sculpture extensively in Switzerland and many northern Italian cities, but most particularly in Milan and Turin. In an article, "Politics on a Pedestal" (1979), I demonstrated how the now-forgotten, much neglected 19th-century monuments were often the result of an aesthetic of compromise. As a corollary, de Chirico seemed to me the obvious figure to investigate in an attempt to understand how the message and/or symbolism of those monuments carried over to an early 20th-century audience. Though I now believe de Chirico used 19th-century sculpture primarily to express personal meanings, the paintings themselves at the 1982 retrospective exhibition, held at the Museum of Modern Art, New York, spoke strongly to me of specific Milanese sculptures and locations and stimulated the research presented here.

I am indebted to my husband, Martin Newhouse, for his perceptive reactions to this material when it was prepared as a paper in November 1983 for the memorial symposium in honor of H. W. Janson at the Institute of Fine Arts, New York University. My colleague Joan Nissman was also an invaluable aid in the final editing, and to her I would like to express my gratitude.

There is no mention of Milan anywhere in Wieland Schmied's geographic delineation of the painter's inspirations. The cities he enumerated are Volo, Munich, Florence, Turin, Paris, Ferrara, and Rome (Schmied, 1982, p. 55).

Maurizio Fagiolo dell'Arco is one of the few authors who do not overstate the importance of the "mythical sojourn in Turin"; he, in fact, names Florence as de Chirico's most important Italian residence (Fagiolo, 1982, p. 33).

De Chirico listed himself as being from Florence each year he exhibited at the Salon d'Automne (Martin, 1978, p. 342). Martin highlights de Chirico's residence in Milan and Florence, and particularly the emergence of Futurism in Milan in 1909, as important to the painter's early mature work.

2 Robert Hughes was, in fact, filmed in front of the Torinese Bottero statue during his discussion of de Chirico in the television series accompanying his book *The Shock of the New* (1981, pp. 215–17). On another occasion Hughes (*Time*, Jan. 24, 1972), referred to the time de Chirico "settled in Turin in 1911." See also Russell (1985, sec. 2, p. 33) for his assumptions concerning the multiplicity of Torinese sources for de Chirico's use of sculpture.

3 Not only is de Chirico's initial mention of his visit to Turin negligible, but it is a memory dominated by the anguish of his gastric problems:

> We decided to leave for Paris. We closed the Florence house and took the train for Turin. I felt quite ill; it was a terribly hot summer in 1911; it was July; in Turin we stopped for a couple of days to visit the exhibition that had just opened. But with the heat and the fatigue of the trip my health worsened. Because I was much sicker and was having bad intestinal pains, we left Turin. (De Chirico, 1945, p. 94, trans. mine.)

Soby (1955, p. 35) credits the "vital impression" made by Turin on the young artist together with the year in Florence as the source material for his Italian squares.

4 Soby (1955, pp. 50–52). Though Soby was certainly aware of the Mole as one of Turin's principal sites (p. 35), he curiously fails to mention it as a source.

Joseph C. Sloane (1958, p. 10, figs. 7, 9) interpreted de Chirico's paintings as possessing a more public symbolism than previously thought; for example, he saw the piazza series as laying bare the inertia of Italy's frozen adulation of the Risorgimento and past history in general and its failure to move into the rapidly industrializing 20th century. Some of Sloane's Italian sources, such as the Mole Antonelliana, improve on points made by Soby; he also notes that the Mole, while begun as a synagogue, later became a civic shrine to Vittorio Emanuele and, more generally, to the Risorgimento.

5 The major paintings of this statue are *The Enigma of a Day; The Serenity of the Scholar; The Joy of Return;* and *The Double Dream of Spring;* moreover, its shadow is cast in *The Mystery and Melancholy of a Street* and possibly in *The Seer*. The motif also appears in several drawings, notably *La Joie* (1913), which anticipates the series of single 19th-century statues beginning in 1914. Other works are: *The Chimney* (1913) (Soby 1955, p. 182), the drawings *The Slumber* (1913) (Soby 1955, p. 81), and an untitled drawing (1914; Soby 1955, p. 83).

6 Soby (1955, p. 52) counts "five capital paintings" with the Ariadne figure in 1913: *The Soothsayer's Recompense; Ariadne; Ariadne's Afternoon; The Silent Statue;* and *The Joys and Enigmas of a Strange Hour*.

7 Fagiolo (1982, p. 33) begins this part of his commentary by stating, "A worthwhile study could be made of the monuments in his painting," but concludes that "such critical identification [of de Chirico's sculpture sources] is of no interest: de Chirico mingles typologies because he does not wish to reproduce any particular monument."

8 The first sentence, referring to the exhibition of *Enigma of an Autumn Afternoon,* dates the passage to 1912 as the painting was shown in the 1912 Salon d'Automne. See Fagiolo, 1982, p. 11.

9 Soby (1955, pp. 48–50). Within this discussion, Soby refers to *The Red Tower* as "the beginning of de Chirico's true maturity as a painter" (p. 50).

10 It should be noted here that de Chirico evokes other cities besides Turin in *The Red Tower*. The round tower of the painting's title echoes most strongly Rome's Castel Sant'Angelo. However, the Castel Sant'Angelo itself played an important role in the Risorgimento. It served as barracks for the French troops who came to the aid of Pope Pius IX and also for the detention of political prisoners. (See *Rome in Early Photographs: The Age of Pius IX,* ed. Ann Thornton [Copenhagen: Thorvaldsen Museum, 1977], pl. 160.) Thus, there are double Risorgimento references in the architecture and sculpture as well as references to both cities of Rome and Turin. Apart from the tower, de Chirico also connected the Enigma of the Arcade with Rome and the Romans (see note 19 below).

11 In the Eluard manuscript dated 1913, the painter mentions "often having read Nietzsche's immortal work *Thus Spake Zarathustra*" (Soby, 1955, pp. 245–46).

12 Moreover, in another part of his *Memorie* (p. 91), the painter directly connects his search for a pictorial equivalent to Nietzschean sensations with the beginning of the Piazza d'Italia motifs:

In Florence [1910] . . . the Böcklin period passed and I began to paint subjects in which I sought to express that strong and mysterious

sentiment that I discovered in the books of Nietzsche: the melancholy of beautiful autumn days, the afternoons in Italian cities. It was the prelude to the piazzas of Italy painted a little later in Paris.

13 Christopher Middleton (1969, pp. 351–55) cites in full Professor Franz Overbeck's letter of January 15, 1889, to Peter Gast, which describes Nietzsche's breakdown. Though Overbeck did not detail the incident of the horse, widely recounted in later versions of the Nietzsche legend (Podach, 1930, p. 82), he referred to a specific collapse in early January: "Now it was clear on Jan. 4, as his landlord later told me—N. had gone out of his mind." And he described the state he had observed in Nietzsche as "the annihilating split in his personality."

14 The letter from Nietzsche dated January 6, but posted January 5, 1889, reached Burckhardt in Basel. This rambling epistle and another sent to Overbeck persuaded these Basel friends to consult a psychiatrist and impelled Overbeck to go to Nietzsche's aid in Turin.

An edition of Nietzsche's collected letters had been published as early as 1900, edited by Peter Gast and Dr. Arthur Seidl, and so de Chirico might have had access to such documents.

15 Soby intends a generic description of 19th-century sculpture but misses the mark in identifying Italian sculpture of the Risorgimento period as Victorian.

16 Robert Hughes (1981, p. 217) repeats this source and further refers to the statue as the "Philosopher" recurrent in de Chirico's paintings.

17 Touring Club Italiano's Guide to Italy, *Torino* (1959), p. 135.

18 The de Chirico text goes further: "there on the wall is a picture one cannot see without weeping," and indeed the Brera is best known for its Pinacoteca. The only painting de Chirico mentions by its title (apart from a short essay on a Castagno exhibit) in all of the 1911–15 manuscripts from the Eluard and Paulhan collections, which Soby published in the 1955 catalogue, is Raphael's *Marriage of the Virgin* in Milan's Brera. This documents the painter's presence at the Brera and also shows that he had quite a high regard both for Raphael and this specific work. Coincidentally, Martin has noted (1978, pp. 342–43) that Medardo Rosso first experienced the "startling insight" of the unions between a figure and its cast shadow "while looking down at figures walking in the sunlight in the courtyard of the Brera palace."

19 The Brera cortile rises on a double-storied system of arcades which is distinct from the single story visible in most of de Chirico's architecture. That the precise architectural setting to left and right does not come from the Brera should be no surprise, however. De Chirico evokes an arcade composed of many sources in memory. Whether it looks more like Brunelleschi's Ospedale degli Innocenti in Florence (as in *The Mystery and Melancholy of a Street* and *The Enigma of a Day*) or recalls Turin's taller arcaded sidewalks (*Still Life: Turin, Spring*), these forms are combined visualizations of the poetic mystery first experienced in Rome:

> Then during a trip I made to Rome in October, after having read the works of Friedrich Nietzsche, I became aware that there is a host of strange, unknown, solitary things which can be translated into painting. . . . There is nothing like the enigma of the *Arcade*—invented by the Romans. A Street, an arch: The sun looks different when it bathes a Roman wall in light. (Soby, 1955, p. 247)

20 Without rejecting absolutely Soby's Torinese choice of G. B. Bottero as the prototype for de Chirico's single statue in the piazza, Sloane proposes the monument to Count Cavour in Milan, also by Odoardo Tabacchi, as another possible source. He also identifies the de Chirico

statue wherever he reappears as a reference to Cavour (Sloane, 1958, pp. 9–10, fig. 7).

21 De Chirico's idealization of his father is somewhat reminiscent of Friedrich Nietzsche's mention of his father, who died when the philosopher was just five years old:

> I regard it as a great privilege to have had such a father: it even seems to me that this exhausts all that I can claim in the matter of privileges—life, the great yea to life, excepted. What I owe to him above all is this, that I do not need any special intention, but merely patience, in order to enter involuntarily into a world of higher and finer things. There I am at home, there alone does my profoundest passion have free play. (*Ecce Homo,* 1908, p. 10)

22 De Chirico's father aided him in drawing a head of Saint John the Baptist by showing the boy how to align facial features on a cross sketched in over the head he was copying. The points and cross were then transferred to his own drawing. "Great was my satisfaction at having learned the system of the two crosses," concluded de Chirico.

23 In fact, the war between the Greeks and Turks broke out in 1897, while the de Chirico family was living at Volos. The city was then occupied by the Turks. The painter remembers these facts with no particular emotion, except in noting that he was "witness to many frightening, agonizing and pitiful spectacles" (p. 28), and turns to a lighter tone as he remembers the English, French, Russian, and Italian war boats that gathered in the harbor to protect the citizens of their respective countries. He delights in describing the Italian boat, appropriately named *Vesuvio,* with its enormous cannon placed in a stationary position so that the entire boat had to be turned in order to point the armament at a given target. He concludes by recalling the commanders of the Italian and French boats, named Ampugnani and Pampelone, both of whom were friends of the family. The bizarre detail that Pampelone was an excellent pianist, whose "speciality was the preludes and nocturnes of Chopin," is inserted in the midst of these scenes of war.

24 I am indebted to Professor James McCredie for this information.

25 Willard Bohn (1981, pp. 132–35). Bohn is one of the first scholars to suggest another interpretation of *The Child's Brain.* He believes the figure, who reappears in the 1917 drawing *The Return,* represents Napoleon III. This identification is based on the appearance of Napoleon's mustache and on an account recorded by André Breton: "de Chirico still admits that he has not forgotten [the phantoms] . . . he has even named two of them for me: Napoleon III and Cavour, and had informed me that he had protracted dealings with them" (quoted in Bohn, 1981).

Now it happens that Breton, as reported by William Rubin in another context, was "famous for not knowing when Picasso was pulling his leg" (1982, p. 78). The seriocomic nature of de Chirico's "admission" must then be taken into account and evaluated as de Chirico's possibly willful complication of Breton's reading of the painter's iconography.

It is a curious fact of 19th-century political alliances that Napoleon III and Vittorio Emanuele wore their mustaches in similar lengthy, waxed, handlebar fashion, with tiny Vandyke beards below. The fleshy appearance of the man in *The Child's Brain* is in fact closer to Vittorio Emanuele's own physiognomy; see fig. 18.

Given the dominance of Vittorio Emanuele in other aspects of de Chirico's symbolic language (e.g., the equestrian monument of Carlo Alberto, which he once misidentifies as that of Vittorio Emanuele, in *Still Life: Turin, Spring* [1914]; as Nietzsche's persona in his madness;

and possibly through the imagery of the Mole Antonelliana [see note 4]), the case is much stronger that it is he who is symbolized here on one level of de Chirico's multiple references.

26 Soby (1955, p. 78) quotes de Chirico "The huge zinc-colored glove, with its terrible golden finger-nails, swinging over the shop door in the sad wind blowing on city afternoons, revealed to me with its index finger pointing down at the flagstones of the pavement, the hidden signs of a new melancholy." Soby interpreted the pointing hand as the "shadow [of the metal glove] . . . cast on the white wall" in *Still Life: Turin, Spring* and also in *The Destiny of a Poet*. Its form is revealed in red in *The Enigma of Fatality* (see Soby, 1955, pp. 196–98). The white lines articulating fingers and nails are too explicit in *Still Life: Turin, Spring* to consider the hand only a shadow, and certainly not the shadow of the more spiky-fingered glove. Because of this multiplicity of source material for a single motif, so common in de Chirico, the Piola pointing hand may indeed form one layer of reference.

27 The statue seen from behind is combined in yet another work, *Drawing* (1914;) with the pointing hand on the same flat white board as in *Still Life: Turin, Spring*. The statue replaces the equestrian monument, yet another reflection of the close association of the two in de Chirico's mind.

28 The only image de Chirico gives of the prodigal son reads thus: "at the end of this road appeared a man walking wearily, leaning on a long stick, with a heavy bag on his back and a coat rolled up and tied with string" (*Hebdomeros,* p. 85).

29 Sloane, who otherwise does not discuss Raphael's pervasive influence in de Chirico, remarks in passing that "the two men [who embrace] . . . could almost be the Plato and Aristotle from Raphael's *School of Athens*" (p. 20).

References

Baldacci, P. (1983). "Le classicisme chez Giorgio de Chirico." *Cahiers du Musée National d'Art Moderne,* no. 11 (Nov.):18–31.

Bohn, W. (1981). "Phantom Italy: The Return of Giorgio de Chirico." *Arts Magazine,* 56, Pt. 2 (Oct.): 132–35.

De Chirico, G. (1945). *Memorie della mia vita.* Rome: Astrolabio.

_____. (1929). *Hebdomeros.* Trans. M. Crosland. London: Peter Owen, 1964.

Fagiolo dell'Arco, M. (1980). *Il tempo di Apollinaire, 1911–15.* Rome: DeLuca.

_____. (1982). "De Chirico in Paris, 1911–15." *Giorgio de Chirico,* pp. 11–34. New York: Museum of Modern Art.

Hughes, R. (1981). *The Shock of the New.* New York: Knopf.

_____. (1972). "Art: Looking Backward." *Time Magazine,* Jan. 24, p. 48.

Martin, M. (1978). "Reflections on de Chirico and *Arte Metafisica.*" *Art Bulletin,* 60 (June): 342–353.

Melville, R. (1940). "The Visitation—1911–1917." *London Bulletin,* June, pp. 7–9.

Middleton, C., ed. (1969). *Selected Letters of Friedrich Nietzsche.* Chicago: University of Chicago Press.

Nietzsche, F. (1908). *Ecce Homo.* New York: Gordon.

Rubin, W. (1982). "De Chirico and Modernism." *Giorgio de Chirico,* pp. 55–79. New York: Museum of Modern Art.

Russell, J. (1985). "Nineteenth Century Sculpture as Seen by a Noble Spirit." *New York Times,* March 24, sec. 2, p. 33.

Schmied, W. (1980). "Turin als Metapher für Tod und Geburt," *Neue Zürcher Zeitung,* no. 255, November 1–2, p. 68.

_____. (1982). "Les sept villes de Giorgio de Chirico." *Giorgio de Chirico,* pp. 55–60. Paris, 1983.

Scott, N. J. (1979). "Politics on a Pedestal." *Art Journal,* 38, no. 3 (spring): 190–196.

_____. (1979). *Vincenzo Vela, 1820–91.* New York: Garland.

Sloane, J. C. (1958). "De Chirico and Italy." *Art Quarterly* 21 (spring): 3–22.

Soby, J. T. (1955). *Giorgio de Chirico.* New York: Museum of Modern Art.

Terino (1959). Milan: Alfieri and Lacroix.

Thornton, A., ed. (1977). *Rome in Early Photographs: The Age of Pius IX.* Copenhagen: Thorvaldsen Museum.

Milly Heyd,
Ph.D.

De Chirico: The Girl with the Hoop

Each of Giorgio de Chirico's paintings presents an undeciphered enigma, a mystery that the abundant literature devoted to his art fails to illuminate adequately. The two essays that follow propose a new, psychoanalytically oriented framework interwoven with an art historical approach for interpreting a number of the major pictures that de Chirico painted during the flowring of his metaphysical phase, between 1911 and 1919.

These interpretations draw on autobiographical writings as well as on available biographical material. Because de Chirico emphasized the impact of his extensive reading on the metaphysical paintings, the role of his literary sources will also be considered.

The themes that concerned de Chirico during his first Parisian period, and afterward during his World War I phase in Ferrara, reveal a continuing preoccupation with problems concerning his family of origin. The artist's relationship with his two siblings, enacted in the context of the concurrent involvement with his parents, profoundly affected de Chirico's oeuvre during these years of struggle to resolve emotional problems rooted in early childhood.

"Now flies the ball; now rolls the whirling hoop." the exiled Ovid wrote nostalgically, thinking of children playing in Rome (*Trista* III, elegy 12). The hoop as a focus of romantic reminiscences found its way into a painting by another "Italian" living outside his country centuries later when the metaphysical painter Giorgio de Chirico depicted a girl playing with a hoop in his famous picture *The Mystery and Melancholy of a Street* (1914; fig.

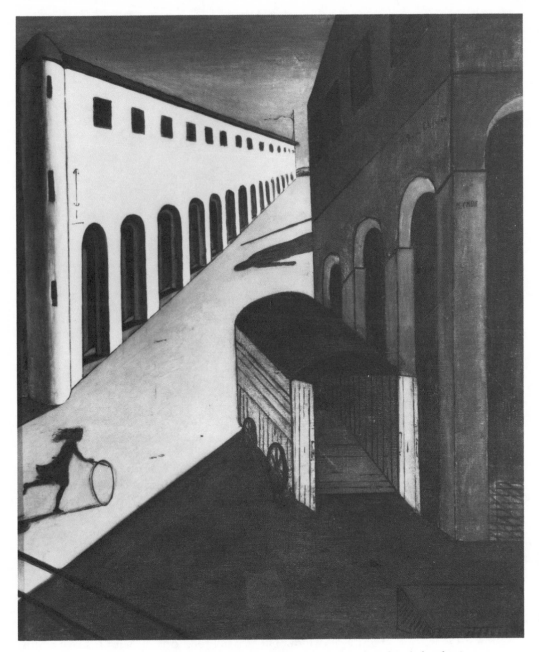

Fig. 1. Giorgio de Chirico, *The Mystery and Melancholy of a Street,*
1914. Oil on canvas. Private Collection. Photo courtesy Acquavella
Gallery, New York.

1), originally owned by Apollinaire. He painted the picture in
Paris during his self-imposed exile, when he longed for his Greco-
Roman past. But whereas Ovid's idealized narration is descriptive
and genrelike, stressing the ball and the hoop, de Chirico's is
more specific, showing a particular girl with a hoop, whose

presence is emphasized by her shadowy appearance. The protagonist presents a disturbing image of nightmarish quality; as a mysterious living shadow, she brings forth associations with life in Hades, the world of the shadow of death.

Soby, one of the earliest modern critics to be interested in de Chirico, noticed the intriguing quality of the painting but could not explain it.[1] He held that the image of the girl derives from Seurat's *Sunday Afternoon on the Island of the Grand Jatte* (1886). In the early version of his book Soby claimed:

> The protagonist of omen in *The Mystery and Melancholy of a Street* is, of course, the girl with a hoop, an image destined . . . to make a profound and lasting impression on the public. Exactly why this particular figure should have appealed to popular consciousness is difficult to say. . . . There is an extreme fascination in watching her progress. She must run for the open light, past the carnival wagon, past the arcades, past the forbidding shadow which lies across her path. Even though she reaches the light she is doomed, for she is herself a shadow retracing the steps which led to her dissolution. (Soby, 1941, pp. 42–43)

Since she is a shadow running in the light, however, the threat to her existence rather lurks in the triangular shadow with which she would merge upon reaching it.

In addition to Seurat's painting, a number of other pictures of the late 19th and early 20th century featured a little girl with a similarly disturbing quality. She appears as a wild creature with a monstrous dynamism in Henri Rousseau's *War* (1894) and plays a very central part in Kirchner's *Street* (1907), where her enormous hat sets her apart from her surroundings. The spectator's attention is thus drawn to this peculiarly encircled little figure who seems to represent a perverted image of childhood. De Chirico's portrayal of the shadowy girl with the hoop is congruent with these earlier figures from Seurat, Rousseau, and Kirchner who, each in his own way, depicted the disruption of the romantic myth of childhood innocence, which persisted in the 19th century through the art of the Impressionists. Reminiscences of childhood now became intricate, as in de Chirico's girl with a hoop, a mysterious puzzle that demands to be solved.

I believe that this painting is central to an understanding of de Chirico's artistic world, that it is autobiographical, and that it sheds light on the mystery of the artist's oeuvre during his metaphysical period. In order to grasp the meaning of the painting, one has to refer to the artist's writings, particularly his memoirs. Both the theme of the painting (the symbol of the hoop, the shadow, the sense of mystery) and the extra-artistic evidence (provided by the artist's own reports about his childhood) call for a psychoanalytically oriented interpretation. Such an interpretation is also relevant historically because de Chirico was probably one of the first major artists to have read Freud in German.

The artist's memories of his very early, formative experiences are crucial to an understanding of the painting:

> My most distant memory is of a big room with a high ceiling. In the evenings it was dark and gloomy in this room; the paraffin lamps were lit and the shades put in place. I remember my mother seated in an armchair; in another part of the room sat my little sister, who died shortly afterwards; she was a little girl of six or seven, about four years older than me. I stood holding in my hand two minute disks of gilded metal, pierced in the centre. They had fallen from a kind of Oriental scarf, completely covered with these little glittering disks, which my mother used to wear on her head. As I looked at the two little disks I believe I thought of timpani or drums, something that should have produced a sound, something that people played or played with, but the pleasure I felt at holding them in my inexperienced little fingers, like the fingers of primitive painters, was certainly linked to that profound feeling for perfection that has always guided my work as an artist. Those identical disks, which matched exactly and glittered, with the perfectly shaped holes pierced in the centre, appeared to me then as something miraculous, just as later Praxiteles' *Hermes* in the museum on Mount Olympus seemed perfect to me and later still the portrait of the *Daughters of Lysippus* by Rubens in the Munich Pinacothek, and a few years ago the famous canvas by Vermeer, *The Mistress and the Maidservant,* in the Metropolitan Museum of New York. (De Chirico, 1945, p. 13)

This description is repeated in the succeeding passage because the author wished to emphasize its content and to create an impression of a recurring, basic memory:

> From that extremely remote memory of my infancy, from that dark and gloomy room which I see again as one sees a dream within the mind, there emerges a symbol that is minute and tremendous, a symbol of perfection: the little gilded discs, each with a hole pierced in the centre, from my mother's Oriental headdress. (De Chirico, 1945, p. 14)

As this was de Chirico's earliest reported memory and the one with which he chose to begin his memoirs, it must have had profound personal meaning for him. Furthermore, this memory contains the clue to the significance of the little girl playing with the hoop and can shed light on other elements in his painting.

De Chirico described this early scene vividly; we can readily imagine the little boy in a room with two feminine figures, his mother and sister, both in armchairs, as if complementing one another. The only elements that brighten this dark and gloomy room are the two gilded disks belonging to the mother. The scene is described from a child's point of view and the sense of space and size differs from that of an adult. Thus the room seems very

big, and from the child's perspective the most minute thing can acquire enormous significance. The young boy holds a beautiful, sensual object, archetypically feminine in its shape, part of his mother. For him it is full of meaning: it is a rounded shape with a pierced center, a shape which he, a boy, lacks. Furthermore, de Chirico described himself as playing with it with "inexperienced little fingers." The child feels inferior compared to the two disks (the mother and the sister), which for him are symbols of perfection. His notion is that feminine perfection is enhanced by its unattainability. Thus we see a little boy facing the mystery of femininity.

These childish comparisons remained at the root of de Chirico's adult comparative attitude toward the world. His memoirs are full of derogatory expressions used to describe the world around him and the artists he did not respect.[2] His early memory was even associated with his later division of artists into those who, like him, had "inexperienced little fingers" (the primitive and modern painters) and those who created "something miraculous" (Praxiteles, Rubens, and Vermeer). All the works mentioned are very sensual. The Vermeer is also directly related to de Chirico's early image of perfection, since the mistress' hairstyle is circular and feminine, intertwined with glittering jewelry—round tactile symbols of perfection. For him it is the quality of the material that determines the quality of the work of art: its perfection.

The polarity within de Chirico between his sense of perfection and his sense of inadequacy is typical of a child at the age of three (the age at which he described himself in the beginning of his memoirs), the age when the process of separation from the mother is at its crest. To use Margaret Mahler's terminology, it is during the rapprochement period (from the second half of the second year) that "the child is at the peak of his delusion of omnipotence . . . that his narcissism is particularly vulnerable to the danger of deflation" (Mahler et al., 1975, p. 228).

De Chirico's allusion to Praxiteles' *Hermes* is also very revealing. His father is conspicuously absent from his first memory. Assailed by his feelings of being engulfed by femininity and attempting to detach himself from it, the artist significantly failed to mention as an example of a perfect work the more traditional image of the mother and child, but rather alluded to a sculpture of a man embracing a child. Thus he presented a paradigm of a father-child relationship as a means of finding refuge from and overcoming the all-engulfing mother.

De Chirico's set of associations began with Hermes as a soothing father and led him onward to Rubens's *Daughters of Lysippus,* a scene depicting a brutal act of rape. In his fantasy only such a violent act would enable him to subdue and overcome the perfect woman. Yet even here he cannot face the woman alone. The mythological scene depicting the inseparable Dioscuri twins, Castor and Pollux, is a dual scene conceived in complementary contrast (one woman is up, the other down, one of the brothers is armored, the other is naked). We see here an unconscious allusion

to the second part of the de Chirico sibling complex—his symbiotic relationship with his brother. He cannot overcome femininity alone but calls for his sibling's support.[3] The third item in his chain of associations, however, Vermeer's *Mistress and the Maidservant,* alluded to his cravings to become part of a household in which the lady of the house had a perfect, circular headdress. He therefore returned to his point of departure—unattainable feminine perfection.

De Chirico's comparative tendency was also reflected in his daring suggestion that perfection is ultimately a matter of plasticity and tactility rather than of spirituality. Thus he rated painting as an artistic form superior to nonplastic arts, such as literature and music (and we might add, to the abstract style of painting itself). His early preference for the tactile over the abstract also anticipated de Chirico's lifelong struggle to decide between his more abstract ("less perfect"), angular, Metaphysical style and his later sensual, "rounded style." Paradoxically and, for the artist, tragically, his Metaphysical style was the one that was hailed, whereas his later attempts at what he considered the more perfect style did not earn him much success. It should be noted that the memoirs were written *after* de Chirico had changed his style and become critical of his earlier Metaphysical work.

The little girl playing with the hoop (replacing the two disks), therefore, should be seen as a displaced symbol of perfection and the two disks, in turn, as a displacement of maternal perfection, which so deeply impressed the young boy. The "minute" yet "tremendous" image of the disk is transformed and enlarged into a full-scale hoop. Both the disk and the hoop are typically objects of "play." But while the playing fingers of the young child were "inexperienced," the whirling of the hoop requires, as we shall see, much control and expertise.

I believe that the little girl playing with the hoop portrayed de Chirico's distant memory of his dead sister. The psychoanalyst Henry Krystal suggested, "the shadowy figure of the girl with a hoop may be an apparitional reference to his dead sister" (1966, p. 220). Krystal, however, did not elaborate further on this matter. A photograph taken in Athens in 1890 shows Gemma de Chirico with her children, Adele and Giorgio. In the photograph Adele has long hair which resembles the hair of the girl in the painting.

Evidence indicates that in 1913 de Chirico read Schopenhauer's *Essay on Spirit Seeing,* which he owned in the French edition. Among other things, the essay deals with the nature of dreams and the possibility of seeing "the phantoms of the departed":

> In our dreams people long since dead figure again and again as living persons because in the dream we do not remember that they are dead. We often see ourselves again in the circumstances of our early years, surrounded by those who were alive at that time and with everything as of old because

Fig. 2. Photograph showing Giorgio de Chirico as a child, holding a hoop. Private collection.

all the changes and transformations that have since occurred are forgotten. (Schopenhauer, 1974, pp. 231–32)

Schopenhauer recognized a similarity between somanbulistic perception, clairvoyance, vision, second sight and spirit-seeing. The ability of the clairvoyant somnabulist to communicate with distant persons is also illustrated by a literary example from the classical world. Schopenhauer emphasized that we learn from the ancients (Odyssey) that the spirit apparitions are shades, "The shadow pictures of the deceased" (p. 284): "Thus what we see . . . is certainly not the deceased man himself, but a mere shadow, a picture of him who once existed which originates in the dream-organ of a man attuned to it" (p. 285).

It seems to me that de Chirico's reference to the spirit of his dead sister is closely linked with Schopenhauer's analysis of spirit-seeing. The philosopher stresses the point that such visions are "not necessarily bound to be the skeleton or other remnant of a corpse, but that other things, at one time in close contact with the deceased, are also capable of [creating those visions]" (p. 287). Perhaps de Chirico depicted his sister with a hoop because they actually shared such a toy once or he even inherited it from her. At least in one of the family albums we see de Chirico as a little boy holding a hoop (fig. 2).

It is a common tendency to idealize the dead, whom we prefer to think of as perfect and unrivaled.[4] This tendency is probably even greater in the case of deceased children who died in a state of innocence. De Chirico as a young child thus found himself in competition with a perfect, dead sister. Her image reflects not only his sense of loss but also his envy and, probably, the guilt this envy evoked. *The Mystery and Melancholy of a Street* is the mystery which leads to the melancholy of death that plagued de Chirico while he attempted perfection. The work, then, sym-

bolizes the mystery and melancholy of perfection, which for de Chirico remained unattainable throughout his artistic life.

The artist's reminiscence of his sister presents a dual perspective on age—that of the child he was then as well as that of the adult who outlived her: "my little sister . . . about four years older than me." This paradoxical phrase sounds like a violation of logic: she was older, and yet, because she died prematurely, she remained little. De Chirico's paradoxical perspective may account for the smallness of the ghostly girl who lives in the "shadow of death."

De Chirico's memoirs also refer to Adele's death: "At that time my little sister died, but I do not remember the occasion." He seems to have repressed the event, for he did, in fact, witness the funeral procession: "Later my mother told me that at the time of the funeral I was sent out for a walk with a nursemaid and she, either from stupidity or spite, stopped with me at the very place where the cortege accompanying my sister to the cemetery was passing" (de Chirico, 1945, 1971, p. 14). This angry evaluation reveals that the event did create a lasting impression on him. Indeed the "cortege" became the wagon of *The Mystery and Melancholy of a Street.*

A similar wagon appears in a number of de Chirico pictures; three of them date from 1914. In *The Mystery and Melancholy of a Street* the doors of the wagon are open as if ready to receive the girl who is running toward it. In *The Anguish of Departure,* (1913–14, fig. 3), the wagon is closed and the child is no longer visible. The title of this picture also seems much more powerful and dramatic than that of the previous painting. The mystery and melancholy that characterize the mood of the work depicting her while she is still alive—though threatened—change into anguish following her departure and the advent of the funeral procession. But in the third picture, *The Enigma of the Day,* (1914, fig. 4), we see the last stage: death is final. The wagon has no wheels at all; closed, it now looks like a coffin. Again, "enigma" is a stronger word than the "mystery" of the title of the first painting of the cycle. Not only did de Chirico the child lose his sister and suffer because of that loss, but through her death he also faced the enigmatic question of the significance of death itself.

The basic enigmas in a child's world (which obviously extend to one's whole life) are the questions "Where did I come from?" and "Where am I going?"—in other words, the mysteries of birth and death and therefore, as the name of the painting suggests, both "mystery" and "melancholy." For de Chirico the child, the concern with death was not an abstract interest but a real, traumatic experience—the death of a sister. In this series of three pictures, painted in Paris, he clearly began to work through the mourning process.

The source of the second shadow dominating the empty space in the painting—a shadow also present in other de Chirico paintings—is a sculpture not shown in the painting. The shadow, representing the father, is directed toward the arcade. This en-

counter between the shade with its phallic shape and the feminine forms of the arcade became almost a cliché in de Chirico's art. Furthermore, the shadow's very separation from the actual body projecting it seems to imply a kind of castration anxiety. The

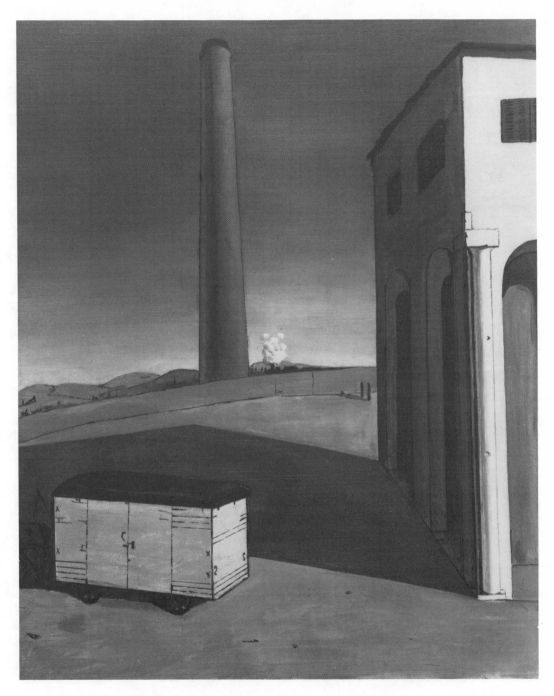

Fig. 3. Giorgio de Chirico, *The Anguish of Departure*, 1913–14. Oil on canvas. Albright-Knox Art Gallery, Buffalo, New York. Room of Contemporary Art Fund, 1939.

painting was completed a number of years after the death of de Chirico's father, whose omnipotence was evidently being questioned, since he had been unable to prevent death (his own and his seven-year-old daughter's). Moreover, the sister's death took

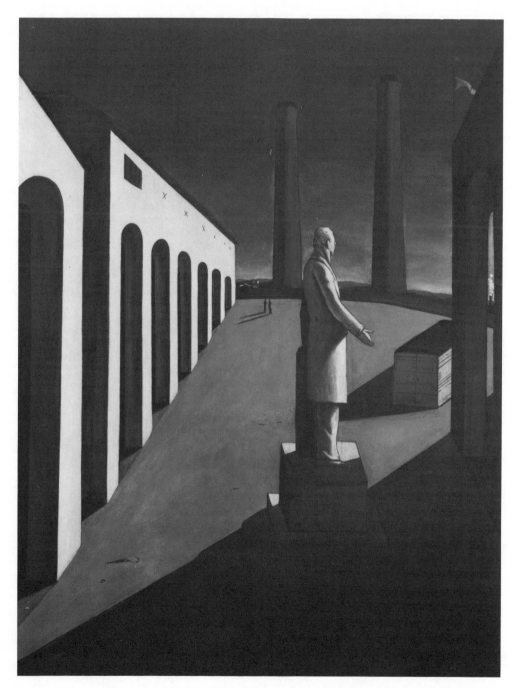

Fig. 4. Giorgio de Chirico, *The Enigma of a Day*. 1914. Oil on canvas. The Museum of Modern Art, New York. James Thrall Soby Bequest.

place when de Chirico was three years old and at the very onset of the oedipal stage, so that the survivor's sense of guilt was doubled. The sister, associated with femininity in the beginning of his memoirs, also served as a substitute for the mother. The strong sense of sorrow, apparent both in the passage from the memoirs and in the painting, may also reflect a sense of guilt, as if her death were the outcome of de Chirico's incestuous cravings as a child, which were also reenacted in his adolescence. His father died when Giorgio was sixteen. Furthermore, it may be possible to assume that this sense of guilt, which was related to the wish to get rid of his father, was doubled since his father died eight years before the painting was begun. De Chirico depicted the fates of the sister and the father, presenting the two in the form of shadows. The phallic shadow aiming toward the arcade echoes the position of the girl, who turns the hoop with a stick. The father and daughter complement each other in the fantasy of the surviving son.

De Chirico himself discussed the meaning of the geometrical shapes in his metaphysical paintings, basing his interpretation on Otto Weininger's ideas: "As an ornament the arc of the circle can be beautiful: this does not signify the perfect completion which no longer lends itself to criticism, like the snake of Midgard that encircles the world. In the arc there is still an element of incompletion that needs to be and is capable of being fulfilled—it can still be anticipated." De Chirico, again adopting Weininger's line of thought, declared: "This thought clarified for me the eminently metaphysical impression that porticoes and arched openings in general have always made upon me" (Carrà, 1968, p. 91). In *The Mystery and Melancholy of a Street,* de Chirico sets side by side the two complementary shapes, the circle and the arch (the arch being repeated in the arcade). De Chirico juxtaposed here what had already reached completion (the circle) with what was still to be reached (the arch). For the girl, who had reached perfection, the inevitable consequence was death.

The inability to achieve perfection and the relationship between geometric shapes (including the hoop) and melancholy form the themes of another undeciphered painting by de Chirico, *Hermetic Melancholy,* (1919, fig. 5). An analysis of *The Mystery and Melancholy of a Street* and the associations provided by the artist in the beginning of his memoirs supplies us with clues for understanding the nature of *Hermetic Melancholy.* The name itself suggests a number of possible interpretations. It could mean a closed-in (internal) melancholy that has no external outlet, a notion also suggested by the suffocating feeling that the painting projects. Yet, it can also be related to the classical head floating above which recalls that of Praxiteles' *Hermes.* De Chirico's title relates hermetic (introverted) melancholy and Hermes. In Greek the hermeneut is the interpreter, the agent. Hermes, in his aspect of tutelary deity of speech and writing, is, therefore, the interpreter of symbols. De Chirico, as we have already seen, had mentioned Praxiteles' *Hermes* in the beginning of his memoirs as representing

96

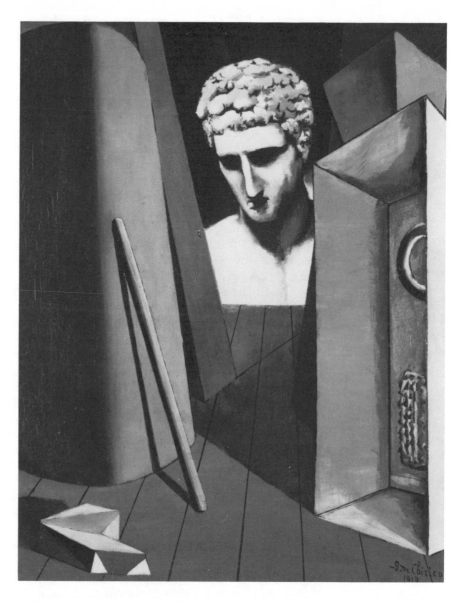

Fig. 5. Giorgio de
Chirico, *Hermetic
Melancholy,* 1919. Oil
on Canvas. Musee
d'Art Moderne. ©
Musees de la Ville de
Paris by SPADEM,
1987.

perfection. Yet, the artist never depicted the complete sculpture
in which the god holds a little boy, leaving it in the form of a
verbal fantasy. There is, however, another more direct visual
source for de Chirico's image—the head a marble statue of an
athlete (360–350 B.C.), itself, in turn, based on Praxiteles' *Hermes.*
The head of the athlete as depicted by de Chirico deviates from
its prototype in the downward inclination of the head, suitable for
a melancholic disposition. This classical athlete is in Munich,
where de Chirico studied at the Academy of Fine Arts, and it
undoubtedly made an impression on him at that time.

What is the meaning of the scene depicted in *Hermetic Melan-
choly* and how are we to account for the enigmatic objects that it
incorporates? On the ground an elongated container stands on
end; inside it we see part of a circular form and below it a

rectangular object. The two shapes resemble biscuits, and the combination of circle and rectangle suggests an allusion to the human figure. The container and biscuits could indicate a baking pan, but they also suggest a coffin with a body inside. Does the girl with the hoop lurk once more behind this imagery? If so, the hoop has lost its complete or perfect shape, just as the Hermes figure has lost his body. It is a scene of separation, of dislocation, of burdened melancholy.

There are other geometric forms in the picture. A stick, similar to the one used by the little girl to trundle the hoop in the 1914 painting, now stands alone, resting against a wall. The curved top of the wall is also reminiscent of the arcade. In the foreground of the picture plane is an odd angular form (or forms) that remains quite unclear and, by de Chiricoan standards, imperfect, despite its geometric quality. These forms, here explicitly associated with melancholy, have a clear visual source in the Dürer engraving, *Melancholia I,* in which the melancholic figure holding the compass represents the saturnine, or depressive, temperament. The latter's melancholy mood is conveyed not only by his sad expression but also by the contrast between the perfect roundness of the sphere resting beside him and the imperfect form of the complex, angular block above it. Both the (incomplete) circle and the odd angular form in *Hermetic Melancholy* seem to echo objects in the Dürer print. De Chirico himself mentioned Dürer in his writings, rating him "a great master" (Carrà, 1968, p. 138).

Throughout his work, de Chirico injected strong emotions into his geometric world. His complex and ambivalent attitude toward the girl with the hoop, both in the original painting and its variation, is an example of this tendency. The hoop, however, represents not only a personal experience of an individual artist but also a long, collective history from different cultures. A chronological study of the hoop will help stress the uniqueness of the de Chirico paintings that feature it.

Hoop-rolling is a game with deep historical roots. Hoops were among the toys with which the ancient Egyptians played. For the Greeks, hoop-rolling was a game of skill. In Sparta, for instance, practicing with a hoop was part of a young girl's education, developing her grace. Hippocrates recommended playing with a hoop as a cure for weak people, and Arthemidorus, in *Dreams* (III, LVII), said that if a person dreams about trundling the hoop, abundance is about to come to him. And yet, even in the classical world we also find a connection between the hoop and death. In an illustration on a vase a youth can be seen holding a hoop, turning backwards toward a bearded man. This scene is interpreted as connoting "the premature death of a man upon his entry into an adult career" (Becqu, 1869, p. 167). This juxtaposition of a child's playfulness with death suggests "premature death."

Lucas Cranach depicted a number of scenes entitled *Melancholy;* in one of them two children play with hoops (1532).[5] Furthermore, the hoop casts a shadow on the ground. It is impossible to

guess whether de Chirico knew this picture, but the recurrence of the suggestive word "melancholy," appearing with children's hoops both in Cranach's and in de Chirico's paintings, is striking. In addition, there is a literary precedent for de Chirico's image in a poem written by the Dutch author Joost van den Vondel, dedicated to the death of his daughter:

> She drove, followed by a zealous troop
> The clanging hoop
> Through the streets
> <div align="right">(Durantini, 1983, p. 221)</div>

In this case, as in de Chirico's painting, the dead girl is remembered as she appeared, trundling her hoop through the streets.

Emblem books often used children's games to convey a moral. For example, the 1682 *Emblemata* depicts a boy playing with a hoop, with the moral: *Besser still gestanden,* "It is better to stand still." In other words, the game is a useless, futile effort; life should be spent on more fruitful tasks than chasing after hoops.

The hoop was also a significant image in 17th-century Dutch art. It acquired both positive and negative moral connotations, sometimes suggesting the virtues of grace (Jan Steen's *Grace*) and love (an attribute of Cupid), because "it has no end, no sharp edges or angles, and will be advanced if pushed" (Durantini, 1983, p. 226). In an earlier example described by Mary Durantini, a 16th-century Brussels tapestry, *A Garden with Games* (p. 228), alludes to the game of love by portraying a man who holds a hoop standing next to a couple playing chess. Hoops are also found in brothel scenes, as in Joachim Beuckelaer's works. According to Durantini, Pieter de Hooch's *Child with a Hoop* conveys more subtle associations with love: "The suggestion that this might be an amorous scene is derived primarily by the retreating figure of the man and by the child holding this particular toy who watches him" (p. 226).

The tense, erotic relationship in the de Chirico painting between the girl with the hoop and the phallic shadow in the background (while the architectural elements are emphasized) echoes a similar kind of suspense in de Hooch's seemingly innocent genre scene. De Chirico is in line with past traditions when he fuses the theme of death with erotic allusions through the hoop.

The meaning of the hoop images in the period 1600–1800 can also be traced through literary texts. In a text written by Jacob Katz in Holland during the 17th century, we find the following description:

> Furthermore, this is a hoop which rolls lightly on the sand and repeats its movement ceaselessly and uniformly with speed. The child who propels it can not foresee that this successive rotation is the kind of life which he may possibly lead. The lives of how many mortals resemble it: they go

around endlessly in the course of the same circle which they have circumscribed; in short, they get up in the morning only in order to go to bed at night. (D'Allegmagne, n.d., p. 8)

The repeated movement of this game echoes the rotation of life and the game becomes a microcosm for the round of human existence. There is a duality in the game, a kind of dramatic irony because the child remains unaware of the parallelism between his game and the futility of the game of life. The trundling of the hoop has a Sisyphean quality, just as life is part of a futile cyclical pattern of which we are usually unaware.

The 18th century provided us with some well-known children's rhymes of a different nature. They celebrated the enjoyment of games, as the dancing master (1728) enthusiastically lured the children into the street:

> Boys and girls come out to play
> The moon doth shine as bright as day
> Come with a hoop, come with a ball
> Come with a goodwill or don't come at all.

But the 18th century also sometimes expressed a more skeptical attitude. The duality in children's games is stressed by contrasting the children, who are innocent of the meaning and consequences of their games, with the philosophical view expressed by the wise adult who watches them. This double perspective is found in a poem by Vitalis (1786):

> On a path running by a brook,
> A river, if you'd like, if to judge by the
> 	quantity of water,
> 		A schoolboy with dexterity
> 		Was rolling a large hoop.
> At this point the path was fine,
> And could be run at a great speed.
> 		But by dint of running,
> 		The hoop still ahead,
> 		The schoolboy still behind
> 		The path became very slippery,
> 		And the meeting of a stone
> First by the hoop, then by the child,
> Made them both roll into the river.
> When the road is good, each one can boast,
> In peacetime every minister is clever,
> But when the path becomes difficult?
> 		And can the danger be seen?
> 						(D'Allemagne, n.d., p. 11)[6]

This text shows how overcoming the difficulties of playing with a hoop may symbolize overcoming difficulties in life. And once more there is a moral question. Does the child see the threat, the danger inherent in the hoop game, which parallels the risk involved in "the game of life"?

A 19th-century book describes a moralistic dialogue between two girls who sing a duet while driving their hoops. The first two lines associate the game with life, the attribute of the goddess Fortuna. As the turning of the hoop requires physical skill to avoid its digression from the narrow path, so human life should be maneuvered within the bounds of virtue to protect it from the threat of wreckage. The precariousness of life is heightened by the very subtle equilibrium of the turning hoop. Fortuna is thus controllable by virtue. The cyclical notion is also described as:

> Time, like a moving hoop
> Will roll from Christmas time
> to new year's day
> And guide to its appointed goal
> the cyclic pageantry of play.
> ("Les Jeudis dans le château," 1842, p. 12)

As we can see in the examples here, throughout history the hoop was a game full of meanings, echoing the cycle of life with its joys, risks, and recurrent patterns. De Chirico's choice of this image, therefore, continues, rather than breaks with tradition. Thus, as in the past, the emblem books and children's rhymes enabled us to decipher meaning, a modern artist's autobiography has become an important code for deciphering contemporary artistic puzzles.

Adele's death occurred when Giorgio was three years old. It is thus pertinent to ask how children at this age understand the phenomenon of death. Richard Lonetto's book *Children's Conception of Death* described the responses of young children from the ages of three to five. He claimed that because of their inability to grasp the irreversibility of death, children view life and death as a "constant flux and interchange." Furthermore, children of this age group "understand death as living on under changed circumstances." For him, this view of death was symbolized by the circle: "The circle contains the unity of what might be seen by adults as apparent opposites, which are continually moving, changing one into the other and back again. . . . [For the child] there is only the flowing of birth into death and death into birth." A child, according to Lonetto, sees this experience as "cyclical, devoid of causality," whereas a more mature person sees life and death as "linear," understanding that there is no way back (Lonetto, 1980, pp. 165–66).

Lonetto's analysis is very illuminating in deciphering the implications of de Chirico's paintings. The girl in the picture is, on the one hand, a mere shadow, yet she goes on living as a playful child, depicted as running with a circular toy. De Chirico sees her from the perspective of a three-year-old child—his age when she died. Thus, the image of the hoop is not only a recapitulation of the two perfect, feminine disks of the artist's early memories, but also a plastic realization of infantile fantasies of the denial of death. The girl is playing with the full cycle of life and death. In

de Chirico's living world, she is a shadow with a very strong presence. This is a unique moment in which the adult artist creates a visual image that corresponds to his deep, primeval visualization of a traumatic event in childhood.

De Chirico's writings also direct our attention to another source of inspiration: Nietzsche's philosophy. Both the artist himself and various critics claim that de Chirico's metaphysical period was largely inspired by Nietzsche's philosophy in general and by *Thus Spoke Zarathustra* in particular.[7] Nietzsche's metaphysical doctrine of Eternal Recurrence, described in the chapter "The Convalescent," is possibly the ultimate formulation of the cyclical conception in the 19th century. According to this theory, every act or event in the universe has already occurred an infinte number of times and will recur again and again in the future: "Everything goes, everything returns; the wheel of existence rolls forever. Everything dies, everything blossoms anew; the year of existence runs on forever" (Nietzsche, 1961, p. 234). This doctrine may have a crushing, despairing effect on ordinary human beings who believe in voluntary control over life's path. But the eternal cycle becomes the ultimate victory over death and temporality. Nietzsche accepts the theory of the wheel of fortune but does not believe in man's capacity to regulate its course. The cyclical view of death is part of a healing process: "heal your soul with new songs, so that you can hear your great destiny" (p. 237).[8] It is the creative process, exemplified here by the new songs, that has a therapeutic quality and therefore heals the convalescent. Following Nietzsche, de Chirico in his writings constantly described himself as a convalescent.[9] The Eternal Recurrence has been interpreted by Fritz Wittels as an expression of Nietzsche's repetition compulsion (Wittels, 1924, p. 95). It seems to me that de Chirico was attracted to this aspect of the philosopher's thought because he found in it an echo of his own state of soul. The girl with the hoop in de Chirico's painting is also an image echoing Nietzsche's doctrine.

De Chirico had to face death twice—both his sister's and later his father's. He confronted it anew in *The Mystery and Melancholy of a Street,* and Nietzsche's emphasis on the cyclical pattern of life could have reinforced de Chirico's cyclical image. By creating this intriguing picture he relived his past experience; by trying to heal his soul, he attempted to make life bearable again. It was here that the young child's cyclical view of life and death and the philosopher's ideas of the Eternal Recurrence met.

De Chirico's repetition of motifs, discredited by critics, should be viewed as his compulsive need to repeat themes that echoed his childhood experiences, in this case, the recurrence of the girl with the hoop. De Chirico's obsession with the ghost of the sister is disclosed not only through the girl with the hoop, but also in a more hidden and cryptic language in pictures such as *The Nostalgia of the Infinite,* (1913–14[?] dated on painting 1911) and *The Enigma of the Day* (1914), where a hidden box is concealed in the dark shadows. De Chirico described the fear he felt upon hearing

the blows of a hammer on a plank, which made him think that "somewhere a man was awake making a coffin." The hidden box was the eternal coffin, forever present after the artist's third year. The ghost of the sister implied for her little brother that the remaining children could also die.[10]

Another picture, *Spring* (1914), discloses the disparity between the positive expectations aroused by the picture's name and the past memories it actually recalled. In spite of its lighthearted name, the atmosphere of the picture is far from joyful. Does the title refer to the child's spring or to childhood as the springtime of life? If so, it is a very severe spring: the child is doll-like and seems to be frozen, as if lying like a martyr in a coffin. It is a female child, and the feminine form of a shell next to it and the boat in the background imply a journey through life to death.

The discrepancy between positive allusions associated with spring and the voyage of the dead child recurs in de Chirico's novel, *Hebdomeros:*

Where are you children? Hebdomeros is in love with Louise, the maid at the house opposite; he has put on his new suit; the bells are ringing in the parish church steeples and the spring is smiling in the kitchen-gardens. Spring! Spring! Funeral procession, macabre vision. Corpses in evening dress. (1929, p. 58)

Love, the new suit, the ringing bells, the smiling spring are overtaken by the macabre vision. The strange plank on which the child lies in the picture can be linked to other descriptions in *Hebdomeros*. For instance, de Chirico compared the cases of violinists at a funeral to "coffins for newborn babies." Furthermore, he states:

But think rather of fine, clear days by the sea-shore, think of those Immortals blessing those who love them and who . . . depart on ships to die far away on the other shore, for they know this to be the best way of returning later to those whom they love and living with them free of rancour and remorse; it is true that they return only as ghosts but, as the proverb says, it is better to return as a ghost than not at all. (Pp. 72–73)

The ghost returns later in the artist's life in *The Street* (fig. 6), a painting executed between 1959 and 1968. The sister appears once more as the girl with the hoop, but there are some notable changes in this late version. The name of the picture is no longer "the mystery and melancholy," because the girl is now merely part of the events occurring in *The Street*. Furthermore, *The Street* is by no means just a copy, but a variation on the earlier theme. Two major alterations should be noticed: the girl with the hoop is not the sole protagonist. There are also two identical male figures who cast a combined shadow; in addition, two parallel bundles lie in

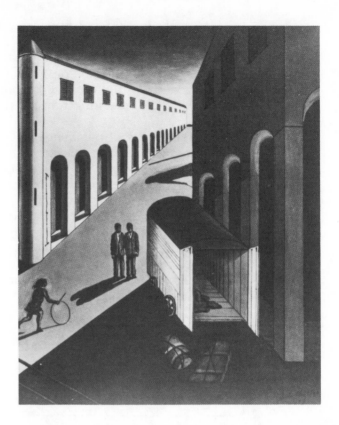

Fig. 6. Giorgio de Chirico, *The Street,* c. 1959–68. Oil on canvas. Private collection.

front of the wagon. Moreover, the girl is no longer a mere shadow; the intriguing shadow is now projected by the two men. As we will see in the second article of this series, the two men are also a recurring image, the image of the artist and his brother, Andrea Savinio.

In *The Street,* then, de Chirico reunites the three siblings. One has to remember that all three were not alive at the same time: the younger brother was born after the sister had died. The only person to know the whole group was de Chirico himself, the sole surviving family member following his younger brother's death in 1952. The fact that in *The Street* the sister is no longer a shadow shows that de Chirico was no longer working through mourning for her death in the same active way. She had now become a memory, revived because of the death of his brother. The intertwining shadow of the two brothers bears a resemblance to a heart and expresses de Chirico's desire to be reunited with his siblings. As we know from the artist's memoirs, his brother's death was due to heart failure. Feeling guilty, de Chirico blamed the doctor: "As a doctor he certainly knew how much physical and mental rest and quiet are needed by people with heart trouble. . . . He should, therefore, have warned me and told me how serious the illness was" (de Chirico, 1945, p. 210). Tragically, Eros' messenger intertwines here with Thanatos, and the heart becomes the angel of death.

However, in 1960 de Chirico returned to his original theme of the girl with the hoop. She appears as the sole protagonist in the canvas *The Street*. (Hitherto unpublished, this work will appear in volume 8 of the catalogue raisonné.) This version reduces the second shadow of the original composition from 1914 so that it reads like a faint memory from the past, rather than as an actual shadow.

The recurrence of this theme in de Chirico's late work attracted the attention of a contemporary Italian artist, Renato Guttuso. In *Homage to de Chirico* (1965), Guttoso drew a realistic portrait of the aging artist, inserting into his features the black silhouette of the girl with the hoop. In this juxtaposition, youth and age are both contrasted and integrated. Guttuso's sensitive portrait also conveys the notion that, toward the end of de Chirico's life, the image of the little girl finally intertwined or fused with his own. This depiction of the artist as a "haunted" being reveals Guttuso's insight into an underlying reason for the fact that, despite his great fame, de Chirico always remained a dejected and gloomy man.

Notes

1 In a more recent reference to the painting, William Rubin treats the theme in similar terms (Rubin, 1982, p. 61).

2 Thus, for example, "Even at that time those Thessalonian street urchins were spurred on by the hatred to bring down my kite, because it was more beautiful and bigger than theirs. In addition, they saw that I lived in a house that was more beautiful than theirs; that I was better dressed than they were and that I must be more intelligent and must know more than they did about many things, and therefore I was an anathema" (de Chirico, 1945, p. 22).

3 There are numerous references to rape in de Chirico's novel, *Hebdomeros,* including a very sensual description, in which the artist related through free association the things that came to his mind from visualizing Rubens's *Daughters of Lysippus:* "Hebdomeros, who had been present at this scene more than once, was always intrigued by the anxiety of the young washerwoman; but this time he thought he had found the reason for it. It must surely be the reminiscences of a mythological type which are upsetting them, he said to himself . . . their feminine imagination, haunted by reminiscenes, always ready to imagine a drama, already anticipating abduction. The centaur crossing the river of the current and carrying with him the woman shrieking and disheveled like an intoxicated bacchante" (de Chirico, 1929, p. 55).

In another context, eating strawberries and cream is associated with the image of committing "rape and incest" (*Hebdomeros,* p. 70). He associates the gentleman following him with the "tempter demon"—the demon in him. This fantasy, in turn, leads him to associate to "the rape of girls" (p. 76). Interestingly, however, when de Chirico mentioned

Rubens's picture in his memoirs, he did not give it its full name, *The Rape of the Daughters of Lysippus,* but rather a censored version of the name, *Daughters of Lysippus.*

4 On this subject see Pollock, 1978, pp. 443–81.

5 This version of Lucas Cranach's *Melancholy* is marked and dated 1532 (Copenhagen, Statens Museum, cat. 1951, no. 146). In this example, three nude children are trying to push a ball (whose circumference is that of the hoop) into the hoop, casting shadows. According to Panofsky and Saxl (1923, p. 150), this representation of melancholy shows the contrast between melancholy and merriment. In de Chirico's version, however, the mood is in line with Dürer's engraving *Melancholia I* (1514), in which the dominant mood is one of dejection.

6 The poem was written originally in French:

> Dans un chemin que bordait un ruisseau,
> Rivière si l'on veut vu la quantité d'eau,
> Un écolier avec adresse
> Faisait rouler un grand cerceau.
> En cet endroit le chemin était beau.
> Et l'on courait d'une grande vitesse.
> Mais à force d'aller courant,
> Le cerceau toujours en avant
> Et l'écolier toujours derrière
> Le chemin devint fort glissant,
> Et le rencontre d'une pierre
> Par le cerceau d'abord, ensuite par l'enfant,
> Les fit tous deux rouler dans la rivière.
> En beau chemin, chacun se fait valoir;
> En pleine paix, tout ministre est habile;
> Mais le chemin devient-il difficile?
> Et le danger se fait-il voir?
>
> (D'Allemagne, n.d., p. 11)

7 On the influence of Nietzsche on de Chirico see de Chirico's own writings, translated and reproduced in Soby, 1955, pp. 244–47. See also Schmied, 1982, pp. 89–107, and Calvesi, 1982.

8 On the therapeutic nature of Nietzsche's writings, see J. Golomb, 1985*a,* pp. 99–109, and 1985*b,* pp. 160–82.

9 Thus, for example: "I see again as in twilight scenes associated with long illnesses, like typhus, and wearisome convalescence" (de Chirico, 1945, p. 14).

10 On the psychological implications of a sibling's death in this context, see Bank and Kahn, 1982, p. 276.

References

Bank, S. P. & Kahn, M. D. (1982). *The Sibling Bond.* New York: Basic Books.

Becqu, L. (1869). *Les jeux des anciens.* Paris: Reinwald.

Carrà, M., ed. (1968). *De Chirico: Metaphysical Art.* London: Thames &

Hudson. Originally "Sull arte metafisica," *Valori Plastici* 1, nos. 4–5 (Apr.–May 1919): 15–18.

Calvesi, M. (1982). *La Metafisica Schiarita.* Milan: Feltrinelli.

D'Allegmagne, H. R. (n.d.). *Sports et jeux d'adresse.* Paris: Librairie Hachette. (Poem by Katz translated from Dutch by Feutry.)

De Chirico, G. (1929). *Hebdomeros.* Trans. M. Crosland. London: Peter Owen, 1964.

———. (1945). *The Memoirs of Giorgio de Chirico.* Trans. M. Crosland. London: Peter Owen, 1971.

Durantini, M. (1983). *The Child in Seventeenth-Century Dutch Painting.* Ann Arbor: University of Michigan Research Press.

Golomb, J. (1985*a*). "Nietzsche's Early Educational Thought." *Journal of Philosophy of Education,* 19:99–109.

———. (1985*b*). "Nietzsche's Enticing Philosophy of Power." In Y. Yovel, ed., *Nietzsche as Affirmative Thinker,* pp. 160–82. Hague: Nijhoff.

Krystal, H. (1966). "Giorgio de Chirico." *Imago,* 23, no. 3: 201–26.

Lonetto, Richard (1980). *Children's Conception of Death.* New York: Springer.

Mahler, M. et al. (1975). *The Psychological Birth of the Human Infant.* New York: Basic Books.

Nietzsche, F. (1961). *Thus Spoke Zarathustra.* New trans. R. J. Hollingdale. Harmondsworth: Penguin.

Panofsky, E. & Saxl, F. (1923). *Dürer's Melancolia I.* Studien der Bibliothek Warburg, 2. Leipzig.

Pollock, G. (1978). "On Siblings, Childhood Sibling Loss, and Creativity." *Annual of Psychoanalysis,* 6:443–81.

Rubin, W. (1982). *De Chirico and Modernism.* Exh. cat. New York: Museum of Modern Art.

Rubin. W. et al. (1982). *Giorgio de Chirico: der Metaphysicker.* Munich: Prestel-Verlag.

Schmied, W. (1982). "Die metaphysische Kunst des Giorgio de Chirico vor Hintegrund der deutschen Philosophie Schopenhauer, Nietzsche, Weininger." In W. Rubin et al., 1982, pp. 87–107.

Schopenhauer, A. (1974). "Essay on Spirit Seeing and Everything Connected Therewith." In *Parerga and Paralipomena* Trans. E. F. Payne. Oxford: Clarendon Press.

Soby, J. T. (1941). *The Early Chirico.* New York: Dodd, Mead.

———. (1955). *Giorgio de Chirico.* New York: Museum of Modern Art.

Weininger, O. (1907). *Über die letzten Dinge.* Vienna: Universitäts Buchhändler.

Wittels, F. (1924). *Sigmund Freud: His Personality, His Teaching, and His School.* Trans. C. Paul. London: George Unwin.

Milly Heyd,
Ph.D.

De Chirico: *The Greetings of a Distant Friend*

This essay attempts to decode two of Giorgio de Chirico's pic-
torial puzzles, *The Jewish Angel* (fig. 1) and *The Greetings of a
Distant Friend* (fig. 2), both closely related and both painted in
1916. This analysis takes into account the artist's biography, his
writings, his familiarity with the work of both Nietzsche (Schmied,
1982) and Freud (Pincus-Witten, 1984), and the relationship
between these two paintings and others in de Chirico's oeuvre.
Both paintings feature a huge, pupilless, schematic eye painted not
as an independent entity but subordinated by being depicted as a
piece of cardboard, with one edge folded over in a Cubistlike
trompe l'oeil. Cubist language, originally used for structural pur-
poses, is applied here in relation to an expressive human feature.
De Chirico utilizes this indirect language to suggest a time
sequence; he does not refer to a present experience but to the
memory of a past occurrence.

De Chirico's use of a Cubist device, a piece of cardboard that is
intentionally dog-eared, reflects the influence of Picasso. As
Robert Rosenblum demonstrated in "Picasso and the Typography
of Cubism," Picasso used the dog-eared device in works such as
Still Life with Calling Card (1914) to suggest, "according to the
traditional rule of etiquette, that the owner of the card has paid a
personal visit, but found no one at home" (1973, p. 68). But
whereas Picasso used this method to allude wittily to his connec-
tions with Misses Stein and Toklas, de Chirico adapted the device
for a painting in a more somber mood. Since the adaptation of
Picasso's method could not have been arbitrary, de Chirico seems

Fig. 1. Giorgio de Chirico, *The Jewish Angel,* 1916. Oil on canvas. Gelman Collection.

to be implying that the Jewish angel has left a calling card that cannot be ignored.

The very bizarre Jewish angel is a conglomeration of wooden objects consisting of rectangular and triangular scaffolding, among which appears a small replica of a railway wagon with a red roof and part of a railroad crossing barrier. In the midst of the geometric shapes, to the left of the staring eye, a serpentine form rises that seems alien to the geometry of the others. The towerlike shape pointing upward conveys a sense of conflict between the inanimate objects and the snake. Furthermore, a clash seems evident between the wish to shape reality, to create a new object from discontinuous parts, and the lack of complete closure in the painting. Although there are several elongated rectangular frames at the left side of the image, none of them forms a complete, closed frame. One right angle continues into another, and para-

doxically, in spite of the geometric nature of the painting, there is no closed or defined area.

How are we to account for the meaning of the painting? In other words, who is the Jewish angel? In de Chirico's novel, *Hebdomeros,* there is a description of an angel associated with Jewish candlesticks:

> His eye was fixed on the line of the sand which the desert winds were now lifting in cones . . . and rising like smoke towards the threatening sky, assuming the biblical form of Jewish candlesticks . . . like that inexplicable and geometric angel, that angel as bare as a tree in autumn, that unadorned and desiccated angel, that angel possessing only the indispensable, the strictly necessary, whom Hebdomeros saw one day rush through the floors of a large apartment house and

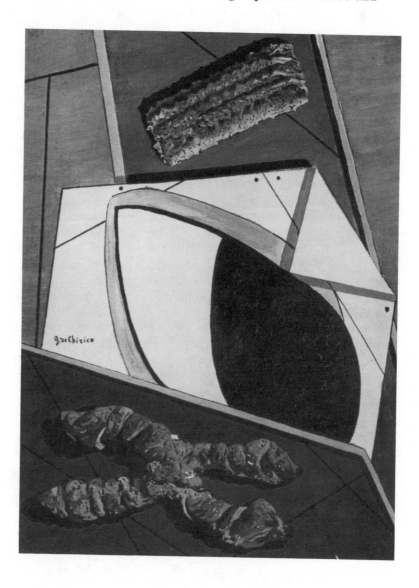

Fig. 2. Giorgio de Chirico, *The Greetings of a Distant Friend,* 1916. Oil on canvas. Collection: Claudio Bruno Sakraischik.

fall into a bedroom, near a bed where, surrounded by officers, visibly overcome, and his family in tears, a very old general was slowly dying. After receiving the dead man's soul, the angel assumed once more the appearance of a tripod hurled into the void and returned with the soul to heaven. (de Chirico, 1929, pp. 36–37)

The death described in this passage represents the death of de Chirico's father, also elaborately portrayed in the artist's memoirs. Furthermore, the appearance of the angel of death conforms to de Chirico's description of his father, a railroad engineer who dwelt in the world of geometry and exact measurements. Thus, for the artist, he metaphorically represented measured, exact, disciplined behavior: "My father . . . was supervising and directing the building of the railway" (de Chirico, 1945, p. 17). And yet, there is a certain paradox regarding the image of the angel-father. Geometry is typically a means of clarifying, of emphasizing the rational aspects of reality, whereas here the angel's nature is enigmatic despite the geometric character. The father remains unreachable and unattainable to the very end.

There is also a tinge of irony in the verbal description, which claims that the wingless angel possesses only the indispensable, whereas he actually lacks the indispensable, namely, life and warmth, since he is "as bare as a tree in autumn . . . unadorned . . . desiccated," that is to say, possessing no moisture and, therefore, no life. Unable either to warm himself or to provide warmth and protection to others, he remains aloof, detached, and lifeless.

The contrast between the geometrical and the serpentine elements in the picture conveys a sense of conflict. It is as if the purified pieces of wood, which are devoid of any human emotion, contrast with another level of existence, snakelike passion and primal sin. A visual struggle thus occurs between the Apollonian and Dionysian, or between the forces of repression and that which is repressed, terminology with which de Chirico was familiar, from his reading of Nietzsche. In this battle, the eye plays the role of the superego. It echoes Redon's ever present, judging eye. In both artists' work it expresses the fact that, in the realm of prohibitions, an eye is watching. This struggle accounts for the fact that the frames in the picture are not closed. The need to control reality is there, and yet reality cannot be completely framed or kept under control.

The watching eye, indicative of a strong sense of guilt, appearing in a painting with such a provocative title as *The Jewish Angel*, recalls another literary source, Kierkegaard's most psychological book, *The Concept of Dread* (1844). In this text the philosopher analyzed the concept of the law in Judaism, which represents a restrictive set of rules and is therefore related to the sense of guilt: "life moreover presents phenomena enough in which the individual in dread gazes almost desirously at guilt and yet fears it" (p. 92). The imagery is closely associated with the imagery in

this painting: "Guilt, like the eye of the serpent, has the power to fascinate the spirit" (p. 92). In this painting the eye and the serpent are separated, and yet the conclusion mirrors an early formulation of a psychoanalytic truth, the fear of guilt: "Guilt only does he fear, for that is the one and only thing that can deprive him of freedom"; in other words, "the opposite of freedom is guilt" (Kierkegaard, 1844, p. 97).

The stern eye of the Jewish angel stands for the severity of the demanding image. From a Christian point of view, the Jewish law represents judgment according to the strict letter of the law, whereas Christianity represents compassion. De Chirico chose the more demanding image as his superego. His rejection of the compassion of Christianity accounts for his placement of the eye next to, rather than within, the triangular shape common in the depictions of the Trinity.

The Jewish Angel, with the inner struggle implied in its depiction, has a biblical source in the struggle of Jacob and the angel. De Chirico related a dream, part of which described his relationship with his father, in imagery that resembles the conflict between Jacob and the angel:

> I struggle in vain with the man whose squinting eyes are so gentle. Each time I grasp him he frees himself, quietly stretching his arms, and these arms have an unbelievable strength, an incalculable power, they are like irresistible levers, like those all-powerful machines, the giant cranes that lift whole lumps of floating fortresses, as heavy as the udders of antediluvian mammals, over swarming shipyards. . . . It is my father. The struggle ends with my *surrender: I give up.* (de Chirico, 1924, p. 165)

It is significant that the human interaction that takes place in the dream, with the contradiction between the father's gentleness and his physical power and the inner struggle between the wish to be freed from his dominance and the wish to surrender to his alluring power, is not expressed in the painting. In the visual realm, the struggle is seen in cold, dissected imagery; the gentleness of the father's eyes is never expressed. In other paintings, we encounter him with his eyes closed (*The Child's Brain,* 1914) or see him from the rear as a sculpture dominating the piazza or as a shadow, forever following the artist's footsteps.

The discrepancy between the visual and the verbal imagery conveys the impression that the artist was too intimidated to face his father in direct, eye-to-eye contact. He could face him only in the realm of dreams or with the distance achieved through verbal expression. In both *The Jewish Angel* and *The Greetings of a Distant Friend,* the eye is dissected and expressionless, haunting the artist by its demanding nature.

In order to understand the significance of *The Jewish Angel,* we must elaborate on the artist's father image, as displayed in his writings and paintings. De Chirico developed the father image as a

theme for his works of art in a modern, psychological way. In the artist's first memory of his father, he was already associated with a mechanical object:

> I remember an enormous mechanical butterfly which my father had brought me from Paris while in fact I was convalescent. From my bed I looked at this toy, with curiosity and fear, as the first man must have looked at gigantic pterodactyls which in the sultry twilight and cold dawns flew heavily with fleshy wings over warm lakes whose surfaces boiled and emitted puffs of sulphurous vapour. (de Chirico, 1945, p. 14)

We are introduced to de Chirico's relationship with his father through this ambivalent description. A toy, given to him as a present, a means of conveying affection, turns out to be an object of fear. The father's toy is enormous, whereas the weak, little child lies in bed, convalescing. There is, therefore, a vast contrast between the size of the toy in the child's eyes and his own self-evaluation. There are also erotic undertones in this comparison, expressed not only through the "enormous" and "gigantic" symbol of the father, the mechanical engineer, but also through the imagery used to describe it. The mechanical butterfly is compared to a pterodactyl, an overwhelming threatening creature rather than a symbol of warmth and protection. The reptile's appearance is also associated with a sexual encounter: The male form flies down heavily over the "female" lake, described as warm, boiling, and emitting puffs. The fantasy of the heavy body of the pterodactyl descending over the lake is both sensual and sexual.

The father's gift both repelled and attracted Giorgio, arousing erotic fantasies. The situation represented by the image of the reptile flying above the lake parallels that of the child lying in bed with the toy above him. Twilight and illness contribute to the dreamlike atmosphere of the description. The artist's comparison of his father with a prehistoric bird endowed him with a kind of awesome, romantic power. His father's strength and historical presence were part of de Chirico's overevaluation of his parent and can be understood as what Freud called the family romance, the "child's longing for the happy, vanished days when his father seemed to him to be the noblest and strongest of men" (1909, p. 235). This tendency also characterizes the following description:

> My father was a man of the nineteenth century; he was an engineer and also a gentleman of olden times, courageous, loyal, hard working, intelligent and good . . . he was a very good engineer, had very fine handwriting, he drew, had a good ear for music, and gifts of observation and irony, hated injustice, loved animals. . . . He was also an excellent horseman and had fought some duels with pistols. (de Chirico, 1945, pp. 15–16)

This description emphasizes the father's overt attributes and generalized attitudes. It provides no insight into his inner life or his attitudes toward his family. It also reveals elements of surprise because de Chirico builds part of his description on contradictions: "hated . . . loved." When one reads a description of parental feelings such as hate and love, one normally expects to find reference to the father's emotions toward his family, particularly toward the son who wrote about him. De Chirico said that the father loved animals but not that the father loved him. Likewise, the account stresses the father's readiness to protect the innocent but not his readiness to protect his son. This aggrandizing assessment of his father provides an unbalanced account that ignores all his faults. Obviously, it functions as a means of elevating de Chirico himself, yet it also conveys the son's feeling of inferiority in relation to his father. The father is "the exact opposite of most men of today, who lack a sense of direction and any character" (de Chirico, 1945, p. 16), but de Chirico himself *is* a man of today and not "a gentleman of olden times."

De Chirico also described his father as puritanical, for example, as one who would not let him ride a bicycle and one whose "opposition . . . was somehow linked to his puritanism" (1945, p. 39).[1] Both the parents, but especially the father, "lived in fear that one of those present might say anything which, however remotely, was connected with love or sex" (de Chirico, 1945, p. 39).

De Chirico's dominant—and domineering—father exerted a strong influence on his son, who imitated him unconsciously as well as consciously. Just as his father had before him, the young artist studied works of art at both Turin and Florence. The father's example also proved irresistible on a deeper level, and de Chirico developed a kind of superego and sense of sexual guilt that mirrored those of his puritanical parent.

The enduring character of this parental image strongly suggests that the male statue or shadow that dominates the piazza of many of de Chirico's Italian urban landscapes really refers to his father. For instance, in *The Enigma of a Day* (1914; see part one, fig. 4), the statue of a frock-coated man, viewed from the side with his right arm upraised and his head turned away from the spectator, presides over the spot by virtue of his size and placement. His prominence contrasts markedly with the diminutive, recessive quality of the two little figures in the background, a contrast that recalls again the artist's description of the overwhelming character of the mechanical butterfly and his own sense of smallness and helplessness.

De Chirico's written references to the male statues he painted certainly support the interpretation that this figure symbolized his father: "The statue of the conqueror of the square, his head bare and bald. Everywhere the sun rules. Everywhere the shadows console. Imprisoned leopard, pace within your cage, and now, on your pedestal, in the pose of a conquering king, proclaim your

victory" (Soby, 1955, p. 253). This last image seems especially significant, for it conveys de Chirico's basic dilemma about his father in the guise of conqueror. We know that the father played a very complex role in the artist's childhood sexual fantasies, but he was also the censor. The conqueror of the square is compared to a wild animal (the leopard) confined within the cage of the frozen sculpture. The victory portrayed by the statue on its pedestal is that of the Apollonian over the Dionysian. The beast in man is overcome by cultural control, or, to use Freudian terms, the id is overcome by the ego and superego. The need for self-control is poetically expressed by de Chirico thus:

> It *desires.*
> Silence.
> It loves its strange soul. It has *conquered.*
> (Soby, 1955, p. 253)

In a photograph from the artist's childhood (fig. 3), the de Chirico family forms two distinct groups. In one group is the artist's mother, who embraces his brother; since she is sitting, they are both of the same height and form a close unit. In the other, de Chirico and his father are both standing, each physically independent of the other. The elder child echoes his father's pose, remaining aloof and refraining from expressing any affection. The photograph suggests that Giorgio has internalized his father's detachment. The coldness of the father and the boy's separation from his mother will later be translated artistically into de Chirico's cold linear style in which objects are separated from each other and hidden intimate motifs and persons are indicated by their shadows. In de Chirico's memoirs he reflected: "Between me and my father, in spite of the deep affection which linked us, there was a certain aloofness, an apparent coldness or, rather, a kind of reserve which prevented those spontaneous effusions found among people of mediocre birth" (de Chirico, 1945, p. 46).

The father's statue, dominating the various Italian cityscapes, is typically portrayed from the back or side in a pose that hides his face and prohibits eye contact, as in *The Enigma of a Day.* Sometimes the statue casts a shadow or appears only as a shadow. This figure dominates his environment, a haunting censor with judicial power. There is a strong sense of a trial being enacted, reminding one that in classical Greece such events took place in the agora.

De Chirico's oeuvre paralleled the struggles with a father image that Kafka depicted in his novels—struggles in which the son's sense of inadequacy and guilt puts him in the position of the convicted, though he does not actually realize what sin is. In *The Trial,* as in de Chirico's paintings, minute figures are judged. In both cases the face of judicial power is not revealed, but it is forever present. The father's eternal presence conveys a punitive function; it becomes part of the artist's own punitive superego.

Fig. 3. Photograph of the de Chirico family. Private collection.

The eye portrayed in *The Greetings of a Distant Friend* carries this same implication of an all-seeing parental superego. The painting contains three zones; in the upper zone there is a biscuit, in the middle one the eye, and in the lowest a peculiar object. This object differs both stylistically and texturally from the graphic, linear quality of the parts above. This contrast echoes that found in *The Jewish Angel* between the geometrical and the serpentine. The peculiar object is a condensation and can be interpreted on a number of levels. On the manifest level, it has been identified as a particular type of baked roll sold in Ferrara called *ciupeta* (Clair, 1983, p. 42). Various Ferrara traditions, passed orally from generation to generation, involve the shape of this bread, more commonly called *copia pane* by the local people. The name suggests that each of its four "arms" is an exact copy of its counterpart and that it therefore represents a fusion, as in marriage. It seems especially significant that de Chirico chose a shape alluding to an intimate state of fusion to depict his relationship with his brother Andrea. De Chirico himself, looking

back to the period in which he created this image, wrote about the attractiveness of the various types of bread sold in Ferrara at the time:

> I began to paint again. The appearance of Ferrara, one of the most beautiful cities in Italy, had impressed me but what struck me most of all and inspired me on the Metaphysical side, the manner in which I was working then, was certain aspects of Ferrara interiors, certain windows, shops, houses, districts, such as the ancient ghetto, where you could find certain sweets and biscuits with remarkably Metaphysical and strange shapes. At the same time I read a great deal. (de Chirico, 1945, p. 80)

This reminiscence, with its description of voyeuristic glimpses into Ferrarese shops and dwellings whose interiors yield visions of the special *copia pane* rolls, reaffirms the private significance for the artist of this characteristic bread of the region. The suggestive shape of the *copia pane* evoked deeply personal associations and images in de Chirico, images that infiltrated paintings such as *The Greetings of a Distant Friend*. It seems especially noteworthy that images of bread, the most fundamental of foods, recurred in the artist's work during the period of his World War I army service in Ferrara. During this period of multiple deprivations, the young man evidently tried to find relief in oral indulgence—or at least in fantasies about food—as well as in depicting foodstuffs in the great canvases of his Metaphysical period.

And yet the textural quality and color of the *copia pane* shown in *Greetings of a Distant Friend* is repellent, connoting feces rather than baked bread. It would seem that de Chirico preserved the basic shape of the bread while metamorphosing its texture. We can therefore establish a temporal sequence connecting the upper and lower zones: the biscuit represented in the upper zone of the canvas has been eaten and digested, and the *copia pane* in the lower zone excreted.[2] This "fecal" substance lies on a red background, a more passionate color than the others in the painting. The image, lying on its red background, is a knot that combines two elongated forms. Such a knot can be found earlier in the artist's work, among the mysteries hidden in the shadows of *Nostalgia of the Infinite*, (1914; fig. 4).

Such shadows in de Chirico's world are shadows of his past life, of his alter ego, expressions of the darker side of his personality. A close look at the shadows of the two minute figures in *Nostalgia of the Infinite* shows that they are fused into a single image. These two tiny figures stand in front of a huge tower that suggests infinity. Infinite cravings are projected; the shadow unites the two separate figures as if in an embrace, but the resulting image suggests a person throwing his hands up in a call for help. The knotted shadow conceals a strong wish to belong, to be one entity, a sensation echoed in the entwined anal image in the later *Greetings of a Distant Friend*.

117

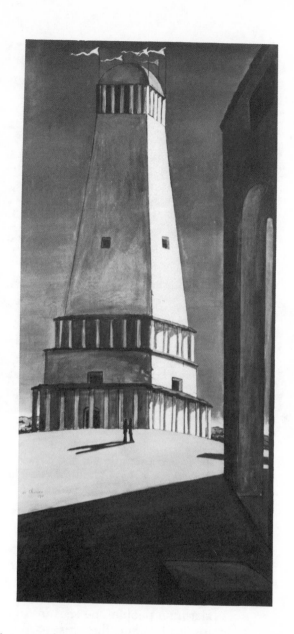

Fig. 4. Giorgio de Chirico, *The Nostalgia of the Infinite,* 1913–14? (dated on the painting 1911). Oil on canvas. The Museum of Modern Art, New York. Purchase.

De Chirico could have found a parallel to his cravings in Nietzsche's Zarathustra, who described the shadow following him as a "wanderer, without a home." This shadow, Zarathustra's alter ego, exclaims: "This seeking for *my* home: O, Zarathustra, dost thou know that this seeking hath been *my* homesickening, it eateth me up" (1909, p. 335). Both literally and psychologically, de Chirico was constantly on the move, never finding a permanent place, always seeking a home.

But who are the two miniature figures portrayed in *Nostalgia of the Infinite?* We encounter them in many of de Chirico's paintings. Their shadows more often remain separate, as in *The Joys and Enigmas of a Strange Hour* (1913), *The Enigma of a Day,* (1914; see part one, fig. 4), *The Melancholy of Departure,* (1914,

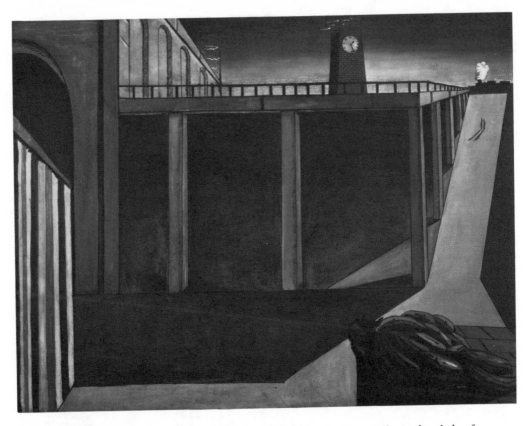

Fig. 5. Giorgio de Chirico, *Gare Montparnase (The Melancholy of Departure)*, 1914. Oil on canvas. The Museum of Modern Art, New York. Fractional gift of James Thrall Soby.

fig. 5), and *The Sailors' Barracks,* (1914). Little figures of this type reflect memories of childhood past. In de Chirico's art, these two little figures symbolize the artist and his brother wandering in the wide world. In his memoirs the artist portrayed his brother Andrea as "small, very small, disturbingly small, like certain alarming people one sees in dreams" (1945, p. 41). In characterizing his brother, the artist used belittling language in contrast to the aggrandizing description of the father. Yet when de Chirico depicted his brother and himself together, the two figures evoked in him a similar response, one of kindred weakness and loneliness. Lost in the world, these two mingled, shadowy configurations concealing hidden mysteries together defy the vast and often empty world.

In *The Greetings of a Distant Friend,* a forbidden embrace between these two occurs under the eye of the censor. It is also here in the realm of experience that the artist's sense of guilt is formulated, and guilt turns this closeness into a repellent anal image. It seems very significant that de Chirico's relationship with his brother drew its imagery from the anatomical part "located in the lower rear and out of sight, a hole from which stinking smells

emerge and even more, a stinking substance—most disagreeable to everyone else and eventually to the child himself" (Becker, 1973, p. 31). It is probably because of such sensations that the biscuit at the top of the canvas has lost its appetizing character and looks instead rather like a piece of soap. Cleanliness is needed, as the basic conflict is between the forbidden passions and the need to restrain them. This conflict also finds its expression stylistically, in the contrast between the purified linear style of this composition and the "fecal" lump into which the *copia pane* has been transformed.

The anal image reflects de Chirico's dilemma: on the one hand, the two paintings discussed describe fragmented images—the eye, parts of a railway, wooden half frames, a biscuit, and the fecal image itself. As Heinz Kohut pointed out, in a state of self-fragmentation, a person returns "to the pleasures he can derive from the fragments of body self" (1977, p. 76). The feces in this case represent the partial reassurance derived from such a fragmented image. De Chirico, through his anal imagery, expressed the dualism of his state, not only his fragmentation but his yearning to belong, his need for a merger.

The picture and its complex meaning take us back to the very early experiences of the young de Chirico, to his earliest "greetings" from an old friend, his brother, his double, his mirror image. It is from this early closeness between the two that the artist's later cravings for merger were born. Throughout his work, de Chirico tried to recapture this early state.

The knotted image has other qualities associated with it: the elongated form resembles that of two snakes whose heads face right. These snakes echo the snaky form appearing in *The Jewish Angel* and, obviously, the role of temptation in the primal sin. There is an additional element here, however, which is also associated with the siblings' relationship. In spite of, or rather because of, the brothers' early intimacy, strong sibling rivalry sprang up, feelings also represented in the condensed biscuit-fecal form. The two elongated, snakelike shapes are displayed together, as if the sexuality of the brothers were being exhibited for comparison. The knotted image suggests therefore a latent homoerotic component in the brothers' relationship. In de Chirico's paintings *Mysterious Baths,* done in 1934–35, the homoerotic cravings become explicit.

In *The Greetings of a Distant Friend* the gigantic paternal eye behind these twin forms serves also as a reminder of Oedipus, whose incestuous triumph led to his remorseful self-mutilation and blindness. The image also recalls Nietzsche's definition of man: "What is this man? A knot of savage serpents that are seldom at peace among themselves" (1961, p. 66).[3] For de Chirico, the serpents symbolize the continuous phallic rivalry that existed between his brother and himself, a rivalry that persisted throughout the artist's long lifetime.

Similar interpretations of snake symbolism can be found in the aphorisms of Otto Weininger, such as: "The fox, the snake seek

to refute the others in order to justify themselves (barking, hissing)" (1907, p. 178). Weininger was also obsessed by the image of the criminal, whom he compared to a snake: "The worm and the snake both have relationships with the hunchbacked criminal. Stinging eyes of certain criminals belong to the reptiles" (1907, p. 128). It seems that de Chirico was attracted to Weininger's world of images. According to Abrahamsen, Weininger, who eventually was driven to suicide by his sense of guilt, related the snake to crime "to hide an unconscious idea he could not bear. Since the snake is a phallic symbol, it is easy to see why it symbolized crime for Weininger" (1946, p. 169). The evidence presented in these essays suggests that Abrahamsen's analysis could apply to de Chirico as well.

The presentation of dual figures or objects that imply comparisons between de Chirico and his brother recur throughout the artist's oeuvre, constituting a leitmotif. Such objects or personages, usually virtually identical except for slight variations in size, appear in many other pictures in addition to the examples cited above. For instance, two palm trees appear beneath an arch in *The Soothsayer's Recompense,* (1913), while dual identical chimneys figure in various pictures, for example, *Self-Portrait* (1913).

Fish, also used in pairs, formed part of the iconography of de Chirico's "Paradise Lost," for fishing was one of the nostalgic memories of his early childhood in Greece. However, the two fish displayed together also expressed competition and invidious comparisons. Thus, two fish float in the upper portion of *The Span of the Black Ladders* (1914), one smaller than the other. In *The Sacred Fish* (1919, fig. 6), two similar fish lie on a trapezoidal platform, a shape loaded with meaning in the work of this artist, who seems to have employed this form as a means of suggesting the mother's presence without actually representing her. This can be inferred from pictures done in 1913, when the artist sometimes represented the mother as the classical Ariadne but also sometimes suggested her presence instead by including a black trapezoidal form presented in elevated perspective, as in *The Delights of the Poet,* 1913. The central aperture in this trapezoid also suggests a displacement of the mother's mons veneris, here represented as a black shape with a fountain gushing water.

Since de Chirico's rivalry with his brother constitutes such a persistent visual theme, the historical background underlying it should be explored. First of all, one must bear in mind that the two brothers remained very dependent on their mother even as adults. During their army service in 1916, both men served in the same place, and in a move typical for the de Chirico family, their mother joined them!

Our mother came to Ferrara and rented a small furnished apartment; we could sleep at home, wash, change our linen, eat plain, good food and, in our own free time, think a little about those aspects of art and thought which had always been

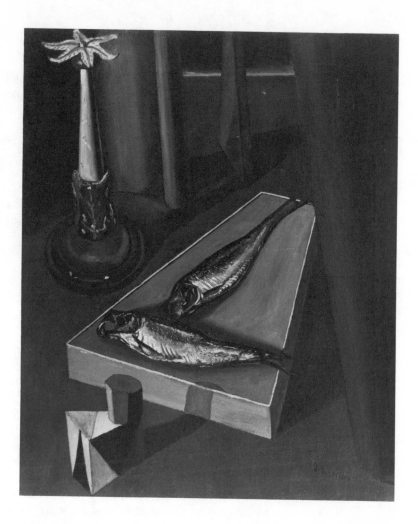

Fig. 6. Giorgio de Chirico, *The Sacred Fish,* 1919. Oil on canvas. The Museum of Modern Art, New York. Acquired through the Lillie P. Bliss Bequest.

the most important part of our lives. I began to paint again. (de Chirico, 1945, p. 80)

The contrast between the plural form, which stresses the common experience of the two brothers, and the first person singular, used in order to emphasize de Chirico's own achievements, recapitulates the basic childhood situation of the de Chirico family.

Giorgio's brother Andrea was born a short time after the death of the sister and seems to have served as her replacement for the mother. This was due not only to the timing of Andrea's birth but also to his appearance. According to de Chirico, Andrea was "the handsome one of the family and our mother was very proud of him." The artist provided a lengthy description of the daily ritual of combing his brother's hair into ringlets, comparing him to a "sun king." If the envied brother's domain was the sun and light, no wonder the son who saw himself rejected chose, as a painter, to develop a secret language of dark shadows. De Chirico also noted that the mother, so proud of Andrea's good looks, took him

Fig. 7. Photograph of Giorgio and Andrea de Chirico with their mother. Private collection.

for walks through town to display him in the streets. In the jealous brother's eyes, the clothes Andrea wore also received special attention. De Chirico associated them with the clothes given to the beloved son Joseph in the biblical story, and he remembered Andrea wearing "big lace collars which stood out against his dark blue jacket" (1945, p. 29).

A photograph of the mother and her sons (fig. 7) shows that the artist's memories were not entirely subjective but were grounded in reality. In the picture, the younger brother is physically closer to the mother, whereas the elder son is behind, trying to be part of the scene, as if he were saying, "I am here also." Though the two brothers wear the same outfit there is a striking difference between their hairstyles. Andrea has longer hair and looks more feminine. His hairstyle substantiates the interpretation that his mother actually saw him as a substitute for her dead daughter. Such a conclusion is also in line with Bowlby's assumption that it is not unusual for parents to replace a dead child by having another. Bowlby, evaluating this phenomenon from a psychologist's point of view, doubts the wisdom of such replacements because they prevent the completion of the mourning process: "The new baby is seen not only as the replacement it is, but as a return of the one who had died" (1980, p. 121). Andrea's birth is a case in point. Since it was a girl who had died, her masculine replacement was given more feminizing treatment.

Andrea served as a replacement of the dead sister not only for the mother, but for Giorgio, who internalized this attitude. This fact illuminates our understanding of certain features in his paintings. In *Melancholy,* 1912 (fig. 8), for instance, the two little shadowy figures can clearly be distinguished as male and female. The picture's title refers to the prominent sculpture representing Ariadne. The artist's obsession with his brother also suggests a

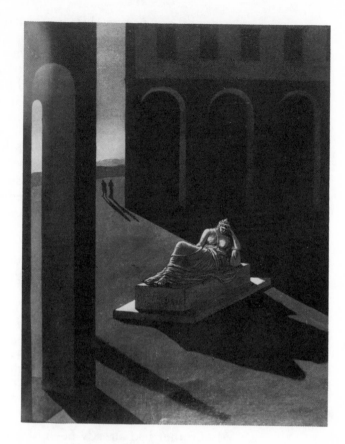

Fig. 8. Giorgio de Chirico, *Melancholy,* 1912. Oil on canvas. Collection: Eric E. Estorick.

conscious or unconscious punning on the similarity between the names Ariadne and Andrea.[4]

In *The Sibling Bond,* Stephen Bank and Michael Kahn pointed out that psychoanalytic writings dealing with sibling relationships present two contrasting points of view. Freud's assumption, based on his personal experience, stressed jealousy and the struggle to dominate springing from rivalry over parental love (see Bank and Kahn, 1980–81). As the name of their book *The Sibling Bond* (1982) suggests, Bank and Kahn also perceived positive aspects of attachment in the sibling relationship, thus following previous researches done by G. H. Pollock (1978). Bank and Kahn, working within a Kohutian framework, believed that siblings sometimes go through processes of incorporation—merging, twinning, and mirroring—resulting in feelings of closeness (Bank and Kahn, 1982, pp. 197–218).

De Chirico's writings and paintings suggest that throughout his life he was obsessed by strong feelings of rivalry toward his brother, and yet, as the merged shadow (*The Nostalgia of the Infinite*) and knot forms (*The Greetings of a Distant Friend*) suggest, there is also a feeling of sameness, as if the two were mirroring one another. The merged shadows could also indicate that a private cryptic language existed, uniting the two in defiance of the rest of the world (Bank and Kahn, 1982, p. 120).

This symbiotic relationship with his sibling, who was a musician,

playwright, and painter, led de Chirico to a series of fruitful contacts with creative artists such as Apollinaire, during his stay in Paris, and Carlo Carrà, during his army service in Ferrara, when he created *The Jewish Angel* and *The Greetings of a Distant Friend*. In his memoirs de Chirico described his relationship with Carlo Carrà almost as a substitution for that which he had formerly experienced with his brother: "My brother was sent to Macedonia. At that time Carlo Carrà came to Ferrara" (de Chirico, 1945, p. 83). Such contacts always ended with bitter, quarrelsome, rivalrous feelings.

As M. M. Gedo has shown, Picasso needed a partner to enable him to create (1980, p. 84). J. E. Gedo analyzed a similar phenomenon between Vincent van Gogh and his brother, a relationship that led to the artist's creative association with Gauguin (1983, pp. 132–33). De Chirico is yet another artist whose creativity was nourished by such contacts. It seems that, however distorted, de Chirico's brother was for him a mirror of childhood and youth.

Krystal suggested that de Chirico's aggression toward his brother was "broken through in the motif of the faceless, soul-less mannequins" that enabled him to overcome his problematic relationship with Andrea (1966, pp. 201–26). This interpretation, tempting as it is, raises questions. The eulogy that de Chirico wrote after his brother's death reveals that his feeling of rivalry persisted even after Andrea's death:

> My brother had already been ill with heart trouble for sometime, but I did not know that it was so serious, and here I believe it is my duty to say that the doctor . . . should have warned me about the seriousness of the illness. . . . The doctor knew of my existence and also knew me personally; he knew that I was the elder brother and my financial situation was better than my brother's. . . . I could have helped my brother, morally, materially, and perhaps could have prolonged his life. (de Chirico, 1945, p. 201)

Beyond the deep guilt and real sorrow that led de Chirico to project these feelings onto the doctor was a still unconscious comparing of accounts in which he stressed his brother's inferior financial situation.

The need to compete is also reflected in the artist's more optimistic, though artistically less interesting, style of the post–Pittura Metaphysica period. In his earlier pictures, the artist conveyed his competition through dualistic, parallel images. The same series of competing dual images continued in his later style, for example, in *Two Horses on the Sea-Shore* (1930). In *The Gladiators* (1931) the struggle becomes overt as the two protagonists engage in combat. In *The Dioscuri* (1934) the two nude males pose next to their horses, displaying themselves for our comparison. *Warriors Resting,* (1929) portrays a moment of fatigue in this everlasting struggle. The motif of the two men casting

shadows was repeated compulsively in de Chirico's art until the end of his life.

In de Chirico's novel, *Hebdomeros,* the knot is mentioned as an inhibiting factor: "He felt that a knot prevented them from moving their arms and legs freely, from running, climbing, jumping, swimming, and diving" (1929, pp. 48–49). It seems as if early fixations upon close family relationships, as exemplified in such pictures as *The Jewish Angel* and *The Greetings of a Distant Friend,* deprived de Chirico of his psychological freedom of movement throughout his mature life. The two paintings are related via their repeated images conveying rivalry and bond. The form of the two "knotted" brothers in *Greetings of a Distant Friend* serves as a displacement of the same affects between father and son in *The Jewish Angel.*

It is interesting briefly to view the topic of the relationship between the brothers from Andrea's point of view. In 1916, Andrea, also a member of the Metaphysical Art circle, wrote a play, *Drama of Noonday Town,* (published in *La Voce;* Carrà, 1968, pp. 165–69). The abandoned Ariadne, long shadows, and arcaded Turin all appear in the play, echoing the vocabulary of images we have encountered in de Chirico's art. Furthermore, the problematic knot also figures in Andrea's vocabulary:

> —The house! the house! friends;
> who amongst us will ever know how to untie
> the enigmatic knot of stone?

Andrea's ambivalence toward his brother is also reflected in the scene in which the actor says: "I stabbed the Prince in his jacket. There flowed out garnet blood." It is quite obvious that at this stage the prince, the one who ruled in the art field, was Giorgio, whom Andrea followed artistically in his plays. The stabbing of the prince echoes the biblical story of the envious Cain, who murdered his more successful brother Abel. The fact that Andrea used the first person in this monologue exposes his fratricidal fantasies. Yet, the play is ambivalent, and we can conclude this article with another quote from Andrea's drama, words that could also have been uttered by Giorgio:

> but I am not alone. I am walking . . .
> the track is double.
> Destiny!

Notes

1 The father's repressed sexuality and aggression were also reflected in his censorship of language: "In our house the words dagger, pistol, revolver,

gun, etc. were never uttered" (de Chirico, 1945, p. 39). De Chirico found an outlet for his father's repressions by portraying the forbidden impulses symbolically in his painting.

2 De Chirico certainly encountered anal imagery in the literature fashionable in the literary and artistic circles in Paris during his stay there. A growing interest in Alfred Jarry's writings emerged particularly in his *Ubu Rex* (1888), in which a variety of anal images appear, starting with the oath *merdre* (translated into English as "shit") and recurring throughout the play. However, whereas Jarry's anal imagery was part of his rebellious attitude, a scandalizing of the bourgeoisie, de Chirico's imagery reflected his personal inner state.

3 In the original German this image is described thus: "Was ist dieser Mensch? Ein Knäuel wilder Schlangen, welche selten bei einander Ruhe haben,—da gehn sie für sich fort und suchen Beute in der Welt" (Nietzsche, 1896, p. 54). R. J. Hollingdale's new translation is, in this case, the most accurate one (Nietzsche, 1961, p. 66).

4 It also seems quite revealing that de Chirico goes into a lengthy description of the jealousy of Andrea Castagno for Domenico Veneziano. He recounts how Andrea struck Domenico to death, pretending to be distressed by the misfortunes of his fellow artist, weeping, "Alas my brother, alas my brother." De Chirico's death wishes toward his brother Andrea are projected here through the distancing story of a painter's rivalry during the Renaissance. The anecdote is published in Soby (1955, pp. 249–50, Appendix "An Exhibition in Florence of Some Works of Andrea del Castagno").

The problematic relationship between the two brothers was also acknowledged by Andrea de Chirico. The younger brother's artistic career was not very successful; he became neither famous as a musician nor internationally acclaimed as an author. It seems likely that de Chirico's written work emerged in competition with Andrea's. Andrea, on the other hand, tried to paint. It is also very significant that Andrea changed his name to Alberto Savinio, in an obvious effort to differentiate himself from his famous brother.

References

Abrahamsen, D. (1946). *The Mind and Death of a Genius: A Biography of Otto Weininger.* New York: Columbia University Press.

Bank, S. P. & Kahn, M. D. (1980–81). "Freudian Siblings." *Psychoanalytic Review,* 67 (winter): 493–504.

———. (1982). *The Sibling Bond.* New York: Basic Books.

Becker, E. (1973). *The Denial of Death.* New York: Free Press.

Bowlby, J. (1980). *Loss.* New York: Basic Books.

Carrà, Massimo, ed. (1968). *De Chirico: Metaphysical Art.* London: Thames & Hudson.

Clair, J. (1983). "Dans la terreur de l'histoire." In W. Rubin, ed., *Giorgio de Chirico,* pp. 39–54. Exh. cat. Paris: Centre Georges Pompidou.

De Chirico, G. (1929). *Hebdomeros.* Trans. M. Crosland. London: Peter Owen, 1964.

_____. (1945). *The Memoirs of Giorgio de Chirico.* Trans. M. Crosland. London: Peter Owen, 1971.

_____. (1924). "The Dream." *La Revolution surrealiste.* In Marcel Jean, ed., *The Autobiography of Surrealism,* p. 165. New York: Viking, 1980.

Freud, S. (1906–8). "Family Romance." S.E., 9:237–41.

Gedo, J. E. (1983). *Portraits of the Artist.* New York: Guilford Press.

Gedo, M. (1980). *Picasso—Art As Autobiography.* Chicago: University of Chicago Press.

Kierkegaard, S. (1844). *The Concept of Dread.* Trans. W. Lowrie. Princeton: Princeton University Press, 1957.

Kohut, H. (1977). *The Restoration of the Self.* New York: International Universities Press.

Krystal, H. (1966). "Giorgio de Chirico." *Imago,* 23, no. 3: 201–26.

Nietzsche, F. (1883). *Also sprach Zarathustra.* Leipzig: C. G. Naumann. First published, 1896.

_____. (1909). *Thus Spake Zarathustra.* Trans. T. Common. London: T. N. Foulis.

_____. (1961). *Thus Spoke Zarathustra.* New trans. R. J. Hollingdale. Harmondsworth: Penguin Classics.

Pollock, G. H. (1978). "On Siblings, Childhood Sibling Loss, and Creativity." *Annual of Psychoanalysis,* 6:443–81.

Pincus-Witten, R. (1984). *De Chirico: Post-Metaphysical and Baroque Paintings.* Exh. cat. New York: Robert Miller Gallery.

Rosenblum, Robert (1973). "Picasso and the Tyopgraphy of Cubism." In R. Penrose, ed., *Picasso, 1881–1973,* pp. 49–77. London: Paul Elek.

Schmied, W. (1982). "Die metaphysische Kunst des Giorgio de Chirico vor dem Hintergrund der deutschen Philosophie: Schopenhauer, Nietzsche, Weininger. In W. Rubin, ed., *Giorgio de Chirico: Der Metaphysiker,* pp. 89–106. Munich: Prestal-Verlag.

Soby, J. T. (1955). "Appendix A: An Exhibition in Florence of Some Works of Andrea del Castagno, 1911–15," pp. 249–50 and "Appendix B: Manuscript from the Collection of Jean Paulhan," pp. 251–53. In *Giorgio de Chirico.* New York: Museum of Modern Art.

Weininger, O. (1907). *Über die letzten Dinge.* Vienna: Universitäts Buchhandler.

Charlotte Stokes,
Ph.D.

Sisters and Birds: Meaningful Symbols in the Work of Max Ernst

How does one discuss in psychoanalytic terms the work of an artist who has read and admired Freud's writings? Although Werner Spies denies that a sophisticated artist like Max Ernst can be understood through application of the psychoanalytic method (Spies, 1971, p. 38), the method can apply to anyone. Analysts can be analyzed. Yet the artist's knowledge *does* complicate the matter. Which part of the artist's work is pure transcription of aspects of his unconscious and which part is quite conscious quotation from his readings of Freud? Freud's case histories, dream interpretations, and explanations of puns could be used by modern artists much as artists in the past had used the Bible. But to the Surrealists, and especially to Ernst, psychoanalysis meant more. Psychoanalysis was at the heart of their method. They took pride in their ability to look within themselves for their subjects; in an artistic sphere they emulated Freud's own self-analysis. Ernst consciously and deliberately set up artistic situations in which he could attempt to plumb his own unconscious. In such an artist's work conscious and unconscious elements intermingle.

Certainly, Ernst did not know modern methods of psycho-analytic treatment; rather he acquired his knowledge of Freud before World War I. From 1910 to 1914 Ernst attended the University of Bonn, where he studied psychology, philosophy, European literature, and art history. At this time psychology was not completely independent from philosophy. It was often taught out of the philosophy department; however, those aspects of psychology that had to do with mental illness were taught by

medical doctors, several of whom were affiliated with the mental hospital connected to the university. Those courses dealing with language and the relationship of society and the individual were taught by philosophers (Trier, 1980). Even so, one of Ernst's teachers, Oswald Külpe, wrote with equal authority *Introduction to Philosophy* and *Outlines of Psychology*. Although psychology was becoming a science, Ernst's formal education placed it comfortably within the humanistic tradition.

While at the university, Ernst was a member of the Rhenish Expressionists, a group of young artists and writers who constituted one branch of the German Expressionists. From the various accounts of Ernst's life during this period, it appears that he developed an interest in Freud not through his classes in psychology but through a member of this group, Karl Otten (Russell, 1967, p. 23; Waldberg, 1958, pp. 80–81; Von Waldegg, 1980, p. 98). This young writer, fresh from his contact with Freud in Vienna in 1913, introduced Ernst to Freud's writings; that is, Ernst learned of Freud in an artistic context. In such books as *The Interpretation of Dreams* (1900) and *Jokes and Their Relation to the Unconscious* (1905), Freud made his theories accessible, even entertaining. His ideas seemed to be an ordering in modern scientific terms of the philosopher Nietzsche's discussions of the natural man, which had great appeal to avant-garde writers and artists. Whatever the therapeutic value of Freud's theories, they seemed to these young people far from the current clinical theories in psychology that equated a return to mental health with a return to conventional life, the life against which they themselves were rebelling.

As he passed from Nietzsche to Freud, Ernst became a modern man, attempting to replace the traditions of philosophical speculation with 20th-century scientific investigation. While psychology in general presented modern ways of defining the problems of human life, Freudian psychoanalysis especially appealed to artists and poets because it was filled with details of common experience and dream images that were poetic and pictorial. Freud's lively writing contrasted sharply with the rather dry writings of mainstream psychologists such as Ernst's teacher, Oswald Külpe, whose theories, derived from Wundt, divided mental processes into segments so small that they hardly seemed related to ordinary life. Whatever its orientation, modern psychology affected the older systems of beliefs which had been dominated by the church and by social and economic classes. For the Surrealists psychoanalysis largely replaced those systems.

From his first introduction to Freud's writings, Ernst began to incorporate "Freudian symbols" into his work. Such symbols appeared in his Expressionist paintings during World War I and in his postwar Dada pieces as well. But from his contact with the French Surrealists, after he moved to Paris in the early twenties, came a greater awareness of psychoanalysis' full possibilities for artistic purposes. In Freud's definition of the nature of human-

kind, Ernst found not only modern subjects but also new approaches to the creative act that replaced outmoded practices.

Ernst was remarkably successful in using his knowledge of Freud to make works of art. From just after World War I through the 1940s, he developed techniques that mobilized his unconscious fantasies and permitted them to gain expression in his art. The first and perhaps most important technique was collage, the method of finding the visionary in the ordinary image (Ernst, 1937, p. 128). Ernst's technique went beyond merely pasting papers together. ("Collage" derives from the French word for "pasting.") Collage provided a method for making connections among images ordinarily unrelated to one another. Thus, Ernst discovered within common mass-produced images the same type of personal truth that Freud had discovered in figures of speech.

By 1929, when he created his "collage novel," *La femme 100 têtes,* a book of collages and poetry, Ernst had developed a method of stimulating his mind to elicit that imagery. He first collected stacks of old magazines and illustrated novels. Then, when his mind was prepared and his body at rest, in a rush of artistic activity, he cut out and combined elements from the illustrations (Russell, 1967, pp. 188–89). The elements in his earlier Dada collages had come from both contemporary and older publications, but few of the engravings incorporated into *La femme 100 têtes* were later than 1900. By choosing 19th-century publications he not only gave formal consistency to his collages, but relived his early experiences by looking at pictures in books and magazines that were available when he was a child. From these images he cut and juxtaposed unrelated images, putting a classical figure into a laundry, a baby in a machine, and a man sleeping in an armchair adrift in an ocean.

In this artistic context Ernst free-associated to bring forth images, much as an analytic patient might produce associations from childhood dreams. Freud may have been the source not only of Ernst's search for material in his own early experience, but for the collage method itself. In a discussion of one of his own childhood dreams, Freud identified a book illustration from which his dreaming mind had extracted a significant detail that played an important role in his dream (Freud, 1900, p. 622). What Ernst found may or may not be a reflection of his unconscious, but he was certainly quite conscious of the mechanism he was setting in motion by leafing though books and magazines and letting the images stimulate a response. This collage method, which involved a relaxed but alert state, was as close to the dream state as the artist could come. His collages are stills drawn from these waking dreams.

Looking through page after page, image after image, Ernst assembled not only individual collages but also a consistent set of images that appear again and again in his work. Two images repeatedly struck a responsive chord in Ernst: the bird and the female form that he would later call "my sister." By the mid-

twenties birds formed a central theme in Ernst's paintings, frottages, and collages. The two sisters also had made their appearances. But the intense effort of creating the 147 collages for *La femme 100 têtes* in 1929 forced these personages to assume names and take on complex personalities in his work. In the popular science magazines Ernst collected for this project, birds were a favorite topic, shown in diagrams and illustrated in their natural environments. The female figure was common in other magazines, both in accounts of 19th-century society and in reproductions of works of art in which the classical female figure dominated. Once codified, the personalities of the bird and the sister would haunt Ernst throughout much of his career.

These characters were fully developed and interreated by 1942, as seen in "Some Data on the Youth of M.E.: As Told by Himself," the poetic autobiography that he wrote for the issue of *View* dedicated to him. The issue also contained reproductions of Ernst's works and essays about him by his contemporaries. Their essays were liberally peppered with references to the bird as the artist's alter ego and symbol. As early as the mid-twenties his friends in the Surrealist movement had used birds as metaphors for Ernst. For example, in 1926 Paul Eluard associated Ernst with the "birds of liberty" in a poem named for him (Eluard, 1937, p. 63). Ernst's fair hair and beaked nose made him look like a sleek bird of prey. The bird with its outlaw connotations was a symbol appropriate to the male. So his friends called him "hunting bird," "nightingale," "swallow." They did not associate him with "sister." The effeminate was purged from the male members of the Surrealist movement because André Breton, especially, opposed any indication of homosexuality.

Unlike the other essays in *View,* Ernst's essay united that personal symbol with his experiences with his sisters. Ernst's oldest sister, Maria, was born on February 24, 1890, the year before Max; Emilie was born on June 21, 1892, just 14 months after him; Luise arrived June 21, 1893; Elisabeth was born on Feburary 28, 1897; and Appollonia (Loni), the Ernsts' last, was born on January 6, 1906 (Teuber, 1980, pp. 49, 52). According to the book of family history and photographs compiled by Max's father, Philipp Ernst, there were two other children who died shortly after birth: their first child, also named Carl, was born February 19, 1889, and Berta, born March 10, 1896 (pages of book reproduced in Teuber, 1980, p. 52). In the *View* essay, Max said that Maria's death, which occurred when he himself was five and a half, introduced him to the "feeling of nothingness and annihilating powers." Later that year delirium brought on by the measles reawakened the annihilating powers and, among other visions, introduced that of a "menacing nightingale." Ernst recalled that when he was 14, the birth of his youngest sister, Loni, was announced at the same moment that he discovered the corpse of "one of his best friends, a most intelligent and affectionate pink cockatoo." He added that from this event came his confusion of birds with people. A bird, Loplop, thereafter became his alter ego,

whose companion was *"Perturbation ma soeur, la femme 100 têtes."* In discussion of his work much has been made of Ernst's identification of himself with the bird alter ego, but the "inseparable" sister has been largely ignored in this regard (Spies, 1983; Stokes, 1983b; Trier, 1971).

Yet the sisters, their births and deaths, danger, Ernst's creative powers, and psychic disturbance were all interrelated with his bird imagery. Indeed, unless one takes the significance of Ernst's sisters into account, the bird alter ego cannot be completely understood. (A case history described by the psychoanalyst Leon Berman throws light on Ernst's obsession with birds. One of Berman's patients was similarly obsessed. This patient kept birds as pets and was an advocate for their preservation in the wild. Although the patient associated his interest in birds with his supposed killing of a female bird, the guilt over the death of the patient's infant sister when he was a small child was the real source of his obsession with birds [Berman, 1978].)

Birds, light and fragile, are a natural symbol for the spirits of the dead. Birds, traveling through the sky over our earthbound heads, seem as weightless as spirits. Birds have free access to Heaven. The Holy Spirit in the form of a dove presided over the conception of Christ. Ernst, who came from a Catholic family, would have been familiar with representations of the Holy Spirit with the Virgin annunciate.

Birds are also associated with the coming of life in nature. Because bird's eggs are the visible bearers of offspring, children associate birds with reproduction. Furthermore, the child often links only the mother bird with egg and offspring; no troubling ideas of sexual intercourse are connected with their birth. In folk tales, birds, in the form of storks, are the bringers of babies. But Margolis and Parker (1972) also point out that these birds have many, often powerful, negative associations as well. For example, storks can bring dead babies as a punishment. A child observing the death of a small sibling might well associate birds with the departure as well as the birth of the rival. Given the strong feelings engendered by siblings, the bird would also be associated with the surviving child's own jealousy and guilt.

One of the paintings chosen to illustrate the 1942 *View* essay associates birds with danger to children: *Two Children Are Threatened by a Nightingale* (1924, fig. 1). Two of Ernst's sisters died young—Maria, who was mentioned in the *View* essay, and Berta Maria. Although Ernst identified the year of Maria's death as 1897 in his essay, his father placed it in 1896, the same year as Berta's (Teuber, 1980, p. 52). In any event, the two deaths were close in time and were no doubt traumatic for the Ernst family. The two threatened children could be these two sisters, or they could be two of Ernst's surviving sisters.

Whichever pair of sisters the two older children in the painting represent, the third and smaller "sister" was probably an allusion to Ernst's youngest sister, Loni. The picture shows a small girl carried by a man whose shape, as Janis pointed out, paraphrases

Fig. 1. Max Ernst, *Two Children Are Threatened by a Nightingale,* 1924. Oil on wood with wood construction. The Museum of Modern Art, New York. Purchase.

that of the nightingale (Janis, 1942, p. 10). Despite the air of menace the picture conveys, these two figures are based on an illustration from a popular 19th-century science magazine that depicts a child being rescued from a burning building by a fireman in an asbestos suit (Stokes, 1983a). He protects, rather than

threatens the child. Loni was born as Ernst was entering adolescence and his more mature nature may have protected her from his earlier, more destructive impulses. Further, he developed a special fondness for his youngest sister (Waldberg, 1958, p. 21). Instead of the menacing nightingale, he became her fond protector.

Two Children Are Threatened by a Nightingale is, as is the *View* essay, Ernst's interpretation of the events of his own emotional life. Both the painting and the essay bear on family relationships, but neither gives a complete picture. Indeed, they give contradictory interpretations. In contrast to the painting, the essay endowed the birth of the last sister with negative, even traumatic implications. Her arrival was associated with the limp corpse of a pink bird, Ernst's good and affectionate friend. In this instance, the term "bird" may well have been consciously employed by Ernst as an ironic reference to the vagaries of his own adolescent sexuality. The slang word for penis in several European languages is bird or some species of bird. In German, Ernst's native language, the word for bird, *Vogel,* is changed into a verb, *vögeln,* meaning "to copulate." Although Ernst presumably would have known this *double entendre,* Freud specifically pointed it out in relation to one of his own dreams in which birds gave pictorial form to his own forbidden sexual feelings (Freud, 1900, p. 622). Ernst realized that birds were associated with his sisters and his feelings concerning them. From this knowledge, gained by exploring his own inner life, he derived his personal symbol, the bird. Then he augmented that symbol with conscious associations derived from many sources: from Freud, common figures of speech, religious symbolism, and so on.

Dr. Berman pointed out that his patient's obsession with birds was the observable "cap" covering a variety of experiences and intense feelings (Berman, 1978). So, too, was Ernst's obsession. However, Ernst very successfully forced it to serve an artistic purpose. The bird with all its conscious and unconscious associations became Ernst's symbol for himself as the artist.

By 1929, when Ernst made *La femme 100 têtes,* the bird had become a clearly defined personage, usually known as Loplop, a name that the artist said came from his experiences with his young son (Jimmy Ernst, 1984, p. 262). In the novel Loplop becomes a protean Surrealist spirit. He can appear as any manner of bird or man. Whatever his form, he is the Bird Superior, the destroyer of traditional religion, and the bringer of chaos (fig. 2). In *La femme 100 têtes,* as in the *View* essay, the bird is also a totemic figure, Ernst's personal identifying symbol, as well as his parent, guide, and protector. Loplop's consort in the "collage novel" is "my sister, *la femme 100 têtes.*" Sometimes she is called Germinal, the "seeded," the springtime month in the calendar of the French Revolution. Sometimes she is Perturbation, the disturber, the force that makes a planet wobble off its orbit. Though she may appear as a 19th-century woman, more often she takes the form of one of the classical draped or nude female figures that Ernst cut

Fig. 2. Max Ernst,
"Loplop, the Bird
Superior, scares away
the last vestiges of
communal devotion."
Plate 58 from *La
Femme 100 têtes*.
Paris: Editions du
Carrefour, 1929.

from engraved reproductions of academic paintings and sculptures.
In the novel, she presides over the first schoolroom fights and,
later, over more mature types of violence. She also attends the
internal trials of the solitary artist, as in figure 3 in which the artist
wears the head of Beethoven. By the middle of the novel, *la
femme 100 têtes* and Loplop are often shown together, a pair of
spirits or muses that guide the development of the Surrealist hero,
Ernst himself.

In the early 1930s Ernst revealed Loplop to be the stand-in for
the artistic aspect of his temperament in the collages and paintings
titled *Loplop Introduces* . . . (often followed by the name of the
subject presented). Typically these collages are dominated by a
line drawing of an anthromorphized easel topped by a schematic
bird's head. On the easel stands a "painting," often represented by
elements fixed to the surface, showing the subject introduced (as
in fig. 4). The collage elements are: photographs, postcards, pages
from drawing and architecture books, marbled endpapers, small
common objects, even samples of his own frottages. In these
works the artist, in his easel persona, presents ordinary people and

Fig. 3. Max Ernst, "Perturbation, my sister, la femme 100 têtes."
Plate 34 from *La Femme 100 têtes*. Paris: Editions du Carrefour,
1929.

objects in the context of art. Ernst raised the subject to the status
of art by removing it from its ordinary environment, isolating it,
or juxtaposing it to other objects to bring out its Surreal, that is,
psychologically real, qualities. By his presentation, Loplop—the
stand-in for the artist—transforms them into art.

Because "my sister" is Loplop's "inseparable" consort, she can
also be seen as an aspect of Ernst's temperament. But as his
female counterpart, she occupies a slightly different place than
Loplop himself does. United with the artist in their common
parentage but distinct from him in gender, she is at once separate
and a part of him. In his *View* essay Ernst revealed that from the
traumas caused by his sisters came the hallucinations and obses-
sions with birds that later formed part of his art. In his early life
"the sister" symbolized the births and deaths of his sisters as well
as his feelings about those siblings. But for the mature artist she
represented his own disturbing sexual desire for women, a desire
that he located in himself and not with the attraction of any one

Fig. 4. Max Ernst, *Loplop introduces Members of the Surrealist Group*, 1931. Cut-and-pasted photograph, pencil, and pencil frottage. The Museum of Modern Art, New York. Purchase.

woman or type of woman. (Although Ernst's adult sexual relationships are beyond the scope of this discussion, it should be observed that "the sister" does not represent an obsession with the child-woman; his wives and lovers, though they all shared his interest in art, were remarkably different from one another in age and accomplishments.) Loplop is the spirit of the Surrealist artist, *la femme 100 têtes,* whose punning name can mean the woman with no head (*sans tête*) or with 100 heads, his own sexual desire that is a primary source of his art.

Although in his works of the 1930s Ernst separated the sister from Loplop, he nonetheless associated himself even more strongly with this female alter ego during this period. She was Marceline-Marie, the main character in another collage novel, *Rêve d'une petite fille qui voulut entrer au Carmel* (The Dream of a Young Girl Who Wanted to Become a Carmelite Nun) of 1930. The novel describes this young girl's sexual and violent dreams as she prepares herself for becoming a nun or sister. (In both German, Ernst's native language, and French, the language in which the novel is written, the word for sister can be used to describe a female sibling as well as a nun.) In his introduction to the novel Ernst recounted an event that occurs early in the plot:

> For it is probably due to the troubles provoked by the coupling of two names of such different significance that, from the beginning of the dream, we will see her split down the middle of her back and wearing the continually changing appearances of two distinct but closely related persons, of "two sisters" as she says to herself in the dream, one of whom she calls "Marceline" and the other "Marie," or "me" and "my sister" (Ernst, 1930, n.p.; my translation).

As in *La femme 100 têtes* the phrase "my sister" rings throughout this novel. The heroine's name, Marceline-Marie, is the key to understanding the web of associations connecting Ernst and this young girl. The first of the heroine's names, Marceline, is the feminine of Marcel, and it may have been Marcel Duchamp, the great Dadaist (who had also created a female alter ego, Rrose Sélavy) who inspired Ernst's choice of this name. The second name, Marie, the French variant of the Latin Maria, is the name of Ernst's sister, whose death caused such a violent reaction in him. Moreover, Maria was his own middle name. Like his young heroine, Marceline-Marie, Ernst's two names begin with *M:* Maximilian Maria. This play on names makes it clear that the artist associated himself with his young heroine. Although most of the collages that show Marceline-Marie split into two figures portray both as women, in several collages the gender of the figures is ambiguous. In figure 5, for example, it seems that the male and female alter egos of the artist himself are being split apart.

Unlike the generalized muselike presence of *la femme 100 têtes,* Marceline-Marie was given a specific identity as a French girl so concerned with the religious life that she wished to enter one of

Fig. 5. Max Ernst, "Already I find my-self alone, alone with myself, facing my-self . . . " Plate 5 from *Rêve d'une petite fille qui voulut entrer au Carmel.* Paris: Editions du Carrefour, 1930.

the strictest orders. Ernst would have known something of this process because his younger sister Luise had become a nun at the beginning of World War I. (Waldberg, 1958, pp. 21–22). In his novel Ernst referred more than once to Saint Theresa of Lisieux, a 19th-century Carmelite nun who was a popular symbol of French faith and patriotism. She had only recently been canonized when Ernst, then living in France, wrote this novel. Further, he recalled the year of his sister Maria's death as 1897, the year that Saint Theresa died. It may have been psychologically satisfying for him to associate himself with the lost sister in these complex ways, but conscious choices based on his knowledge of contemporary psychological literature also played a role in the character of Marceline-Marie.

In Ernst's novel Marceline-Marie experiences dreams or visions with strong religious themes. In the past the religious content of such experiences was accepted as either the holy visions of saints or the evil visions of witches. But in the 19th and early 20th centuries psychologists explained such events as the hysterical symptoms of a sick mind or nervous system. Modern science

replaced religion as the interpreter of human experience. Although the visions that male saints experienced were not considered supernatural, they were often explained as having a physical cause, such as epilepsy. Not only were female saints more commonly cited in modern discussions of visionary experience, but their visions were usually attributed to a deprivation of sexual satisfaction. James Leuba, whose opinions, though extreme, are well within the range of psychological opinion, in the 1920s, wrote: "We must surrender to the evidence: the virgins and the unsatisfied wives who undergo the repeated 'love-assaults of God' . . . suffer from nothing else than intense attacks of erotomania, induced by their organic need and the worship of the God of love" (1925, p. 151).

The female, then, because of her perceived innate weakness or greater susceptibility, seemed to most writers more likely than the male to experience the hysterical symptom of visions. Moreover, most writers stressed the importance of the "passive state," more often associated with women, as a requirement for permitting the visionary experience to *come to* the visionary (Leuba, 1925, pp. 77–78, and Laignel-Lavastine, 1931, pp. 78–80). At least in a theoretical sense, passivity was a characteristic of Surrealist artistic activity. Ernst asserted: "the purely passive role of the 'author' in the mechanism of poetic inspiration . . . by unmasking as adverse to inspiration all 'active' control through intellect, morality, or aesthetic considerations" (Ernst, 1934, p. 134). To illustrate this point, Marceline-Marie's dreams unfold while the heroine sleeps through the entire novel.

Psychological writers of the period mentioned other phenomena found in Ernst's novel: the inappropriate responses in religious situations and sexual fantasies triggered by violent pictures in church. In "The Devil and the Psychoneurotics," one of a series of lectures given in Paris in 1927, M. Jean Vinchon discussed a "woman who suffered from erotic and agonizing ideas whenever, in church, she found herself looking at sacred images, chiefly the Way to the Cross or the pictures of the tortures of the Saints" (Laignel-Lavastine, 1931, p. 115). He also discussed the obsessions, "unhealthy ruminations," and "neurotic doubt" of a young girl who, at the time of puberty, decided to join the Carmelite order. In closing, Vinchon said: "She can only think of romantic adventures, ideas of marriage, and she suffers at such times terrible anguish" (Laignel-Lavastine, 1931, p. 115). This discussion is almost a paraphrase of the dream adventures of Ernst's young heroine, whose religious images are charged with sexual allusions. (See fig. 6.) Ernst could have heard these lectures or read about them, but similar accounts were common in contemporary psychological literature dealing with visions.

Thus, when Ernst developed his female alter ego, he turned to psychological literature for the type of person who would be consistent with Surrealist ideas of inspiration: the female religious visionary who, according to contemporary psychologists, actually suffered from hysteria. According to Freud, hysteria, no matter

142

Fig. 6. Max Ernst, "Marceline-Marie: 'My place is at the feet of a merciful husband.' Tresses: 'To dream, to dream, and to babble on sick Friday.'" Plate 40 from *Rêve d'une petite fille qui voulut entrer au Carmel,* Paris: Editions du Carrefour, 1930.

what its manifestations, resulted from sexual urges and privations (1905a, p. 24). The Surrealists very much admired the hysterics for their visions. The Surrealists were also aware that the mentally ill were often incapable of communicating their experiences in an artistic form. (In his autobiographical book *Nadja* [1928], Breton was awed and fascinated by the irrationality of his heroine, but noted her inability to progress past a certain point in the drawings he encouraged her to make.) Ernst solved that dilemma by introducing his other alter ego, Loplop. The visionary female side called forth the imagery, but the male artistic side, Loplop, made the art object. Ernst's little heroine then fit well within the beliefs of both the Surrealists and contemporary psychologists. Ernst's own personal need underlay his conscious and theoretical choices: the dreams of Marceline-Marie satisfied all his complex requirements.

Although assigning the roles of male and female to different functions of the mind was hardly new, it was a useful concept. Several times during his 1927 lecture series, Laignel-Lavastine referred to the *anima* and the *animus,* or the contemplative soul and the discursive spirit, and to the *mens* and the *ratio,* or the

unconscious self and the discursive intelligence. In the literature he quoted, the female was given the roles of *anima* and the *mens,* that is the role of the irrational part of the mind open to the flights of imagination and to the mythic experience (Laignel-Lavastine, 1932, pp. 57–61 and 99–106). Laignel-Lavastine even mentioned a lecture by the Surrealist poet René Crevel: "in the course of which he smote the *ratio,* which has the great defect of being logical, hip and thigh, while he exalted the *mens,* showing the quality of psychological dynamism it contains" (Laignel-Lavastine, 1931, p. 59).

While the *mens* might characterize the "psychological dynamism" that Ernst ascribed to his "sister," the *ratio* certainly does not characterize Loplop. Ernst redefined the old concept of the *ratio* into the part of the mind that forms, chooses, and places— that is, the activities of the artist. In contrast to the old systems in which the two parts of the mind are in conflict, Ernst's arrangement permits the *ratio* to give substance to the sightings made by the *mens.* Yet there is no small irony here. The female is the chaotic free-form element. Her visions become art only if tamed, limited by a male icon-maker. In the synthesis of his two alter egos, Loplop and "my sister," Ernst gave the formula for the Surrealist artist.

In 1942, the same year he wrote the revealing *View* essay, Ernst synthesized his two alter egos in a large-scale oil painting, *Surrealism and Painting* (fig. 7), in which male-female, bird-sister, visionary-iconmaker all came together. Like the Loplop collages, this canvas depicts both a presenter and a painting, but unlike those earlier works, *Surrealism and Painting* suggests the rich inner sources for the flat work of art. Giant, fleshy birds intertwine into a love-knot from which a snakey hand emerges to paint. The painting hand is connected to the male head that turns inward, eyes closed, toward the open-eyed female interior. She is at once inside and outside, at once part of him and the model on the pedestal. But the "painting" on the easel is closer to the patterns on the pedestal than to the sexual model on it. Most of the picture, including the birds, was not made with the automatic techniques the picture seemingly touts; the painting within the painting and the pedestal were made from spatters and drips shaped partly by chance and partly by design.

Ernst formed his early experiences into art just as thoughtful painters in the past worked the theological niceties of a biblical event into an altarpiece. The themes of the bird and the female presence Ernst called "my sister" are not only pictorial but carry a highly personal charge because they derive from his inner life while depicting a subtle array of applications of psychoanalysis and other contemporary psychological theories. Ernst's artistic strength comes from his ability to combine what he consciously knew about such theories and what came from his own inner life. The resulting images are truly personal, yet they speak a language accessible to anyone with eyes.

144

Fig. 7. Max Ernst, *Surrealism and Painting,* 1942. Oil on canvas.
Private collection. Photo © SPADEM/VAGA, New York, 1986.

Note

The research and the photographs for this essay were funded by an
Oakland University Faculty Research grant, which I gratefully
acknowledge.

References

Berman, L. E. A. (1978). "Sibling Loss as an Organizer of Unconscious
Guilt: A Case Study." *Psychoanalytic Quarterly,* 47:568–87.

145

Breton, A. (1928). *Nadja*. Trans. R. Howard. New York: Grove Press, 1960.

Eluard, P. (1937). "Max Ernst." *Cahiers d'art* (Special Max Ernst Issue), 63.

Ernst, J. (1984). *A Not-So-Still Life*. New York: St. Martin's/Marek.

Ernst, M. (1929). *La femme 100 têtes*. Paris: Editions du Carrefour.

———. (1930). *Rêve d'une petite fille qui voulut entrer au Carmel*. Paris: Editions du Carrefour.

———. (1934). "What Is Surrealism?" Trans. G. Bennett. In L. R. Lippard, ed., *Surrealists on Art*, pp. 134–37. Englewood Cliffs, N.J.: Prentice-Hall, 1970. Originally in *Austellung* (exh. cat.). Zurich: Kunsthaus, October 11–November 4, 1934.

———. (1937). "Beyond Painting." In L. R. Lippard, trans. & ed., *Surrealists on Art*, pp. 118–34. Englewood Cliffs, N.J.: Prentice-Hall, 1970. Originally "Au dela de la peinture." *Cahiers d'Art* (Special Max Ernst Issue): 13–46.

———. (1942). "Some Data on the Youth of M.E., as Told by Himself." *View* (Speical Max Ernst Issue), sec. s., no. 1 (Apr.): 28–30.

Freid. S. (1900). *The Interpretation of Dreams*. Trans. & ed. J. Strachey. New York: Avon, 1965.

———. (1905a). " A Case of Hysteria." *A Case of Hysteria, Three Essays on Sexuality, and Other Works. Standard Edition*, 7:1–122. Trans. & ed. J. Strachey. London: Hogarth Press, 1978.

———. (1905b). *Jokes and Their Relation to the Unconscious*. Trans. & ed. J. Strachey. New York: Norton, 1963.

Janis, S. (1942). "Journey into a Painting by Max Ernst." *View* (Special Max Ernst Issue), sec. s., no. 1 (Apr.): 10–12.

Külpe, O. (1909). *Outlines of Psychology*. Trans. E. B. Titchener. London: Swan Sonnenschein.

———. (1913). *The Philosophy of the Present in Germany*. Trans. M. L. Patrick & G. T. W. Patrick. London: George-Allen.

Laignel-Lavastine, M. (1931). *The Concentric Method in the Diagnosis of Psychoneurotics*. New York: Harcourt, Brace.

Leuba, J. H. (1925). *The Psychology of Religious Mysticism*. London: Routledge & Kegan Paul, 1972.

Margolis, M. & Parker, P. (1972). "The Stork Fable: Some Psychodynamic Considerations." *Journal of the American Psychoanalytic Association*, 20, no. 3 (July): 494–511.

Neff, T. A. R., ed. (1985). *In the Mind's Eye: Dada and Surrealism*. New York: Abbeville Press.

Russell, J. (1967). *Max Ernst: Life and Work*. New York: Abrams.

Spies, W. (1983). *Max Ernst: Loplop: The Artist in the Third Person*. Trans. J. W. Gabriel. New York: Braziller.

———. (1971). *Return of La Belle Jardiniere: Max Ernst, 1950–1970*. New York: Abrams.

Stokes, C. (1983a). "The Equivocal Ernst: Some Sources and Interpretations of Max Ernst's *Two Children are Threatened by a Nightingale*." *Arts Magazine*, 53, no. 5 (Jan.): 100–101.

———. (1983b). "Surrealist Persona: Max Ernst's Loplop, Superior of birds." *Simiolus*, 13, nos. 3–4: 225–34.

Teuber, D. (1980). "Die Familie Philipp Ernst." In W. Herzogenrath, ed., *Max Ernst in Köln: Die rheinische Kunstszene bis 1922*. pp. 49–54. Cologne: Rheinland-Verlag GmbH.

Trier, E. (1971). "Homage to Loplop." In *Homage to Max Ernst*, Special Issue of *XXe Siècle Review*, pp. 34–39. New York: Tudor.

146 ———. (1980). "Was Max Ernst studiert hat." In W. Herzogenrath, ed., *Max Ernst in Köln: Die rheinische Kunstszene bis 1922,* pp. 63–68. Cologne: Rheinland-Verlag GmbH.

Von Waldegg, J. H. (1980). "Max Ernst und die rheinische Kunstszene 1909–1919." In W. Herzogenrath, ed., *Max Ernst in Köln: Die rheinische Kunstszene bis 1922,* pp. 89–110. Cologne: Rheinland-Verlag GmbH.

Waldberg, P. (1958). *Max Ernst.* Paris: Jean-Jacques Pauvert.

Leon E. A.
Berman, M.D.

The Role of the Primal Scene in the Artistic Works of Max Ernst

The application of psychoanalysis to literature and art has been a
fascinating (if controversial) interest since the time of Freud.
While Freud had a rich background and deep personal interest in
these subjects, his was more than a romance with aesthetics. He
believed the works of creative artists expressed universal psycho-
logical themes that could provide valuable confirmation and elu-
cidation of psychoanalytic concepts. The ego fluidity of the artist,
his access to his own unconscious and the language of primary
process, and his capacity to communicate personal experience in
universal symbols make him one of "the few to whom it is
vouchsafed . . . with hardly any effort to salvage from the whirl-
pool of their emotions the deepest truth to which we others have
to force our way, ceaselessly groping among torturing uncertain-
ties" (quoted in Kris, 1952, p. 23). While psychoanalysts cannot
explain the secret of creativity, Freud concluded, creative artists
have much to contribute to our understanding of the deeper
layers of the human psyche.

One such artist was the Surrealist painter Max Ernst. Surprising-
ly, he is not mentioned in the literature of applied psychoanalysis,
although the psychoanalytic significance of his work has been
appreciated by art historians (see Stokes, 1982 and 1983). One of
the most inventive and literate exponents of the Surrealist school,
he is credited with first giving Surrealism its visual form: of
translating stream of consciousness and automatic writing into
artistic imagery.

Along with many of his fellow Surrealists, Ernst was fascinated

with Freud's ideas on the unconscious, dreams, and symbolism (although the appreciation was not mutual; Freud did not think very highly of the Surrealists). But Ernst's interest in psycho-analysis went much further. While an undergraduate student at Bonn, he studied Freud's writings. He was particularly impressed with *The Interpretation of Dreams* and *Jokes and Their Relation to the Unconscious*. He worked for a period of time in a mental hospital and actually thought of becoming a psychiatrist.

The writings and artistic works of Max Ernst contain many themes rich in psychoanalytic significance. This paper will consider one of them: the primal scene. While studies in applied psycho-analysis are always burdened with questions of validation, a study of Ernst presents a special problem: How does his familiarity with psychoanalysis and the writings of Freud affect the credibility and spontaneity of his "free-associative" autobiography and works of art? This question will be taken up later.

One of the most powerful and consistent organizing themes in Ernst's work is the primal scene. Since first described by Freud in 1890, this time-honored concept has continued to demonstrate its clinical validity in the memories, fantasies, and dreams of patients in psychoanalysis. Like many technical terms that have wide application, the term primal scene has become a psychoanalytic cliché and can use occasional redefinition.

The primal scene refers to the scene of parental intercourse. The fact that it is a *scene* emphasizes the importance of the audience—the onlooker. The fact that it is *parental* identifies the onlooker as the child. Primal scene, then, refers to the child's view of his parents in the act of intercourse, whether it is the memory of a real event, a fantasy, or some combination of the two. Although actual memories of primal scene are rarely re-covered in the course of psychoanalysis, its derivatives regularly find their way into patients' associations. It has come to be appreciated as the consummate drama of the oedipus complex: "an organizing concept that integrates a whole set of unconscious fantasies, which in turn serve as the dynamic base for subsequent symptom formation, character structure, and even sublimation" (Arlow, 1980, p. 25).

It is not surprising that such a powerful, universal psychological constellation would manifest itself in many areas of our culture. Primal scene imagery is central to many important myths and rituals and contributes widely to literature and art (see Róheim, 1934; Pederson-Krag, 1949; Bradley, 1967; Edelheit, 1971). Psy-choanalytic studies of a number of creative artists have demon-strated the important role of primal scene fantasies in their lives and in the themes of their artistic works (see Greenacre, 1955, 1973; Kligerman, 1962; Edelheit, 1971; Simon, 1977; Arlow, 1978).

To appreciate the scope and intensity of feelings condensed within primal scene images, we must consider the typical reactions of a child witnessing or imagining such a sight. It is usually traumatic, for it arouses such powerful emotions that it threatens

to overwhelm the child's immature ego.[1] The scene is often interpreted as being very aggressive—that the parents are fighting or that daddy is killing mommy. This, in turn, stirs up tremendous fear and aggression in the child, as well as sexual excitement. He feels jealous and rejected. Something enormously important and exciting is taking place from which he is excluded. As the child develops and sees the mother become pregnant and give birth to siblings, he struggles with his dawning awareness of some vital connection between these momentous events and what transpired in the parents' bedroom. It becomes one of the great mysteries of childhood.

The concept of primal scene encompasses more than the sights, sounds, or fantasies of parental intercourse. It includes all of the powerful attendant emotions: terror, rage, jealousy, excitement, rejection, inadequacy, and loneliness. It also includes feelings of confusion; intense curiosity about sexuality, conception, and birth; and the wish to participate—to have intercourse, make babies, and have babies. This whole agglomerate of feelings, fantasies, and events invests the primal scene with an aura of confusion, mystery, and magic. It may weave itself into the adult personality in a variety of neurotic symptoms or character traits affecting such functions as sexuality, seeing, hearing, sleeping, curiosity, learning, memory, and the like.

Before examining references to the primal scene in Ernst's work, I wish to stress two points. First, while I use the term "primal scene memories" to describe these references, it is understood that we have no way of knowing if they were conscious or unconscious and whether they were memories of actual events, or fantasies, or some combination of the two. Second, focusing on a single theme cannot help but seem reductionistic. Although I believe that primal scene memories played a significant role in Ernst's artistic work, they were by no means the only motive force. Such works are the product of multiple conscious and unconscious elements as well as social and cultural influences. Ernst was an artist particularly attuned to memories from childhood and derivatives from his unconscious. It would be expected, therefore, that his works would reflect numerous psychological themes.

The writings of Max Ernst offer valuable insights into his life, his art, and his experience of the creative process. Of particular interest is his brief autobiographical sketch, "Some Data on the Youth of M. E. As Told by Himself" (Ernst, 1942, pp. 28–30). Reading this rambling, free-associative autobiography, one is struck by the absence of Ernst's mother. She is mentioned only twice: in the first sentence telling of his birth in 1891, and as a subject in some drawings at age five. The main character and antagonist in the narrative is Max's father.

Little Max's first contact with painting occurred in 1894 when he saw his father at work on a small water color entitled "Solitude" which represented a hermit sitting in a beech-

forest and reading a book. There was a terrifying, quiet atmosphere in this "Solitude" . . . Even the sound of the word "Hermit" exercised a shuddering magic power on the child's mind . . . Max never forgot the enchantment and terror he felt, when a few days later his father conducted him for the first time into the forest (Ernst, 1942, p. 28).

This memory (or screen memory) from age three is typical of Ernst's childhood memories: a vivid series of impressions in which looking predominates, accompanied by feelings of terror, fascination, and magic. This combination is highly suggestive of the primal scene.

Two years later, little Max was emulating his father by creating his own drawings, which depicted what he wished to be when he became a man: a railroad guardian.

Maybe he was seduced by the nostalgia provoked by passing trains and the great mystery of telegraph wires which move when you look at them from a running train and stand still when you stand still. To scrutinize the mystery of the telegraph wires (and also to flee from the father's tyranny) five-year-old Max escaped from his parents' house. Blue-eyed, blond-curly-haired, dressed in a red night shirt, carrying a whip in the left hand, he walked in the middle of a pilgrims' procession (Ernst, 1942, p. 29).

In a kind of sleep-walking state and armed with a masculine symbol (the whip), little Max acts out his forbidden, grandiose, oedipal wishes: to defy father and do the things that big men do.

His second memory about painting involves more critical, competitive feelings toward his father. Seeing his father suppress a tree in the landscape he was painting because it disturbed the composition, Max felt a growing sense of anger. The insincerity and lack of integrity he perceived in his father's "candid realism" kindled the revolt that would eventually flare into his Surrealist and Dada art.

For Max Ernst, the act of artistic creation was infused with childhood feelings and fantasies and was experienced as highly erotic, aggressive, magical and forbidden. It was organized around fantasies of the primal scene, with feelings of awe and competition toward his father. Father, the amateur painter, first introduced him to the frightening, exciting adventure. Max emulated his father, then revolted against him, feeling he could do it better. He was eventually punished for his audacity when, as an adolescent, father burned one of the books he had written.

Creativity also became intimately associated with the fear of death. At the age of six, Max watched his sister die. Later that year, while racked with fever and fearful that he might follow her into "nothingness," he externalized this fear in the form of a vision—a kind of waking dream—of a menacing bird.

First contact with hallucination. Measles. Fear of death and the annihilating powers. A fever-vision provoked by an imita-

tion-mahogany panel opposite his bed, the grooves of the wood taking successively the aspect of an eye, a nose, a bird's head, a menacing nightingale, a spinning top and so on. Certainly little Max took pleasure in being afraid of these visions and later delivered himself voluntarily to provoke hallucinations of the same kind in looking obstinately at wood-panels, clouds, wallpapers, unplastered walls and so on to let his "imagination" go. When someone would ask him: "What is your favorite occupation?" he regularly answered, "Looking" (Ernst, 1942, p. 30).

This is a common enough occurrence in the nightly lives of children, with or without fever. They attempt to replace an overwhelming inner panic with some external danger that can then, usually with the help of the parent, be dispelled. The parent answers his cry, turns on the light, and reassures the child that the frightening monster is only a piece of furniture. The monster is often a projection of the child's own aggressive impulses along with the anticipated punishment for them, and frequently relates to primal scene fantasies.

But for little Max, the potential artist, it did not stop here. To gain mastery over the fear, he forced himself to re-experience it, to provoke the vision over and over. The process of image-making became a favorite pastime. What began as terror was transformed into pleasure and eventually into artistic creativity. It is a beautiful example of the special capacity for sublimation seen in the artistically gifted child (Greenacre, 1957). This mechanism for mastering anxiety would play a vital role in the development of Ernst's art.

Similar elements are woven into his memory from age fifteen, when the death of his beloved pet bird was directly associated with the birth of yet another sister, Loni.

First contact with occult, magic and witchcraft powers. One of his best friends, a most intelligent and affectionate pink cockatoo, died in the night of January the 5th. It was an awful shock to Max when he found the corpse in the morning and when, at the same moment, his father announced to him the birth of sister Loni. The perturbation of the youth was so enormous that he fainted. In his imagination he connected both events and charged the baby with extortion of the bird's life. A series of mystical crises, fits of hysteria, exaltations and depressions followed. A dangerous confusion between birds and humans became encrusted in his mind and asserted itself in his drawings and paintings (Ernst, 1942, p. 30).

By the age of fifteen, Max had seen the deaths of two sisters and a beloved bird, and the births of a brother and four more sisters. Birth and death, conception and destruction, birds and siblings became intricately associated in his mind—shifting, interchangeable images in a fabric of mystery, magic, and terror. These would form the themes of his artistic works. The turbulent

emotions surrounding these memories, states of altered consciousness and wavering sense of reality, would periodically recur throughout his life, and, when they did, would catalyze the evolution of new techniques. The most direct reference to primal scene in Ernst's writings is a "waking dream" he dates between ages five and seven which was "suddenly remembered" in adolescence.

I see before me a panel painted, very crudely, with large, large black strokes on a red background. This imitation mahogany reminds me of organic forms: a menacing eye, a long nose, the enormous head of a bird with long black hair, etc.

In front of this panel a dark shiny man begins to make gestures which are at once deliberate, buffoonish, and (here I rely upon much earlier memories) uproariously indecent. This curious personage sports my father's upturned moustaches.

Legs wide apart, knees bent, trunk leaning well forward, he carries out a number of leaps in slow motion. Then he smiles and takes out of his pocket a large pencil made of some soft material which I cannot identify exactly. He gets down to work. Blowing heavily, he makes hurried black marks on the imitation mahogany. New shapes, as abject as they are unexpected, take their place on the panel. Animals, by turn ferocious and slimy, become so vivid, so lifelike, that they fill me with horror and anguish. Well pleased with what he has drawn, the strange character rounds up his zoo and piles it into a kind of vase which he draws, for this purpose, in the empty air. He turns them all round and round in the vase with ever faster and faster movements of his pencil until eventually the vase itself begins to spin round and turns into a top. The pencil turns into a whip, meanwhile, and I realize that this strange painter is my own father. Now he lays on the whip with all his might, accompanying each stroke with a terrible gasp and heave of his breath, like a blast from some enormous and furious steam-engine. Beside himself with the effort, he sends the loathsome top spinning and jumping around my bed. In it is a compendium of all the horrors that he can conjure forth, in his amiable way, with his revolting soft pencil on a panel of imitation mahogany.

One day I was examining the problem—I was an adolescent already—of how my father must have conducted himself during the night of my conception. Suddenly there arose within me, as if in answer to this filial question, the memory, exact in every detail, of this waking dream which, till then, I had entirely forgotten. And ever since I have been unable to rid myself of what is, on the whole, a distinctly unfavourable impression of my father's behavior at the time in question. This is, I may add, an entirely gratuitous impression, and one which may be quite unjust—for, if one thinks the thing through (quoted in Russell, 1967, pp. 13–14)

Ernst's "waking dream" contains many of the same features described in his brief autobiography. Once again, even on the night of his conception, his mother is not mentioned. Presumably, she is the panel of imitation mahogany, the canvas on which the main character, his father, performs his fantastic, obscene, horrifying act of creation. Along with the mahogany wood panel, other familiar symbols make their appearance: the pencil, the whip, the spinning top, the furious steam engine. These are repeated throughout his artistic works.

This remarkable description of the primal scene portrays such vivid symbols and expresses such classic emotions that one might wonder if it is perhaps *too* convincing; a *too* perfect confirmation of psychoanalytic theory, especially in view of Ernst's familiarity with Freud's writings. In the daily practice of psychoanalysis this is a regular consideration, particularly with analytically sophisticated patients. Experience has taught us not to rely on any single memory (or other datum), but to seek confirmation in themes that recur in diverse forms and from various sources: through free associations, dreams, fantasies, memories, and as observed in acting out in life and in the transference.[2] It is with this kind of power and consistency that references to the primal scene occur throughout Ernst's works.

Ernst describes his discovery of the process of collage as follows:

> One day in 1919, finding myself in rainy weather in a town on the banks of the Rhine, I was struck by the obsession exercised upon my excited gaze by an illustrated catalogue containing objects for anthropological, microscopic, psychological, mineralogical, and paleontological demonstrations. There I found such distant elements of figuration that the very absurdity of this assemblage provoked in me a sudden intensification of the visionary capacities and gave birth to a hallucinating succession of contradictory images, of double, triple, and multiple images which were superimposed on each other with the persistence and rapidity characteristic of amorous memories and of hypnagogical visions. (quoted in Lippard, 1970, p. 120)

His description of discovering frottage (rubbing) has a similar quality:

> Departing from a childhood memory in the course of which a false mahogany panel facing my bed played the role of optical *provocateur* in a vision of near-sleep, and finding myself one rainy day in an inn by the sea coast, I was struck by the obsession exerted upon my excited gaze by the floor—its grain accented by a thousand scrubbings. I then decided to explore the symbolism of this obsession and, to assist my contemplative and hallucinatory faculties, I took a series of drawings from the floorboards by covering them at random with sheets of paper which I rubbed with a soft pencil. When

gazing attentively at these drawings, I was surprised at the sudden intensification of my visionary faculties and at the hallucinatory succession of contradictory images being super-imposed on each other with the persistence and rapidity of amorous memories.

As my curiosity was now awakened and amazed, I began to explore indiscriminately, by the same methods, all kinds of materials—whatever happened to be in my visual range—leaves and their veins, the unravelled edges of a piece of sackcloth, the brushstrokes of a modern painting, thread unrolled from the spool, etc., etc. Then my eyes perceived human heads, various animals, a battle ending in a kiss. (quoted in Lippard, 1970, pp. 120–21)

Both of these accounts begin with Ernst finding himself in unfamiliar surroundings on a rainy day. He is then suddenly "struck by the obsession exerted upon [his] excited gaze" by some commonplace object: pictures in a catalogue, the wood grain in the floorboards. By concentrating on these objects he experiences "a sudden intensification of [his] visionary faculties" and the production of "hallucinatory" images associated with "amorous memories." What follows then is the "discovery" of a new technique. The familiar elements of intense, excited looking and amorous memories suggest a connection with the primal scene. This is reinforced by the idea of sudden, accidental discovery: like the child accidentally discovering the parents in bed.

One might speculate on the psychological process by which primal scene memories played a part in the development of Ernst's new artistic modes. Perhaps, during a period of loneliness, painful childhood memories re-emerged or threatened to re-emerge into consciousness: memories of something he saw (or longed to see) that made him feel angry, frightened, left out, and inadequate. Utilizing a defensive maneuver developed in child-hood, he dealt with these painful images by turning passive into active: by "intensifying" his vision with feelings of pleasure. At the same time he focused his gaze on innocuous, commonplace objects; harmless, nonthreatening sights, in contrast to the over-whelmingly stimulating primal scene. The sexual excitement he once experienced was expressed in an orgasmic act of artistic creation.

Ernst's techniques of collage and frottage were the culmination of many years of thought and experiment and many diverse influences (Spies, 1968). His descriptions of their sudden, acci-dental discovery may relate more to associated primal scene memories than to the actual process by which they evolved. In my speculative reconstruction, primal scene memories not only con-tributed the emotional stimulus, but were also woven into the techniques themselves.

In frottage, random objects were covered by sheets of paper which were then rubbed with a soft pencil to bring out the underlying pattern. The first subject Ernst selected was the wood

grain in the floorboards—reminiscent of the mahogany panel that provoked his fever-vision in childhood. His "curiosity was now awakened and amazed," like that of the curious child who awakens to the amazing sight of parental intercourse, and he proceeded to explore varieties of other materials. The goal of the frottage process was to minimize participation of the artist's conscious mind, to produce the work automatically. "The author is present at the birth of his work as an indifferent or passionate spectator and observes the phases of its development" (Lippard, 1970, p. 121). The process itself seems to be a compromise between the wish to conceal and the wish to reveal. Bringing into view the forms concealed beneath the sheet and observing the process as a spectator are highly suggestive of primal scene memories. Being present at the birth of his work, along with drawing on wood grain with a soft pencil, harks back to the "waking dream" of observing father's performance on the night of his own conception.

References to the primal scene are also discernible in Ernst's comments on collage. He defines the mechanism of collage as follows: "I am tempted to see it as the exploitation of *the fortuitous encounter of two distant realities on an unfamiliar plane* (to paraphrase and generalize Lautréamont's celebrated phrase: *'Beautiful, like the chance meeting of a sewing machine and an umbrella on a dissecting table'*)." (quoted in Lippard, 1970, p. 126) This was its essence: the unexpected, "absurd coupling" of two totally unrelated, incompatible realities in a strange place. In this act they would become mysteriously transformed "into a new absolute, poetic and true: umbrella and sewing machine will make love" (quoted in Lippard, 1970, p. 127). One can hardly imagine a more eloquent expression of a bewildered child's impression of the scene of parental intercourse.

Ernst's fascination with collage never left him. He became obsessed with collecting illustrations from popular books and magazines on a whole variety of themes. The subjects didn't seem to matter; he only required them to be rather flat, neutral, commonplace elements. "I should have had a bad conscience," he declared, "if I had used elements that I loved already" (Russell, 1967, p. 189). As his collection grew, it waited for the right moment. Then, in 1929, while staying at a farm in the Ardeche, he became ill and was confined to bed for a couple of weeks. In that familiar state of loneliness and isolation, reminiscent of the situation that provoked the "fever-vision" of his childhood, he was once again overcome by a powerful creative force. As he gazed at the illustrations, he began to see them split apart and recombine in new, grotesque forms. Once again he was struck by "the sheer absurdity of their conjunction" (p. 189), and the "terror" produced by so combining these commonplace elements. The result was *La Femme 100 Têtes* (The Hundred-Headless Woman), the first of his collage novels.

This remarkable book was composed in a fury: 147 collages in barely two weeks. The terse captions under the full-page collage

Fig. 1. Max Ernst, "And the volcanic women raise and agitate with a menacing air the hind parts of their bodies." Plate 64 from *La femme 100 têtes*. Paris: editions du Carrefour, 1929.

reproductions refer only glancingly to the pictures, and together they outline an ambiguous "plot." The collages themselves present bizarre, often bewildering combinations of images (fig. 1). Body parts and object parts are disconnected, transposed, and recombined. Dimension, relationship, and perspective are ignored or purposely distorted. Bodies and objects are suspended at wierd angles or allowed to float freely in air. Images come and go in fantastic settings: fish in trees, logs in a midnight sky, and Titans in a laundry. Accompanying subtitles describe the images at random, producing what sound like mysterious riddles: "A scream of large diameter stifles the fruit and the pieces of meat in the

coffin"; or, "One will discover the germ of very precious visions in the blindness of wheelwrights" (Ernst, 1929, pls. 46, 83). The themes are unlimited. There are eviscerated babies, immaculate conceptions, liquid dreams, flesh without flesh, eyes without eyes, and the masturbation of fresh leaves. Ernst's personal phantom makes his appearance—Loplop, the Bird Superior. And weaving throughout the story is the haunting, repetitive chant, "Perturbation, my sister, the hundred headless woman" (pls. 34, 72, 77, 86, 94).

According to Ernst, *La Femme 100 Têtes* was composed "with systematic violence" (quoted in Lippard, 1970, p. 123). In it he achieved the highest aspiration of Surrealism: a world in which the natural order has been destroyed. He also created a profoundly moving representation of the primal scene. The reader is assailed by a cinematic series of pictures. They are fragmented clues, like memories and dreams. They are violent, frightening, haunting, sensuous, exciting, absurd, and most of all, bewildering. As the pictures pass before our eyes, we are made to experience the feelings of a child witnessing the primal scene. We are not sure what's going on, who's doing what to whom, and what it all means. We are tantalized by almost understanding and then being plunged back into confusion. If we look to the subtitles for help (as a child might ask the adults), we hear enigmatic riddles that only compound our confusion.

A powerful legacy of primal scene trauma is the wish for revenge (Arlow, 1980). In *La Femme 100 Têtes* Ernst gains his revenge by doing to us (the readers) what he experienced his parents doing to him. We can look but we will never really see, we can strive to know but we will never fully understand, and the mystery will continue to haunt us.

Max Ernst was a Surrealist painter, a leading member of the school, profoundly influenced by his fellow artists and writers. The emotions he expressed through his work, the anger, rebelliousness, and wish to destroy the natural order, were emblematic of the Surrealist movement and were shared by his colleagues. One might question, therefore, the validity of proposing a personal dynamic in his case. Was Ernst drawn to the Surrealist movement because it provided the perfect vehicle for the expression of emotions relating to his primal scene memories? Are we to assume that the other Surrealists were similarly motivated, that they also needed an outlet to discharge primal scene tension? In a certain sense this may be true.

The Surrealist movement was bred in the desolation that gripped Europe in the wake of the First World War. People lost faith in their leaders and in their social, political, and religious institutions. A wave of cynicism and nihilism spread throughout the intellectual community. Surrealism became the artistic expression of this pervasive sense of anger and disillusionment. Its purpose was to shock, to knock some sense into society, and to expose its fraudulence and hypocrisy.

Popular movements usually make contact with deep, universal

emotions. In the Surrealist movement we can recognize the familiar adolescent rebellion and, following this back to its earlier antecedent, the outrage and disillusionment of the defeated oedipal child. In the aftermath of the Great War, most of Europe had witnessed something akin to a primal scene. For Max Ernst, and perhaps for his fellow Surrealists as well, this time in history resonated with an earlier traumatic time in their childhood. They now wished to retaliate: to shock as they felt shocked, to destroy as they felt destroyed.

Nowhere was this more dramatically enacted than in the Cologne Dada Exhibition of 1920. Ernst and his colleagues created an artistic primal scene that was designed to provoke and dumbfound the public. The exhibit was entered through a lavatory. The opening ceremony was performed by a small girl, dressed for her first communion, who read a selection of indecent poems. (An exquisite reversal of the primal scene in which the child shocks the adults!) The works of art displayed were inscrutable, outrageous, and obscene. The effect was precisely as intended. Ernst was summoned by the police and the exhibition was closed by public demand. It caused the final break between Max and his father. The elder Ernst was outraged, and his last words to his son were, "my curse be upon you!" (Russell, 1967, p. 55). Little Max had achieved his revenge.

Notes

1 How traumatic the experience will be depends on a variety of factors: the child's age, developmental level, frequency of exposure, relationships of parents to the child and to each other, etc. (see Esman 1973; Blum, 1979).
2 Unconscious conflicts can express themselves through a variety of actions ranging from simple ones like slips, mistakes, or habitual acts, to more complicated, elaborate behavior patterns such as repetitive sexual affairs. A most revealing arena in which unconscious conflicts may be acted out is the transference—the whole complex of feelings the patient experiences toward the analyst.

References

Arlow, J. (1978). "Pyromania and the Primal Scene: A Psychoanalytic Comment on the Work of Yukio Mishima." *Psychoanalytic Quarterly*, 47:24–51.

159 _____. (1980). "Revenge Motive in Primal Scene." *Journal of the American Psychoanalytic Association,* 28:519–41.

Blum, H. (1979). "On the Concept and Consequences of the Primal Scene." *Psychoanalytic Quarterly,* 48:27–47.

Bradley, N. (1967). "Primal Scene Experience in Human Evolution and Its Fantasy Derivatives in Art, Protoscience and Philosophy." *Psychoanalytic Study of Society,* 3:203–77.

Edelheit, H. (1971). "Mythopoiesis and Primal Scene." *Psychoanalytic Study of Society,* 5:212–33.

Ernst, M. (1929). *La Femme 100 Têtes.* Paris: Editions du Carrefour.

_____. (1942). "Some Data on the Youth of M. E., as Told by Himself." *View* (Special Max Ernst Issue), sec. 5., no. 1 (Apr.): 28–30.

Esman, A. (1973). "The Primal Scene: A Review and Reconsideration." *Psychoanalytic Study of the Child,* 28:49–81.

Greenacre, P. (1955). "It's My Own Invention: A Special Screen Memory of Mr. Lewis Carroll." *Psychoanalytic Quarterly,* 24:200–44.

_____. (1957). "The Childhood of the Artist: Libidinal Phase Development and Giftedness." *Psychoanalytic Study of the Child,* 12:47–72.

_____. (1973). "The Primal Scene and the Sense of Reality." *Psychoanalytic Quarterly,* 42:10–41.

Kligerman, C. (1962). "A Psychoanalytic Study of Pirandello's *Six Characters in Search of an Author.*" *Journal of the American Psychoanalytic Association,* 10:731–44.

Kris, E. (1952). *Psychoanalytic Explorations in Art.* New York: International Universities Press.

Lippard, L. (1970). *Surrealists on Art.* Englewood Cliffs, NJ: Prentice-Hall.

Pederson-Krag, G. (1949). "Detective stories and the Primal Scene." *Psychoanalytic Quarterly,* 18:207–14.

Róheim, G. (1934). "The Evolution of Culture." *International Journal of Psycho-Analysis,* 15:387–418.

Russell, J. (1967). *Max Ernst: Life and Work.* New York: Abrams.

Simon, N. (1977). "Primal Scene, Primary Objects, and Nature Morte: A Psychoanalytic Study of Mark Gertler." *International Review of Psycho-Analysis,* 4:61–70.

Spies, W. (1968). *Max Ernst.* New York: Abrams.

Stokes, C. (1982). "Collage as Jokework: Freud's Theories of Wit as the Foundation for the Collages of Max Ernst." *Leonardo,* 15:199–204.

_____. (1983). "Surrealist Persona: Max Ernst's Loplop, Superior of Birds." *Simiolus,* 13:225–34.

Leonard
Shengold, M.D.

A Psychoanalytic Perspective on Sister Symbolism in the Art of Ernst and de Chirico

In their essays on the art of Giorgio de Chirico and Max Ernst, Milly Heyd and Charlotte Stokes emphasize how these artists compulsively repeated something of their traumatic past in their art—specifically, repetitive visual symbols alluding to unresolved feelings about a dead sister. But the psychic presence of conflicts over sibling rivalry, incest, and murder are too universal to characterize the individual or to explain the oeuvre of an artist.

De Chirico and Ernst were contemporaries, and both played major roles in the Surrealist movement—de Chirico as the great prophet or prefigurer of the style still unnamed when he painted his metaphysical canvases and Ernst as a first-generation member of the Surrealist movement. Yet how unlike their works are (apart from early imitations of de Chirico by Ernst)—in form, style, variety and intensity; and they were very different human beings. That Ernst's wives and lovers were remarkably different from one another in age and accomplishment implies much about his adaptability and tolerance for variation in his living. Ernst's capacity for pleasure is obvious, and it is reflected in the rich, witty, instinct-discharging, inventive diversity of form and content of his oeuvre. De Chirico's style and manner, by contrast, are subject to much of the inhibiting arid defensiveness that is part of his subject matter; that defensiveness seems to be correlated with a more inhibited existence, a "discontented life," in Heyd's felicitous phrase. Both the life and the art seem deficient in humor and in carnal juices.

Imagine how differently the convivial and outwardly exuberant (although emotionally unpredictable) Ernst and the introverted

and solitary de Chirico would have behaved on a psychoanalyst's couch, how differently they would have responded to the injunction to say whatever came into their minds. Psychoanalysis offers an unique way of getting to know a human being. It gives the fullest view of the dynamic play of the patient's unconscious mind—a picture of the past and of the present constructed largely from the patient's transferences and resistances. So many petty, shameful and terrible things are communicated; and much more of the patient's pathology gets presented than do aspects of his health, creativity, and joy. If both men were to say to their hypothetical analyst, "Dr. Spielvogel, I am a great artist," Dr. S. would have to take this assertion partly on trust. Of course some of their creative talent would inevitably be revealed by way of flashes of ingenuity and wit, of verbal and pictorial facility. But a biography written by an analyst (especially with the rule of abstinence cutting him off from direct contact with the artist's work) would probably amount to a monstrous distortion of the life of the artist. Since pathology rather than health gets elucidated, it is probable that little insight about the artist's creativity would have emerged from his treatment that would differentiate his analytic associations from those of anyone else, say from a postal clerk's. And if that postal clerk had also lost a sister in childhood, his reaction (as revealed to Dr. Spielvogel) might turn out to be closer either to de Chirico's or to Ernst's than the two artists' psychoanalytic behavior would resemble one another's.

The essays that Heyd and Stokes have written about these two artists show slightly different methods of applying psychoanalytic insights. Stokes traces out and provides interpretations for the theme of *bird* and its link or "companion" of *sister* throughout Ernst's work, convincing us of the importance of these motifs, rooted in childhood traumata—but there is no attempt to correlate this with Ernst's later personality; the *content* of his work is stressed. The study of the artist's subject matter is perhaps the most proper one for applied analysis; it does not touch on the "unanalysable artistic gift" (Freud, 1927, p. 179). Heyd presents a classical applied analytic paper in "The Girl with a Hoop," on the model of Freud's Leonardo study (1910). She connects certain paintings and writings of de Chirico with a childhood memory of the artist to try to derive something "central" about his psychology and conflicts. This is more ambitious and, inevitably, less successful—exposing, I feel, some of the inherent arbitrariness of applied analysis.[1]

I want to try to reconstruct in a general way (i.e., for postal clerk as well as artist) something of what the impact on a child of the birth and the loss of a sister might have been. A child's inchoate awareness develops toward identity in a narcissistic world in which its own body and its mother's comprise the universe—a universe which subsequently extends to include the nursery. The mother, or the mothering figure remains paramount, but later much is transferred onto the father. These primal figures retain their basic importance—in external life, and intrapsychically—as

parts of the self. The presence of older siblings and the birth of new ones threaten the child's sense of narcissistic centrality. The dangers of loss of the parents and their love augments the burgeoning instinctual aggression which can threaten to over- whelm mental images of the parents and of the self. Much of this threat is transferred to the unwelcome and dispensable siblings. The primal crime story of Cain and Abel portrays this shift— murderous feeling toward the parent is directed onto the sibling, and brother kills brother out of rivalry for the parents' love. Guilt over death wishes toward a sibling always contains the deeper layer of transferred death wishes toward a parent. The death of a sibling means that the parent too can die—and guilt over death wishes makes the surviving child expect the punishment of his own death. (Of course, love can also be transferred onto a sibling, but this generates conflict and neurosis only when it is of incestuous intensity or is brought into relation to hate and destructive impulses.) The original predominantly destructive pre- oedipal conflicts about parents are later transformed by develop- ment of the oedipus complex which subsequently links incest and murder; this, too, can be displaced onto a sibling.

A sister, like any figure or object in the external world—such as Ernst's sister-linked bird or de Chirico's hoop—will inevitably be used to portray many aspects of one's self and of important others. Ernst's autobiography begins with a description of himself as a very special kind of bird: "On the second of April at 9:45 A.M. Max Ernst hatched from the egg which his mother had laid in an eagle's nest and over which the bird had brooded for seven years" (1961, p. 7). As Stokes demonstrates, Ernst used the name Loplop to mean himself, his bird alter ego, his sister, or his "parent, guide, and protector."[2] The bird can also stand for a body part—with ambiguous bisexual connotations. For example, its flight can evoke an erect penis; if the bird represented is a bird of prey, the underlying connotation may be that of a destructive sadistic penis, or self. The dead pink cockatoo that figured so prominently in Ernst's recollections of the birth of his youngest sister suggests associations to the limp or castrated penis. Sisters, like birds, can serve multiple symbolic purposes, as they did in the pictures and writings of Ernst. As Stokes demonstrates, Ernst's generic "sister" symbolized his feminine self, for example, *Max-imilian Maria*, Ernst's given name, and his identification with his heroine *Marceline-Marie*.[3]

As the object for masculine wishes, the sister is both *not-mother* and yet a close displacement from mother, incestuous but less forbidden. Ernst documented in his paintings and in his writings his consciousness of oedipal rivalry with his exacting amateur painter-father—that prodigious manufacturer of babies. Ernst ana- lyzed his own primal scene dream involving oedipal rivalry with his sexually aggressive father (see Russell, 1967, pp. 13–14). Ernst's father was named Philippe. This was a name that was meaningful to Freud[4] and entered his association to his own "oedipal" dream in which he saw "my beloved mother, with a

peculiarly peaceful, sleeping expression on her features, being carried into the room by two (or three) people with bird's beaks and laid upon the bed" (1900, p. 583). This dream is almost directly depicted in the tenth plate of the Oedipus chapter of Ernst's *Une semaine de bonté,* except that the woman is portrayed as bound and gagged. Freud wrote that the bird-headed people were probably derived from his recollections of illustrations in Philippson's Bible that were based, in turn, on representations of falcon-headed gods on an Egyption funeral stele. Reading this in *The Interpretation of Dreams* must have affected Max Ernst, Philippe's son. His paintings of Oedipus feature bird's heads, and bird-headed figures abound in the Oedipus chapter of *Une semaine de bonte.* There is an easy displacement to sister here.[5]

As Stokes indicates, Ernst was able not only to *express* his preoccupation with the contradictory, ambivalent, and ambiguous meanings involving a sister, but consciously and actively to *synthesize* them, to see them as dynamic creative forces in his theoretical writings about art, and to depict them in his paintings and collages. This was part of the healthy integrative force that operated in his life as well as in his artistic creativity. He was not psychoanalyzed, but he was able to make conscious creative use of his psychoanalytic knowledge. He proved capable of that psycho-*synthesis* which should follow a good psychoanalysis, for Ernst successfully synthesized his male and female tendencies in his art.

I now turn to de Chirico and the relationship between his art and his memories of the sister who died during his early childhood. Heyd emphasizes de Chirico's autobiographical reminiscence linking his mother and sister with two minute pierced discs of gilded metal. She connects this memory and its associations to the painting *The Mystery and Melancholy of a Street* because she believes that the little girl who plays with the hoop in this picture portrays de Chirico's actual memory of his dead sister. But additional meanings for the images of sister and pierced discs suggest themselves. Heyd refers to many of the general denotations of sister that I have outlined above, especially to *sister* as actual sister, and as mother. But there is a feminine dimension equally applicable to the two discs as female symbols—the symbolization by these elements of the artist's feminine self. Heyd mentions the boy's admiration for the two discs as involving feminine perfection that he himself lacked. But the two pierced discs could symbolize the boy's own "feminine" receptive openings—his mouth and his anus. The "mystery of femininity" for de Chirico surely also included the puzzling and disturbing femininity within himself.[6] And, taking note of the hand-held, paint-brush-like, phallic-shaped stick with which the girl guides the hoop in the painting (a stick which could symbolize the artist's *control*), then the feminine-and-phallic "girl with the hoop" for me convincingly stands for the divided sexual nature of the artist himself.

Direct references to the father are significantly absent from this first memory, although the artist's associations to the Hermes statue ("a man embracing a child"), as well as to Rubens's painting

of rape seem to refer to the father. The tender and brutal father is in contrast to the "perfection" of femininity alluded to by the Vermeer and the two gilded discs— but this perfection, as Heyd suggests, is a perfection to be penetrated and destroyed. The artist's childhood memory leads to associations on our part to parents and siblings, to themes of death and incest that may have been in the artist's mind as well.

In *The Mystery and Melancholy of a Street,* the sister can also stand as a displacement for the father (both were dead when the painting was created). He is more directly represented, as Heyd points out, in the phallic shadow toward the top of the painting.[7] But the father is always *also* a defensive displacement away from the primal parent, and the specific significance of a frightening and phallic mother was very great for de Chirico. These meanings are not mutually exclusive, and we would need the subject's reactions to be at all sure of our priorities.

Heyd believes that *The Mystery and Melancholy of a Street* is central to understanding de Chirico and his work.[8] One can agree with this while adding an important generalizing modification: any of an artist's paintings *can* become "central" just as any dream of a patient can lead to key associations that eventually could reveal his major conflicts and past traumata.

If this speculating psychoanalyst were to vote for the work that seems closest to de Chirico's psychopathology, I would choose his famous painting of 1914, *The Child's Brain* (fig. 1). In my opinion this depiction of the powerful father of Giorgio's childhood throws more light on the arc (one might even say the hoop) of de Chirico's oeuvre and psychology in a life which can be seen as eventually coming full circle, from an early rebellion against the father to an ultimate identification with him. I say this because the father seems to me to have influenced de Chirico more than anyone else. He died when the boy was 16. *The Return of the Prodigal Son* was repeatedly painted by the artist, and many of his paintings contain trains penetrating space, evoking the generative power of his father, the railroad engineer. Soby provided an especially dramatic interpretation of the father symbolism contained in *The Child's Brain,* describing it as:

> one of the most *implacable* images in de Chirico's early art. It is usually accepted as a portrait of the artist's father, motivated by fears of parental authority. The figure is *terrifying* in its flabby pallor and in the *hideous masculinity* of the jet-black moustache, eyelids, and hair. Its eyes are closed, as Robert Melville has said, "for the simple reason that the child (de Chirico) would not dare to look if they were open" (1955, p. 74; italics mine).[9]

The naked father of *The Child's Brain* appears in a half-length view, standing behind a parapet that hides his genital area. He reaches toward a closed book resting on the parapet, an action that may depict symbolically his possession of the mother; the book is penetrated by a phallic-shaped bookmark.

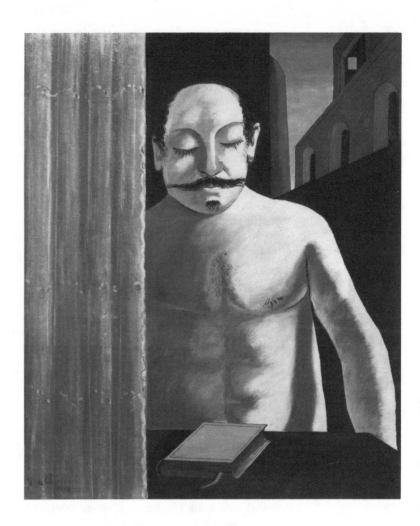

Fig. 1. Giorgio de Chirico, *The Child's Brain,* 1914. Oil on canvas. Moderne Museet, Stockholm.

The closed eyes (the theme of one of Freud's dreams about the death of *his* father) would show not only the boy's fear of his "implacable" father's disapproving gaze, but also the artist's self-punitive identification with his dead parent, forever blind to the world, like the mythical Oedipus. This view is implicitly expressed by Breton's 1950 "correction" of the painting, *The Awakening of the Child's Brain,* which shows a photograph of de Chirico's canvas with a single change: a retouching that opens the father's eyes.

During the 1920s, de Chirico rejected the revolutionary pre-Surrealist metaphysical style that earned him an important place in art history in favor of the "perfection" of a more realistic manner of painting. His later pictures feature recurrent depictions of "realistic" half-naked warriors, gladiators, horses, and centaurs (his father was an avid horseman), along with revivals of figures from his metaphysical period, the "statues and dummies [which] are not happy creatures; they are sad empty vessels, unserviceable and untenanted forms" (Picon, 1977, p. 54). But de Chirico's allegedly more "realistic" macho images are just as empty; Haftmann speaks of the "petrified gladiators" (1961, p. 181) who occupy a number

of these paintings. The artist's writings from this period show him as not only "something of a hypochondriac" (Soby, 1955, p. 76) but even rather grandiose and paranoid. He had by this time fused his inner picture of himself with that of his idealized image of the "brutal" repressive father of his childhood memories; there is a late "realistic" portrait of himself as a bullfighter. And his paintings are full of the return of the repressed homosexuality, that hallmark of paranoia—a homosexuality he consciously despised and inveighed against.[10]

This discussion has scarcely alluded to de Chirico's powerful and domineering (phallic?) mother, with whom he lived for so long and whose influence on him may very well have been greater than his father's. Soby notes that de Chirico's "shyness and fanatical devotion to his mother held him apart from other artists" (1941, p. 13). Both the artist's mother and father seem to have been "all-engulfing," as Heyd suggests. Think of the unanalyzable ambiguities toward both parents latent in this statement from de Chirico's *Memoirs:* My father "was also an excellent horseman and had fought some duels with pistols; my *mother* preserved a pistol bullet, set *in gold,* which had been extracted from my father's right thigh after one of his duels" (1945, p. 16; italics mine). This passage comes two pages after de Chirico recounts the "memory of my infancy" (p. 14) involving "the little *gilded* discs" (my italics).

To return to the contrast between these two Surrealist artists, perhaps the most important difference apparent to a psychoanalyst who is called upon to comment is that Ernst made cognizant and creative use of his knowledge of Freud, particulary of the dream and the unconscious. (For example, Freud's case history of Dora [1905] was a major source of part of Ernst's novel in collage, *Une semaine de bonté;* see Maurer, 1986.) De Chirico, in contrast, did not try to follow or explore Freudian ideas, although he was undoubtedly aware of them. He unselfconsciously exposed and depicted aspects of his unconscious mind in his early paintings. Later on when he presumably became frightened of what he had portrayed and revealed, he disavowed his early "metaphysical" style, possibly in an identification with the repressive aspect of his father.

The styles of these two painters also reveal their contrasting ways of defending against and discharging their drives. De Chirico features a defensive emptiness—a reduction by abstraction, symbolism, and emotional isolation; only sadness and a sense of mystery are dependably felt by the observer. Soby quotes Melville as describing de Chirico's work as possessing an eroticism "as subtle and innocent as Watteau's" (1955, p. 89), but this appears to me to be a misrepresentation; de Chirico shows neither Watteau's humanity nor his marvellous joy in miraculously portrayed human flesh. Indeed, de Chirico's metaphysical pictures are completely devoid of living people; symbols replace flesh and blood. The cannon and balls represented in *The Philosopher's Conquest* may stand flagrantly for the male genitals, but they do so

in an emotionally empty fashion. His style permits the expression of drives but reduces them in the service of fashioning a de-realized, faceless world of things and automatons. With all de Chirico's intelligence, he shows so little conscious humor. I do not make these statements to minimize the importance or lasting impact of de Chirico's art, but rather to suggest some of the reasons that may have later led him to abandon and disavow the rebellious work of his early manhood.

Ernst also uses abstraction and symbolization in his art, but to such a different effect. His cutting up and distorting of images is full of aggression and defensive isolation, but his work also reflects a creative restitution that presents a reshuffled new universe. This is especially obvious in the collages. In his works the repressed returns transformed but still full of passion, humor, and life. I have given less space to Ernst partly because he is more complex and enigmatic than the self-consciously enigmatic de Chirico. But most of all I feel a psychoanalyst can say more about the impeding effect of pathology on de Chirico's career, on the reasons for the "artistic suicide" (Spies, 1970, p. 87) that made him reject his own early work, than one can about the exuberant health and exploratory creativity that kept Ernst vibrant into his eighties.

Notes

1 For example, the theme of "the girl with the hoop" I would enlarge to "the girl with the stick and the hoop." The phallic stick in *The Mystery and Melancholy of a Street* is held out from the girl's extended hand like a paintbrush, suggesting de Chirico's identification with the figure. In the late, more realistic reworking of the painting, *The Street,* the stick is in an "erection" position. There is also a stick in *Hermetic Mystery.*

2 Ambiguities and multideterminations abound here. *Loplop* can also mean "child." Max Ernst's son, Jimmy, reports (1984, p. 262) that his father told him that he had derived the name from Jimmy's words (imitating its sound) when asking for his beloved rocking horse: "gallop, gallop." This anecdote recalls the assertion that the name of the Dada movement derived originally from the French baby-talk word for rocking horse. (I am indebted to Mary Gedo for pointing this out to me.)

3 The reiteration of the syllables *Ma-Ma* in Marceline-Marie's name suggests that the sister here also stands for the mother—the mother who is passively possessed as well as the phallic mother and the mother who actively gives birth. The *Femme 100 Têtes* could be called the *Soeur 100 Têtes.*

4 Freud had a half-brother named Phillip who was old enough to be his father. The child Freud displaced the odious responsibility for fathering an unwanted younger sibling onto this dispensable half-brother. In writing of his oedipal dream, Freud associated to the fact that, as a child, he had learned about sex from a concierge's son named Phillip.

5 Was Ernst aware that, among ancient Egyptians, intermarriages sometimes occurred within the royal primary family? A number of intermarriages between royal half-brothers and half-sisters are noted in New Kingdom records. Since several of these unions produced offspring, they were evidently not merely ritual marriages.

6 The two gilded discs from the artist's first memory appear rather directly in *The Mystery and Melancholy of a Street* as the wheels of the wagon.

7 The blackness of both the phallic shadow and of the entire lower right area toward which the little girl runs may have other meanings besides the obvious ones of death and nothingness. For instance, it may represent the blackness of the parent in the dark (primal scene) and, as the blackness of pubic hair and/or body openings, can signify castration.

8 In her other essay in this volume "The Greetings of a Distant Friend," Heyd does consider the importance of a number of other paintings as reflections of additional aspects of the artist's psychic life.

9 I added the italics to stress the subjective quality of Soby's reaction to the paternal image. The father seems to me to be as sad as he is terrifying. Later in this same description Soby committed an interesting parapraxis when he described the father "with long doughlike arms prophetic of the painter's later mannequin figures" (Soby, 1955, p. 74); actually only the left arm is visible, the right being completely hidden by a fluted column in the foreground.

10 His repressive father, although a duellist (cf. the "one-armed" father in *The Child's Brain*), did not allow the mention of guns—or of sex—in the home (both father and son had obvious trouble with impulses of sadistic violence); and handguns do not appear in de Chirico's work. Cannon and cannon balls do, in open (if empty) erotic symbolism. The reappearance of the girl with the hoop in the late paintings (that Heyd mentions) would, in this context, signify not only the return of the feelings associated with the dead sister, but also that aspect of these involved with de Chirico's identification with the feminine: his submission to, and wish to rejoin, his dead father.

References

De Chirico, G. (1945). *The Memoirs of Giorgio de Chirico.* Trans. M. Crosland. London: Peter Owen, 1971.

Ernst, J. (1984). *A Not So Still Life.* New York: St. Martin's-Marek.

Ernst, M. (1961). "An Informal Life of M. E. (as told by himself to a young friend)." In W. Lieberman, ed., *Max Ernst: Catalogue of the Max Ernst Exhibition at the Museum of Modern Art,* pp. 7–24. New York: Museum of Modern Art, 1961.

Freud, S. (1900). *The Interpretation of Dreams. Standard Edition,* 5.

———. (1905). "Fragment of an Analysis of a Case of Hysteria." *Standard Edition,* 7:7-122.

———. (1910). "Leonardo da Vinci and a Memory of His Childhood." *Standard Edition,* 11:59-138.

———. (1928). "Dostoevsky and Parricide." *Standard Edition,* 21:177-98.

Haftmann, W. (1961). *Painting in the Twentieth Century.* 1:174–81. New York: Frederick A. Praeger, 1966.

170

Maurer, E. M. (1986). "Images of Dream and Desire: The Prints and Collage Novels of Max Ernst." In R. Rainwater, ed., *Beyond Surrealism,* pp. 37–93. New York: New York Public Library.

Picon, G. (1977). *Surrealists and Surrealism.* New York: Rizzoli.

Russell, J. (1967). *Max Ernst: Life and Work.* New York: Abrams.

Soby, J. T. (1941). *The Early Chirico.* New York: Dodd, Mead.

_____. (1955). *Giorgio de Chirico.* New York: Museum of Modern Art.

Spies, W. (1970). "Exile in Space and Time: The Work of Giorgio de Chirico in Milan." *Focus on Art,* pp. 87–90. New York: Rizzoli, 1982.

Andrew
Abarbanel, M.D.

A Note on Magritte's Use of the Shroud

Fig. 1. René
Magritte, *Person Med-
itating on Madness.*
1928. Oil on canvas.
Private Collection.
Photo: Giraudon/Art
Resource, New
York.

This note suggests a psychoanalytic interpretation of René
Magritte's painting *Person Meditating on Madness* (1928; fig. 1).
Such an analytic study of Magritte's work poses particularly
delicate problems, because he so resented and resisted psycho-
analytic approaches to his art. For example after hearing an
interpretation of *The Red Model* as a castration theme, he wrote to
his friend Louis Scutenaire: "It's terrifying to see what one is
exposed to in making an innocent picture" (Torczyner, 1979, p.
58). Magritte's own sophisticated study of imagery and representa-
tion must have seemed far more satisfactory to the artist than such
naive applications of psychoanalytic symbolism to his work.

Fortunately, psychoanalysis has long since transcended such
simplistic interpretations of works of art. Especially since the
introduction of ego psychology and the inclusion of cognitive
psychology, psychoanalysis has focused on the ego in its inte-
grative and problem-solving roles. Magritte, too, was intensely
preoccupied with the study of problems and problem solving.
"Each picture [is] the site of the solution of a new problem,"
Breton wrote of Magritte's work (Torczyner, 1979, p. 7). It seems

171

particularly interesting that Magritte focused on problems that are becoming increasingly important to psychoanalysis: the problem of the relation of the thing to its representation, or to its context, or to the unconscious mental associations attached to it. Had Magritte known that these issues would come to preoccupy analysts, perhaps his feelings toward this discipline might have softened.

Or perhaps not. But whatever Magritte felt about psychoanalysis, an adaptive, problem-solving approach does shed light on his work and its internal meanings. This is especially true if we study the effect of his mother's death on the future artist's work. Mary M. Gedo has cogently shown that the mother's apparent suicide was a traumatic event that echoes throughout Magritte's oeuvre (1985). The present note applies this idea to one group of Magritte's paintings, the small series of "shroud" canvases, plus *Person Meditating on Madness*. The best-known pictures from this series are the two versions of *The Lovers* and *The Heart of the Matter*, all from 1928. Each of these three paintings shows the protagonists enshrouded in canvaslike coverings.

Many years after his mother's death, Magritte told his friend Scutenaire that her body had been found with her nightgown covering her face (Scutenaire, 1947, pp. 71–72). Investigations conducted by the art historian David Sylvester have since disproven the details of this story (1978, pp. 52–53), but this fact makes the fable all the more interesting to the analyst. The recollection can now be understood as a creative product, and its construction and distortions can yield insights into how Magritte's mind operated.

If we examine *Person Meditating on Madness* closely, a connection with the shroud paintings suggests itself. The expression on the "meditator's" face suggests a fascination, an almost demonic delight, a pleasure reminiscent of the sense of "aha!" or the so-called *Aha-Erlebnis*. More specifically, the young man's expression seems to convey the thought: Aha! I'll use paintings *on* canvas and *of* canvas to help solve the problems weighing on me. The blank surface at which the young man stares thus represents cloth both as the canvas ground itself and as the painted shroud depicted *on* the canvas. The picture, then, is the concretization of an unconsciously crystallized plan on Magritte's part to use his artistic talent to resolve the conflicts resulting from his mother's suicide. Specifically, he could use the canvas ground both to represent on its surface, as well as to conceal within the subject matter of his paintings the troublesome effects of his adolescent trauma. At the same time, he could begin to consolidate an identity, that of an artist. This important task could then be safeguarded from the effects of the traumatic loss.

On this basis we can understand the memory of his dead mother that Magritte later reported to Scutenaire as a *screen memory*, that is, a retrospectively distorted creation, motivated originally by the young Magritte's insight that he could recruit his

impressive artistic talents to cope with the effects of his mother's suicide. *Person Meditating on Madness* concretizes this *Aha-Erlebnis.*

The dual nature of the shroud image, as matrix and as subject matter, suggests another viewpoint that can enrich our understanding of this image: Magritte used the canvas as shroud as a transitional object. In the terms D. W. Winnicott (1953, pp. 89–97) used to define this concept, the artist treated the canvas illusionistically and creatively in an attempt to comfort himself, to "blanket" the troublesome issues relating to his mother's drowning. As a transitional object, it represented aspects of both the self and the object (i.e., the lost mother) and was created in the setting of a separation in order to deal with that separation.

We can better understand the significance of the shroud imagery in Magritte's oeuvre by concentrating on three interconnected themes that recur throughout his art and that relate, in turn, to *Person Meditating on Madness:* the use of surprise, the emphasis on the relationship between the actual and the possible, and the study of the relationship of the image to thought. The painting represents these themes in the surprise and experience of discovery shown on the face of the "meditator" as well as in the complex imagery of the blank surface being meditated upon.

Both in his art and in his life, Magritte revealed a predilection for creating surprises. He was something of a prankster in his social interactions, capable of pulling thoroughly unexpected—and sometimes even physically painful—tricks on friends and acquaintances. In his art, he continually created dramatic and surprising effects by depicting ordinary objects in novel contexts or juxtapositions. When one considers the traumatic effects the mother's suicide must have imposed on the future artist, his later fascination with surprise effects reveals itself as the transformation of a passive experience into an active one. Originally the helpless victim who suffered a sudden, unbearable loss, Magritte became instead the master of surprises, the skilled manipulator who could control others through his art, then enjoy observing the effects of his amazing creations on the spectator. Thus, he simultaneously identified with the mother both as the lost object and as the aggressor.

Another aspect of Magritte's work that seems relevant here is his interest in the relationship between the possible and the actual. In his published writing, he emphasized that his artistic interest was specifically focused on the range of possible manifestations of aspects of the concrete, rather than on the concrete actuality itself. Interestingly, cognitive psychology teaches that during early adolescence, the individual develops the full cognitive ability necessary to think about abstract possibilities and potentialities (Piaget and Inhelder, 1969). Thus, the adolescent Magritte had only recently begun to attain the physiological maturity that permits fully abstract thinking when he was suddenly faced with the overwhelming task of integrating the seemingly impossible event: his mother's suicide. Such an overwhelming challenge to his

capacity to understand led to a traumatic fixation at this level of cognition. He remained preoccupied with problems of multiple possibilities and interpretations of concrete situations and events. The question: What does this really mean? became a constant feature of his thinking.

An observation of Alfred H. Stanton allows us to integrate these concepts with a third aspect of Magritte's work, his preoccupation with the relationship of the image to thought. Stanton noted that the response of a person first learning of the death of a loved one is almost invariably a spoken "no!" (personal communication). Modern ego psychology teaches that this experience of "no," uttered in the setting of such a traumatic awareness of separation, recapitulates, almost instantaneously the original psychological events of the development of the capacity to say "no" during infancy. As shown by Spitz, Mahler, Piaget, and others, such "no" experiences include turning away from the breast (repeated now as a turning away from the painful awareness of loss), the understanding and awareness of separation (repeated now as separation from the actual lost loved one), and the ability to form internalized images of a separate self and other. For the adolescent Magritte, this psychological response of "no" involved fixations of psychological processes as basic as the formation of images and the relationship between images, thinking, and meaning.

Person Meditating on Madness, then, depicts an act of mastery in each of these areas. The surprise is mastered by the protagonist, a projection of the triumphant young Magritte himself, portrayed as he reaches a solution for handling the terrible emptiness resulting from his mother's abrupt departure. His alter ego is represented at the very moment he experiences that "aha" sensation, satisfactorily attaining a set of inferences from the myriad of potential meanings of the "madness" he confronts. Finally, the complex, multiple aspects of the image of emptiness, blankness, and materiality are integrated by the meditator into an affirmative solution. His affirmation, the "aha" expression, symbolizes his mastery of the trauma that had originally motivated his activity.

Although this conclusion is speculative, the visual evidence provided by the *Person Meditating on Madness* and the related "shroud" pictures suggests that Magritte's false recollection of the enshrouded mother was a retrospectively distorted but highly creative and adaptive solution to the multiple problems her death had caused him. It was thus a screen memory constructed from his unconscious awareness that he could use his artistic capacities to try to come to terms with this event.

Magritte's use of the shroud in this small series of paintings, then, represents his ongoing and multifaceted attempts to deal with his painful past so that he could live a useful personal and creative life. As such, *Person Meditating on Madness* represents and concretizes the moment at which this solution occurred to him.

References

Gedo, M. M. (1985). "Meditations on Madness: The Art of René Magritte." In T. A. R. Neff, ed., *In the Mind's Eye: Dada and Surrealism,* pp. 63–84. New York: Abbeville Press.

Piaget, J. & Inhelder, B. (1969). *The Psychology of the Child.* New York: Basic Books.

Scutenaire, L. (1947). *René Magritte.* Brussels: Librairie Selection.

Sylvester, D. (1978). "Portraits de Magritte." Trans. Ann Perez. *Retrospective Magritte,* pp. 47–76. Exh. cat. Brussels: Palais des Beaux-Arts, Oct. 27–Dec. 31, 1978, and Paris: Musée National d'Art Moderne, Centre National d'Art et de Culture Georges Pompidou, Jan. 19– Mar. 9, 1979.

Torczyner, H. (1979). *Magritte: The True Art of Painting.* New York: Abrams.

Winnicott, D. W. (1953). "Transitional Objects and Transitional Phenomena." *International Journal of Psycho-Analysis,* 34: 89–97.

Stephen L. Post, M.D.

Surrealism, Psychoanalysis, and Centrality of Metaphor

Sigmund Freud was not the first to discover the human unconscious, although he was its first cartographer. However convenient it may seem to assign this vast territory to psychoanalysis, it is hardly the province of a single discipline. The humanities in particular have addressed it implicitly for centuries. Within the arts, the Surrealist movement is noteworthy for its spectacular dedication to unconscious processes. Given its contemporaneity with psychoanalysis it may be fruitful to examine the role of the latter in its development and to try to appraise Surrealism from a modern psychoanalytic perspective.

Psychoanalysis came into being at the turn of the century, and Surrealism, founded not long afterward, drew heavily upon its early discoveries and theories. Breuer and Freud's *Studies on Hysteria* (1895) and Freud's magnum opus, *The Interpretation of Dreams* (1900), were closely perused by many of the Surrealists, especially by André Breton, who was a psychiatrist of sorts as well as writer, artist, and principal advocate of the Surrealist movement. Freud himself was considered one of the patron saints of Surrealism, an accolade which apparently did not delight him. Only in 1938, after a sitting with Dali, who likened his skull surrealistically to a snail, did he soften his assessment of Surrealists as "complete fools (let us say 95%, as with alcohol)" (quoted in Jones, 1957, p. 235). His own interest in art was directed primarily to the past.

Although it is unclear to what extent the psychology of Surrealism derived from psychoanalysis, it is certain that it had other

177

roots. A younger sibling of Dada, itself an absurdist, nihilistic reaction to the perceived failures of Western civilization, Surrealism, led by former Dadaists such as Breton, Aragon, and Picabia, maintained many of Dada's contradictory attitudes toward society and history. The positivist individualist capitalist materialism of the 19th century, its technological dehumanizations justified by a destitute rationalism and supported by a petrified religion—so the argument went—had found its definitive realization in the most devastating and pointless war in all history. Old faiths had perished, old traditions had been discredited; the old worldviews were bankrupt, and reality must be discovered in novel forms which first of all required dismantling the existing order. Like Dada, Surrealism was supposedly a revolutionary way of life. Unlike Dada, it sought a new reality to replace the old. Acknowledging antecedents such as Bosch, Dürer, Blake, Goya, Hugo, Henri Rousseau, Rimbaud, and Lautréamont, as well as the art of primitive peoples and of psychotics, the movement placed great emphasis on discoveries by the revolutionary science of psychoanalysis while tending to discount in its public statements more traditional contributions from recent and ancient history (Alexandrian, 1970, pp. 9–26). However, like the adolescent who repudiates but unconsciously emulates his parents, Surrealism not only rejected both Rationalist and Romantic traditions, along with their Greco-Roman antecedents, but at the same time drew heavily upon them. Surrealists and their advocates discoursed rationally about Surrealism while celebrating its supposed irrationality. As with the Romantics, so with the Surrealists, the child became father of the man and individual idiosyncrasy became more than ever an avenue to universal truth. Bishop Berkeley's pre-Romantic idealism and Descartes's exposition of the "egocentric predicament" were familiar to Surrealist writers, as were Hume's enlightened dissections of causality, theology, and self, not to mention Nietzsche's latter-day pronouncement of the death of God. As for the unconscious mind, Surrealists not only were conversant with dream theories of Freud, but also were aware of Charcot's priority over Freud, aware of Mesmer, perhaps Brentano, certainly Schopenhauer. Directly or indirectly they were influenced by predecessors recent and ancient who in one way or another had discerned the reaches of the unconscious and the language of the dream.

Another significant 19th-century precondition to Surrealism was the acceleration of scientific discovery. By the turn of the century Einstein's relativity theory had upset the entrenched Newtonian view. There remained no absolute center of the universe—earth, sun, or any point in space-time. "God does not throw dice," a statement attributed to Einstein, seemed inconsistent with his own findings. Earlier, as Lewis Mumford (1975, p. 42) has emphasized, Roentgen had subtly disturbed the world with his discovery of X rays; what had looked solid and substantial had turned out not to be. Pound it as he might, the British philosopher G. E. Moore could not entirely convince his colleagues that a table was still a

table. In addition, the young 20th century had to contend with the uncertainty principle of Heisenberg, the quirky electrons of quantum physics, and the incongruous but necessary coexistence of wave and particle theories of light. Conviction seemed to have given way to a bewilderment of uncertainty and paradox. Surrealists, then, confronted worlds of science and belief in which, to quote Yeats, "Things fall apart; the centre cannot hold; mere anarchy is loosed upon the world."

The fearful disintegration of prevailing world views—economic, political, religious—which ushered out the 19th century was accompanied, not coincidentally, by an intensified scrutiny of that primal source of psychological reality, woman: *Cherchez la femme.* If the once-reliable world was falling apart, how reliable could she be? Could she, indeed, be accountable? Woman, hitherto idealized variously as a fragile maiden, gentle mother, goddess, or virtuous Victorian, became the fascinating embodiment of unfathomable reality—of life and death, of sexual madness, or even, as in the dying words of Mr. Kurtz in Conrad's novella *Heart of Darkness,* of horror. ("The horror! The horror!" gasped Kurtz as he died. The narrator, when asked later by the widow what had been Kurtz's last words, gently replied that the last word he had spoken was her name.) This intense ambivalent preoccupation with woman was to be renewed by the Surrealists in the 1920s and 1930s, but with seemingly less horror, and with an irreverent playfulness. Nevertheless, the grotesquerie of Surrealist imagery gave evidence of a persistent dread underlying its arresting humor.

The last throes of the 19th century—a century described by Thomas Mann (1928) as twice the size of our own—have been eloquently described by Carl Schorske (1980, pp. 2–3) in his book *Fin-de-Siècle Vienna,* a volume which begins with a memorable description of Ravel's composition *La Valse,* which in its complicated beauty and accelerating disintegration, punctuated finally by caesuras of abysmal silence, depicted the death agonies of the 19th-century world. The ensuing emptiness that was to pervade our own century was discernible early on in the aimlessness of the Dadaists and the blatantly or latently desolate wastelands and anatomical disfigurements executed in the midst of zest and quest by the Surrealists. So it was that the 19th century bequeathed to the 20th a disturbance of faith in Christian democracy, in progress through industrialism, in individuality, in ancestral ideals, and even in the shape and substantiality of the objective world. These events largely preceded psychoanalysis. Certainly the psychological foundations of Surrealism derived from much more than psychoanalysis. Indeed, it is likeliest that both movements were manifestations of an overall historical trend toward deepening psychological awareness.[1]

Nonetheless, psychoanalysis did inform the activities of the Surrealists. They took great interest in Freud's exposition of the meaning of dreams and of the unconscious imagery and mentation to which dreams provided a special window. Especially were they impressed by his emphasis upon sexual impulses, most particularly

in hysteria, which they viewed simplistically, to the extent that Aragon and Breton wrote an editorial in 1928 defining it in part as follows: "Hysteria is a more or less irreducible mental condition characterized by the subversion of relations established between the subject and the moral world. . . . This mental condition is based upon the need for a mutual enticement, which explains the prematurely accepted miracles of medical suggestion (or countersuggestion). Hysteria is not a pathological phenomenon and can be considered in every respect a supreme means of expression." Calling hysteria "the greatest poetic discovery of the end of the 19th century," the authors inquired, "Does Freud, who owes so much to Charcot, remember the time—confirmed by the survivors—when the interns at Salpètrière confused their professional duties and their taste for love, after nightfall, when the patients met them outside or received them in their beds? Afterwards those women patiently recounted, for the good of the medical cause which does not defend itself, their (supposedly pathological) mental attitudes under the influence of passion, which were so precious to them and are still precious to us as human beings. After 50 years, is the school of Nancy dead?" they asked (quoted in Waldberg, 1965, pp. 61–62). Assuredly it was not for Breton and Aragon, as they chose to perceive it. Psychoanalysis, on the other hand, did not view hysteria as simply the expression of sexuality; nor would most psychoanalysts today be likely retrospectively to view the patients at Salpètrière as neurotically hysterical, but rather as bordering psychosis, or frankly psychotic, if with hysterical features. In addition, while love is most probably an essential component of a therapeutic relationship, a night in bed together is not often the most genuine or helpful expression of that love. Indeed, for some fragile personalities a sexual experience, or invitation, may be overwhelming.

But to Surrealists the unconscious was the realm of what Breton called "the marvelous" (1934). Mad love, "l'amour fou" (1937)—"convulsive love," he also said (1928, p. 190)—was the only love worthy of the name. (At least at times: for Breton, as for Surrealist writers generally, consistency was an inconsistent virtue [Schneede, 1973, foreword, and pp. 21–28].) Of course, the sleep of reason also begets monsters; the unconscious was also the realm of the hideous. Nevertheless, Surrealists, rather unlike Freud, were intrigued rather than deterred by monstrous visions of inner depths. These, too, were marvelous. There was an optimistic fascination with evil and hate as well as with love. In the political realm some Surrealists, including Aragon and Breton, did not hesitate to urge that the good guys kill the bad guys, via communist revolution, Surrealist revolution, or both (Aragon, 1925). Perhaps the Surrealists were able to advocate full-scale liberation of repressed erotic and destructive impulses because they also anticipated a beneficent, psychoanalytically enlightened "transmogrification" of such impulses, once set free, into more sublime forms; perhaps also they were influenced by a then-popular inference drawn from psychoanalysis that since repression

was associated with illness, repression therefore should be abolished altogether. Possibly they were sustained as well by their belief in the power of liberated sexuality to overcome or neutralize human destructiveness. In the First Surrealist Manifesto of 1924 Breton wrote as follows:

> We are still living under the reign of logic, but the logical processes of our time apply only to the solution of problems of secondary interest. The absolute rationalism which remains in fashion [has imposed] such narrow boundaries that experience revolves in a cage from which release is becoming increasingly difficult. . . . In the guise of civilization, under the pretext of progress, we have succeeded in dismissing from our minds anything that, rightly or wrongly, could be regarded as superstition or myth; and we have proscribed every way of seeking the truth which does not conform to convention. It would appear that it is by sheer chance that an aspect of intellectual life—and by far the most important in my opinion—. . . has, recently, been brought back to light. Credit for this must go to Freud. On the evidence of his discoveries . . . perhaps the imagination is on the verge of recovering its rights. If the depths of our minds conceal strange forces capable of augmenting or conquering those on the surface, it is in our greatest interest to capture them; first to capture them and later to submit them, should the occasion arise, to the control of reason. The analysts themselves can only gain by this. But it is important to note that there is no method fixed *a priori* for the execution of this enterprise, that until the new order it can be considered the province of poets as well as scholars, and that its success does not depend upon the more or less capricious routes which will be followed. (quoted in Waldberg, 1965, p. 66)

Emphasizing the omnipotence of the dream, Breton stated that "when the time comes when . . . we succeed in realizing the dream in its entirety . . . then we can hope that mysteries which are not really mysteries will give way to the great Mystery. I believe in the future resolution of these two states—outwardly so contradictory—which are dream and reality, into a sort of absolute reality, a *surreality*, so to speak." Breton was not beyond commending the waking hallucinations and illusions of madmen. "They are," he said, "people of a scrupulous honesty, and whose innocence is equaled only by mine. Columbus had to sail with madmen to discover America. And see how that folly has taken form and endured" (quoted in Waldberg, 1965, p. 16). (In that era Breton could say this without irony.) So there was in Surrealism the belief—partly derived from Hegel—that ultimately opposites might be reconciled in some new synthesis of superrealism which would restore a natural, meaningful balance to human life individually and collectively.

Surrealists absorbed themselves with messages and clues from the mental interior wherever they might emerge: in symbolism,

automatic writing and drawing (graphic and pictorial language were often combined), spontaneous absurdity and incongruity, and other expressions of apparent irrationality—consistent, incidentally, with Freud's description of unconscious thought—such as condensations of past, present, and future time; the commingling of opposites; the equation of parts with wholes; and the celebration of uninhibited amoral impulsiveness. The outcomes of these activities were sometimes inspired and sometimes contrived, as if copied out of a dream book.

Surrealism has been divided, somewhat artificially, into two general forms, the emblematic (or automatic, or accidental) and the naturalistic (or intentional) (Waldberg, 1965, pp. 8, 38). The emblematic involved spontaneous and unmodified imagining by means such as automatic writing or drawing. Surrealist naturalism employed symbolism and other apparent manifestations of the irrational unconscious mind, spontaneous in origin yet controlled in expression, realistically depicted in a setting of traditional representation, so that a bizarre effect—and a new world, objectifying the world of dream—was created by the incongruous union of the two levels of thought. To understand this better, we might briefly recall the psychoanalytic description of the mind's topography (Freud, 1900). According to this theory psychological life in the human being emerges out of a primordial unconsciousness and thereafter moves toward a hierarchy of mental contents through accumulations of experience. In the first months and years of life the infant learns that ruthless impulses are unacceptable to parents and others; as a consequence these impulses and whole constellations of thought and feeling connected with them may be relegated to unconsciousness. Experience not repressed resides in an area of the mind called the preconscious, which is accessible to consciousness simply through an effort of attention. Preconscious mentation derives importantly from the child's relationships with others; consequently it develops a close structural connection to language. Consciousness itself was viewed by Freud as an instrument to scan preconscious contents for relevant information.

So the topographic theory of the mind distinguished a more rational, linguistically imbued, outwardly oriented preconscious layer, overlying an unconscious stratum, the latter containing both primordial unverbalized contents and repressed contents involving impulses once expressed more or less consciously to the outside world (especially mother and father) but rejected (or perceived to be by the child) so that lasting repression became necessary. So went Freud's theory of 1900. By 1923 he had found it inadequate and therefore superimposed a newer structural theory addressed not so much to mental areas or contents as to mental organizations and agencies. These he designated as "It," "I," and "Above-I," the last of which included the "Ideal I." (The German words used by Freud were *Es, Ich,* and *Uber-Ich.* Only in translation into English were they Latinized, into Id, Ego, Superego, and Ego Ideal. For this discussion the closer translation—still unpopular in this country—will be used: it is doubtful that Breton and his

compatriots read Freud in English.) The "It" Freud viewed as the source of biologically based drives; the "Above-I" (and the "Ideal I" represented internalizations of the moral standards of parents and society; the "I" mediated among these agencies and the outside world in order to insure optimal adaptation. The "I" was closely related to the self—more closely than was apparent in the translation "ego." All of these agencies contained degrees of unconsciousness. The "It" was entirely unconscious and its derivatives perceived as somewhat alien by the rational individual. (*Es,* as Bettelheim has pointed out [1982], is also used in German in referring to a child.)

So the psychoanalytic perception of the self, the "I," differed from the belief professed (most of the time) by Surrealists that the only self of any importance was to be found in the instinctual unconscious. True, the goal of psychoanalytic therapy, like the aims of Surrealism, was to make the unconscious conscious; where "It" was, Freud said, there shall "I" be. To some Surrealists this may have sounded like an attack by a psychoanalytic St. George upon the dragon of repression. And to a degree Freud himself may have meant it that way. But he saw the removal of repression not so much as unleashing redemptive forces, or liberating some primal self, as bringing irrational, primitive impulses under rational, civilized control. Some years later Freud was to reiterate this, saying that the voice of the intellect was soft but insistent (1927, p. 53). It has even been said of Freud's successors, the so-called ego psychologists, that they placed too great a premium on reason and not enough on irrational but creative unconscious and preconscious activities.[2] (To this day, perhaps in its zeal not to do harm, psychoanalysis is less venturesome than Surrealism in this regard.)

The Surrealists, on the other hand, while giving lip service to the value of occasional rational control, generally saw the liberation of the unconscious as an unmitigated good. At times it was claimed that the real self and the only valid reality, surreality, were to be found entirely in the unconscious; at other times they were said to be found through a reconciliation between the rational and the irrational—but with heavy emphasis upon the irrational as an underestimated mental activity hitherto depreciated and wrongfully barred from consciousness (Mathews, 1977, pp. 1–30). In either case the emphasis was upon the surpassing virtue of the irrational: rationality, by contrast, was decried as obsolescent Cartesianism characteristic of a failed and corrupted society of bourgeois individualists. The unconscious was seen as containing redemptive universal symbols. The discovery of an innate inner symbolic language at once personal and universal was a principal goal of Surrealism. (Incidentally, this belief in universal unconscious symbols was closer to the theories of Jung than Freud.) If this symbolism was at all rational, certainly it was not the syllogistic rationalism of the past. Freud saw a dichotomy of "I" and "It"; in a therapy or other healthy development "It" contents would, in becoming conscious, become part of the "I,"

operating within the pre-existing structure of the "I." This was hardly descriptive of revolutionary change. What significant change might take place through psychoanalysis was viewed by its practitioners as an evolution of mental powers into ampler and more mature forms, especially noteworthy among which was maturation of moral attitudes from crude dichotomies of right versus wrong to more individualized ethics appreciative of relativities and of situational difference. The Surrealist image of personality change, on the contrary, was eruptive: the prevalent personality structure of the times as viewed by the Surrealists could be likened to a diseased and withered fruit, its nutritious interior increasingly constricted by a malignant rind of morality and custom, which for survival's sake must be entirely peeled away. What there was of the person in that rind could well be dispensed with, since it was merely part of a bankrupt individualism.[3]

Similarities and differences between psychoanalysis and Surrealism were also reflected in attitudes toward dreams. The dream according to Freud originated in some event of the previous day or two which resonated with, and thus reinforced, certain repressed inner impulses; in sleep these impulses would continue to stir, producing dream imagery which rather undisguisedly expressed those wishes. Such a dream unmodified would usually be intolerable to consciousness and hence would provoke all sorts of anxieties; so it was necessary to censor the dream, disguising it in often complicated ways and eventually, especially after waking, rationalizing and otherwise repeatedly reorganizing the dream—all quite unawares. So the manifest (remembered) dream tended to be a highly complicated, disguised representation of the unconscious mind, requiring considerable decoding for its understanding, a process in which the patient's free associations and the analyst's interpretations interacted. The Surrealists approached the dream differently: in keeping with their repudiation of the mundane, day residue was overlooked; similarly, the significance of censorship was minimized; the symbolism of the dream was seen not as disguise, but as revelation of a marvelous mystery in language deeper and truer than the language of reason; the secondary elaboration of the dream, with its rationalization by the dreamer into acceptable form, tended to be discounted, so that the manifest, disguised dream was often mistaken for its latent sources. Nevertheless, since manifest dreams usually are less disguised in their expression of unconscious impulses than are waking thoughts, especially to those gifted in detecting unconscious meanings, and since some dreams are less disguised than others, Surrealists often felt confirmed in their interpretations of dreams.

In addition to dream imagery, Surrealists explored other linkages with the unconscious, such as uncensored fantasy and free association. Along with the visual arts, temporal forms such as literature and music were especially suited to these aims. Consider, for example, the heroine of Leiris's (1943) surrealistic novel

Aurora—astride the peak of a pyramid, rotating through force of the wind in her hair to an ecstatic bloody immolation. Hardly less vivid is Breton's (1928) depiction of a sphinxlike, sensuous, suicidal *Nadja*. Yet the pictorial image—the primary language of the dream—remains the most natural expression, by itself or in combination, of the unconscious. Luis Buñuel's films are classic Surrealism; likewise the operatic *Les Mamelles de Tirésias* of Apollinaire and Poulenc and *Le Boeuf sur le toit* of Milhaud and Cocteau (both works collaborations, as was often the case with Surrealism). But canvas alone sufficed for the imagination of Ives Tanguy, a painter of unearthly yet strangely organic apparitions. And who, having seen them, can forget the bird women of Max Ernst, the eerie yet elegant incongruities of René Magritte, the graphic and photographic inventions of Man Ray, or (however much one might wish to forget them) the limp timepieces of Salvador Dali? Or Joan Miro's playful imagings combining the childlike, the atavistic, and the sophisticated (qualities, one might add, which make especially ominous his occasional darker paintings, such as *The Half-Open Sky Gives Us Hope* of 1954)? In all of this, one senses inspired artistry. Whether what we have come to think of as profundity is widely prevalent in Surrealist works seems less certain. Automatic writing, for example, may have been less successful than painting as a Surrealist medium, even though the quickness of its execution—giving little time for disguise— might be expected to facilitate representation of the undisguised unconscious. Perhaps a reason for lack of depth in automatic writing lies in the medium of language, which can be no more than a derivative vehicle of unconscious expression, tied as it is in its origins to social intercourse, to convention, and to psychological defense. Painting, in its turn, contained an element of delay which may have interfered with spontaneity. Automatic drawings, such as those by André Masson, might offer the best opportunity for spontaneous expression, and some of his are certainly marvelous. Picasso met for a time with the Surrealists, and it is possible that the economy within his later works—and perhaps those of Arp—drew upon this influence.

By contrast with the informed economy of these two artists, Surrealists were committed at least fitfully to discovery and representation of universal unconscious imagery undistorted by second thoughts. To that extent they themselves might disclaim profundity, which requires reflection. But Surrealism was dedicated as well to the resolution of dream and reality. Here reflection becomes possible. An example would be Magritte's simple representational painting of a smoking-pipe, subtitled *This Is Not a Pipe,* implying a distinction among (1) the real, tangible pipe out there in space which the painting might purport to represent, (2) the image of the pipe as represented on canvas, (3) the unique actuality and potentiality of the depicted object in contrast to all other objects among which it is ordinarily classified, and (4) other, subtler associations elicited by the written subtitle. Perhaps especially in Magritte but in many other Surrealist works

as well, these apparent self-contradictions are in fact implicit dissections of experience into substantial, perceptual, conceptual, and linguistic components. Magritte's paintings are the more compelling for their highly objective depictions of subjective states, rendering them persistent as well as unsettling. Probably the incongruities of experience, especially of inner and outer reality, are better represented by the Surrealist naturalists such as Magritte than by the advocates of pure spontaneity and automaticity. Magritte's paradoxical statement, "This [pipe] is not a pipe," is in keeping with observations by 20th-century scientists, such as the following: "If we ask, for instance, whether the position of the electron remains the same, we must say 'no'; if we ask whether the electron's position changes with time, we must say 'no'; if we ask whether the electron is at rest, we must say 'no'; if we ask whether it is in motion, we must say 'no'" (Oppenheimer, 1954).

In some of its forms, then, Surrealism attained a vision both unsettling and prescient. It seemed also to have intrinsic shortcomings. The stated Surrealist intent to describe mental processes rather than create works of art may invalidate complaints that Surrealism lacked emotional depth and mature empathic sensibility. But failures of inspiration also accrued to the Surrealist method itself, inviting preposterousness for its own sake, or compulsive repetition of serendipitous image and style (as in the later works of Dali), or (though hardly the property of Surrealism alone) escape into private inscrutability. One consequence among others was that a professed Surrealist communalism could become the extremest individualism. In fact, while concurring with communists about the evils of individualism, the Surrealists—the best of them—were so idiosyncratic that authorship of their canvasses and other art works could easily be identified.

Here we touch upon another aspect of Surrealism for which psychoanalysis has relevance—the sporadic convergences of Surrealism and Trotskyism, and communism in general, at least as perceived at first by the Surrealists. Early psychoanalytic conceptions of an unconscious mind implied for some the existence of an inborn symbolic language at once individual and universal. Freedom of expression, then, would lead paradoxically to transcendence of individualism. Such at least was the inference of the procommunist Surrealists. Whether genetically inherent or experientially acquired, the existence of some universal imagery does seem probable, in view of findings from cultural anthropology, mythology, primitive art, toxicology, and other areas. However, to the extent that it is universal such imagery is not only enabling but also is predetermined and therefore limiting. Contrary to Surrealist theory, it may be most accurate instead to regard the figures of Surrealism as expressions of primary process thinking, the vehicle of irrationality so named by Freud, which employs common forms (condensation, displacement, and symbolization—processes well-known to Surrealists) to arrive at common and uncommon sense, universal and/or idiosyncratic. Belying its own protestations, Surrealism gave rise to highly individualistic state-

ments; in contrast to communism, which inevitably moved toward annihilation of individual freedom and, so, toward the very dehumanization against which it had originally protested, Surrealism seems to have maintained its belief in self-determination as a basis of social communion.[4]

The development and preservation of the self have become matters of widespread contemporary concern; new knowledge in this area enables us now to look back upon Surrealism with better understanding. Actually, our "new" knowledge had some of its beginnings long ago in Freud's *Interpretation of Dreams*. We have alluded already to the distinction Freud made, in the process of decoding dreams, between two types of mentation, the primary and the secondary processes (1900, pp. 588–609). The secondary process is related to syllogistic thinking, to rational objectivity as we have traditionally understood it, and to the structure of spoken language. Oriented toward outer "objective" reality, it serves as a bridge between individuals and is necessary for both refined and commonsense communication.[5] It is predominantly characteristic of preconscious and conscious thought. By comparison with primary process it proceeds slowly, sometimes at a pace commensurate with verbal discourse. The primary process, on the contrary, is preverbal in its origins, conducts trial and error processing at lightning speeds, is heavily influenced by emotion and appetite, expresses itself in loaded symbolism and other highly condensed forms, and appears generally irrational to the outside world. Originally the primary process was thought of as a language peculiar to the unconscious; we know now that it tends to be present at preconscious and conscious levels as well; but in mature and sane individuals it is modulated and modified as necessary by secondary-process thought.

Prototypical of the primary process might be the thinking of the hungry infant, who organizes reality around the urgency of that hunger, according to what gives pleasure or pain.[6] Tied as it is to feeling and appetite, at its roots it is egocentric in the extreme and hence is given to wishful thinking and other self-centered distortions of reality. Contrary to Surrealist beliefs, for anyone to live sensibly in the world requires objective secondary-process correction of the primary process. A child soon learns that should he close his eyes, or sleep, or die, the world will go on without him. Over time, such tolerable objective modifications of self-centered thinking promote the maturation and continuing accessibility, rather than suppression, of primary-process functions; their evolution, subject to suitable accommodation to the world of reason and objectivity, undergirds enduring self-possession and self-regard. No less important is enlistment of primary process, in conjunction with secondary process, in the service of creativity and empathy.

But it is also true that the primary-process self, through its rootedness in biological hunger of one sort or another, functions in the service of what Freud (1911) called the pleasure principle, and accordingly is so oriented toward satisfaction of the appetites

that it is capable of being quite unscrupulous—of easily exchanging one possible source of satisfaction for another and thus of being surprisingly impersonal toward others. "Any port in a storm," the saying goes. Or, "Men are like streetcars; if you miss one, another will come along soon." Satisfaction of an appetite may therefore contribute nothing to a deepening of personal relationships; on the contrary, indiscriminate satisfaction-seeking under the dominance of uncontrolled primary-process impulses may have a fragmenting effect on personal relationships and the experience of self, even though the physical satisfaction obtained, along with the satisfaction of influencing someone else, may enhance momentarily one's sense of aliveness and importance. So by itself, unmodified by realistic appreciation of the individuality and needs of others, the primary process can subserve a disintegrative sensationalism. At its worst, Surrealist art and behavior, like some modern counterparts, seemed deliberately to preclude understanding and participation by others; and to that extent, apart from the hostility implicit in this exclusion, it took on an auto-erotic quality—one of self-stimulation producing temporary satisfaction but, in the absence of connectedness with others, ultimately engendering personal isolation and disintegration. Such may have been the fate of Surrealism as a movement; in recent decades (especially since the death of André Breton in 1966) its supporters have been hard put to point out that Surrealists new and old still are active among us (Rosemont, 1978, pp. 1–139).

With the advantage of hindsight we can see now that the expression for its own sake of sexual or violent imagery out of the unconscious as advocated by Surrealist leaders was better suited to exhibitionistic and other narcissistic gratifications than to the liberation of humanizing impulses. Especially in his later writing, Freud did not automatically equate sexuality with love (1920). (Nor did he equate violence with self-actualization.) Impulsive sexual discharge under the dominance of the pleasure principle (celebrated, as we recall, by Surrealists)—i.e., the primary process-dominated urgency for immediate gratification—he saw as not necessarily in the service of a unifying Eros, or love, but potentially in the service of a death instinct, of self-annihilation, and of entropic disintegration. The ability to tolerate frustration, to delay gratification, to think and consider before acting, Freud subsumed under what he called the reality principle (loathed by Surrealists), in the service of mature and considerate love, convulsive or otherwise. In many instances, then, the "It"-dominated pleasure principle, aimed as it was at immediate sensual satisfaction, worked paradoxically in the service of the death instinct, toward the disintegration of the person and of human relationships, while the "I"-dominated reality principle, postponing physical satisfaction, acted in the service of deep, generous love and unitedness. In this regard psychoanalysis and Surrealism were at odds, at least theoretically.[7] The behavior of the Surrealists, of course, was often inconsistent with Surrealist theory; their optimistic humanism and their often affectionate camaraderie be-

spoke a capacity for more than caprice; and their rebellion against stultifying moralism, the latter itself a means of keeping distance, must have seemed rejuvenating to others of that era as well as to the Surrealists. Indeed, in some ways Surrealism seems less to resemble a narcissistic personality disturbance than to resemble adolescence—vital, grandiose, idealistic, inconsistent, impulsive, extremist, obsessed with sex, attracted to rationalizable violence, capable of poignant affection, and—on sunny days—humorous and playfully creative.

Emergence from adolescence usually is marked by establishment of an enduring sense of identity, direction, and responsibility, buttressed by self-respect sufficient to permit humility and generous empathic appreciation of others. To the degree that Surrealism can be thought of as adolescent in character, we may ask whether it moved on to maturity. Our answer, I believe, would have to be no; there is little evidence that Surrealism, among other humanistic movements of this century, has evolved substantially or compellingly (Waldberg, 1965, p. 44). Although Surrealist precedence could be demonstrated for more than a few 20th-century artistic and social trends, Surrealist spokesmen instead have fitfully claimed and disclaimed paternity, preferring finally to insist upon the "occultation" of the original movement as unique and unalterable (Alexandrian, 1970, pp. 218–32; Waldberg, 1965, p. 43).

As a consequence, official Surrealism seems to have been self-ordained to an arrested adolescence, arbitrary and uncompromising, aloof from the common herd, out of touch with changing times. Surrealists continue to plumb their private (and possibly universal) unconscious processes without much evidence of compassionate or empathic engagement.[8] (A similar disposition, let it be said, has been imputed by some critics to psychoanalysis.) Revolutionary declamation has not become evolutionary participation. One reason for this apparent arrest may be found in Surrealists' needs to avoid themes of sadness and loss—inferentially apparent as these may be in Surrealist activity. Explicit refusal to traffic with the past may have interfered with the mourning of it that is necessary for growth, somewhat as the sadness and mourning of adolescent separation from parents may be forestalled by denunciation of them. Too often in such instances the outcome is a rebellious stay-at-home, postponing citizenship, *dépaysé*, dislocated (to borrow Surrealist adjectives). Such may be the future of Surrealism if it remains unable to acknowledge its parents—beyond unfavorable comparison with adolescent heroes—and in mourning them, more fully come to grips with the elements of their tragedy, the collapse of 19th-century aspirations. But the loss of hope embodied in the failures of parents is hard to mourn if there are no other resources, inside or outside, to draw upon. Our century is wracked by the irretrievability of old hopes; under the circumstances, one might understandably prefer to indict one's antecedents rather than acknowledge their travail and accept their legacy.[9]

Derivative schools of art probably have not surpassed Surrealism. It seems hardly an advance, for example, to move from decalcomania to aleatory music, or from the absurd festivities and experiments of the Surrealists to the Happenings of the 1960s and 1970s. And, one can ask, how do Ernst, Arp, Magritte, Matta, Giacometti, Poulenc, and Miro compare with Warhol, Oldenburg, Rauschenberg, Lichtenstein, Christo, Cage, and Serra? (Favorably, in this opinion.) Although current assessments are hazardous, it may be fair to say that our generation is long on technique and technology, but short on vision. The pervasive sense of emptiness and sterility which ushered in this century seems to persist despite a proliferation of experimentation, extremist and minimalist, much of it in keeping with the spirit if not the letter of Surrealism.

Let us have one more look, then, at Surrealism, the failures of which may be even more informative to us than our own. The mood of emptiness that permeates our century appears to have been prefigured in the canvasses of the young proto-Surrealist de Chirico—monumentally vacant cityscapes and still lifes, vast but confining, nostalgic and full of loss and longing, with gaping arches and shafts of light gone cold, and looming, strangely expanding shadows, ominous and deathly. A comparable mood of desolation and menace, explicit or (more often) denied, in the foreground or in the background, is detectable in Surrealist works generally. Like de Chirico, Surrealists seem to have struggled with loss of sustaining belief in the world around them, a dwindling which they sensed was undermining even the capacity of people to love one another. Faith seems to come to us both from above and below, so to speak—from the objects of our highest aspirations and from our own foundations. Before the 20th century, Western civilization was traditionally patriarchal; its decline has been accompanied by a decline in the valuation of the father within the family. (De Chirico's father, as his paintings imply, was physically absent much of the time; he died in the artist's adolescence.) The image of such a father as internalized by the child in his or her personal development may then be intact, but may also be wanting in faith, zest, and challenge. Since one's internalized reward system ordinarily is no more inspiriting than was the parental image from which it has been derived, fulfillment of one's father's standards may be curiously unsatisfying. In the back of our minds instead is the parental lostness, which, along with our own lack of much else to believe in, dulls our satisfaction with success. "Is this it? Is this all there is?" we are likely to ask ourselves. As the patriarchs are found wanting, life by their standards becomes devoid of meaning and direction. Mitscherlich, a German psychoanalyst, has referred to 20th-century civilization as "society without the father" (1963). *Pari passu,* faith in God the Father seems also to have dwindled.

Faith from "above," then, has been wanting. Faith from "below," on the other hand, derives from the natural love between mother and child which engenders basic trust and confidence. "There, there, don't worry; Mother is here, everything will be all

right." But behind mother, as Rilke remarked some 75 years ago, is darkness. What if Mother senses that everything will not be all right? May that disrupt the liveliness and the optimism which she ordinarily would engender in her child? What if she has also learned—from male chauvinists, feminists, and social scientists—to devalue herself and/or her mothering instincts? Then faith from below is missing, as well as faith from above. Such twofold insufficiencies of faith are sufficient causes of individual and social emptiness, along with feelings of unreality which can be frightening in the extreme. Dread of such emptiness can induce people to embark on exhibitionistic instinctual forays, erotic or murderous, disorganized or militant, the satisfaction of which, however intense, gives only temporary relief until the inevitable emptiness sets in again. (Coppola's film *The Godfather,* Part Two, provides a vivid illustration.) Such are the narcissistic and borderline personalities which have become a major concern of contemporary psychoanalysis.

As Huston Smith once put it, human beings seem to be "condemned to meaning." The Surrealists struggled, it would seem, to deny or compensate for meaninglessness and emptiness, and also to find new sources of meaning. If their vision fell short, it was not in their appreciation—far ahead of many others—of the human unconscious, but in their exclusive emphasis upon it, endorsing its unmodified liberation as curative, while deploring rationality. From our present-day perspective it appears that this theoretical posture prevented Surrealism from making the most of what was otherwise within its grasp. André Breton envisioned a convergence of dream and reality. He even suggested that, "If the depths of our minds conceal strange forces capable of augmenting or conquering those on the surface, it is in our greatest interest to capture them; first to capture them and *later* to submit them, *should the occasion arise,* to the control of reason" [italics added]. How one could "capture" "strange forces capable of . . . conquering those on the surface" without first beefing up the rational surface forces, he did not specify. Surrealists extolled mythology and other seemingly irrational expression. What they undervalued—*had* to undervalue probably, given their position in history—was rationality, including that which inevitably participated in their art as well as their rationalizations of it. Given the knowledge that we have now—knowing the insanity of exclusive subjectivity and the sterility of exclusive objectivity—we may be able to conceive a deeper reality (or surreality, if you will) as residing in an amalgamation of the two, in a centrality of metaphor. Surrealists then and now have assigned to metaphor (an expression which at once equates and contrasts entities) an intrinsic role in their graphic and plastic experiments. In theory and practice, however, Surrealist metaphor was determinedly happenstance, at most disconnectedly serendipitous, disavowing rational intention. Perhaps the closest thing to intentional metaphor exists in the works of proto-Surrealists such as de Chirico and extraordinary Surrealists such as Magritte. Magritte's painting and state-

ment, "This is not a pipe," calling attention to the illusory nature of imitative representation, manifestly precludes even the weak metaphor of resemblance. Yet his disclaimer serves to encourage alternative, positive metaphors on the part of viewers. If "this" is not a pipe, what else is it? Indeed, it is a devil's furnace. (Surrealist imagery is supposedly nonanalogical and nontendentious, but facilitates novel associations in its audience.)[10] For the statement "This (pipe) is a devil's furnace" to have meaning and impact requires a background awareness that the two objects are in fact quite different. Thus metaphor is manifestly irrational but implicitly rational: hence the paradox—"Is (is not)"—that characterizes metaphor. (Simile, by contrast, is explicitly rational and therefore lacks the paradoxical vitality of metaphor.) Magritte's painting, like other Surrealist products, invites metaphor but confines it to the perceptions of beholders.

Furthermore, in its self-definition Surrealism—although it considered its statements metaphoric—actually amputated one of the legs of what might otherwise have been metaphor, by denying rationality within the work of art. "Is not" is thus abolished, leaving only "Is." "Is" embodies the unexpected conjunction or fusion of seemingly disparate entities. Ernst's bird-woman is neither bird nor woman nor bird and woman: It is a new object altogether. (That this is impossible is Surrealistically immaterial.) We are left, then, not with a metaphor, but with a condensation, conflating contrasting entities on the basis of a common disposition toward them (or on the basis of chance).[11] The metaphor cries out in many such paintings, yet must be officially denied by Surrealism, which claims to create only new realities and to transcend—not extend—the old.[12] Out of horror at overfamiliarity with the discredited past, as we have seen, Surrealism has remained officially apart from our evolving everyday world, away from what it calls "the common herd" (Breton), in favor of its own world of idiosyncrasies, like a perennial bachelor fearful that to wed is to bed the old and bid the new goodbye. "Total revolt" remains the watchword of Surrealism, and Surrealism remains *dépaysé*.

In spite of such shibboleths, however, much of the appeal of Surrealism lies in the metaphors it evokes in its audiences, themselves free from the shackles of theory. Unfortunately, most Surrealist practitioners have continued insistently to disavow any meaning other than novelty. As a consequence the employment of metaphor has continued to be accidental and rather aimless.[13]

As they saw it, nevertheless, Surrealists were speaking in metaphor and demonstrating its validity. In fact, in their undoubted familiarity with such imagery, Surrealists probably surpassed the science upon which they drew most heavily, psychoanalysis, which to this day tends to overvalue logic and look askance at paradox, and in its therapeutic method treats metaphor (which is manifestly synthetic) mostly as a means of attaining objective discrimination (which is analytic). Surrealism has learned from psychoanalysis; psychoanalysis in turn could learn from

Surrealism: that subjectivity is intrinsic to experiential validity as well as vitality; that empathy, as children know, is usefully extensible to inanimate objects; that irrationality does make sense, not just within an individual, but in the objective physical world. As for the rest of us, perhaps we could learn to give greater respect to the irrational and the unconscious—some of us—*and* to give greater respect to reason and comprehensibility—others of us. That done, we might profitably put our heads together and, informed by the adventures of Surrealism, learn once again to integrate inner subjective reality—the world of imagination and dream—and outer objective reality—the world of rational and irrational discourse—and, so, to invigorate our language with new metaphors adequate to the complexity of our time.

Notes

An earlier version of this essay was presented at the St. Louis Art Museum in April, 1981, as part of a series of lectures and exhibits entitled "Documents of Surrealism."

1 Another such movement, phenomenology, deserves greater acknowledgment for its influence on Surrealism than will be given in this discussion. Suffice it to say that attempts to liberate experience from preconception were intrinsic not only to psychoanalysis and Surrealism, but also to Husserl's phenomenological de-emphasis of conventional figure-ground resolutions.

2 Rosemont (1978, p. 2) writes that "recognition of the validity and significance of Freud's work by no means makes of Surrealism an 'offshoot' of psychoanalysis. Whereas a psychoanalysis leaves untouched, or even widens, the chasm between dream and action, Surrealism dismantles the barriers between these contradictory states and strives toward their dialectical resolution. Thus, while always defending Freud's fundamental discoveries and freely utilizing psychoanalytic methods of investigation, Breton none the less could specify that 'we reject the greater part of Freudian philosophy as metaphysics.'" The Surrealist position was shared by at least one psychoanalyst of our era, Jacques Lacan, who had close connections with Surrealists personally and through his poetry (Izenberg, 1983), concurring in their celebration of the unconscious as redemptive and expressive of the authentic, uncompromised self. He believed that Freud's intentions were best fulfilled by the liberation, rather than the analytic taming, of unconscious psychic life.

3 A "rind" so perceived not only could represent constricting social forms but also an intolerable personal existence within a schizoid shell. For a recent discussion of art and psychosis, see Arnheim (1986), who suggests that psychotic and modern art are similar insofar as emancipated inner form and feeling overcome the necessity for representational verisimilitude in both groups. But the differences outweigh the similarities. Schizoid personalities may defend their intactness behind an insulating

shell, safe from outer disruption; psychotic individuals in turn often protect themselves from the outside world by affective and cognitive detachment through denial or distortion of it. Surrealist naturalists such as Magritte and Ernst detached themselves from the outer world with conscious intent in order to facilitate novel representations. Emblematic Surrealists such as Masson, to be sure, even relinquished conscious control in order to promote uncensored expression out of the deeps; however, they did so deliberately. Naturalistic Surrealism, then, bore only an apparent resemblance to psychotic and schizoid cognitive withdrawal, while the resemblance of emblematic (or automatic, or accidental) Surrealism to psychotic eruption was comparably limited—notwithstanding attributions then and now of mental degeneracy to modern art and of special creativity to psychosis. Nevertheless, as we shall see, some shortcomings of Surrealism may be compared formally to creative deficiencies observed in psychotics. It is true also that Surrealists saw health in insanity: "The art of those who are classified as mentally ill constitutes a reservoir of mental health" (Breton, 1948, quoted in Rosemont, 1978, p. 64).

4 It should perhaps be noted that, as with communism, so with Surrealism freedom moved too easily to absolutism, in which artists and writers were judged according to their conformity with Surrealist dictates and if necessary expelled from the movement (Schneede, 1973, p. 27). It should also be noted that official Surrealism never broke with communism, although Breton strongly repudiated Stalinism (Rosemont, 1978, pp. 125–32).

5 "Common sense" often refers to consensus, the shared opinion that people would be expected to have under given circumstances. So it could seem, unjustifiably, to be rooted entirely in rationality. A second, related meaning is that of Aristotelian "common sense" or "sixth sense," a synthesis of the other five. Recent research is suggestive of astonishing inborn synaesthetic capacities in human infants, corresponding most closely perhaps to the condensations and displacements of primary process thinking (Stern, 1985, pp. 154–56).

6 Another basis of primary-process displacement and condensation may reside in the inborn synaesthetic mental circuitry mentioned above.

7 In recent years psychoanalytic writers such as Noy (1969) have emphasized that the self is importantly rooted in primary-process organizations and functions that continue to evolve throughout life: contemporary psychoanalysis might view Surrealist theory less as incorrect in this regard than as insufficient, excluding or discounting as it does the necessity of a contrapuntal secondary process.

8 Most Surrealists would strenuously deny that they are not compassionately and empathically engaged. Here the subject may know better than the scrutinizer; however, statements such as the 1970 "Declaration of War" in the official American Surrealist publication Anvil, out of Chicago, hardly seem compassionate and empathic (Rosemont, 1978, p. 121), even if the stated goals of Surrealism are freedom, love, and an end to "miserabilism" (p. 126).

9 Surrealism, of course, did acknowledge antecedents. But they were mostly out of the mainstream of Western thought and society. Heraclitus, who has acquired prominence during this century, is an example. Such antecedents might be thought of not so much as ancestors as adopted parents, or as figures in what psychoanalysis calls a "family romance," in which one imagines oneself as having parents other than the actual ones. Perhaps most important is the resemblance of these antecedents to adolescent heroes.

10 Since contradiction is characteristic of Surrealism, statements about it usually require qualification (a scholarly but most un-Surrealistic activity). In this instance it should be noted that Surrealists, notwithstanding their stated avoidance of connotational intention, also recommended analogy as an antidote to that which, to quote "The Platform of Prague" (Rosemont, 1978, p. 109), "paralyzes [reason] into alienating systems: the principle of non-contradiction and the principle of identity."

11 Surrealist optimism often seems to derive from condensation founded preferentially on eroticism rather than hate or fear. "Words are making love," declared Breton.

12 Matthews (1977, p. 9), in disagreement with the present discussion but in accord with Surrealist language, discerns an abundance of metaphor (as well as simile) in Surrealist artistry, "widening the gap between rational discourse and the language of surrealism." Clearly we differ in our definitions of metaphor. "A flower is a bird of salt" (an apparent metaphor quoted on the same page) is a statement of revealed new identity omitting any appeal to reason or recognition of dissimilarity. To this reader it is absurdity impersonating serendipity. Matthews (p. 196) states that "the most serious error anyone could make about the surrealist use of metaphor is to assume that it refers back to its constituent elements." Such a Surrealist posture discourages any attempt to connect metaphor, even eventually, with consensually validatable objectivity, thus apparently also precluding Surrealist metaphor as a basis for social action. One seems obliged to conclude that within Surrealism there are metaphors and metaphors.

13 Surrealists have argued that for them chance is not haphazard since it is courted in specific ways, such as free association, "voluntary hallucination," or Surrealist games such as "L'Un dans l'autre" (Matthews, 1977, pp. 150–56) and "The Exquisite Corpse" (Waldberg, 1965, pp. 93–95). To the extent that such methods succeed, the evoked imagery, however marvelous, is likely to seem minimally connected to the artist's own being and intention. The Surrealist becomes a witness, or at most a vessel and a refiner of revealed imagery, rather than a center of initiative drawing upon inner resources to resolve compelling concerns. (A comparable limitation inheres in the explicit psychoanalytic model, insofar as free association is prescribed rather than permitted to evolve.)

References

Alexandrian, S. (1970). *Surrealist Art.* Trans. G. Clough. New York & Washington: Praeger.

Aragon, L. (1925) "Ethical Sciences: Free to You!" *La Révolution surréaliste,* no. 2 (Jan.).

Aragon, L., & Breton, A. (1928). "The Quinquagenary of Hysteria (1878–1928)." *La Révolution surréaliste,* no. 11 (Mar.).

Arnheim, R. (1986). "The Artistry of Psychotics." *American Scientist* 74 (Jan.–Feb.): 48–52.

Bettelheim, B. (1982). "Reflections: Freud and the Soul." *New Yorker,* Mar. 1, pp. 52–93. Reprinted in *Freud and the Soul.* New York: Alfred A. Knopf, 1983.

196

Breton, A. (1928). *Nadja*. Paris: Gallimard.

_____. (1934). *Qu'est ce-que le surréalisme?* Brussels: René Henriquez. See English edition, *What Is Surrealism?* Trans. D. Gascoyne. London: Faber & Faber, 1936.

_____. (1937). *L'amour fou*. Paris: Gallimard.

Breuer, J., & Freud, S. (1895). *Studies on Hysteria*. S. E., 2.

Freud, S. (1900). *The Interpretation of Dreams*. Standard Edition, 4 & 5.

_____. (1911). "Formulations on the Two Principles of Mental Functioning." *Standard Edition*, 12:218–26.

_____. (1920). "Beyond the Pleasure Principle." *Standard Edition*, 18:1–64.

_____. (1923). "The Ego and the Id." *Standard Edition*, 19:12–66.

_____. (1927). "The Future of an Illusion." *Standard Edition*, 21:5–56.

Izenberg, G. (1983). The Vicissitudes of Freudian Interpretation. (Unpublished manuscript.)

Jones, E. (1957). *The Life and Work of Sigmund Freud*, vol. 3. New York: Basic Books.

Leiris, M. (1943). *Aurora*. Paris: Gallimard.

Mann, T. (1928). "Freud's Position in the History of Modern Thought." In *The Thomas Mann Reader*, pp. 450–66. Ed. J. Angell; trans. H. Lowe-Porter, New York: Alfred A. Knopf, 1950.

Matthews, J. H. (1977). *The Imagery of Surrealism*. Syracuse: Syracuse University Press.

Mitscherlich, A. (1963). *Society without the Father*. Trans. E. Mosbacher. London: Tavistock.

Mumford, L. (1975). "Reflections: Prologue to Our Time." *New Yorker*, Mar. 10, pp. 42–63.

Noy, P. (1969). "A Revision of the Psychoanalytic Theory of the Primary Process." *International Journal of Psycho-Analysis*, 50:155–78.

Oppenheimer, J. R. (1954). *Science and the Common Understanding*. New York: Simon & Schuster.

Rilke, R. M. (1910). *The Notebooks of Malte Laurids Brigge*. Trans. M. D. H. Norton. New York: Norton, 1949. Reprinted, New York: Capricorn Books, Putnam's, 1958.

Rosemont, F., ed. (1978). Introduction. *André Breton: "What Is Surrealism?" and Selected Writings*. New York: Pathfinder Press for Monad Press.

Schneede, U. (1973). *Surrealism*. Trans. M. Pelikan. New York: Abrams.

Schorske, C. (1980). *Fin-de-Siècle Vienna*. New York: Knopf.

Stern, D. (1985). *The Interpersonal World of the Infant*. New York: Basic Books.

Waldberg, P. (1965). *Surrealism*. New York: Oxford University Press.

Donald Kuspit,
D.Phil., Ph.D.

Surrealism's Re-Vision of Psychoanalysis

One never, never thinks of science as preparation for art, of psychoanalysis as preliminary to Surrealism, of the revolution of psychoanalysis paving the way for the revolution of Surrealism. Quite the contrary, it is the other way around: art is propaedeutic to science. Heinz Kohut, in his "hypothesis of artistic anticipation," gives "the great artist" credit for being "ahead of his time in focusing on the nuclear psychological problems of his era" (Kohut, 1977, p. 285), but it is "the investigative efforts of the scientific psychologist" (ibid., p. 296) that comprehensively and coherently realize the goal of understanding what the artist had only intuitively recognized. Art is reduced to (subtly trivialized as?) one among many realms of examples for psychoanalysis. Can one imagine that Surrealism might finish something that psychoanalysis began, that Surrealism might grasp the full ramifications of psychoanalysis better than psychoanalysis itself, that Surrealism might be an attempt to actualize the full potential of psychoanalysis, a potential it itself is unconscious of, or disavows through its reluctance to take a larger role for itself in society than it ordinarily has? Can one develop a "hypothesis of scientific anticipation," giving the great scientist credit for being ahead of his time in focusing on the nuclear epistemological problem of his era—the problem of his era's sense of reality—but holding that it is the communicative efforts of the critical-dialectical artist that reveal its dramatic lifeworld import, that is, its significance for individual and social life?

Accounts of Surrealism routinely acknowledge its debt to psy-

choanalysis, evident in Surrealism's self-definition as "psychic automatism in its pure state," that is, "thought" undictated to, free of "any control exercised by reason, exempt from any aesthetic or moral concern" (Breton, 1970, p. 20). Who speaks of the debt that psychoanalysis should feel it owes to Surrealism for advocating, as a social practice, the relaxation of conscious control on the unconscious, especially when such advocacy misinterprets psychoanalysis, which does not regard the "free" expression of the unconscious as liberation from the "repression" of civilization? This misunderstanding of the meaning of repression[1] seems all the more grotesque in view of the fact that for Freud only civilization, with its adult advocacy of reason, can liberate us from the unconscious forces that enslave us with their irrational, infantile determinisms. Freud advocated "the progressive strengthening of the scientific spirit" that, along with the maintenance of "the instinctual barriers," "seems to be an essential part" of civilization (Freud, 1933, pp. 245–46). It is liberation from the unconscious that is necessary, however much, at certain times, liberation from the consciousness fostered by society seems necessary.

Prima facie, the questions asked above seem ridiculous and absurd. They should not have been asked, for psychoanalysis and Surrealism seem in irreconcilable conflict, despite the borrowings of the latter from the former. Yet the challenge of the questions shows psychoanalysis in a new light. The questions point to an unexpected flaw in it—not a structural defect, but a certain lack of clarity about the social consequences of its epistemology, a kind of self-castration in its conception of itself as no more than scientific research, an unexpected reluctance to make any serious change in the world (Freud suggests that one has to endure it, not change it), an unusual selling itself short as a revolutionary understanding of psychological reality and its pervasiveness, an odd reluctance to examine the full implications of psychological reality for the "common sense" of reality, which is left to society's control. To transform the basic sense of reality—to change fundamentally the commonsense conscousness of phenomenality—as Surrealism thinks psychoanalysis can do, and has done, is to revolutionize society.[2]

Like the Surrealists, psychoanalysts may, in André Breton's words, look like "strange animals" to enlist in a strange revolutionary cause—changing society by changing common sense, the ordinary social sense of reality—but Breton's appropriation of psychoanalytic theory is in effect an expression of faith that psychoanalysts can "prove [themselves] fully capable of doing [their] duty as revolutionaries" (Breton, 1970, p. 32). The fact that, in retrospect, psychoanalysis has not done its revolutionary duty—made the most of its revolutionary sense of reality—can itself be psychoanalytically interpreted as a sign of psychoanalysis' immaturity or arrested development. It is not so much that psychoanalysis is socially reactionary while being psychologically revolutionary—as though it is inherently impossible to be both at the same time, the effort being too great (with no recognition that

to be psychologically revolutionary is already to be socially revolutionary). Rather, psychoanalysis does not know itself as well as it thinks it does: its self-analysis—including the full understanding of its import and power—is incomplete. Surrealism can be understood as an attempt to further the self-understanding of psychoanalysis, to educate it more completely about its social import, to demonstrate, to psychoanalysis itself as well as to the world at large, the revolutionary power of psychoanalysis' "teaching" of psychological reality.

The apparently "nihilistic," disordered sense of reality Surrealism advocates—a sense of reality as irreducibly charged with unconscious content, inherently irrational—while seemingly derived from psychoanalysis, carries its ideas to a supposedly absurd extreme. Breton not only wants to make us conscious of our unconscious sense of reality as a dream but insists that we never lose this sense; that is, however decipherable or analyzable, the experience of reality as a dream can never be entirely expunged from our psyche. This is in sharp contrast to psychoanalysis, which seems to be based on the assumption that it is once and for all possible to separate the infantile sense of living in reality as in a private dream from the adult sense of reality as what is objectively—ultimately scientifically—given. For Breton, the sense that reality is a dream—a dream that we cannot awaken from for all our interpretation of it, a childish sense of reality-as-dream that remains irreducible and ineradicable for all the adult consciousness of reality we develop, for all the success with which we "convert" pleasure principle into reality principle, id into ego—is our deepest experience of it. Thus, Breton, while accepting the psychoanalytic idea that the apparent absurdity of the manifest dream content, "upon closer scrutiny," reveals "a certain number of properties and of facts no less objective" for being latent or unconscious, maintains that the *extreme degree of immediate absurdity*" (Breton, 1970, p. 19) that the world subliminally appears to have—signalling that we always perceive it as implicitly a dream—whatever our efforts to demonstrate that it is far from absurd on reflection, can never be entirely overcome. For Breton, the world can never be seen with completely clear eyes, nor does it ever appear to be completely free of absurdity. (Surrealism deliberately cultivates this appearance of immediate, extreme absurdity.) This is no doubt because one never entirely overcomes one's childhood "sentiment of being unintegrated" in the world, which leads to the feeling "of *having gone astray,* which I [Breton] hold to be the most fertile that exists." It is in one's childhood that one "comes closest to one's 'real life' . . . childhood where everything . . . conspires to bring about the effective, risk-free possession of oneself," an "opportunity" that "knocks a second time" in Surrealism (ibid., p. 25). The "precious terror" of childhood indicates that in it reality and dream are integrated in a single "surreality," affording a sense of complete self-possession.

The Surrealist concept of surreality—"the great Mystery . . . the future resolution of these two states, dream and reality,

which are seemingly so contradictory, into a kind of absolute reality, a *surreality*" (Breton, 1970, p. 15)—is in part a major correction of the psychoanalytic assumption that unconscious and conscious thought can be clearly distinguished, even absolutely separated. Understood as directed to psychoanalysis, surreality announces that this assumption is erroneous. Psychoanalysis should know better, for its clinical evidence repeatedly demonstrates that the great mystery of surreality is always and already within us. Breton himself implicitly believes that surreality is all-pervasive, even if this is rarely realized (in true art)—that dream and reality have the same root in the psyche, are intertwined like the snakes of the caduceus, and that awareness of this has always been an aspect of genuine self-awareness. Surrealism, with its repeated demonstrations of the "unusual ferment" generated by ated by the resolution of "the old antinomies" of dream (unconscious) and (conscious) reality (ibid., p. 28), is living proof of this, an attempt to make it self-evident. (Dali's "paranoiac-critical activity" is an experimental method for making manifest the surreality that is universally latent.) For Breton, surreality is absurd and nonsensical to psychoanalysis, which sharply divides unconscious from conscious thought because of its reluctance to deny common sense, which would disrupt society. Common sense is Cartesian; it assumes that one can finally have clear and distinct consciousness of reality, that is, a consciousness free of all corrupting, obscuring taint of unconscious thought. Free of unconscious "guidance" and influence, thought can at last become truly adult—scientific. (A Comtean idea implicit to psychoanalysis.)

Breton would like, in effect, to liquidate the commonsensical Cartesian residue in psychoanalysis, not only because it is an epistemological error, but because it keeps psychoanalysis from realizing the full extent—sweeping character—of its revolutionary understanding of the sources of the sense of reality, which cannot help but have a major social effect. From Breton's point of view, psychoanalysis, in becoming more of a medical (psychiatric) than philosophical enterprise—although Freud spoke of it as positioned between medicine and philosophy—shows itself to be of common-sensical service to society rather than "absurdly" critical of it. It wants to cure the "sick" of their unconscious, uncommon, "mad" sense of society's reality—their intimate micropolitical experience of it as catastrophic, almost annihilating—and get them to believe that society is a healthy place that makes possible self-integration and self-fulfillment rather than a monstrous place that disintegrates the self. It wants to restore the sick to a supposedly healthy society—as though their perception of it as sick, that is, not conducive and even deliberately detrimental to self-integration and self-fulfillment, was an absurd delusion—with its "healthy" common sense of things: it wants to establish self and society in a mythical reciprocity, restore them to a lost paradise of trust. It never even seems to cross psychoanalysis' mind that the common point of view—common sense, with its emphasis on what is

conscious and socially sanctioned—is invalid and insidiously unhealthy, fundamentally wounding, that is, dangerous to self-integration and self-fulfillment.

Apart from Breton, psychoanalysis' present self-imposed limitation of its efforts to the clinical situation suggests a subtly diminished self-regard, especially from the perspective of its original wide-ranging ambition. It is as though psychoanalysis has censored itself, is holding its tongue about the civilization it inhabits—as Freud never did, although Breton probably felt Freud never went as far in his critique of civilization as Surrealism. Breton thus offers Surrealism as a critique of psychoanalysis. Surrealism wants society—not only the individual—to become conscious of its unconscious determinisms. The facade of society's seemingly "successful" common sense should be shown to be a lie and shattered. For Surrealism, sickness is Dadaist disgust with common sense and a depth perception of the sickness of the world—of the world that makes the individual sick. Psychoanalysis should attend as much to cleaning out the Augean stables of the world's unconscious as to "curing" the sick individual—even more to society than the individual, if only to demonstrate to the individual that society is so sick that it is suicide to trust or accept on face value society's common sense. In a sense, Breton implies that psychoanalysis is in a double bind. Its theory of the power and workings of the unconscious is on target, but its cure of the sick returns them to a sick world, and so is in a sense self-defeating, or at best a temporary reprieve. Is it that psychoanalysis does not want to stand up to and change the world—despite the world's profound sickness, manifest through the recurrent breakdown of "compromise formations" (social contracts) and the tyrannization of one part of society over another—because psychoanalysis is part of that illness itself? As Karl Kraus wrote, "psychoanalysis is that mental illness which regards itself as therapy" (Kraus, 1977, p. 227); that is, psychoanalysis is another symptom of society's sickness, repeated breakdown.[3]

The heart of this sickness seems to be what Breton called, in 1956, the "crime" of "miserabilism": "the depreciation of reality in place of its exaltation" (Breton, 1972, p. 348). When Breton noted, in *The First Surrealist Manifesto* (1924), "the hate of the *marvelous* which rages in certain men" (Breton, 1970, p. 15), he was already speaking of miserabilism, for the marvelous, which is "always beautiful . . . in fact only the marvelous is beautiful (p. 15), is the imagination's exaltation of reality. Miserabilism means in effect, as Breton wrote in *The First Surrealist Manifesto,* "to reduce the imagination to a state of slavery," which "would mean the elimination of what is commonly called happiness" and "to betray all sense of absolute justice within oneself" (p. 11). The Surrealists' moral understanding of the imagination is made clear by Louis Aragon's assertion, in the *Challenge to Painting* (1930), that "the relationship born of the negation of the real by the marvelous is essentially of an ethical nature, and the marvelous is

always the materialization of a moral symbol in violent opposition to the morality of the world from which it arises" (Aragon, 1970, p. 37).

For Breton, society, with its commonsense morality, fosters miserabilism; psychoanalysis must foster the antimiserabilism of the imagination. When Breton wrote "that freedom, acquired here on earth at the price of a thousand—and the most difficult renunciations, must be enjoyed as unrestrictedly as it is granted, without pragmatic considerations of any sort, and this because human emancipation—conceived finally in its simplest revolutionary form, which is no less than human emancipation in *every respect*, by which I mean, *according to the means at every man's disposal*—remains the only cause worth serving," (Breton, 1960, pp. 142–43), he was attacking miserabilism. The exaltation of reality through the enjoyment of freedom is the enemy of the depreciation of reality and experience of it as miserable. (Or banal. One recalls Baudelaire's assertion that "banality is the only vice.") When he insisted "that around himself each individual must foment a private conspiracy, which exists not only in his imagination—of which it would be best, from the standpoint of knowledge alone, to take account—but also—and much more dangerously—by thrusting one's head, then an arm, out of the jail—thus shattered—of logic, that is, out of the most hateful of prisons" (Breton, 1960, p. 143), he was implicitly expressing his ambivalence about psychoanalysis, which at once takes account of the private conspiracy against public logic in the imagination but does not dare shatter the logic of the social jail, that is, encourage imagination to become critical action. This statement, originally made in 1928, of course goes far beyond Breton's advocacy of "beloved imagination" in *The First Surrealist Manifesto,* which he liked because of its "unsparing quality" (Breton, 1970, p. 11).

Breton gives us some sense of what such critical action would be when he speaks of Nadja's misunderstanding of it. Becoming "mad" because she "lost that minimal common sense which permits my friends and myself, for instance, to *stand up* when a flag goes past, confining ourselves to not saluting it" (Breton, 1960, p. 143), she apparently was incarcerated in a psychiatric hospital. It is worth noting that such conformity to common sense, in the letter if not the spirit, seems a pallid revolt—far from the "*complete nonconformism*" Breton advocated (Breton, 1970, p. 26)— in sharp contrast to the "revolt [for which] none of us must have any need of ancestors," yet whose ancestors are Rimbaud, Lenin, Alphonse Rabbe, and Sade (1970, p. 30). It seems a long way from Breton's conception, in *The Second Surrealist Manifesto* (1929), of Surrealism as "a tenet of total revolt, complete insubordination, of sabotage according to rule," a doctrine which "expects nothing save from violence. The simplest Surrealist act consists of dashing down into the street, pistol in hand, and firing blindly, as fast as you can pull the trigger, into the crowd" (1970, p. 29). For all his proclamations to the contrary, when it comes to concrete practice, Breton's theory of violence remains "idealistic," despite

his insistence on "the necessity to put an end to idealism properly speaking" (1970, p. 31). Surrealism may "usher [us] into death," as he wrote in *The First Surrealist Manifesto,* but more by the violence of the imagination than literal violence. Death, after all, is for Breton, just another "secret society" (1970, p. 23), which is what in effect he thought Surrealism was. Whatever he wrote, Breton retained his practical common sense—enough common sense of reality not to be incarcerated as mad.

For Breton, psychiatric places of "so-called social conservation" were "detestable," for they reinforce with a vengeance society's common sense of reality. "Madmen are *made* there, just as criminals are made in our reformatories," because, "for a peccadillo, some initial and exterior rejection of respectability or common sense, [society] hurl[s] an individual among others whose association can only be harmful to him and, above all, systematically deprive[s] him of relations with everyone whose moral or practical sense is more firmly established than his own" (Breton, 1960, p. 139).[4] Madness was a necessary alternative to common sense for Breton—the madness which gave one a sense of the marvelousness of reality that was missing from the commonsense awareness of it—but he never forgot that madness "has aptly been described [as] 'the madness that locks one up'. . . . We all know, in fact, that the insane owe their incarceration to a tiny number of legally reprehensible acts and that, were it not for these acts, their freedom . . . would not be threatened. I am willing to admit that they are, to some degree, victims of their imagination, in that it induces them not to pay attention to certain rules—outside of which the species feels itself threatened—which we are all supposed to know and respect" (Breton, 1970, p. 11). Breton had no wish to be incarcerated—Surrealism did not mean to be a legally reprehensible act—or to become a victim of his imagination, however violent it might become, however possessed by the sense of the marvelous it might become. Nonetheless, despite his vacillation and restraint in acting out the violent impulses of the imagination as though they were marvellous in themselves— despite his retention of a minimum of common sense—Breton saw the rebellious possibilities of the imagination in a positive psychological light, for they alone could overthrow miserabilism. Breton's revolt was against the "miserable" common sense of reality; the exaltation of the marvelous would slowly but surely lead to social ferment and change, to a society where, in Trotsky's words—quoted with approval by Breton in *The Second Surrealist Manifesto*—"man's liberated egotism—an extraordinary force— will be concerned only with the knowledge, the transformation, and the betterment of the universe. . . . But we shall reach this stage only after a long and painful transition, which lies almost entirely before us" (1970, p. 35). For the Breton of *The First Surrealist Manifesto,* psychoanalysis is *the* instrument for the emancipation of imagination, in effect the liberation of man's egotism. For the Breton of *The Second Surrealist Manifesto,* Marxism seems to have become the major instrument of emancipation, but it is an

imaginative Marxism—a Marxism with imagination as its center, a Marxism that does not forfeit the sense of imagination that can overthrow miserabilism, which is as a great an enemy of knowledge and social change as of the marvelous. Breton may have turned to Marxism because he thought that psychoanalysis could not escape becoming a form of psychiatric miserabilism—psychiatric common sense about madmen, which demands that they be incarcerated, in theory as well as literally. For Breton, miserabilism was symbolized by psychiatric institutions' enforcing common sense, with its vulgar sense of reality.

Breton's attempt to turn psychoanalysis into a revolutionary Weltanschauung—or rather to demonstrate that in fact it was implicitly one—can be regarded as an extreme statement of a trend within psychoanalysis itself in the pre-American, pioneering days of the 1920s. Russell Jacoby has pointed out that "It is important to realize that the Freudians of the first and second generation were primarily cosmopolitan intellectuals, not narrow medical therapists." There was, among them, a sizable number of "political Freudians," including Siegfried Bernfeld, Otto Fenichel, Edith Jacobson, Henry Lowenfeld, and Annie Reich, "whose collective devotion to social theorizing . . . kept alive the breadth of classical psychoanalysis." "When American psychoanalysis embraced a neutral clinical theorizing, it simultaneously became inhospitable to cultural and political psychoanalysis" (Jacoby, 1983, p. 10), which was repressed.

The ideas of Otto Gross, who "preached a doctrine of sexual and cultural emancipation, based on psychoanalytic principles—or his interpretation of those principles" (Jacoby, 1983, p. 43)— were repressed. Gross, who died in 1920—the period of transition from Dadaism to Surrealism—held that "the psychology of the unconscious is the philosophy of revolution" (quoted in Jacoby, 1983, p. 43). This is *in nuce* the position of Surrealism, which did not understand itself as inventing a new style or literary strategy for art-making—it has been trivialized into this by conventional art history—but as a revolutionary attempt to emancipate the unconscious in everyone, and thus to revolutionize everyone's sense of reality. This emancipation was regarded as the first step in the establishment of a new, nonauthoritarian personal and interpersonal space—in the liberation of the self and human relationships. While this liberation did not always lead to peaceful relations—the conflicts between the Surrealists indicate as much— it did attempt to subvert the authoritarian or patriarchal structure of society. (It can be argued that Surrealism's "advocacy" of women—Breton in effect appropriates Nadja's "wisdom" the way Socrates appropriated Diotima's wisdom—was part of its rejection of authoritarianism, although the sometimes exclusively sexual terms in which woman is depicted suggests patriarchalism.[5] Surrealism can be understood as a transition from authoritarianism to antiauthoritarianism, that is, not entirely free of patriarchal attitudes if wishfully so.)

Gross, like the Surrealists later, regarded psychoanalysis as the basis of a "new ethic" directed against crippling "authoritarian institutions" (quoted in Jacoby, 1983, p. 43). Gross even recognized an issue that was later to trouble Surrealism and such radical psychoanalysts as Wilhelm Reich: "authoritarianism infested and distorted the aims of the revolutionaries themselves. The revolutions of the past failed, Gross declared, because the revolutionaries harbored an authoritarianism bred by the patriarchal family. They secretly loved the authority they subverted and reestablished domination when they were able" (p. 43). Just as "he proposed that psychoanalysis should help revolutionaries develop freer sexual relations that would break the chain of patriarchal authoritarianism," so Surrealism in effect proposed free emotional relations with others—openness about the character of one's inner feelings, images, thoughts, that is, about "emotional truth" (Breton, 1972, p. 18)—to free one from common sense, implicitly authoritarian in its dismissal of many feelings, images, and thoughts as irrational, that is, beside the practical point of "reality." Indeed, common sense implicitly believes that one supreme authority—reason—can be established in the psyche. This establishes a master-slave dialectic in the psyche, a hierarchy in which reality principle triumphs over pleasure principle, ego dominates id. This simply reverses the natural (biological) hierarchy of the psyche—civilizes it, as it were. For Surrealism, the point is to transcend, through surreality, the contradiction embodied by this hierarchy and establish the reciprocity of the opposites. Only such reciprocity is truly antiauthoritarian.

Insistence on telling the emotional truth is the other side of Breton's attack on "what is vulgarly understood by *the real*" (Breton, 1972, p. 2). In a sense, Surrealism is a strategy for not adapting to the vulgar view of reality yet surviving socially, that is, not being punished for the "madness" of nonadaptation by being incarcerated. Surrealism deliberately and subtly cultivates nonadaptability, or minimum adaptation—just enough so that the Surrealist will not be stopped externally and inhibited internally from telling the emotional truth. The sum and substance of the Surrealist revolution is the creation of a Weltanschauung of revolutionary emotional nonconformism. It is revolution with just enough commonsense conformity to prevent its suppression—a perverse case of what Philip Rieff has called "the triumph of the therapeutic" (1968). In a mithridatic paradox, Surrealism internalizes just enough of society's authority to resist it inwardly, that is, not to allow it total domination of the psyche. That is, it conforms outwardly just enough not to be stopped inwardly, just enough for the inner revolution of the imagination to ferment and insidiously catalyze outer change. The Surrealists show that revolution is also a "compromise formation."

Joseph D. Lichtenberg, in attempting to answer the question, "Is there a Weltanschauung to be developed from psychoanalysis?" points out that psychoanalysis, in its mainstream form, can constitute a kind of Weltanschauung, despite Freud's denial

that it does. In Freud's words, a Weltanschauung is "an intellectual construction which solves all the problems of our existence uniformly on the basis of one overriding hypothesis, which, accordingly, leaves no question unanswered and in which everything that interests us finds its fixed place," making one "feel secure in life, . . . know what to strive for, and how one can deal most expediently with one's emotions and interests" (quoted in Lichtenberg, 1983, pp. 203–4). According to Lichtenberg, the conception and use of psychoanalysis as a Weltanschauung is an abuse of it, in that it closes psychoanalysis down, closes it to scientific discovery and innovation (p. 219). It becomes a system of illusion not unlike religion, which Freud attacked as the main threat to—enemy of—the scientific approach, which is adult in its openness to new questions rather than closed because in complete possession of all answers (p. 223). Is Surrealism—and the notion of psychoanalysis as a means of social revolution and change—another misapplication of psychoanalytic understanding, closing it down into a religious Weltanschauung of salvation, insinuating it into every aspect of life as a miraculous method that can solve all problems?

Surrealism is not the Saint Paul of psychoanalytic belief. While refusing the idea that psychoanalysis can function as a Weltanschauung, Freud nonetheless asserted that that psychoanalysis adheres "to the scientific *Weltanschauung*" (quoted in Lichtenberg, 1983, p. 203), falling into subtle contradiction. For by associating science and Weltanschauung, he unwittingly assumes that science will, if not solve all problems on the basis of one overriding hypothesis, function melioristically and thereby effect a discreet, civilizing revolution in life and society. This is exactly what Surrealism assumes. It attempts to show the melioristic—ethical—character of the epistemological revolution wrought by psychoanalytic science. Surrealism regards psychoanalysis as the most revolutionary of the human sciences, that is, the science with the greatest potential for effecting a fundamental beneficial change in human life and society because it demonstrates the fundamentality of the unconscious to the sense of reality.

For Surrealism, such a demonstration makes psychoanalysis a major weapon in the war against miserabilism. It benefits us because it shows our inherent tendency to romanticize, in Novalis's sense—to discover the extraordinary in the ordinary. As such, it is an art as well as a science; Surrealism can be understood to make explicit the implicit artistic character of psychoanalysis, to put it to full artistic use, to reap its artistic benefits. As a science, it is full of "classic pessimism," that is, it is a profound acknowledgment of the depth of the difficulty of achieving reason and realism, and thus of the limitations and incorrigibility of humanity. As an art, it shares the Rousseauian "romantic" belief that "man is by nature . . . of unlimited powers, and if hitherto he has not appeared so, it is because of external obstacles and fetters" (Hulme, 1936, pp. 255–56). Psychoanalysis is shot through and

through with this paradox, which Surrealism vividly articulates. It is extremely sensitive to the misery of life but believes in the possibility of "cure"—of a new "romantic" outlook on life, that is, a fresh integration of personal power that can overcome obstacles with the cunning of reason, that is more than emotionally and intellectually equal to the challenge of reality. In a sense, the Surrealist transformation of the object—the discovery of "the *expectant* character that emanates from surrealist objects" (Jean, 1980, p. 304)—affirms this romanticism in the very act of acknowledging the "pessimistic" character of the world. It involves a romanticizing of pessimistically perceived objects, that is, objects experienced as banal. They are "cured" by Surrealist experimentation with them—transfigured, so that their character is shown to be far from completely exhausted by their banal objectivity, richer in significance than might be imagined from a commonsense point of view. They become at once consciously (pessimistically) known and unconsciously (romantically) experienced, and as such signs of the great mystery of surreality.

It is worth noting that in the context of his discussion of psychoanalysis as a possible Weltanschauung, Freud, in examining "the three forces which can dispute the position of science," mentions art as "almost harmless and beneficent, [because] it does not seek to be anything but an illusion. Save in the case of a few people who are, one might say, obsessed by Art, it never dares to make any attack on the realm of reality" (Freud, 1933, p. 219). But Freud's dismissal of art as an illusion—his careful distinction between "illusion (the results of emotional demands . . .) and knowledge" and his sense that art, like all illusion, "drains off . . . valuable energy which is directed towards [knowledge of] reality and which seeks by means of reality to satisfy wishes and needs as far as this is possible" (pp. 218–19)—ignores art's power to rejuvenate life by romanticizing it. Where common sense deadens, art's uncommon sense revitalizes. Without the energy to live—the energy repressed by common sense, incarcerated by special conformity—knowledge of reality is futile.

Notes

1 Erich Fromm has analyzed the confusion between Freud's concept of psychological repression and the Marxist concept of social repression in his critique of Herbert Marcuse. According to Fromm (1970, p. 28), Marcuse uses "'repression' for both conscious and unconscious data," thus losing "the whole significance of Freud's concept of repression and unconscious. . . . !ndeed, the word 'repression' has two meanings: first, the conventional one, namely, to repress in the sense of oppress, or suppress; second, the psychological one used by Freud . . . namely, to

remove something from awareness. The two meanings by themselves have nothing to do with each other. By using the concept of repression indiscriminately, Marcuse confuses the central issue of psychoanalysis. He plays on the double meaning of the word 'repression,' making it appear as if the two meanings were one, and in this process the meaning of repression in the psychoanalytic sense is lost—although a nice formula is found which unifies a political and a psychological category by the ambiguity of the word." Fromm goes on to say (pp. 28–29) that "the ideal of Marcuse's 'non-repressive' society seems to be an infantile paradise where all work is play and where there is no serious conflict or tragedy Marcuse's revolutionary rhetoric obscures the irrational and anti-revolutionary character of his attitude. Like some *avant garde* artists and writers from Sade and Marinetti to the present, he is attracted by infantile regression, perversions and . . . in a more hidden way by destruction and hate. To express the decay of a society in literature and art and to analyze it scientifically is valid enough, but it is the opposite of revolutionary if the artist or writer shares in, and glorifies the morbidity of a society he wants to change."

2 Surrealism goes through many changes during its development, but the one element that remains constant—through ideological thick and thin—is its critique of the conception of "what is vulgarly understood by *the real*" (Breton, 1972, p. 2). As Breton says, for the Surrealists "reality is not only important theoretically," "but . . . it is also a matter of life and death" (Breton, 1970, p. 31). Breton is skeptical of those who pin "all their hopes on what they choose to call 'reality'" (1972, p. 44) and argues for "a particular philosophy of immanence according to which surreality would be embodied in reality itself and would be neither superior nor exterior to it" (ibid., p. 46).

3 In his critique of psychiatry, Breton anticipates Foucault, Guattari, Laing, and Szasz, among others. Breton's description of "Professor Claude at [the hospital] Sainte-Anne, with his dunce's forehead and that stubborn expression on his face" (Breton, 1960, p. 139)—the psychiatrist who puts words into his patient's mouth, "convicting" the patient of madness—is directly to the point.

4 For an excellent account of the Surrealist attitude to women, see Xaviére Gauthier, 1980.

References

Aragon, L. (1970). *Surrealists on Art,* ed. L. Lippard. Englewood Cliffs, NJ: Prentice-Hall.

Breton, A. (1960). *Nadja.* New York: Grove Press.

———. (1970). *Surrealists on Art,* ed. L. Lippard. Englewood Cliffs, NJ: Prentice-Hall.

———. (1972). *Surrealism and Painting.* New York: Harper & Row.

Freud, S. (1933). *New Introductory Lectures on Psycho-analysis.* Trans. W. J. H. Sprott, rev. J. Strachey. New York: Norton.

Fromm, E. (1970). "The Crisis of Psychoanalysis." *The Crisis of Psycho-analysis.* Greenwich, CT: Fawcett.

209 Gauthier, X. (1980). *Surrealismus und Sexualität, Inszenierung der Weiblichkeit.* Berlin: Medusa Verlag.

Hulme, T. E. (1936). "Reflections on Violence." *Speculations.* London: Routledge & Kegan Paul.

Jacoby, R. (1983). *The Repression of Psychoanalysis.* New York: Basic Books.

Jean, M. (1980). *The Autobiography of Surrealism.* New York: Viking Press.

Kohut, H. (1977). *The Restoration of the Self.* New York: International Universities Press.

Kraus, K. (1977). *No Compromise: Selected Writings of Karl Kraus.* New York: Ungar.

Lichtenberg, J. D. (1983). "Is There a Weltanschauung to Be Developed from Psychoanalysis?" *The Future of Psychoanalysis,* ed. A. Goldberg. New York: International Universities Press.

Rieff, P. (1968). *The Triumph of the Therapeutic.* New York: Harper & Row.

Section Three | **The Position of the Artist in the Modern World**

Mihaly Csikszent-
mihalyi, Ph.D.

The Dangers of Originality: Creativity and the Artistic Process

The exhibition of works from the Prinzhorn collection of psychotic art, which toured various American museums in 1985, raises with a new urgency the old question of the relationship between art and insanity. To what extent is it true that there are common mental processes shared by artists and by people whom we consider to be mentally disturbed? And if there are commonalities, are these inherent to the making of art, or are they due to arbitrary historical accidents? Even though we may have no conclusive answers to these questions, it is important periodically to review the evidence bearing on the issues and revise our tentative conclusions.

It is a widely held belief that men and women who practice the visual arts display a peculiar temperament. Over four centuries ago, Giorgio Vasari described the Florentine artists he knew as having "received from nature a certain element of savagery and madness, which, besides making them strange and eccentric . . . revealed in them . . . the obscure darkness of vice." (Vasari, 1550/1565, p. 232). The notion that artists are, or at least ought to be, somewhat mad acquired further legitimacy from the ideology of Romanticism, and then from the tenets of the various artistic movements at the beginnings of this century.

Over twenty years ago, at the University of Chicago, Professor Jacob Getzels and I began a study of young artists in an attempt to find empirical validation for this portrait of the alienated artist. One part of this research consisted in giving some 200 advanced art students a standard personality inventory, and then comparing

their profile of personality traits to that of a cross-section of people of their age and education who were not in art school. The results clearly showed that there was some truth to the old stereotype.

Young artists of both sexes were very significantly less outgoing and more reserved than average students their age. They were more serious and less frivolous. At the same time, they were less bound by morality and social norms, less conventional, and more imaginative. Art students were high on the need for personal autonomy and experimentation and low on conservativism and dependence. On six of the sixteen dimensions of personality measured by the tests, male and female art students differed very sharply from "normal" students. In addition, their performance on tests that measured patterns of cognitive functioning showed that their thought processes tended to be more original and more informed by a need for novelty (Csikszentmihalyi and Getzels, 1973; Getzels and Csikszentmihalyi, 1976).

What do these differences mean? It seems clear that people who are attracted to art, at least in our culture, tend to be highly individuated persons who stand outside the normal network of social relations and cultural constraints. Their aloofness from conventions is also reflected in the quality of their thinking, which is more "original," that is, unlike what is typical for the culture.

It is very likely that these two patterns are related. To be original, one must distance oneself from the average, from the normal. Those who are too involved in social relationships will have a hard time separating their thoughts from commonly accepted thought patterns. To be original, one must to a certain extent be alienated. The danger, of course, is that originality might slip into autism or into "idiocy," the Greek word for being alienated from the community of one's peers.

The price one pays for originality is already shown clearly in the results of our follow-up study of these same young artists. Twenty years later, the men who had shown the greatest originality in art school and who had the most pronounced artistic personality traits—who were withdrawn, aloof, nonconventional, imaginative, autonomous—were earning significantly less money, had significantly lower social status, and had had much more checkered occupational careers than their less original peers (Stohs, 1984). Yet, surprisingly, it was these "unsuccessful" men who were still painting twenty years later, and the average income from the sale of their art, while still quite modest, was almost twenty times larger than that of their more prosperous colleagues who had found safer and better-remunerated occupations outside the field of art. In other words, originality helps one to become an artist, but it is an obstacle to the achievement of the more conventional rewards dispensed by society.

An even greater danger that confronts those who break away from the safety of shared norms and shared thoughts is that eventually they might lose touch entirely with the commonly held reality and have to spend the rest of their lives exploring the inner

world of their imagination in utter solitude. If that point is reached, the person might be forcibly removed from the community and, like the artists represented in the Prinzhorn collection, be isolated in a mental institution.

What is most striking about the Prinzhorn Collection of art created by hospitalized patients is that the work of the so-called insane is very difficult to distinguish from the work of a sample of representative contemporary "sane" artists. It is quite certain that this would not have been true a hundred years ago, or at any other time in the previous millennia of the history of culture.

Before the turn of the century, most of the pictures in that collection would have been immediately identified as products of abnormality and rejected by contemporary artists as unworthy of their craft. By contrast many young artists today would give an arm and a leg to achieve the nightmarish intensity of Prinzhorn artists like Franz Buhler, reputedly a paranoid with delusions of grandeur; or the serene symmetry of the manic Peter Meyer; or the mastery of color displayed by Else Blankenhorn, who believed she was married to Kaiser Wilhelm and who painted elaborate 300 million billion denomination banknotes to finance the resurrection of the dead.

It is true that when all these pictures are collected in one space, as they were in a recent exhibition at the Smart Gallery of the University of Chicago, and when they are clearly labelled as the work of the insane, we can easily see recurrent formal elements that differentiate them from the majority of "normal" art. There is the famous *horror vacui,* the tendency to fill in every inch of the sheet so that no blank paper is left visible. There is the compulsive piling up of decorative detail, the ritualized repetition of ambiguous symbols. There is the interpenetration of shapes producing shifts in figure-ground perception. There are anguished human faces and malevolent horned beasts. All of these are presumably standard features of schizophrenic art. It is all the more surprising then to reflect that such formal elements, singly or in combination, no longer serve to distinguish these drawings from the work of normal artists. If they were to be hung in any gallery, interspersed among a selection of contemporary drawings, few eyebrows would be raised. In all probability they would be accepted as perfectly valid aesthetic statements. The art of the insane and mainstream art have come to converge and to overlap to the extent that they are no longer separable.

What is the reason for this convergence? I am not trying to suggest that modern artists have all become insane. Nor am I suggesting that the so-called insane represented in the Prinzhorn Collection were prophetic seers who anticipated the shape of Western culture a few generations in advance. The explanation is likely to be less romantic but more complicated and equally thought-provoking.

The reason that the features of schizophrenic art have been assimilated into mainstream artistic expression is part of the general rejection of realistic art, whose aim was to achieve sensory

harmony through "classical" formal devices. In the first two decades of our century, the remaining rearguard of Apollonian art was denounced as the corrupt fantasy of a hypocritical social system. Karsten Harries writes of the great watershed of contemporary art: "Realistic art has become an impossibility" (Harries, 1968, p. 61). Another critic notes: "Reality—that meant allotments, industrial products, mortgages, everything that could be given a price . . . reality, that meant war, hunger, humiliation, power. The spirit knew no reality" (Benn, 1958, p. 245).

Many forces, ideological and material, converged to undermine traditional art. Two ideological blows were especially powerful. The first issued from the writings of Karl Marx. He discredited the autonomy of aesthetics, which ever since Plato claimed a direct line of descent from the sources of ultimate Being. Marxist critics discounted such pretensions by arguing that artistic values and tastes were only an excrescence of property relations, evolved to support the superiority of the ruling classes. Bourgeois art was a weapon in the class struggle; it lent a spurious air of moral superiority to the affluent, who used it to impress and thereby to oppress the exploited masses.

The second main ideological attack came from misguided applications of Freud's work. The discovery of the unconscious suggested, at least to many epigoni of Freud, that the rational harmony of classical art was nothing but a defensive denial of the real dynamics of the psyche. At best, it was sublimation; at worst, it was a repression of men's true desires. What mattered most to people were not the ideals illustrated by the pretty pictures in museums. These were just pale metaphors for the forces that really rule the human psyche. Alerted by such warnings, ambitious young artists eager to show their modernity had no choice but to delve into raw experience, explore the darkest recesses of instinctual striving, in the hope of finding rock-bottom truth in the uncharted regions of the unconscious.

Although it was Hermann Goering, Hitler's *Reichsmarschall,* who said, "When I hear the word *Culture,* I reach for my holster," his sentiment was repeated by Socialists and Anarchists, Futurists and Surrealists, vulgar Marxists and vulgar Freudians, and by just plain fashionable intellectuals all over Europe.

At the same time, historical events of a more concrete nature were operating to discredit traditional art. World War I, with its senseless waste of millions of lives, the Great Depression, which turned long-established social hierarchies upside down, the ill-fated comet of fascism, the Second World War, the nuclear threat—these and other recent events have made the complacent bourgeois culture in which Western art had been snugly ensconced for the past several centuries utterly obsolete.

These real historical events, combined with the theoretical interpretations of Marx and Freud, have forced modern artists to express, in their work, the insanity of contemporary life. In the past, pain and fear could be credibly transformed through a symbolic vocabulary that gave meaning to suffering: It is enough

to think, for instance, of the scenes of Christ's Passion in Western art or the excruciating torture of martyrs like Saint Sebastian, Saint Lawrence, or Saint Catherine, of the various depictions of the Flood or the Last Judgment. These scenes of horror reflecting real historical experiences were redeemed by the belief that for the faithful these sufferings only lasted a short while and were followed by endless bliss.

The modern artist has no access to symbols that will alleviate existential pain. Beliefs that point to a better world are suspect as defenses, rationalizations, repressive ideological constructions. The artist is left to deal directly with the raw suffering of human existence. And when he reaches into the psyche without transforming cultural symbols, what he finds there are the same nightmares that haunt the insane.

Modern art claims to be more realistic than its predecessors, because it penetrates to the roots of human experience. It claims to see beyond the search for visual harmony, which is unmasked as a plot of the ruling classes, as a deception of the superego. The "bottom line" for the ideologists of modern art has been the unadorned animality of man, the instinctual basis of behavior. Only primitive impulses can be trusted; everything tainted by culture is suspect. In the early decades of the century artists like Klee and Chagall turned to the art produced by preliterate tribes, by children, and by the insane because only there could they find an uncorrupted vision.

The problem is that the truth modern art has been seeking is actually rather boring. When stripped of the dreams culture weaves around it, reality is repetitive and confusing. Art in the past tried to move beyond the dismal conditions of existence and create a new reality that did not yet exist. By mistrusting this transcendental project, modern art has run the risk of giving up on the justification for its existence.

Einstein once quoted Schopenhauer as follows: "one of the most powerful motives that attracts people to science and art is the longing to escape everyday life" (Nisbet, 1976, p. 12). This longing was well expressed by one of the young painters I interviewed in the course of our studies. He answered as follows the question "Why do you paint?"

> I like to look at these things, that's why I paint . . . I paint only objects with personal significance, those that have meaning for me. With them I create a little world of my own. In my paintings I usually include New York, cats, my uncle; a car, a railroad, or some other sort of transportation, for instance roller skates; addresses, numbers; a dragon coming out of the kitchen. Once I put a boot in a ship to symbolize a trip to Italy; mother, girl friends, myself; organic shapes— trees, plants . . . these things have many different meanings to me, and I enjoy them all. I would like to fly out of the window like the airplane I paint, or be with the person I like and whom I paint. (Getzels and Csikszentmihalyi, 1976, p. 147)

For this young painter the brush is a magic wand that makes his wishes come true. His charming naïveté is unusual, but in one way or another all artists work in order to "create a little world of their own." And, as Einstein noted, the same is true of scientists. The beautifully ordered universes of Copernicus, Galileo, and Newton, and the elegant systems that describe atoms and galaxies are not "real" in the sense that they exist out there in nature. They are man-made worlds describing a reality that would make no sense unless apprehended through symbolic representations. Modern artists believed they could discover truth in the basic human condition, in the insights of the primitive or the insane. But art cannot discover. It can only create.

The symbolic worlds we interpose between ourselves and reality are indeed a form of escape. They are projections of dreams and desires, of insights and intuitions. The worlds of science and art are not necessarily true or beautiful. But they do provide alternatives to the narrow world our senses and instincts recognize. In this sense, the escape they provide often turns into a new reality. The make-believe order imagined by artists and scientists has a way of convincing people of its truth. Once accepted, their vision does become real; in this sense art and science do transform reality and make cultural evolution possible.

Of course, not all art or all science deals with the creation of new ways of seeing. As Thomas Kuhn (1970) noted, what most scientists do most of the time is "normal science," the systematic exploration of a paradigm made possible by a relatively rare shift in theoretical perspective. A new artistic style, a new expressive form is similarly rare; most artists are busy extending accepted aesthetic formulas to as many different concrete instances as possible. Art, like science, is largely redundant. But, at least in terms of the Western worldview, the highest peaks of art and science are those rare flights of imagination, those great feats of originality that result in the discovery of a new symbolic order.

What does this originality we so highly prize consist of? I would like to define it here as the ability to conceive convincing relationships within a set of imaginary or concrete elements never linked before. How original an idea will be depends on the kind and number of elements it combines and on how compelling the relationship envisioned is. Thus originality ranges from a way of wearing a scarf with flair all the way to a new conception of the universe. An original piece of music will put together a previously nonexistent pattern of sounds; a poem will combine verbal images and rhythms; a painting will blend shapes and colors; and an original scientific theory will bring together seemingly unrelated ideas and facts.

The original artist, for example, is ever mulling over a vast congeries of impressions, looking for a connection, a sudden attraction or resonance among them. Sometimes an unusual shape accidentally encountered, like the distorted shadow of a crane projected on the blank wall of a building, might set off reverberations that evoke other forms, other settings, until the artist,

obsessed by the dynamic geometry that has taken possession of his mind, is forced to start drawing, to cover sheets and canvases with the permutations of the relentless shape.

The impressions artists work with come from many sources. One that is very prevalent among contemporary painters contains the memories of childhood. Whether the viewer realizes it or not, and often also unbeknown to the artist, the images that form the core of a great number of modern works represent the rage or the ecstasy of childhood which the artist tries to recapture in order to integrate it in current experience (Csikszentmihalyi, Getzels, and Kahn, 1984). Such works occasionally achieve a magical synthesis of past and present, an abolition of objective time, a healing through the reactivation of former pain which can now be better tolerated by the mature person. We might call such an achievement "abreactive originality," borrowing a term from psychoanalysis to describe the successful release of psychic tension through the symbolic reordering of repressed traumatic experiences. Of course, these childhood elements are usually unrecognizable in the painting or sculpture, often even to the artist. For years an artist might paint huge canvases of desolate landscapes strewn with mournful monoliths and only gradually realize that what is being explored is the pervasive loneliness of the early years.

A second set of elements that often recurs in contemporary works reflects current pain. For example, an artist might unconsciously represent concern with dissolving relationships through a canvas containing a central shape fragmented into several pieces. A rootlike structure recurring in a series of canvases points to another artist's preoccupation with a chronic spinal disease. Rage at a messy divorce expresses itself through the unprecedented eruption of harsh colors. A move from one location to another will almost inevitably change the content and form of an artist's work: moving from Chicago to the Southwest, for instance, will make the painter's palette much more vivid. In other words, the elements of the new symbolic pattern are often those pieces of the artist's current experience which are the most problematic, the most disruptive. We might speak of "cathartic originality" when a visual structure brings intrapsychic conflict into a more harmonious expression.

A third source of inspiration for the work of contemporary artists issues from conflicts in the sociocultural environment. One painter might become obsessed with the discordant stimuli of city life and recombine on the canvas the spaces, shapes, lights, and movements of the urban landscape. Another will respond to various facets of female experience, as Judy Chicago did, and use these as the elements for new patterns of symbolic order. Many black artists have been moved to explore their Afro-American heritage. Israeli artists can hardly avoid returning to themes inspired by the Holocaust. Some, like Leon Golub, respond to atrocities committed by corrupt representatives of Western power against defenseless inhabitants of the Third World. An increasing

number of artists take as their source of inspiration the conflict between nature and the encroaching forces of technology. Those who succeed in these attempts display "historical originality," in that they relate in meaningful ways the discordant elements in the sociocultural environment. The risk is that of turning art into propaganda, but the potential gains are high. Trying to come to terms with social chaos can be at least as beneficial as exploring personal trauma is.

Theoretically the highest form of artistic inspiration consists in the elaboration of visual impressions, or "formal originality." The artist who is responsive to perceptual elements in the environment, who breaks them up and recombines them in new patterns, is considered the most pure practitioner of the craft. As a virtuoso of vision, the artist expands the use of the eye for processing information. This fourth major source of inspiration is simply the never ending variety of visual stimulation which can be ordered according to many different representational schemes. Practically all of the most influential recent paradigmatic shifts in art, from Impressionism to Cubism to Abstract Expressionism and beyond, consist in new ways of representing a presumably unchanging visual reality.

And this leads us to the last major set of elements that artists usually work with. This includes the world of art itself, the social system and cultural history of art. It is a common complaint among young artists that "contemporary art feeds on art." It is probably accurate to say that the work of most artists does not deal primarily with personal history, with current problems, with the state of the world, or even with immediate visual experience. The average canvas reflects only the reality of the subworld of art. It responds to the latest trends; its elements reproduce elements of former paintings. To understand what a painting is about one must know the recent history of the gallery scene in New York—and that knowledge is usually quite sufficient. "Stylistic originality" consists in a novel recombination of the formal elements used by previous artists.

These five sources provide most of the elements out of which present-day artists attempt to create new patterns of order. Of course, these five are presented here as Weberian "ideal types," as prototypes rather than as mutually exclusive descriptive categories. In reality, works of art usually include more than one of them, and the most original ones might include all five. *Guernica,* for instance, combines elements of Picasso's own personal history, the stresses of his life at that time, and the atrocities of the Spanish Civil War with novel visual symbols and the latest stylistic challenges. In that painting different levels of reality are inseparably integrated: The history of Spain, the history of 20th-century painting, and the history of Picasso from infancy to the time he attacked the canvas.

If we look at modern art this way, the similarities between the praxis of modern painting and schizophrenic art are again quite remarkable. The function of art in both cases is to go beyond a

reality that is difficult to tolerate. "There's just got to be something more!" said one of the artists in our study when asked why he painted. In both cases, the attempt is to restore order in consciousness. Like the young man who painted dragons coming out of the kitchen, mental patients also paint only objects that have personal significance, from which a little personal world can be created. And like these patients, modern artists embark on their journey unprotected by the symbolic shields of cultural values—even though, in their efforts to make sense of their experiences, both use cultural symbols extensively. It is true that the art of the insane contains relatively more attempts at abreaction and catharsis and is less motivated by the solution to visual and stylistic problems than the art we find in normal collections. Yet when everything is said and done, the appearance of the work itself can no longer give an unambiguous clue as to whether its maker is to be counted among the sane or the insane.

As I have tried to argue, the reason for this similarity is that in both cases we are dealing with people who are unusually sensitive, imaginative, and unable—or unwilling—to use the accepted social forms to make sense of their experiences. These similarities presumably have always existed between people who were original but still in touch with the rest of humankind and those who drifted beyond the pale. What is new to our particular historical epoch is that artists have not been able to work within the context of an ordered symbolic universe because the existence of such an order has been discredited. Instead, they were forced to look for patterns among the raw instinctual processes of the psyche. In doing so, they met the psychotic on his own ground, and the two visions became difficult to distinguish.

So far I have been stressing the formal and the functional similarities between the art of normal painters and the art of schizophrenics. It is now time to say something about the differences.

Perhaps the main formal peculiarity of psychotic art is its obsessive detailed repetitiveness. Of course, this is not a necessary distinction either. Many of the works in the Prinzhorn Collection display fluid rhythms, and many modern artists who pass for sane cover the canvases with compulsive detail. But by and large it is true that certified psychotics tend to fill their drawings with redundant ornamentation. This feature reflects a particularly intense need for the schizophrenic to achieve order among the elements of consciousness. It seems that what differentiates most the mental state of the schizophrenic from normality is what psychiatrists have called "stimulus overinclusion." This condition has been defined as "perceptual experiences characterized by the individual's difficulty in attending selectively to relevant stimuli, or by the person's tendency to be distracted by or to focus unnecessarily on irrelevant stimuli" (Shield, Harrow, and Tucker, 1974, p. 110).

The psychotic is flooded with information over which he has no control. Even the simplest choice—what to look at, where to

move his foot—becomes problematic. A patient might say, "My thoughts wander round in circles without getting anywhere. I try to read even a paragraph in a book, but it takes me ages." Or, "If there are three or four people talking at one time I can't take it in . . . I would get the one mixed up with the other" (McGhie and Chapman, 1961, pp. 109, 106). Again, this psychotic experience is on a continuum with the normal: we all occasionally experience similar difficulties in controlling our attention. But apparently for the schizophrenic this is a chronic state. Compulsive drawing might therefore be an enormous relief from the buzzing confusion of the typical schizophrenic experience, especially when all other avenues of expression are blocked. By redrawing the same detail over and over, the patient gets visual confirmation that he can indeed control his attention and temporarily be a master of his own soul.

When normal people are bored at a meeting or a lecture, they will also resort to doodling patterns reminiscent of the psychotic, and for the same reason: to focus attention when the mind, stupefied by irrelevant information, begins to wander. People under pressure who are forced to remain immobile will also doodle compulsively. For instance simultaneous translators at international conferences typically fill out notebook after notebook with ornamental detail or repetitive squiggles as they try to focus their attention on the two streams of language passing through their heads. What for the so-called normals is a temporary crutch, for some schizophrenics becomes a constant need.

The second, and in many ways the most radical, difference between artists who stand on opposite sides of the shifting boundary of normality is that for the insane the world they create is a real world, while the normal artist is aware of the "as if" nature of the world he creates. Adolf Wolfli, the Swiss schizophrenic whose life and work Professor Prinzhorn was able to document quite extensively, apparently believed quite literally that he had visited the various galaxies on those space voyages he described in thousands of drawings. Else Blankenhorn believed that the lovely banknotes she was painting were valid currency. The symbol and the signified fuse in the work of the psychotic; imagination becomes reified. This is the worst danger inherent in originality, that we may lose the distinction between the emergent reality inside our heads and the stubborn reality that resides in the heads of other people or in the physical conditions of the external world.

Life would be a paltry thing if man had to live entirely according to rules set down by genetic heredity or the physical environment. If we could not make up private worlds into which to retreat occasionally, worlds that looked different from the outside world and were differently constructed, the human species would not be distinguishable from other forms of life. The future of our species depends on our ability to conceive of new ways of living, new experiences, new values, new forms of coexistence. In this struggle of the imagination to create a better world the artist,

together with the scientist and with all the other ontological innovators, has an important role to play. But this task, like all the great epic quests, is a dangerous one. If the artist is too sensitive to the limitations of the present reality, if he is too grieviously wounded during his development, he may reject actuality entirely and retreat forever into the world of imagination. When the dialectic tension between what *is* and what *could be* is prematurely resolved in favor of one or the other of the two poles, life becomes intolerably impoverished. Living only in the world as it is, we become mechanical puppets moved by outside forces. And if we disregard what *is* entirely, we are condemned to let our minds be ruled by the random caprice of a brain unequipped to provide order to experience from within its own structure. Thus the art of the insane is a limiting case that shows the power of original imagination, as well as its potential dangers.

Note

An earlier version of this paper was read at the Symposium on Psychoses, Neuroses and Art, held on April 20, 1985, at the University of Chicago. The research reported herein was funded by the Spencer Foundation.

References

Benn, G. (1958). *Essays*. Wiesbaden: Limes.

Csikszentmihalyi, M. & Getzels, J. W. (1973). "The Personality of Young Artists: An Empirical and Theoretical Exploration." *British Journal of Psychology*, 64: 91–104.

Getzels, J. W. & Csikszentmihalyi, M. (1976). *The Creative Vision*. New York: Wiley Interscience.

Harries, K. (1968). *The Meaning of Modern Art*. Evanston, IL: Northwestern University Press.

Kuhn, T. S. (1970). *The Structure of Scientific Revolutions*. Chicago: University of Chicago Press.

McGhie, A., & Chapman, J. (1961). "Disorders of Attention and Perception in Early Schizophrenia." *British Journal of Medical Psychology*, 34: 103–16

Nisbet, R. (1976). *Sociology as an Art Form*. London: Oxford University Press.

Shield, P. H., Harrow, M. & Tucker, G. (1974). "Investigation of

Factors Related to Stimulus Overinclusion." *Psychiatric Quarterly,* 48: 109–16.

Stohs, J. A. (1984). "Midlife Career Paths of Former Art Students." In M. Csikszentmihalyi, J. W. Getzels & S. Kahn, eds., *Talent and Achievement,* pp. 86–119. Chicago: University of Chicago (Research Report)

The Prinzhorn Collection: Selected Work. (1984). Exh. Cat. Champaign Urbana: University of Illinois Press.

Vasari, G. (1550/1565). *Lives of the Most Eminent Painters, Sculptors and Architects.* New York: Random House, 1959.

Aaron H. Esman, M.D.

Cézanne's Bathers: A Psychoanalytic View

The special, even unique, role of the sequence of drawings and paintings of bathers in Paul Cézanne's oeuvre has been pointed out many times. Cézanne's dedication, particularly after his period of quasi-apprenticeship to Pissarro, to the practice of painting directly from what he called the "motif" is legendary. In his letters to and conversations with younger painters he returned relentlessly to this theme. In an early letter to Zola he is explicit: "You know all pictures painted inside, in the studio, will never be as good as those done outside" (Rewald, 1976, p. 112). Indeed, it was his determined pursuit of this self-imposed imperative that led him to his death. As Lindsay (1969) tells it, on October 15, "He started off on foot for the motif (with) his water color knapsack on his shoulder. While he was working a heavy rain storm blew up. For a while he stayed at his easel hoping the weather would clear. Drenched and chilled he at last went off, but the strain of plodding through the storm, hampered as he was, was too much. He collapsed by the road-side and was found later by the driver of a laundry cart who . . . brought him back, half-conscious, to the rue Boulegon" (p. 341). He never recovered; he died a week later.

For the greater part of his long career, Cézanne returned obsessively to the bather theme. Always executed in the studio, rarely, if ever, using live models, the bather scenes occupied an ever greater role in his creative life, as the scale of the paintings grew ever larger and more complex. Such a combination of ruminative preoccupation on the one hand and deviation from

what was for him virtually a moral imperative on the other cries out for interpretation—interpretation that seeks to link aspects of both form and subject matter in a coherent account of the underlying (unconscious if you will) intentions and fantasies that generated this lifelong effort to realize what, for Cézanne, proved endlessly unrealizable.

The psychoanalytically trained aesthetician Ellen Handler Spitz (1985) has definds three ways in which psychoanalysis can be and has been applied to the study of art and the artist. The first of these, the pathographic method, exemplified by Freud's (1910) pioneering essay on Leonardo, seeks to demonstrate connections between the artist's work and the unconscious conflicts that presumably determined it. In this mode the work of art is treated as equivalent to a symptom or dream and biographical data are used in a manner analogous to the analysand's associations.

The second approach is that in which the work of art itself becomes the focus of study. Here the artifact is treated as autonomous and the interpreter seeks, largely through a study of formal and stylistic elements, to explicate the role of defensive and integrative factors. This mode is congruent with psycho-analytic ego psychology.

The third model studies audience response, in which the aesthetic experience is seen as the outcome of the collaboration between artist/artifact and audience. This model correlates with recent object-relations theories such as those of Margaret Mahler and Donald Winnicott and makes use of current studies in early infant development with their emphasis on "attunement" and "fitting together" of mother and baby.

I should like in this discussion to attempt to organize the data along these three dimensions. Although much that I will cite will be familiar (see Reff, 1962, 1983), it may be that a systematic ordering of the material in this way will illuminate some dark corners or bring some elements into sharper relief.

To begin, then, with pathography. The bather theme was the culmination of Cézanne's intensely ambivalent and highly conflicted effort to deal with the human—and particularly the female—figure. Zola depicted it well in his novel *L'Oeuvre* in his description of the artist Claude, clearly modeled on his friend Cézanne: "Chaste as he was, he had a passion for the physical beauty of women, an insane love for nudity, desired but never possessed, but he was powerless to satisfy himself or to create enough of the beauty he dreamed of enfolding in an ecstatic embrace. The women he hustled out of his studio he adored in his pictures, he caressed them, outraged them, even shed tears over his failure to make them sufficiently beautiful or sufficiently alive" (quoted in Lindsay, 1969, p. 101). Cézanne was terrified of physical contact. "Women," he said, "are cows, calculating, and they'd put the *grappin* into me." Thus, his pious statements about his unfulfilled wish to pose models nude out of doors bespeak, not lack of opportunity or, particularly after his father's death, the lack of financial means, but the inhibition imposed by his own fears of women's sexuality. More of this later.

Fig. 1. Paul Cézanne, *Woman Diving into the Water,* 1865–70. Watercolor on paper. Nation Museum of Wales, Cardiff.

The bather theme appeared, in rudimentary form at least, relatively early in Cézanne's work, as early, that is, as 1859, when at the age of 20 he added a sketch of a group of male bathers to the back of one of his letters to Zola, one of those many letters in which the two friends recalled the idyllic outings of their youth along the banks of the Arc. Again, Zola's description is most graphic. "When hardly 12 they learned to swim and they loved to dabble in pools with deep waters, to pass whole days naked, drying themselves in the hot sand. . . . this trickle of pure water . . . prolonged their childhood" (quoted in Lindsay, 1969, p. 16). It has seemed clear to all who have written about it that it was just this wish to recapture and prolong his his early adolescence that provided one of the most powerful motives for Cézanne's lifelong immersion in the bather theme (fig. 1).

The psychoanalyst would note, however, the intensity of this adolescent memory, its idealized and idealizing quality. the (figuratively speaking) roseate aura that seems to surround it, and

228

would wonder if this was not what is knows as a "screen memory." As defined by Laplanche and Pontalis, the screen memory is "a childhood memory characterized by its unusual sharpness, and the apparent insignificance of its content. The analysis of such memories leads," they say, "back to indelible childhood experiences and to unconscious fantasies" (1973, pp. 410–11). In the absence of data we are, in the best pathographic fashion, left to speculate on the nature of those screened-over experiences and fantasies. Our knowledge of normal early adolescent development would certainly lend support to the conjecture, adumbrated by Meyer Schapiro, that these Arcadian nude disportings may well have stimulated homoerotic fantasies, even experimentation of one sort or another. Could it be that this man whose life was characterized by unremitting conflict with and paranoid fears of women, longed nostalgically for a youthful period of untroubled, guiltless, doubtless unconscious but deeply felt erotic pleasure? Certainly he never experienced such unalloyed delight in any of his relations with women, including (or particularly) with the woman he reluctantly and belatedly made his wife and whose company he subsequently avoided as much as possible.

Not, of course, that his homoerotic longings were in later years free of conflict, however they may have been disguisedly expressed, or, in the jargon, "sublimated," in his work. Emile Bernard told of a day when, "coming home from the motif they took a shortcut on steep ground. Paul, ahead, caught his foot and

Fig. 2. Paul Cézanne, *Bathers*, 1895–1900. Pencil and watercolor on paper. Bridgestone Museum of Art, Ishibashi Foundation, Tokyo.

almost fell. Bernard took hold of his arm to steady him. Paul exploded with rage, cursed furiously, pushed Bernard off, and dashed away throwing wild, terrified glances over his shoulder. Bernard followed him to the studio and tried to explain, but Paul, with his eyes starting out of his head, wouldn't listen. 'I allow no one to touch me. Nobody can put his *grappin* on me'" (quoted in Lindsay, 1969, p. 327). This violently paranoid reaction strongly suggests that Cézanne was in terror of homosexual assault from behind—doubtless the legacy, in part at least, of his conflictual passive submission to his father's tyrannical domination, but also reflecting the rigid repression and projection of his own homosexual impulses. Yet these occasionally broke through, as in the watercolor *Male Bathers* (1900; fig. 2), of which Geist says, "The work is agitated, both in the artist's touch and in the gestures of the man. The reason is not far to seek: The second figure, facing the seated first bather, has a well-defined phallus which is flung or pointed upward, the only unequivocal rendering of this feature in the oeuvre, replete as it is with images of nude men in all mediums" (1985, p. 19). Geist omits to say, however, that this rampant phallus not only faces the "seated first bather" but is at the level of his mouth.

Another such breakthrough can be seen, I believe, in the 1875–80 painting (and its preparatory drawing) *The Battle of Love* (fig. 3). In this classically derived compendium of primal scene fantasy, the two nude figures grappling in the center of the composition are both unmistakably female. This is, I would suggest, a striking representation of Cézanne's presumably unconscious fascination with homoerotic recreation. One could conjecture, therefore, that the strict sexual segregation characteristic of the Bather paintings was multiply determined not only by his defensive need to avoid the anxiety inherent for him in the heterosexual confrontation, but also by the pressure for gratification of his unconscious homosexual urgings.

Reff (1962) has directed our attention to another group of bather images—that of the solitary male bather with outstretched arms (fig. 4). This subject is based on an enigmatic posture which, Reff has shown in a scholarly tour de force, evolved through a series of drawings that, he suggests, implies a specific sexual conflict for which Cézanne found a representable compromise. Reff's interpretation is plausible and internally consistent though, of course, impossible of substantiation. We can certainly believe that Cézanne was as guilt-ridden about his masturbatory impulses, rooted as they must certainly have been in fantasies of the most exquisite perversity, as he was about his manifest sexuality.

Were it not for Reff's meticulous reconstruction of the evolution of this image, we could, perhaps, add yet another to that catalog of formal explanations he has dismissed. The figure in question is clearly the same as the one represented in the Museum of Modern Art's *Bather* (fig. 5). It would seem somewhat arbitrary to subject one of these images to psychosexual in-

230

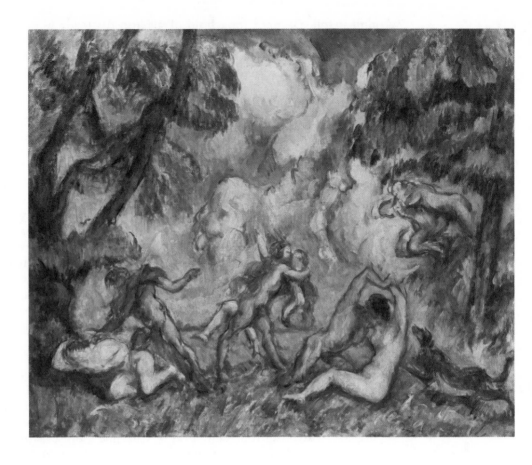

Fig. 3. Paul Cézanne, *The Battle of Love,* 1875–80. Oil on canvas. National Gallery of Art, Washington, D.C. Gift of the W. Averell Harriman Foundation.

terpretation to the exclusion of the other. This bather is standing—or striding—on what is clearly level terrain. Unlike him the man (or boy) with outstretched arms appears to be standing on a rocky promontory, on unstable or uneven ground.

The body language of his posture, in this painting at least, is that of a man attempting to balance himself as one would in walking a narrow plank or in crossing a stream on stepping stones. His intent downward gaze would seem to support this reading. Now a contemporary self-psychologist of the Chicago school might well read this posture as a visual metaphor for a man seeking to maintain the balance of his self-organization, to avert disequilibrium or, even, the disintegration of the self. Certainly this reading, which I do not necessarily recommend, could readily apply to Cézanne, who was engaged through his adult life in a continuous struggle against dark inner forces that threatened constantly to disrupt his psychic integrity. The *Bather with Outstretched Arms* may indeed, then, be a disguised self-portrait, but of what aspect of the self is not entirely clear.

This brings us to our second model of psychoanalytic investigation of art—the study of the artwork as autonomous and of the

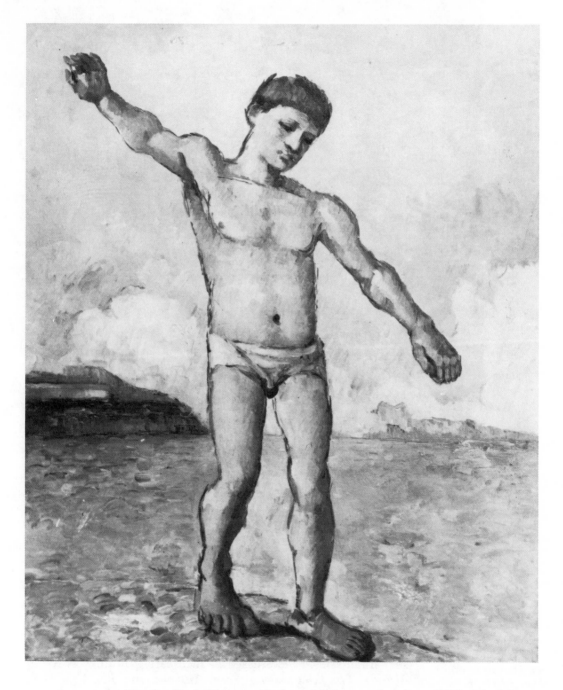

Fig. 4. Paul Cézanne, *Bather with Outstretched Arms,* 1885–87. Oil on canvas. Private collection, Paris.

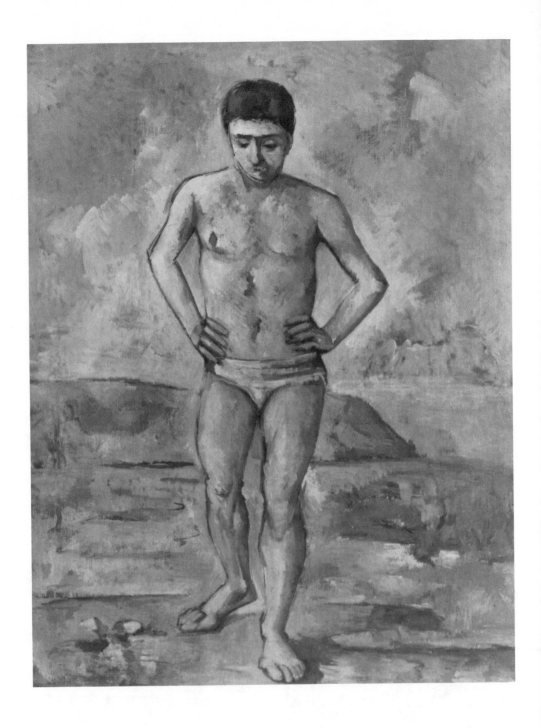

Fig. 5. Paul Cézanne, *The Bather,* c. 1885. Oil on canvas. The Museum of Modern Art, New York. Lillie P. Bliss Collection.

characteristics of style. It has often been said that Cézanne's defensive posture against his turbulent, violent, and perverse sexual fantasies, as expressed in such early paintings as *A Rape, A Murder, The Temptation of Saint Anthony,* and *The Wine Grog* is represented in his mature work by an increasing classicism. Nowhere is this better shown than in the late bathers (figs. 6 and 7)

with their friezelike groups of figures, each in its static posture in a shallow space; as Reff has said of the early *Bathers at Rest* (fig. 8), "in total estrangement from each other." The figures became, as Krumrine (1980) has put it, increasingly like statues, frozen in their gestures, uncommunicative. Krumrine has likened the framing trees in the late (last?) Philadelphia version (fig. 6) to a "Gothic arch." I would suggest, however, a closer resemblance to a classical pediment (fig. 9), in which figures are molded to fit the confines of the architectural structure. This would represent the ultimate statement of Cézanne's classicizing defense and the clearest visual expression of his lifelong admiration of classical models in literature and in art.

The increasingly "abstract" quality of the figures in the Bathers series raises an important, if unanswerable question about the nature of artistic choice. Was Cézanne's progression from Romantic excess to near-Cubist abstraction the consequence of conscious intention based on purely aesthetic decisions, or, in psychoanalytic jargon, on the operation of autonomous ego functions? Or, to what degree was it the result of increasingly rigorous defensive efforts to maintain the repression of intense and often perverse erotic fantasy? One cannot, of course, know. But in Cézanne's case the defensive contribution must have been great indeed. In his study of Michaelangelo, Leibert (1983) says, "the manifest solution of the latent and unconscious conflict in the artist, the work of art *does not* have the effect of 'working through'—that is, of permanently altering the central mental representation of himself and of others and bringing about basic changes in other aspects of his internal psychological organization and outlook. Thus, as each artistic endeavor inevitably fails in this respect, the underlying conflict will reappear. Each new artistic solution to it will be somewhat different from the previous one but still motivated toward a similar end" (p. 6).

It would seem that, given the obsessive repetition of the bathers theme in his work, Cézanne was never able to achieve a true conflict resolution; he was internally compelled to return to the theme over and over again, each time attempting yet another variation to address yet another aspect of the conflict. In this view I part company with John Gedo (1983), who has suggsted that Cézanne was able to "execute works of the highest order when neither the medium nor the subject matter impinged on his delusional world" (p. 193). The subject matter of the bathers impinged directly on Cézanne's delusional—or better said, intensely conflictual—world; Cézanne was able nonetheless to create masterpieces around it through a definable system of defensive measures leading to successful compromise formations through which his forbidden impulses could achieve acceptable or nonthreatening expression—an expression that eluded him in his daily life.

I have a further suggestion, which I offer with some diffidence and hesitation. The frontally aligned figures occupying the shallow space of the later bathers evoke in me another association with

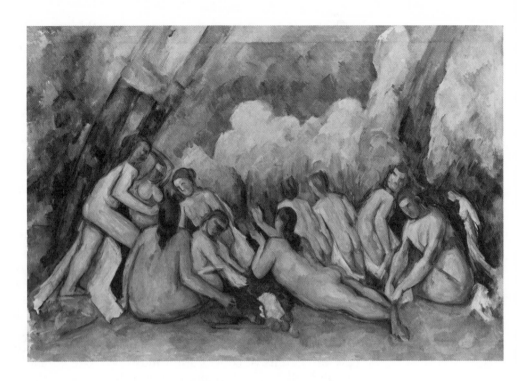

Fig. 6. Paul Cézanne, *Bathers,* 1900–06. Oil on canvas. National Gallery, London.

classical art, that of the Hellenistic or Roman sarcophagus of the sort that Cézanne could have seen in his wanderings through the Louvre. Could it be that Cézanne in these culminating works was looking not only backwards to his idyllic athletic youth, but also forward to the stillness of death? Certainly in his late years, from 1895 on, he was preoccupied with death. Reff (1983) has demonstrated for us the reiterative nature of this theme as exemplified with increasing frequency in Cézanne's paintings of skulls, on some of which Bernard saw him working in 1904 while he was also struggling to complete his *Large Bathers.* While these last works anticipate the future of painting in the 20th century, their influence surely seen in what has been called the first painting of the 20th century, Picasso's *Les Demoiselles d'Avignon,* painted only two years after Cézanne's death, they may also have for Cézanne anticipated his own inevitable and impending future. Can it be, then, that the river in these final summations of his life's work represented for Cézanne not only the Arc but the Styx?

When we turn to the third of Spitz's modes of inquiry, that of aesthetic response, we find ourselves on less solid ground—in the realm of phenomenology rather than hard data, reliant more on theory than fact. In general terms we deal with what Winnicott (1951) called "transitional phenomena," with intersubjectivity, with the mystery of affective communication, with the question of the degree to which the viewer's affective experience mirrors or resonates with the experience—never mind the intention—of the artist. Certainly Cézanne tells us over and over again of the

235

intensity of his absorption in, even his sense of identity with, his "motifs." At the same time, according to Gasquet, he describes the response to painting as a experience of fusion with the work and of merging with the artist:

> [A painting is] an abyss in which the eye is lost. All these tones circulate in the blood. One is revivified, born into the real world, one finds oneself, one becomes the painting. To love painting one must first have drunk deeply of it in long draughts. Lose consciousness. Descend with the painter into the dim tangled roots of things, and rise again from them in colors, be steeped in the light of them. (Quoted in Milner, 1957, p. 25)

There is good reason to believe that Cézanne, like every painter his own first audience, must have experienced something akin to this loss of distance with his bathers, given the persistence of his absorption with this theme. The viewer's aesthetic response to them will, of course, be determined by his own life experience, aesthetic sophistication, conflicts, and the like. But he is certainly helped in achieving the kind of response Cézanne describes by certain elements of the manifest content—the omnipresence of water, for instance, with its oral and tactile associations; the "primitive" quality of the figures in their Arcadian setting; their vague and sometimes undefined gender features, all of which seem to promote the viewer's access to the kind of early develop-

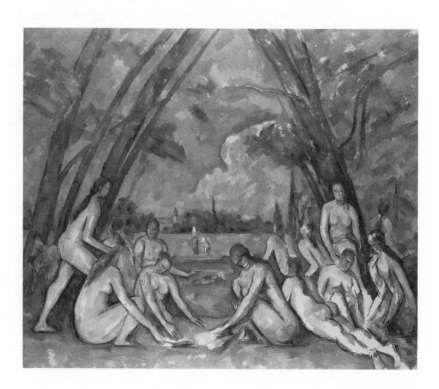

Fig. 7. Paul Cézanne, *The Large Bathers*, 1906. Oil on canvas. Philadelphia Museum of Art. Purchased: W. P. Wilstach Collection.

236

mental experience of which Cézanne speaks, which in Kris's terms could be considered a "regression in the service of the ego," generating what Rose (1980) calls "controlled ambiguity," or, in Keats's words, a "negative capability" that is the essence of aesthetic response.

The appeal of Cézanne's bathers has always been something of an enigma. What in these pictures, with their ungainly, manifestly de-erotized figures, sketchy in their nervous outlines or rendered more solidly, but without the sensuousness of Courbet's or Manet's nudes—what leads us to deal with them as masterpieces, linger over them with a pleasure that to a modern viewer transcends that which we experience before Renoir's libidinous lushness? Cézanne, it seems to me, fulfills to a remarkable degree Freud's early formulations of the artist's psychology and of the aesthetic experience—formulations that have generally been superseded by more "up-to-date" ego-psychological ones. In 1911 Freud said, "the artist is originally a man who turns away from reality because he cannot come to terms with the renunciation of instinctual satisfaction which it at first demands, and who allows his erotic and ambitious wishes full play in the life of fantasy. He finds the way back to reality, however, from this world of fantasy

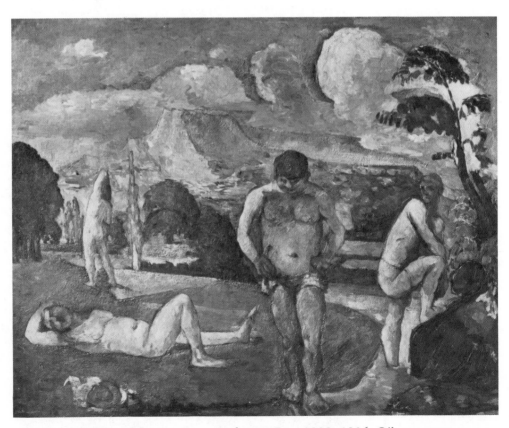

Fig. 8. Paul Cézanne, *Bathers at Rest,* 1895–1906. Oil on canvas.
© Copyright The Barnes Coundation, Merion, PA.

Fig. 9. Reconstruction of the East and West Pediments, Temple of
Zeus at Olympia, 5th century B.C. After Franz Stucnicka. Re-
produced by permission of Hermer Fotoarchiv, Munich.

by making use of special gifts to mold his fantasies into truths of a
new kind which are valued by men as precious reflections of
reality" (p. 224). And in 1913: "He represents his most personal
wishful fantasies as fulfilled; but they only become a work of art
when they have undergone a transformation which softens what is
offensive in them, conceals their personal origin and, by obeying
the laws of beauty [!!] bribes other people with a bonus of
pleasure . . . art is a conventionally accepted reality in which,
thanks to an artistic illusion, symbols and substitutes are able to
provide real emotions. Thus art constitutes a region halfway
between a reality which frustrates wishes and the wish-fulfilling
world of the imagination" (pp. 187–188).

This statement may fail of applicability to many artists, even to
Cézanne in much of his life work. But in the case of the bathers it
strikes me as stunningly appropriate. Cézanne was, it appears,
beset for a lifetime by fantasies of sexual abandon, consumed by
voyeuristic and bisexual longings which he was internally com-
pelled to hold in check. Schapiro (1958) suggests that in his still-
life paintings he achieved even more successful disguise through
his beloved apples—apples of love, apples of seduction. In the
Bathers, however, without abandoning the figure, he succeeded in
transforming his forbidden erotic fantasies into the pure gold of
art.

Yet all this being said, we must be modest in our pretentions to
explanation. Merleau-Ponty says, "If Cézanne's life seems to us to
carry the seeds of his work within, it is because we get to know
his work first and see the circumstances of his life through it,
charging them with a meaning borrowed from that work. . . . His
life was the projection of his future work" (1948, p. 20). From the
complex tapestry of his life we select threads that provide us with
the illusion of understanding; there is nothing more we can do.
But we are far from truly understanding what made him
Cézanne—what enabled this son of half-educated provincials,
growing up in relative isolation from the centers of culture, in an

environment hostile to all advanced trends in art and politics, burdened himself with conflicts that are, in the end, ubiquitous and fairly banal—what made it possible for him to become the greatest painter of his time and the *fons et origo* of the art of our century.

References

Freud, S. (1910) "Leonardo da Vinci and a Memory of His Childhood." *Standard Edition*, 11:59–138.

———. (1911). "Formulations on the Two Principles of Mental Functioning." *Standard Edition*, 12:213–26.

———. (1913). "The Claims of Psychoanalysis to Scientific Interest." *Standard Edition*, 13:163–90.

Gedo, J. (1983). *Portraits of the Artist*. New York: Guilford Press.

Geist, S. (1985). "Cézanne's Watercolors." *New Criterion*, 3:14–22.

Krumrine, M. (1980). "Cézanne's Bathers: Form and Content. *Arts*, 54:115–23.

Laplanche, J. & Pontalis, J. B. (1973). *The Language of Psychoanalysis*. New York: Norton.

Leibert, R. (1983). *Michelangelo*. New Haven: Yale University Press.

Lindsay, J. (1969). *Cézanne: His Life and Art*. New York: New York Graphic Society.

Mahler, M. et al. (1975). *The Psychological Birth of the Human Infant*. New York: Basic Books.

Merleau-Ponty, M. (1948). "Cézanne's Doubt." In *Sense and Non-Sense*, pp. 9–25. Chicago: Northwestern University Press, 1964.

Milner, M. (1957). *On Not Being Able to Paint*. New York: International University Press, 1973.

Reff, T. (1962). "The Bather with Outstretched Arms." *Gazette des Beaux-Arts*, March, pp. 173–90.

———. (1983). "Painting and Theory in the Final Decade." In W. Rubin, ed., *Cézanne: The Late Work*, pp. 13–54. New York: Museum of Modern Art.

Rewald, J. (1976). *Letters of Cézanne*. 4th ed. New York: Hacker.

Rose, G. (1980). *The Power of Form*. New York: International Universities Press.

Schapiro, M. (1958). "The Apples of Cézanne." In *Modern Art: Selected Papers*. New York: Braziller, 1978.

Spitz, E. (1983). *Art and Psyche*. New Haven: Yale University Press.

Winnicott, D. (1951). "Transitional Objects and Transitional Phenomena." In *Through Pediatrics to Psychoanalysis*. New York: Basic Books, 1975.

Catherine C.
Bock, Ph.D.

Henri Matisse's Self-Portraits: Presentation and Representation

The artist's self-portrait has long been a vehicle of self-presentation to patrons and to a wider public. In modern times, however, the painted self-portrait has frequently functioned as a vehicle of self-discovery, wherein the artist re-(re)presents himself. Confronting himself initially (and literally) in a mirror image, the artist re-presents himself in the further doubling of the mirror image by means of the one he or she creates on the canvas. The latter represents a further objectification of the self. On the other hand, the painted self-portrait subjectivizes the artist's image through his inner self-reflection—self-knowledge acting as a "corrective" to the mere mirror likeness. Although the result of this self-finding, the finished canvas or print, is sometimes made available to the public, the essential nature of the searching self-portrait is private. Its end is the activity itself, as a means of self-understanding or self-affirmation. The public exhibition of these expressive modern self-portraits, of course, works (and often consciously on the part of the artist) either to reaffirm or to alter the public's conception of the artist-subject and what it may expect from him or her.

The French painter, Henri Matisse (1869–1954), I propose, engaged in two kinds of self-portraiture throughout his life. In his drawn and painted images he was engaged in the interrogation of self, a private scrutinizing meditation on his own countenance for the purpose of finding and centering his personality. I would suggest that this mode, a mostly—but not exclusively—modern phenomenon of psychological self-consciousness, even narcissism, corresponds to the traditional notion of the "true" portrait, that is,

one which, while achieving a reasonable likeness, disengages as well the character, temperament, and distinctive traits of the sitter and in so doing tells the viewer something of a more general nature about human beings. Matisse himself so defined the core of artistic representation: "There is an inherent truth which must be disengaged from the outward appearance of the object to be represented . . . [in the case of portraiture] the expression of the intimate character and inherent truth of the personality" (quoted in Flam, 1973, pp. 173–74). He wanted to reach, as Gertrude Stein said of her literary portraits, the "bottom nature in people" (Stein, 1935, p. 138).

The second type of self-portraiture or self-portrayal by Matisse, I would suggest, is that of the photographic portrait, taken by another, of the artist in his studio. In these, Matisse presented himself to his public as a particular kind of man, an artist, and thereby educated his audience about his character and the role of the modern artist more generally. As an artist with a traditional academic fine arts education, Matisse was fully aware of the nature of courtly or formal portraiture and its function as propaganda in the broadest sense. Official portraiture conveys an image of a private person as a public one, through a conventional pictorial rhetoric that both mirrors and helps to shape a society's values. As a man whose first thirty years were lived in the nineteenth century, Matisse saw this genre of painted portrait gradually replaced by the official portrait photograph (English, 1984). In the same period, Matisse witnessed the rise of the journalistic interview which, by quoting the subject directly, becomes a vehicle of immediate self-presentation by the interviewee. Matisse personally favored this type of interview-article. It parallels the photographed portraits as a public "self-image" that the artist was able to utilize to his advantage.[1]

Matisse's life, both as man and artist, was essentially self-absorbed and self-centered. In his youth, he confessed, he had found his individual style by reaching within himself, by consulting his own desires: What do I want? he asked himself (Flam, 1973, p. 132). Later, he admitted to seeking through art to understand himself (Flam, 1973, p. 72). Despite this, Matisse made surprisingly few self-portraits. For the most part, he counted on identification with his model, that is, the objects or persons that were the subjects of his plastic transformations, to reveal and to release certain qualities in himself.[2] But he characterized, nevertheless, all of his work as a kind of portraiture: he quoted Rembrandt with satisfaction as saying that after all he (Rembrandt) had done only portraits. And Matisse's own last word on art was an essay entitled "Portraits," published in the year of his death, which accompanied a luxury volume of reproductions of his work in that genre (Flam, 1973, p. 150).[3]

Let us briefly look at the first type of self-portrait: the indisputable, handmade *autoportrait*. The artist executed only 4 known self-portraits in oil or, possibly, 5, if one counts the double portrait with his wife, *Conversation*, of 1909. (I am excluding in

this paper the canvases in which the artist included himself as the painter of the model.) Self-portraits in the graphic media are more numerous but tend to cluster in particular periods: about 1900, 1 etching-drypoint and 16 drawings, of which 12 are substantive studies of the head (7 front face); and in 1912, 2 casual sketches. Between 1916 and 1923 there are 8 quick sketches and 1 lithograph, the latter a carefully worked out frontal study of the head. After this, aside from a few occasional single sketches, there are 3 isolated suites of self-portrait drawings in 1934–35, in 1937, and in 1939. During World War II (1940–45), Matisse drew his own countenance on 3 separate occasions, resulting in some dozen drawings. In the late 1940s he made a group of self-portrait lithographs and, in 1952, two years before his death, 3 known frontal self-portrait drawings.[4] These some 60-odd drawings and 10 prints seem fairly numerous, unless one sees it as the production of over sixty years in which Matisse drew every working day and in which for some extended periods drawing was his primary medium. It appears still more meagre when we learn that the artist did hundreds of drawings of a single model until he had understood that model from within.

In his essay "The Psychodynamics of the Frontal Self-Portrait," Francis V. O'Connor establishes a model of the human life course as a tool, a heuristic device, to analyze an artist's stylistic and iconographic development (O'Connor, 1985, pp. 175–85). O'Connor shows that dates of artists' frontal self-portraits tend to correlate with periods that he terms ones of "situational transition" in the life course of the artist (changes in health, career, marital situation) or with points of natural transition in the life cycle (the onset of middle age, retirement, etc.). The calm, hieratic self-portrait, O'Connor postulates, signals a process of self-integration, literally "centering," that the artist is undergoing at such potentially disorienting transitional points in his life. The model O'Connor constructs is particularly useful for the person who lives to an advanced age: it is comprised of two 49-year (7 × 7 years) major phases, subdivided into four eras of 7-year cycles (3 and 4, 3 and 4). Crucial changes would then occur at ages 21, 49, and 70.

At 21, the first three 7-year cycles of childhood, puberty, and youth are completed; at 28, professional training is finished, original work commences and, at 35, the artist is capable of sustained self-renewal or, alternatively, cedes to sterile repetition or self-doubt. The period of age 42 through 49 is that of high maturity as well as of the classic "midlife crisis" with its task of "creating and sustaining a more centered sense of self." O'Connor characterizes the next three-cycle period—from ages 49 to 70—as one of "self-patronage," when the person establishes his or her own interiorized goals, enjoys recognition, and undertakes mentorship. In this period, a person discards acculturated masks for the honor of pleasing oneself. O'Connor terms the last era—age 70 to the end of one's life—the era of abstraction, the reduction and simplifying of experience. Along with a certain "creative

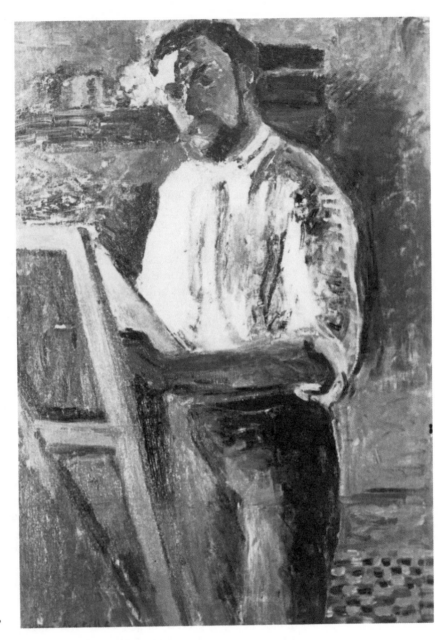

Fig. 1. Henri Matisse, *Self-Portrait at the Easel,* c. 1900. Oil on canvas. Private collection. © ARS, NY/SPADEM, 1987.

isolation, the art of the aging shows 'a retreat from realism, an impatience with established technique and a craving for complete unity.'"

Now Henri Matisse is not mentioned in O'Connor's article, but the French painter's groups of self-portraits cluster at points in his life in such a way as to conform perfectly to the conceptual model. Even more intriguing, as we shall see, is that the photographic portraits seem also to relate to transition points in the artist's life. Accompanying the handmade self-portraits, they often provide a public counterimage to them. What is more, in every

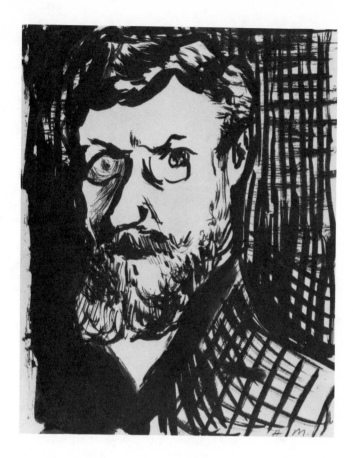

Fig. 2. Henri Matisse, *Self-Portrait,* 1900. Brush and ink. Private collection. © ARS, NY/SPADEM, 1987. Photo: MNAM, Centre G. Pompidou.

self-portrait "cluster" executed by Matisse there is at least one frontal head study. It is the frontal self-portrait that O'Connor persuasively argues is a significant icon of well-being, power, and harmony with the universe.

The greatest number of Matisse's self-portraits were made around 1899–1900; that is, beginning the fifth cycle of 7-year periods at about 29 years of age. In 1898, the artist had lost his beloved teacher, Gustave Moreau. Matisse had married in January of the same year and by 1900 was the father of a daughter and of two infant sons under two years of age. The still unknown artist found himself back in Paris with little means of support for his family and with an artistic reputation and career at loose ends. This personal and professional uncertainty, however, was countered by the "revelation" he had had of pure color during a year spent in Corsica and southern France (January 1898 to January 1899), a revelation that brought him firmly into the camp of modernism, by way of Impressionism. Artistically, he felt he had found his true path; ironically, it was at the price of totally alienating his father, a businessman, upon whom he was, to that point, still totally dependent.[5] These turning point years, 1898–1901, are rich in ambivalent self-portraits.

Two oils of this period *Self-Portrait at the Easel* (fig. 1) and *Self-Portrait* (1900; Schneider, 1984, frontispiece) convey the tension

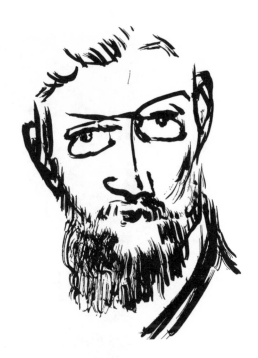

Fig. 3. Henri Matisse, *Self-Portrait,* 1900. Brush and ink. Private collection. © ARS, NY/SPADEM, 1987.

in the artist's image of himself. They also set forth the two types of portraits we have distinguished above: the artist demonstrating his *métier* (the *beau portrait*) and the artist as an emerging individual (the *vrai portrait*). At the easel, as a painter, Matisse is not without dignity, even authority, but the style is curiously tentative. The color hesitates between light-inflected local hues and the divided tones of Impressionism. The artist's blurred form struggles to assert itself in clarity of space and contour; he is portrayed as an emerging apprentice to the shaping of his own brand of modernism. The not-quite frontal head of the other portrait is surely one of the most expressive, or Expressionist, images Matisse ever produced. The face strains to compose itself from the sonorous, unresolved inferno of acid purples and reds. The expression is agonized, as of someone on the edge of his nerves; the mouth opens on a soundless utterance. To the left is an almost obliterated easel (or canvas); behind, a door filled with mysterious blue light beckons. Because of his wretched financial situation in these years, Matisse seriously considered abandoning his career as an artist. It was a temptation he overcame.[6]

The more intimate drawings of 1900 convey the same irresolute search for control: the pen drawings obsessively scan the page in search of form and solidity, the thin professional visage peers at itself anxiously through opaque spectacles (fig. 2) or comforts itself with pipe-and-old-cap familiarity. The final centered images are of an absorbed artisan's concentration in the engraving, *Self-Portrait as Etcher* (in Barr, 1951, p. 312), and of severe discipline and fierce purpose in the brush and ink drawing, whose frontal version projects an air of stern triumph and authority (fig. 3). This

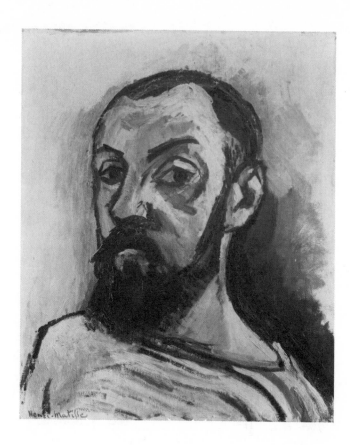

Fig. 4. Henri Matisse, *Portrait of the Artist,* 1906. Oil on canvas. Statens Museum for Kunst, Copenhagen. Photo: Hans Petersen.

largest body of Matisse's self-portraits conveys the dramatic contest between timid discouragement and bold self-confidence that marked a period of rapid change in the artist's life and of accelerated professional growth.

Six years later, the artist painted himself again, this time in a pose and style reminiscent of Cézanne (fig. 4). Though not fully frontal, the effect is highly confrontational, bold, yet diffident, forceful, yet with a youthful defiance. The artist is here 36 years old, beginning the second cycle of the second era of O'Connor's schema. Matisse had just been identified in the previous year, 1905, as the leader of a new movement of young colorists labeled Fauves. Matisse had found his public and a set of powerful patrons, but at the price of a certain noisy notoriety that was foreign to his cautious nature. The artist was about to begin a decade of his strongest and most innovative work. The image shows him fully cognizant, and wary, of its challenges, yet confident of its fruitful outcome. The striped sailor's jersey and bold paint handling suggest a vigorous new embarkation. In a letter to his painter friend, Henri Manguin, from the summer the self-portrait was painted, Matisse wrote: "I am completely absorbed in painting, trying to see a little further, and, above all, trying to collect and organize my sensations. I think back continuously over

ouré de légendes ! Les
des êtres mythiques il
ntemporain qui est un

; il fait envie ; il fait
C'est un toqué, voilà
ntis qu'il est sincère ! "

Henri Matisse
(par lui-même)

Fig. 5. Henri
Matisse, self-portrait
illustration. *Cahiers
d'Aujourd'hui*, 1913.

the work I have done in the last ten years—and I tell myself that
the main thing is to be completely myself" (quoted in Schneider,
1984, p. 730).

It was not until six years later that the artist put forth another
self-portrait. He made a small frontal self-portrait that was pub-
lished as the frontispiece of a major article on his work, written
by his friend, the socialist deputy of Montmartre, Marcel Sembat
(fig. 5). That article of 1913 signaled Matisse's full acceptance—at
43 years, beginning the last cycle of the second era of O'Connor's
life course—in Parisian modernist circles, despite the fact that
Cubism was the reigning style. The tendency toward caricature, or
at least a portrayal that shows the artist wide-eyed and still a bit
credulous, may be an antidote to the suave photographed portrait
of 1911 (Aragon, 1971, 1:163). Taken in Moscow, where he was
feted as a major international figure, and published there in a
contemporary journalistic account of his visit, the photo shows the
artist under his portrait, *Girl in Green Dress* (1909), in the house
of his Russian patron, Shchukin.[7] Another elegant portrait of the
period, Edward Steichen's photo of c. 1910 (fig. 6), was published
in *Camera Work* in 1913. (We will return to this photo later.)

Matisse had by 1912 earned a European reputation of consider-
able distinction, but when he reopened a studio in Paris in 1913 it
was as an apprentice to the "methods of modern construction"
developed by his younger peers, the Cubists. The sketch for

Sembat's article shows a man self-assured enough to indulge in a little public self-mockery; it matches the tone of the article itself, which opposes the still-prevalent notion of Matisse as a *naïf* or a charlatan with the author's own view of the artist as a sober and accomplished searcher for essentials through a process of abstraction.

Matisse painted his last self-portrait in oil as he approached the age of 49, the end of the first large phase of his life cycle.[8] In 1918, just before settling in at Nice where he was to live the remainder of his life and just before the change of style that marks off the 1920s, Matisse summed himself up in a full-figure portrait (fig. 7). He shows himself at work in a small hotel room; the expected Riviera sunshine had not materialized, so the painter utilized his time indoors to paint himself. All respectability in his three piece suit, using the suitcase at his feet as an improvised easel, he dominates the picture-plane, spilling out of the frame on three sides. The umbrella in the bucket, hooking over the washstand, wittily echoes the paintbrush in his hand. The washstand, with its splash-board, itself mimics a still life painting with basin and pitcher, a pseudo-canvas of the same shape as the palette hooked on the artist's fleshy thumb. The color scheme is subdued, even realistic, except for the cheeky, coral-pink floor that, refus-

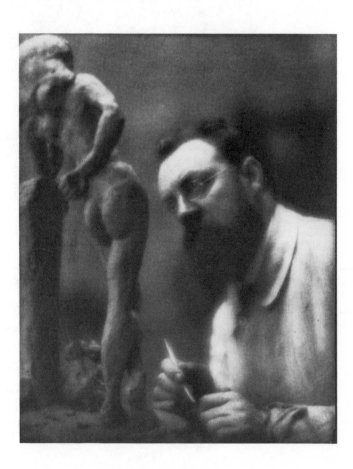

Fig. 6. Edward Steichen, *Henri Matisse,* c. 1910. From *Camera Work,* 1913, 42–43. Photogravure. The Museum of Modern Art, New York. Gift of William A. Grigsby.

248

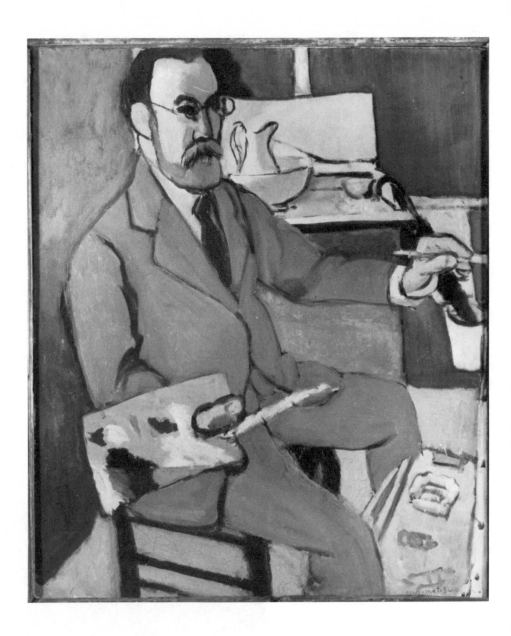

Fig. 7. Henri Matisse, *Self-Portrait,* 1918. Oil on canvas. Musée Matisse et Herbin, Le Cateau, France.

ing to recede in perspectival depth, jumps instead to the flat of the plane, asserting its artificiality.

The audacious pink floor in a seemingly sober portrayal suggests that there are other displaced signals in the canvas. Jack Flam calls attention to "the position of the paintbrush he holds in his palette hand (set right next to his meaty thumb), which thrusts across his trousers like an erect phallus." Certainly, Matisse's way of life at 48 years of age was to change rather dramatically; his children grown, his wife effectively living apart for the better part of the year, his reputation assured, he was to embark on a life style less domestic, more obsessively devoted to his art, and more sexually permissive than he had led previously. The young female

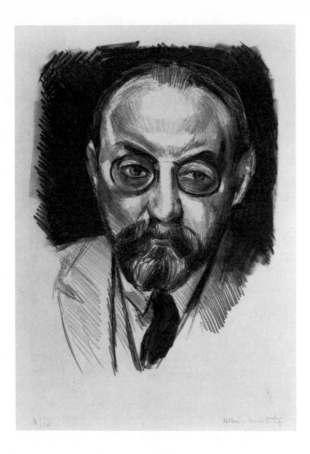

Fig. 8. Henri Matisse, *Self-Portrait,* c. 1920–25. Lithograph. Courtesy of The Art Institute of Chicago. Gift of Mrs. Horner Hargrave.

model was to become his major subject and, as if to give himself permission, he allied himself artistically with older Impressionist painters who loved women: Courbet, Manet, and Renoir. While suggesting that the propriety of the image, including the clothing, constitutes an "expressive form of masking," Flam concludes that "the solid beefiness of his torso, the passivity of his pose, the intensity of his self-absorption, and the animal energy that one senses beneath the placid surface combine to create an image of unsettling frankness" (Flam, 1986, p. 473).

For the next 15 years, with one exception that I know of, Matisse drew his own image primarily when one was needed for a publication. The exception is an interesting one, a carefully worked lithograph of probably 1922 (fig. 8). I know of no immediate publication of this image; its close, frontal scrutiny seems to be a private act of self-assessment by a man of great shrewdness and control. Matisse's public acceptance had just been crowned with the first purchase of one of his paintings by the Luxembourg Museum in Paris (*Odalisque with Red Trousers,* 1921) and the first purchase of a work by a major American museum, the Detroit Institute of the Arts (*The Window,* 1915). When the director of the latter museum, Reginald Poland, wrote of the acquisition, he included a verbal depiction of the painter: "His home is ordered, immaculate and attractive. He, himself, is the

model head of a family, wholesome and systematic. He admires the great paintings of the past. . . . Surely a man . . . who in his own life is wholesome, human, sane and well ordered must be sincere and have good reason for painting as he does" (1923, pp. 4–5). The lithographed self-portrait confirms this judgment. The svelte modulation of half-tone greys, the idealized realism of the presentation, and the appraising penetration of the expression bespeak an artist in successful command of his gifts and his desires, and in control of his public image. The weight of his accomplishment is rendered with rather sleek satisfaction.

In an important interview of the period by Jacques Guenne, Matisse dwells on a long reminiscence of the hardships and struggles of his youth, of temptations overcome, and of the slow process of finding his own voice. His present self-assurance (i.e., in 1925) is marked. Speaking of the influence of Cézanne on his early efforts, Matisse asserts: "Not to be strong enough to withstand an influence without weakening is a sign of impotence. . . . I believe that the artist's personality affirms itself by the struggle he has survived. . . . I have accepted influences but I think I have always known how to dominate them" (quoted in Flam, 1973, p. 55).

In published images, however, from around 1920 on, Matisse was to let the photograph present this image of authority and dignified seriousness to his public, an image befitting a successful man beginning the second major phase of his life course. What did the artist think of photography as a medium? Matisse had often contrasted the nature of photography with that of painting. As early as 1908, the year he wrote his major statement "Notes of a Painter," the artist expressed himself on photography in *Camera Notes,* coming down squarely on the side of straight or documentary photography:

> Photography can provide the most precious documents existing and no one can contest its value from that point of view. If practiced by a man of taste, the photograph can have an appearance of art. But I believe that it is not of any importance in what style they have been produced; photographs will always be impressive because they show us nature, and all artists will find in them a world of sensations. The photographer must therefore intervene as little as possible, so as not to cause photography to lose the objective charm which it naturally possesses, notwithstanding its defects. By trying to add to it, he may give the result an echo of a different process. Photography should register and give us documents. (Quoted in Flam, 1973, p. 40)

Matisse often reiterated the documentary nature of the photograph: the photo renders a multitude of details; it is devoid of feeling, neutral, and, therefore, can be a tool of disinterested information about the model or help neutralize influences from other styles on the painter's imagination. While photography has

usurped the place of portraiture in painting for rendering an exact likeness, it is finally inferior to painting in Matisse's view since it cannot inspire a feeling of escape and spiritual elevation as art is able to do. Art, in other words, is able to provide calm and a lightness of spirit to the viewer, while photography only provides detailed information and is suitable for accurate ("anthropometric") portraits.[9]

Matisse used portrait photography, just as he used interviews, to represent himself to his public. It is significant that the increased use of the journalistic interview (the first having been given by Brigham Young to Horace Greely in 1859) parallels the widespread popularity of photographic portraits. Both purport to be "speaking likenesses" of the subject, truthful by means of their factuality, empirically straightforward and without the interpretive overlay that traditional portraits or biographical essays possess. Purporting to be true likenesses, and destined for public consumption, they are particularly susceptible to manipulation either by the interviewer or the subject interviewed; hence, they correspond to the official or public portrait of tradition rather than the true or psychological portrait (Boorstin, 1961, pp. 15, 45–46; Lubin, 1985, pp. 155–56).

If controlled by the interviewee, a journalistic interview can be considered a kind of public self-portrait. Matisse was well aware of this and encouraged the interview format. Baldly, in an interview in March 1913, at the height of the uproar over the International Exhibition of Modern Art in New York, commonly called the Armory Show, Matisse begged his American interviewer, Clara MacChesney: "Oh, do tell the Amercan people that I am a normal man; that I am a devoted husband and father, that I have three fine children, that I go to the theatre, ride horseback, have a comfortable home, a fine garden that I love, flowers, etc., just like any man" (quoted in Flam, 1973, p. 53). Early photos show the artist as just that—a normal man, though possibly more calm, controlled and thoughtful than many. They mean to counteract the wild beast reputation and the direct evidence of the paintings, whose strong color, willful distortions, and reductive simplicity had given rise to accusations of the Fauve artist as a madman, fraud, or at the very least "bohemian."

Early photos show Matisse as eminently respectable, a family man. A photo of about 1911 published by Flam (1986, p. 268), which shows the artist on horseback with his children, was printed originally as a postcard, for quick messages to friends and patrons. A variant, with his old friends Marquet and Camoin—two rather unadventurous School of Paris painters—was published by the artist's dealer in the journal *Bulletin de la vie artistique* in August 1920.

One of the earliest published photos of Matisse (fig. 6), taken by Edward Steichen in 1909 and published in *Camera Work* in 1913, shows Matisse in romantic chiaroscuro, dreamily contemplating his work-in-progress, more academic than revolutionary. This work, like the MacChesney interview, was published

during the negative publicity of the Armory Show. The photo was used again for publicity in 1915 and in the early twenties, when Matisse was painting his most voluptuous studio nudes and odalisques—the photo possibly a counterimage to one of the artist as hedonist or libertine.[10]

Always sensitive to his public abroad, Matisse was more likely to use a suave portrait studio type of photograph in the catalogs for foreign exhibitions. At the Leicester Gallery exhibition of his works in 1919, the catalog featured a photo of Matisse by an unknown photographer, Malcolm Arbuthnot, nearly as romantic as Steichen's: the artist is shown in an elegant suit, very *soigné,* with his hand supporting his head in a thinker's pose. Henry McBride's 1929 monograph on the artist carried Man Ray's sober, professional photograph of the artist, all gold-rimmed spectacles and tweeds. A profile variant made during the same session was used in an Italian monograph on Matisse of 1931 by Giovanni Scheiweiler. The frontispiece of *Matisse, Picasso, Braque, Laurens,* a 1938 exhibition in Copenhagen and Oslo, is a very beautiful 1933 photo portrait by the Hungarian photographer Rogi-André (Rosa Klein). The artist, severe and pensive, supports his head on his hand in the attitude of an intellectual or writer, rather than a studio artist.

The message of these portraits is clear enough: the viewer is to take the artist as a serious professional, even an intellectual. Matisse often placed them in tandem, however, with the occasional self-portrait pen drawings that he did during the same period. These pen drawings have a lighter, self-deprecating quality that provides a contrast to the gravity, the near pompousness, of the photos. While in London with the Ballet Russe as set and costume director for the ballet *Le Rossignol,* for example, and while he sat for the Arbuthnot photo, Matisse lightly sketched his portrait in a rondel on stationery from the Savoy hotel. In an oval frame which may be the hotel mirror, the painter gives himself to his public in a moment of wry self-scrutiny, allowing us an over-the-shoulder glimpse in the theatrical dressing-table mirror of his success.[11] We might think it the private doodling of a nervous first-nighter but for the fact that Matisse used a variant of it as the frontispiece for a monograph, the first in the series on modern painters published by the *Nouvelle revue française* in the twenties, again authored by his friend, the statesman-collector, Sembat. The combination of a dignified photo with a witty sketch occurs again in the catalog for his important 1931 show in Berlin at the Thannhauser Gallery. There he juxtaposed a very proper, almost severe, photo of himself (taken by Marc Lenoir) working at his sculpture table as frontispiece to the catalog, while a near-caricatural self-portrait drawing appears on the cover.[12]

Working photos of Matisse became more important in the 1930s; they accorded well with the activities of the vigorous, 60 year-old artist and with the photojournalistic spirit of the decade. The artist made long trips in the early thirties, beginning with a trip around the world whose real destination was Tahiti.[13] The commission for the Barnes Foundation mural in Merion, Pennsyl-

vania, brought him to the United States several times. These trips, as well as other somewhat unusual commissions, attracted the press coverage that the artist's international reputation commanded. Photos of Matisse working on a ladder for his mural commission, conferring with typesetters for his illustrated books, sketching from nature for future projects, drawing from the model in his studio all point to the image of the artist as *homo faber*.

To some extent, these photos act as a counterweight to Matisse's paintings of the period, which portrayed scenes of leisure, sensuality and dreamy reverie. A 1926 photo (Cowart and Fourcade, 1986, p. 31) carries the message of the artist as disciplined, dignified and utterly aware of the fictitiousness of the staged middle-eastern tableau that the odalisque paintings of this period enact. Matisse made this clear to his interviewers as well. He told the editor Tériade in 1933: "One gets into a state of creativity by conscious work. To prepare one's work is first to nourish one's feelings by studies [of the model]. It is these studies which permit the painter to free his unconscious mind" (quoted in Flam, 1973, p. 66).

As Matisse approached 69 (in O'Connor's schema, the last great point of change in the life course), hand-drawn self-portraits reappear and photo portraits become more numerous. Matisse's life between 65 and 69 was full of event. These years, 1934 to 1939, were of course politically and socially tumultuous, but they saw as well important changes in the artist's personal life. Around 1934–35, Matisse became involved in the last great intimate relationship of his life, painfully extricating himself from a 35-year marriage through a bitterly contested legal separation. He also began to experience at that time the first warnings of the intestinal illness that was nearly to take his life in 1941.[14]

In 1934–35 he produced a series of powerful brush and ink portraits that focus on his upper face, particularly the eyes. The gaze is full of power and perspicacity; the images show the seat of a powerful intellect directing a penetrating, almost hypnotic glance. One of the images (fig. 9) is full face, beaming, the beard radiating like a mane or sun: the artist in love and at the height of his powers, working on the suite of nudes that would culminate in the large *Pink Nude* of the Cone Collection. Too revealing, too personal, the partial face was used for the monographs by Florent Fels (Fels, 1929) and a variant of it in Roger Fry's updated monograph on Matisse of 1935.

The next suite of self-portraits, in 1937, has lost this euphoric strength. In a severe series of charcoal portraits, Matisse turns sharply to confront himself with sour and disapproving gaze (fig. 10). The artist, in poor health, confessed to the writer Montherlant that he thought he was going to die and that made him angry, because "he would have liked to *finish*" his life's work (Flam, 1973, p. 78; italics Montherlant's). The self-scrutiny is severe but the series included one full-face portrayal in which the expression, though sober, suggests self-acceptance and interior stability.

At 69, on the eve of World War II, Matisse did a series of

254

some fifteen pencil self-portraits.[15] Nine years later he published
four of them in the exhibition catalog *Henri Matisse: Retrospective*
for the show at the Philadelphia Museum of Art. They accom-
panied an article entitled "Exactitude Is Not Truth." The artist
used them as an example of his ability to disengage from ap-
pearances the "inherent truth" of his character. Of these portraits
Matisse wrote:

Among these drawings, which I have chosen with the greatest
of care for this exhibition, there are four—portraits per-
haps—done from my face seen in a mirror. . . .
 The different elements which go to make up these four
drawings give in the same measure the organic makeup of the

Fig. 10. Henri Matisse, *Self-Portrait,* 1937. Charcol and estompe. The Baltimore Museum of Arts. The Cone Collection, formed by Dr. Claribel Cone and Miss Etta Cone of Baltimore, MD.

subject. These elements, if they are not always indicated in the same way, are still always wedded in each drawing with the same feeling—the way in which the nose is rooted in the face—the ear screwed into the skull—the lower jaw hung— the way in which the glasses are placed on the nose and ears—the tension of the gaze and its uniform density in all the drawings—even though the shade of expression varies in each one.

It is quite clear that this sum total of elements describes the same man, as to his character and personality, his way of looking at things and his reaction to life, and as to the reserve with which he faces it and which keeps him from an uncontrolled surrender to it. It is indeed the same man, one who always remains an attentive spectator of life and of himself. (Quoted in Flam, 1973, p. 119)

During this same period, the late 1930s, Matisse developed a rapport with a number of important photographers, Brassaï and Henri Cartier-Bresson among them, who were allowed to develop picture essays of the artist in his studio. In 1939 Matisse, renting a Paris studio from a sculptor-friend, called his favorite photographer for a photo session that resulted in a widely published series. Brassaï, the photographer whom he summoned, wrote of

Matisse: "He loved being photographed or filmed. Whenever I made any portraits of him, he was always impatient to see them. . . . He was always preoccupied with 'what he looked like.' He often said to me: 'I'm really a very gay man . . . but I have a sullen expression. I am always being taken for some gloomy professor. I look like an old bore. . .' And it was true. Matisse was a jovial man, but laughter was not becoming to him. It disfigured him. He was constantly trying to find an accurate reflection of himself in his portraits, but very seldom succeeded; if they were severe, they belied his real nature; if they were laughing, they caricatured him" (Brassaï, 1967, p. 257).

Of the 1939 session, Brassaï has given a good account, remarking that "standing in his bright, light-flooded studio in his white smock, Matisse looked like the chief of staff in some hosptial" (Brassaï, 1982, p. 125). The photos summarize the images of the artist-at-work and draw the sharpest possible (self?)-portrait of the artist as a devoted and detached practitioner of a sacred ritual, the sage devoted to beauty, the shaman-scientist who is to be excused from acting responsibly and effectively in the real world. The photos were taken in early June 1939; the artist is "free, quiet, and alone" in a timeless white cell. Three months later, on September 1, Germany invaded Poland, and on September 3, Great Britain and France entered World War II. Interestingly enough, these photographs were not published until 1943 but were published rather widely thereafter, fixing a particular image of the artist after his personal brush with death and after the war. He seemed then not only inviolate but invincible.[16]

After his serious surgery in 1941, Matisse felt as if the next years—they turned out to be fourteen (O'Connor's two cycles), ages 70 to 84—were given to him beyond his alotted time, a gift of years to be spent in utter freedom and joy of creation. The scattered self-portraits of the last years show him serene or whimsically self-mocking. At the war's end, in 1945, he made two frontal portraits that express his relief and contentment; one, part of a series of drawings in the same felt hat, was chosen frequently for postwar monographs as a frontispiece portrait.[17] The other, a lithograph of 1945 (fig. 11), is a kind of apotheosis of Apollonian serenity, a universalized mask of radiant centeredness. That symmetrical mask appeared increasingly in photos made by some of the most famous photographers of the era: Robert Capa, André Ostier, Dimitri Kessel.

Alexander Liberman describes Matisse as being in charge of these sessions: "Because I wanted to photograph him, he got out of bed. I returned to the living room. He entered, impeccably dressed in brown trousers and a loose beige jacket. He sat down in an armchair, his legs assuming, as they crossed, the pose for a formal portrait. There was an extraordinary grandeur in his bearing. He sat like a king, patient and purposely severe. Of all the painters I have seen, Matisse was by far the most awesome; physically and emotionally he kept his distance" (Liberman, 1960, p. 22). Two photographs show him so posing, one by Gomez-

Sicre of 1949 (Barr, 1951, p. 30), the other by Cartier-Bresson of 1951 (*Matisse photographies,* 1986, p. 87). The Rogi-André photo of 1933, mentioned above, is remarkably similar in pose and feeling to these two, verifying the persistent self-image, described by Liberman, that Matisse offered the photographer.

Cartier-Bresson was a favorite photographer of Matisse's last years. Like Brassaï, he was originally trained as a painter, in the same fine arts tradition as Matisse. Both understood the decorum of the *beau* portrait, as opposed to the *vrai.* The "fine" portrait is attentive to the public role or social position of the sitter, and is careful to stage him with appropriate gestures within an appropriate setting. Both understood that the photographic portrait of artists or professionals had replaced the traditional type of portrait or self-portrait of the artist in his studio, with his family, or engaged in public life or official functions.

Fig. 11. Henri Matisse, *Self-Portrait (Mask),* 1945. Lithograph. © ARS, NY/SPADEM, 1987.

Cartier-Bresson understood that the photographic portrait, at its best, could combine the elements of an authentic image with a kind of self-projection intended for posterity, that is, the ideal or essential self as embodied in one's position or social role. This is clear from the following statement by the photographer: "One of the touching features of portraiture is that it reveals the permanence of mankind, even if only in the family album. We must repect the surroundings which provide the subject's true setting, while avoiding all artifice which destroys the authentic image. Faced with the camera, people offer their best 'visage' to posterity. It is their hope, blended with a certain magic fear, to outlive themselves in this portrait, and here they give us a hold" (Cartier-Bresson, 1968, introduction). In other words the "true" and the "fine" portraits might be combined when the sitter is able to

project his inner self onto the photographic plate of the totally sympathetic photographer. Hence, these antithetical modes can coalesce in portraits that are both private and public portrayals.

Matisse's last intimate, honest portrayals of himself—"true" portraits of his last days—show him slipping off center, or as a gnomelike presence with blind spectacles. His last self-portrait shows a hand failing in firmness; the last photographic portraits as well sometimes show an eye failing in sharpness, the painter's gaze vacant and unfocused. The most widely reproduced late Cartier-Bresson and Hélène Adant photos, however, show a beaming childlike Buddha in a garden of fullness and delight (Barr, 1951, p. 32; Aragon, vol. 2, pl. 208). Surely these official views of the artist-sage mean to present the happy outcome of a life lived solely, if selfishly, for Art—that demanding god.

In the 1938 interview with the French writer, Henri de Montherlant, already alluded to, the artist thought he was near death. Referring to the expensive exotic birds that he owned, Matisse said: "When I thought I was done for, I said to my wife, see how right I was to buy these birds for my enjoyment! You must always do what gives you pleasure." To this remark, Montherland responded in the following manner: "These were profound words, beyond their seeming ingenuousness. So much more profound than those idiots who say to you indignantly, 'So, you think that man is born for happiness?' These stupid Western-ers! 'What have I done? I lived, I made myself happy,' wrote Gallieni to Lyautey. . . . You really have to be a stupid Westerner not to experience a certain *grandeur* before such men who are reaching old age and, *having accomplished their work,* say: 'And then, I made myself happy.' For there is also the greatness of wisdom which is none other than that of intelligence" (quoted in Flam, 1973, p. 79; italics Montherlant's).

Matisse's late photographs radiate this pleasure in having made himself happy, having finished his work. He often said that the last years, after his near-fatal surgery, were a gratuitous addition to his career. In them, he created a whole new way of working, with his paper cutouts. These late works, along with his chapel at Vence, were the crowning achievements of his long career. Signif-icantly, for the most part they are commissioned public works, made for the use and pleasure of others.[18]

Since Matisse thought of his work as a gift to others, he was able to unite the personal happiness and satisfaction of old age with something more altruistic. It is no wonder that the private portrait and the photographic portrait come together in the final years, since self-centeredness had been transformed from the base metal of egoism to the gold of benevolence toward others— achieved through the legacy of his art. Private and public goods had come together; hence, the public and private image could be conflated.

If one is not convinced that the last photos of Matisse in Tériade's garden are in some way self-portraits, one need only look at Matisse's late decorative mural, *Apollon.* There a smiling

Apollonian mask of serenity surrounds itself with brilliant cutout designs of ordered nature. One must recognize the radiant visage as Matisse's, "free, quiet and alone," enclosed in a surround of nature and culture which have been harmonized. The artist's idea of happiness was that of a garden regained, surely that paradise of primary unitary bliss available only in earliest childhood. Still, the artist has had to struggle to regain it. "The model is for me a sort of springboard," he said, "a door which I must force for access into a garden in which I am alone and so blessed—even the model only exists for my use" (quoted in Aragon, 1971, 1:235). The integration of the artist's personality is achieved and the image is one of apotheosis and radiant self-sufficiency.

Notes

1 From 1907 on, when Guillaume Apollinaire first wrote on Henri Matisse in *La Phalange* (Flam, 1973, pp. 31–32), articles on Matisse tend to be heavily laced with direct quotations by the artist, descriptions of him and his home or studio, and phrases that are strongly redolent of Matisse's earlier written or oral statements. The direct interview is explicable in the early years of Matisse's career by the necessity of avant-garde artists to explain their innovative works, in lieu of experienced critics who would ordinarily take on the work of interpretation. With Matisse, since he was articulate and eager to talk about his work, the interview pattern persisted. Long after he needed to, he seemed to be solicitous of a broader public—characterized by goodwill but limited aesthetic experience—whose education he undertook in his published interviews. To this middle class public from which he himself emerged, Matisse insisted on the professional nature of his calling and on the propriety and ordinariness of his "life as a man." He obsessively presented himself as an indefatigable worker and wholesome human being, however pushed he was by "he knew not what" to become an artist (quoted in Fourcade, 1972, pp. 319–20).

2 A number of times, Matisse referred to this process of self-searching by means of "doubling" with the object of his painter's scrutiny. "I have searched for myself everywhere," he wrote in a questionnaire of 1946 (quoted in Schneider, 1984, p. 569). This search involved an exchange between himself and the model: "After a certain moment [of sketching] it is a kind of revelation, it is no longer me. At these moments there is a veritable doubling of myself: I don't know what I am doing, I am identified with my model" (quoted in Couturier, 1962). At another time he admitted: "It is in entering into the object that one enters one's own skin. I had to make this parrot with colored paper. So! I became the parrot. And I found myself in the work" (quoted in Flam, 1973, p. 140.) And again, he told Tériade: "I continually react until my work comes into harmony with me. . . . At this final stage, the painter finds himself freed and his emotion exists complete in the work. He himself, in any case, is relieved of it" (quoted in Flam, 1973, p. 74). "The work is the

emanation, the projection of self. My drawings and my canvases are pieces of myself. Their totality constitutes Henri Matisse" (Flam, 1973, p. 144).

3 It is in this remarkable and primary statement that Matisse links his interest in portraits to what he termed "the revelation of the post office." He recounts that, as a young man in a post office in his native Picardy, he began to doodle, to make a woman's head, and that to his surprise the head turned out to be a portrait of his mother. From this experience, he admitted to learning: (1) to trust feeling and memory over observation and reasoning, (2) that "the mind which is composing should keep a sort of virginity for certain chosen elements" and maintain "a hand completely given over to unconscious sensations which spring from the model," and (3) that portraiture suggests "the possibility of an almost total identification with the model." The linkage between the identification with the model in portraiture, Matisse's self-portraits, and the unconscious surfacing of his mother's features in a modelless female portrait requires an exploration that considers Freudian and Lacanian theories on ego-formation, narcissism, and the mirror stage of the imaginary. But that would be fully the subject of another paper. Here, I will simply acknowledge such probable links without developing them.

4 The account of Matisse's self-portrait oeuvre is necessarily approximate. There is presently no catalogue raisonné of Matisse's drawings or oil paintings, only of his prints. I am indebted, in my attempt to account for all known self-portrait drawings, to the work of John Klein, who is now writing an extended study of Matisse's portraits and self-portraits as his doctoral dissertation for Columbia University. Klein has graciously shared with me his original research on a good number of unpublished self-portrait drawings, many of which were to have been exhibited in 1986 in a show at the Musée Matisse et Herbin in Le Cateau, France, curated by its director, Dominique Szymusiak, and with a catalogue essay by Klein. This exhibition, unfortunately, has been indefinitely postponed; one hopes that it will soon be rescheduled, for the sake of the hitherto unknown works from private collections that would be made available for public viewing.

5 The basic biographical sources for Matisse's life are Barr (1951) and Flam (1986); Schneider (1984) adds much personal data on Matisse in his chronology section (pp. 715–40) and throughout his long text. The recent catalog on *Henri Matisse, the Early Nice Years, 1916–1930* (Cowart and Fourcade, 1986) discreetly makes available new information from the period it explores. Aragon's study (1971) is full of psychological insights on the artist. Much specific biographical material is still unknown, carefully restricted by the Matisse heirs who believe that the public's "right to know" the intimate details of the artist's life is a limited one. A memoir of the artist in the 1930s, written in 1947 by Jane Simone Bussy, the daughter of the artist's old friend, Simon Bussy, has recently been published (Bussy, 1986). More personal and more wittily malicious than most memoirs of Matisse (which ordinarily tend to hagiography), it is not the less insightful for that. I have made use of the published information about Matisse as well as insights gained from years of meditation on his work and writings; I have refrained from speculations beyond those which such general biographical data warrants.

6 These works remain in the Matisse family collection. The former, with the artist at the easel, has been published and exhibited; the latter, the more Expressionist portrayal, was first published by Schneider in 1984. That the works had a special significance for Matisse is inescapable; that

the "Expressionist" portrait was a self-presentation that he wished to keep private seems evident as well.

7 This photograph was published in an article, "U Matissa," by Ya. Shik, a poet, translator, journalist, and collector, in *Rannee utro,* October 26, 1911, during Matisse's first visit to Russia. The interviewer describes Matisse: "His face recalls that of a scientist rather than an artist. . . . [His is] sober, dry, logical speech." In a long citation, Matisse is quoted as saying: "Art, in my opinion, is a mirror reflecting the artist's soul. In his pictures the artist should reveal only himself. And everything serving as an object of creativity should be for him merely a pretext to reveal his soul time and again. Therefore, first and foremost, I require of the artist: sincerity and modesty. He should, if he's a real artist, avoid any pose and show his 'I' as it is, without feeling embarrassed that his private world is not a very great one; it may not be a great one—but it's his, only his." The information on Matisse's stay in Russia is from Yu. A. Rusakov (1975, pp. 284–91).

8 Matisse visited Nice early in 1918, staying a few months; he returned the next year for the winter months and thereafter lived the major part of every year in the Mediterranean city. His wife, who had maintained their residence near Paris in Issy-les-Moulineaux, joined him permanently in 1928 in a larger Nice apartment. The so-called "Nice Period" usually refers to those years chronicled in the recent National Gallery of Art exhibition, i.e., 1918-1930, and denotes the more realistic style of those years as well.

9 Besides the statement on photography quoted in full in the text, Matisse's comments on photography appear in: "Statement to Tériade [On Creativity]," 1933 (Flam, 1973, p. 66); "Matisse's Radio Interview: First Broadcast," 1942 (Flam, 1973, p. 92); "Matisse-en-France," 1943 (Flam, 1973, p. 167); "Looking at Life with the Eyes of a Child," 1953 (Flam, 1973, p. 148); "Interview with Charbonnier," 1950–51 (Flam, 1973, p. 140); and "Portraits," 1954 (Flam, 1973, p. 150). A letter from Matisse to Simon Bussy (May 25, 1934) on his use of photographs in the fashioning of posthumous portraits of the Cone sisters from Baltimore is reprinted in the new book, *Matisse Photographies,* p. 20. The latter, which contains many previously unpublished photographs of the artist, accompanied an exhibit of photographs of and by Matisse that was held at the Musée des Beaux-Arts, Jules Cheret in Nice during the summer of 1986. The catalog reveals a surprising number of unpublished photos taken by Matisse when he was in Tahiti in 1930; more of these appear in the catalog *Matisse et Tahiti* for a show held concurrently in Nice at the Galerie des Ponchettes from July 4 to September 30, 1986.

10 In 1915, the Steichen photo was used as the frontispiece in the catalog of Matisse's Montross Gallery exhibition in New York. It appeared again in a monograph, *Henri-Matisse,* with essays by Elie Faure, Jules Romains, Charles Vildrac, and Léon Werth, published in 1920. Three years later, when this book was reissued in a deluxe edition with the same text and entirely different reproductions of Matisse's more current work, a variant of the Steichen photo, taken at the same 1910 session, was reproduced, as well as a photograph by Man Ray of Matisse painting his young model, Henriette Darricarrère. Significantly, the model, then Matisse's mistress, is cropped from the picture; only the painter painting remains. The uncropped photograph was first reproduced in Aragon (1971), 1:88.

11 One of these sketches was published in Fels (1950), p. 158, without date or comment. It is through John Klein's typescript catalog that I have the details of the Savoy Hotel stationery. The sketch used for the 1920

Sembat monograph was cut as a wood engraving by Jules Germain. The Arbuthnot, Rogi-André, and Lenoir photographs appear in catalogs available at the library of the Museum of Modern Art, New York.

12 Matisse's oscillation between seeing himself as a serious, dedicated, and irreproachable figure of dignity and as a somewhat ridiculous, self-centered, gaily irresponsible figure of levity is brought out in the Jane Bussy memoire. The following observations are worth quoting at length:

"Matisse," Auguste Bréal used to say, "cannot get over the fact that he is Matisse. He can hardly believe his luck." And indeed the egoism of Matisse is something at once so colossal and so childishly simple and natural that one cannot call it vanity. He does not consider himself the greatest painter in the world but, quite simply, the *only* one, for others do not exist in themselves, but only in relation to him. . . . I remember that once we were discussing the possibility of his going to London to see a unique exhibition of Chinese art that was being held there. But after a few conventional remarks about the wonders of oriental art he suddenly gave way to sincerity: 'After all I don't think I shall go. I don't really want to go. I don't really take an interest in it. I only take an interest in myself. *Je ne m'interesse qu'à moi!*' And so saying he blushed rosy red and buried his face in his hands. For he is perfectly aware of his own peculiarities and when he is with intimates he will own up to them with a curious and almost disarming mixture of shame and pride. (Bussy, 1986, p. 81)

13 A photograph of Matisse taken in Tahiti by the German filmmaker F. W. Murnau accompanied a three-part interview of the artist by Tériade in *L'Intransigeant,* October 20, 1930. The painter, tanned and vigorous at 60 years of age, is shot against an extended palm branch which, reaching across the horizontal photograph, bursts into a silhouetted halo of radiating fronds just behind his head. Another photo by Murnau of Matisse in Tahiti has just been published in *Matisse photographies* (1986, p. 39).

14 See the Bussy memoire (1986) for a sometimes hilarious, sometimes painful, account of Matisse's domestic trials in the decade of the 1930s.

15 That the series consists of this many variants, I know through Klein's research. Only five have been published: the four in the Philadelphia restrospective catalog, and another in Schneider (1984), p. 412. I am also indebted to Klein for knowlege of the frontal self-portrait in the 1937 series in charcoal.

16 The first reproduction I could find from the Brassaï series was in *Homage* 2 (June 1943), a luxury magazine produced in Geneva during the war; another appeared in *Labyrinthe* 8 (May 15, 1945) accompanying an article by Georges Courthion, "Le Peintre et son modèle." These photos seemed particularly relevant for the artist who had survived major surgery in 1941 and the privations of the war and occupation. He seemed to be a national treasure that had been preserved unscathed. Two self-portraits made immediately after his surgery were published (with in-progress variations) only after his death (Rouveyre, 1956, pp. 66–74). The significant quotation about being "free, quiet, and alone" was originally cited in Raynal, (1950, 2:28). Matisse's full statement reads: "When I started to paint I felt transported into a kind of paradise In everyday life I was usually bored and vexed by the things that people were always telling me I must do. Starting to paint I felt gloriously free, quiet, and alone."

17 There are a number of other variants of Matisse in this felt hat, as well as many photographs of him in the same headgear by Cartier-Bresson and Hélène Adant. One remarkable for an intensification of the same contented, detached, otherwordly expression is the drawing of 1944,

without the hat, which is reproduced in Aragon (1971), 2:158. The transparency of Matisse's gaze matches the lucid economy of the spare graphism of his drawing against its white ground. It is uncannily similar to a photograph of Matisse by André Ostier that appeared in the catalog for the 1945 postwar Matisse retrospective at the Victoria and Albert Museum in London. In the same felt hat and felt smoking jacket, Matisse gazes out of the Ostier photograph with the same inward, pensive, transparent look of someone who, having figuratively returned from the grave, has loosened his ties to the material world.

18 A famous photograph by Dmitri Kessel (Aragon, 1971, 2:180) shows Matisse in his greatcoat, sitting in the Chapel of the Rosary at Vence. On one side of him are the stained glass floral designs of the windows, alluding to nature, the free play of light and color, joy; on the left can be seen the austere black and white drawings of the Stations of the Cross, alluding to the painful playing out of a man's life, constraint, and suffering. Matisse, majestic in his cashmere greatcoat, is seated—with the solemn kingly presence described by Liberman—between the two elements, in perfect stasis and balance.

References

Aragon, L. (1971). *Matisse, roman.* 2 vols. Paris: Gallimard.

Barr, A. H., Jr. (1951). *Matisse: His Art and His Public.* New York: Museum of Modern Art.

Billeter, E. et al. (1985). *Das Selbsportrait im Zeitalter der Photographie.* Bern: Benteli.

Bonnafoux, P. (1985). *Portraits of the Artist: The Self-Portrait in Painting.* New York: Skira, Rizzoli.

Boorstin, D. (1961). *The Image: A Guide to Pseudo-Events in America.* New York: Atheneum.

Brassaï, J. (1967). *Picasso and Co.* New York: Doubleday.

———. (1982). *The Artists of My Life.* Trans. R. Miller. New York: Studio, Viking.

Bussy, J. S. (1986). "A Great Man." *Burlington Magazine,* 128 (Feb.): 80–84.

Cartier-Bresson, H. (1952). *The Decisive Moment.* New York: Simon & Schuster.

———. (1968). *The World of Henri Cartier-Bresson.* New York: Viking.

Chevrier, J. F. & Sagne, J. (1984). "L'Autoportrait comme mise-en-scène," *Photographies,* 4 (April): 45–82 (entire issue devoted to this theme).

Couturier, M. A. (1962). *Se garder libre (Journal 1947–54).* Paris: Editions du Cerf.

Cowart, J. & Fourcade, D., ed. (1986). *Henri Matisse, the Early Years in Nice, 1916–1930.* New York & Washington, DC: Abrams & the National Gallery of Art.

Diehl, G. (1954). *Henri Matisse.* Paris: Pierre Tisné.

Duthuit-Matisse, M. & Duthuit, C. (1984). *Henri Matisse, Catalog Raisonné de l'oeuvre gravé établi avec la collaboration de Françoise Garnaud.* 2 vols. Paris: Lucien Goldschmidt, distributor.

264

English, D. E. (1984). *Political Uses of Photography in the Third French Republic, 1871–1914.* Ann Arbor: University of Michigan Research Press.

Fels, F. (1950). *L'Art Vivant de 1900 à nos jours.* Geneva: Pierre Cailler.

Flam. Jack D. (1973). *Matisse on Art.* London: Phaidon & New York, 1978.

———. (1975). "Some Observations on Matisse's Self-Portraits," *Arts,* (May): 50–52.

———. (1986). *Matisse: The Man and His Art.* Ithaca: Cornell University Press.

Fourcade, D. (1972). *Henri Matisse, écrits et propos sur l'art.* Paris: Hermann.

Freund, G. (1980). *Photography and Society.* Boston: David R. Godine.

Fry, R. (1935). *Henri Matisse.* London: A. Zwemmer.

Goldscheider, L. (1937). *Five Hundred Self-Portraits from Antique Times to the Present Day.* Vienna: Phaidon.

Kessel, D. (1985). *On Assignment: Dmitri Kessel, Life Photographer.* New York: Abrams.

Levey, M. (1982). *The Painter Depicted: Painters as a Subject in Painting.* New York: Thames and Hudson.

Liberman, A. (1960). *The Artist in his Studio.* New York: Studio, Viking.

Lingwood, J., ed. (1987). *Staging the Self: Self-Portrait Photography 1840s–1980s.* London and Plymouth: National Portrait Gallery & Plymouth Arts Center.

Lubin, D. M. (1985). *Act of Portrayal.* New Haven: Yale University Press.

MacChesney, C. T., (1913). "A Talk with Matisse, Leader of Post-Impressionists." *New York Times Magazine,* March 9.

Matisse et Tahiti (1986). Nice: Cahiers Henri Matisse, 1, Galerie des Ponchettes.

Matisse photographies (1986). Pref. by X. Girard; essay by J.-F. Chevrier. Nice: Cahiers Henri Matisse, 2, Musée Matisse.

O'Connor, F. V. (1985). "The Psychodymanics of the Frontal Self-Portrait." *Psychoanalytic Perspectives on Art,* 1:169–221. Hillsdale, NJ: The Analytic Press.

Poland, R. (1923). "Modern Paintings Acquired." *Bulletin of the Detroit Institute of the Arts.* 5, no. 1 (Oct.): 4–5.

Ray, M. (1963). *Self-Portrait.* Boston: Little, Brown.

———. (1980). *Man Ray: The Photographic Image.* Ed. N. Janus, trans. M. Bara. Woodbury, NY: Barrons.

Raynal, M. (1950). *Histoire de la peinture moderne.* 3 vols. Geneva: Skira.

Rouvèyre, A. (1956). "Matisse évoqué." *Le Revue des arts,* June 2, pp. 66–74.

Rusakov, Y. A. (1975). "Matisse in Russia in the Autumn of 1911." *Burlington Magazine,* (May): 284–91.

Saisselin, F. G. (1963). *Style, Truth and the Portrait.* New York and Cleveland: Harry Abrams & the Cleveland Museum of Art.

Schneider, P. (1984). *Matisse.* Trans. M. Taylor & B. S. Romer. New York: Rizzoli International.

Sembat, M. (1913). "Henri Matisse." *Cahiers d'Aujourd'hui,* 4 (April): 185–94.

——— (1920). *Matisse et son oeuvre.* Paris: Nouvelle Revue Française.

Snyder, J. & Allen, N. W. (1975). "Photography, Vision and Representation." *Critical Inquiry,* 2 (autumn): 143–69.

265 Sobieszek, R. A. (1975). "Photography and the Theory of Realism in the Second Empire: A Reexamination of a Relationship." In *One Hundred Years of Photographic History: Essays in Honor of Beaumont Newhall*, ed. V. D. Coke. Albuquerque: University of New Mexico Press.

Stein, G. (1935). *Lectures in America*. New York: Random House.

K. Porter
Aichele, Ph.D.

Self-Confrontation in the Early Works of the Vienna School

In 1956 the late Austrian critic Johann Muschik gave seven Viennese painters a collective identity as the Vienna school of Fantastic Realism. They were Arik Brauer (b. 1929), Ernst Fuchs (b. 1930), Rudolf Hausner (b. 1914), Wolfgang Hutter (b. 1928), Fritz Janschka (b. 1919), Anton Lehmden (b. 1929), and Kurt Steinwendner (b. 1920).[1] In the history of postwar European art the Vienna school occupies a chronological niche corresponding to that of the New York school in the United States. Beginning in the mid-1940s, the Fantastic Realists experimented with the Surrealist technique of automatism and skimmed from the lexicon of psychoanalysis theories about the role of the unconscious in the creative process. So too did Arshile Gorky, Adolph Gottlieb, and Jackson Pollock, the "myth-makers" among the Abstract Expressionists, but with radically different results (Sandler, 1970, pp. 62–71). Since the inception of the Vienna school during the years following World War II, the meticulous illusionism of the Fantastic Realists has remained constant, the ranks of adherents to the school have swelled, and its geographical boundaries have spread beyond the city limits of Vienna. In America there has been a revival of interest in the figurative painting that was produced contemporaneously with the abstract art of the New York school, and a panoply of variations on what has been called the "new Realism" now coexists with the precision of Photo-Realism and the confrontational force of the Neo-Expressionists. Given this resuscitation of the stubbornly persistent Realist tradition, it is curious that the Vienna school of Fantastic Realism has received

relatively little notice in English-language publications.[2] The following study of seven emblematic self-images will summarize the genesis of the Vienna school and interpret the distinctive imagery of the founding artists.

With the exception of Hausner, who completed his formal training in 1936, the painters who would constitute the new Vienna school were enrolled at the Academy of Fine Arts just after the war. Initially Janschka worked with Sergius Pauser, while Brauer, Fuchs, Hutter, and Lehmden studied under Robin Anderson. By 1946 they had all joined Steinwendner in the studio of Albert Paris Gütersloh (1887–1973), the painter, author, and critic appointed to the faculty of the academy in 1945. A contemporary and close friend of Egon Schiele, Gütersloh had published and exhibited throughout Europe until the early 1930s, when his works were branded degenerate by the Nazis.[3] In postwar Vienna this opprobrium gave him the reputation of a modernist. When the future Fantastic Realists arrived in Gütersloh's studio, each was in a state of transition. In Gütersloh's expressively distorted figure painting and his predilection for literary subject matter, they recognized a temperament attuned to their tentatively formulated ambitions. Sensing that what they were compelled to say could not be expressed within the confines of the academic tradition, they were drawn to Gütersloh because he was known to encourage his students to abandon academic convention in the search for a unique form of self-expression. Although Gütersloh was not the sort of teacher who cultivated disciples in his own mold, he did stimulate in his students the development of an innate penchant for exacting draftsmanship.

Gütersloh's indulgent presence was an essential catalyst in the evolution of a new school of Viennese Realism, but the work of the new generation would have assumed an altogether different character had it not been for the concurrent influence of Edgar Jené (b. 1904). Jené was a German native who had met André Breton during a period of self-imposed exile in Paris between 1924 and 1933. He subsequently moved to Vienna, where he attached himself to the periphery of the academy and became the art director of *Plan,* a review of contemporary art and literature. In artistic circles still bound by the formal concepts of early 20th-century art, Jené's pictures of spectral figures in infinite, airless spaces were novel curiosities. His importance for the young Viennese painters, however, lay less in his latter-day metaphysical paintings than in his contribution as a proselytizer of Breton's theories. In 1945, five years before he published the Surrealist manifestos and other articles by Breton under the title *Surrealistische Publikationen,* Jené organized discussions of Surrealist theory. His doctrinaire exposition of Breton's writings was supplemented by the participation of a psychoanalyst who explained the basic principles of Freudian and Jungian analysis.[4] Jené's role in introducing Breton's theories to the birthplace of psychoanalysis was not unlike that of John Graham, whose *System and Dialectics of Art* generated curiosity about the unconscious among artists begin-

ning their careers in New York. Under Jené's tutelage the future
Fantastic Realists began to experiment with free association and
dream imagery. Their initial experiments with psychic automatism
differed from those of Gorky, Gottlieb, and Pollock in that the
Viennese painters remained committed to Realism of subject
matter and traditional techniques.

By 1947 the protégés of Gütersloh and Jené were showing
their works in exhibitions sponsored by the Viennese chapter of
the International Art Club.[5] What distinguished them from their
contemporaries was not a homogeneity of style, but the common
denominator of Realism distorted by exaggeration of relative scale
and proportion. This new Viennese Realism was grounded for-
mally in traditional modes of representation and thematically in
images of self-confrontation. The artists' conscious decision to
revive the formal vocabulary and disciplined techniques of the
Renaissance masters was motivated by two factors: one was their
admiration for the technical virtuosity of Dali, whose paintings
they first saw in 1947 at an exhibition organized by the French
and Russian ministries of culture; the second was their search for
stability in the social and cultural chaos of postwar Vienna. A
similar reactionary turn to the past had been manifested by artists
active in Europe and America after World War I. It is therefore
not coincidental that Muschik's designation of "Fantastic Realism"
is a variation on "Magic Realism," the term applied by Franz Roh
to the painting of post–World War I Germany that exemplified
the attitude of New Objectivity (Muschik, 1974, pp. 51–52).
Although the painters of the Vienna school were not political or
social satirists, their works were similar to those of Otto Dix,
George Grosz, and Rudolf Schlichter in the use of forms and
techniques ultimately derived from the art of the 15th and 16th
centuries. Like Dix's *Artist and His Muse* (1924; Löffler, 1960),
the self-images to be examined in this study are recognizable
portraits made expressive through formal distortion and symbolic
content. The symbolism in the early works of the Vienna school is
inextricably bound to the theme of self-confrontation. Sensing
what Lionel Trilling later diagnosed as "a crisis in our culture"
(1955, p. 33), the Viennese painters sought to restore a balanced
relationship between self-knowledge and contemporary culture.
The theme of self-confrontation is also one that the younger
painters inherited, via Gütersloh, from the Viennese Ex-
pressionists. Their reinterpretations of images such as Schiele's
brutal *Self-Portrait Nude* (1910; Comini, 1978) reflect their ex-
posure to Surrealism and a need to explore their respective
identities as artists in a world ravaged by World War II.

At the same time that Georges Bataille was urging the Sur-
realists to fill the vacuum created by an absence of myth (cited in
Jean, 1967, p. 343), the painters of the Vienna school began to
draw on classical and religious mythology in an attempt to resolve
the conflicts they had experienced both cerebrally and in actuality.
During the 1940s and 1950s Rudolf Hausner responded to the
memory of fascist suppression and the still constant threat of

Fig. 1. Rudolf Hausner, *Adam Himself,* 1960. Mixed media on wood panel. Collection: Dr. Eduard Plangger, Vienna. Photo: Lichtbildwerkstätte "Alpenland."

atomic annihilation by assuming the mythical and therefore indestructible identities of Odysseus and Adam. *Adam Himself,* 1960 (fig. 1) is one of numerous variations on his first self-portrait as Adam which dates from 1956. In this version a lurid light with the intensity of neon illuminates the head of Hausner and the bulbous torso of a female. Hausner identified the woman as his anima and the long pin she holds in her raised hand as an object remembered from his mother's workshop (Hausner, 1974, p. 55). Questioned about the psychoanalytic implications of his imagery, Hausner acknowledged having been influenced by Freud's *The Ego and the Id* (Mayr, 1979).[6] It was in this essay that Freud introduced the theory of the "complete Oedipus complex" to explain how personality development is affected by the "complicating

element of bisexuality" (Freud, 1923, p. 33). In the context of Freud's "complete Oedipus complex," which is manifested by strongly ambivalent attitudes toward the mother as well as the father, the hatpin can be interpreted as a symbolic double entendre, referring at once to the sexual instinct and the death wish. As a phallic symbol it alludes to Hausner's infantile sexual desires toward his mother. Conversely, it is an instrument of self-sacrificial destruction that will inflict punishment for the tabooed incest. Although this personal dimension of the picture is enhanced by the specificity of Hausner's fleshy facial features, he has insisted that the Adam pictures are ultimately less personal than universal (Mayr, 1979). It is the universal character of Hausner's Adam that has led Gustav René Hocke to characterize the artist as a "medium" through whom modern man can explore the depths of his unconscious (Hocke, 1974, p. 113). The archetypal identity of *Adam Himself,* the androgynous nature of the figure, and the iconic rigidity of its pose all express the artist's conviction that his private anxieties and internal conflicts are common to the human condition in general. Like the Adam figure of Jewish legend, Hausner's Adam is a metaphysical receptacle of the collective soul of mankind.

The androgynous figure in *Adam Himself* recalls the Surrealists' quest to reconstitute the "primordial androgyne," a type that can be traced through a rich body of literature and visual imagery to Plato's *Symposium.* A possible source of Hausner's knowledge of the myth is Jung's essay, "The Psychology of Transference," in which the hermaphrodite is equated with a state of totality that existed when male and female were united in a single entity (Jung, 1946, p. 216).[7] Jung borrowed from numerous alchemical and mystical texts, including the writings of the 17th-century German mystic Jakob Böhme. Böhme maintained that Adam in his perfect state of grace incorporated both sexes, but that in giving birth to Eve, he separated himself from the female principle and was subsequently victimized by it. Believing that the real tragedy of man's fall from grace lay in the separation of the male and female principles, Böhme contended that man could recover a perfect state of harmony only by reintegrating the two.[8] Böhme's ideas were cited by Albert Béguin in an article on the androgyne published in the 1938 issue of *Minotaure* (Béguin, 1938, pp. 10–13, 66). Following the publication of Béguin's essay, Victor Brauner, André Masson, and René Magritte painted pictures in which the androgyne symbolized the union of opposites. Hausner's male and female forms are incorporated in a single body and are thus ostensibly integrated. Yet the female principle clearly has a destructive will of its own. The adversarial role of the female therefore reflects a state of kinetic conflict rather than a consummation of the cyclical process of unity. As Robert Knott has pointed out, the Surrealists frequently emphasized the violence inherent in the metaphysical sexual struggle as an element essential to eventual unity (1975, p. 39). Similarly, Hausner, who described *Adam Himself* in terms of "the principle of partnership"

Fig. 2. Anton Lehmden, *Pair,* 1953. Watercolor on paper. Private collection.

(Mayr, 1979), recognized the implied violence in his picture as a step in the process of resolving the conflict between male and female, or the conscious self and what he perceived as the subversive force of the unconscious.

Like Hausner's *Adam,* the male figure in Anton Lehmden's *Pair,* 1953 (fig. 2), is a self-portrait in which the artist casts himself in the role of an archetype. Lehmden's archetypal identity is not specified in his title, but is instead implied in his physical features. In the ethnocentric view of a Western European, Lehmden's distinctive cranial structure and Slavic features would give him the primitive appearance of a primordial man. The density of Lehmden's short, incisive brushstrokes creates strong contrasts of light and dark that heighten a perceptible sense of tension in his facial expression. The apparent source of this tension is the provocative mien of the partially obscured female. It can be assumed that, like Lehmden, the female counterpart of the *Pair* has both an archetypal and an individual identity. The cluster of coral grapes that hangs from her ear suggests one of two possible collective personas. She could be Eve as temptress and procreator, or the female component of Dionysus. In either case she is associated with fecundity, and the troubled expression on the artist's face suggests that she is a disquieting presence. The woman who assumes this symbolic identity is also Lehmden's wife, Helene

Palermo, whose physical features are so similar to his that her face appears to be a profile of his face.

Lehmden may well have been familiar with the poems written by Louis Aragon about and to his wife Elsa. In evoking Elsa as both the source of his creative energy and a mirror image of himself, Aragon implicitly identified her with one level of his own personality (Aragon, 1942, pp. 30–31, 95–110; 1963, pp. 224–27). The painters of the Vienna school knew translations of Aragon's works by Werner Riemerschmid, a writer and popular radio broadcaster. Moreover, they were familiar with the Jungian concept of the anima, or "soul image," from their introduction to the principles of psychoanalysis. Jung described the evolution of the anima as a process of transference from one reflective image to another. The first of these is a mother image, the second a man's love choice—theoretically a woman who corresponds to his own unconscious femininity (Jung, 1928, p. 189). The Jungian anima assumes multiple roles, including that of the positive, mediating force in the creative function. However, Jung also recognized the anima as a potential source of conflict. In his essay on Picasso he noted that the artist's unconscious can assume the form of "the Dark One," personified as an archetypal female figure such as Eve (Jung, 1932, p. 140). Freud's disciple Otto Rank also explored the concept of a negative "soul image" in the context of the creative instinct. Rank warned that the woman who serves as both muse and mistress can generate a conflict between the seductions of life and the demands of art (Rank, 1932, p. 52). If Lehmden was drawing on these ideas, his *Pair* can be interpreted on three levels: it is a double portrait of himself and his wife, a metaphorical image of the artist's conscious and unconscious selves, and a comment on the role of the female personification of the unconscious in the creative process.

The parched, monochromatic landscapes inhabited by Lehmden's figures are in striking contrast to Wolfgang Hutter's tropical gardens. Hutter's paintings are Boschian in the abundance and ripe fecundity of their imagery, though not in their Biedermeier preciosity. *The Painter in His Garden,* begun in 1950 and completed ten years later (fig. 3), telescopes Hieronymus Bosch's apocalyptic worldview into a stage set for self-analysis. Unlike the Paradise panel of Bosch's *Last Judgment* in the collection of the Vienna Academy of Fine Arts, Hutter's hothouse Eden is not the untainted habitat of Adam before the Fall, but a playfully embroidered reflection of the sheltered, relatively untroubled milieu in which Hutter was cocooned during his youth. And in lieu of Bosch's three vignettes, which condense the story of Adam into concentrated narrative units, Hutter substitutes the temporal continuum of his own life span. Like many of Hutter's early works, *The Painter in His Garden* is an autobiographical drama played out in a botanical paradise that might have been designed for the theater. Hutter's stage set is occupied by puppets whose programmed movements are not unlike those of Olympia, the me-

chanical doll who seduces the hero of Jacques Offenbach's *Tales of Hoffmann*.[9] This descriptive analogy can be extended to elucidate the meaning underlying the theatrical artifice and technical virtuosity of Hutter's picture, for just as Offenbach's *Tales of Hoffmann* is an opera that explores the art of opera, Hutter's *Painter in His Garden* is a picture about the art of painting. Although Hutter's picture is neither as bitingly cynical nor as profoundly serious as Offenbach's opera, the two works are similar in that both dramatize an essentially Romantic obsession with the antagonistic relationship between women and art.

The overturned amphora, which is the only sign of disruption in Hutter's painted paradise, is a traditional symbol of the womb and, by implication, of the artist's struggle to assume for himself the role of giving birth. As a progeny of the post-Freudian era, Hutter was conditioned to see the act of painting as a substitute

Fig. 3. Wolfgang Hutter, *The Painter in His Garden*, 1950–60. Oil on canvas-covered panel. Collection: Willi Zehnder, Vienna.

for the primal act of procreation. He has, nevertheless, insisted that his works be understood not in intellectual terms, but as "dreams metamorphosed" (Hutter, 1965, p. 119). Even in disclaiming intellectual pretense, however, he alluded to Ovid's *Metamorphoses*. Hutter may not have read the *Metamorphoses* in its entirety, but *The Painter in His Garden* offers ample evidence that he knew Ovid's myth of Narcissus. It is typical of Hutter that he transformed Narcissus's passion for his own reflection into a whimsical fantasy on self-contemplation. The three self-portraits in *The Painter in His Garden* represent successive stages in his life. From left to right are a cameo of the pubescent Hutter emerging from a petal, a full-length view of the artist as a young man, and a portrait of the artist as a performer or public persona. In keeping with the concept of painting as a metaphor of self-generation, the

Fig. 4. Fritz Janschka,
Self-Portrait, Act I,
1947. Pencil on
paper. Collection:
The City of Vienna.

artist's model and her painted image are also self-reflections. A psychoanalyst of the Freudian school would interpret these multiple images of the self as projections of a narcissistic ego ideal that replaces the lost narcissism of childhood (Freud, 1914, p. 94; 1910, pp. 59–137). As if in anticipation of such an explanation, Hutter slyly inserted a mirror image of himself in the guise of a monkey. This capricious, self-mocking twist to the myth of Narcissus as it is interpreted by Freud and other psychoanalysts is as characteristic of Hutter's work as the lush exuberance of his leguminous forms.

By projecting himself upon a stage, Hutter achieved the psychological distance that allows the self to become an object of detached analysis. Fritz Janschka introduced this device in his *Self-Portrait, Act I,* 1947 (fig. 4). It is immediately apparent that the setting of Janschka's drawing is no metaphorical Eden. Inscribed

on the rim of the moving picture drum in the right background are the words *Das Grosse Welttheater,* the German title of Calderón de la Barca's allegorical drama. In Calderón's play, which Janschka saw performed at Vienna's Burgtheater, the director is God and the performers represent a range of human types. Similarly, Janschka's *Self-Portrait, Act I* is directed by a force beyond his control. The world theater in which *Act I* takes place is as vulnerable to destruction as the crushed papier-mâché city in the foreground. Like Europe after the war, it is a disintegrated world characterized by dualism rather than unity. References to dualism are found in the composite figure of the mythological Janus, whose presence symbolizes a state of chaos, and in the schizophrenic self-portrait of the artist, who plays the role of solo protagonist. The helmet adorned with an emblematic skull and the fish scales that encase his torso are the armor of self-protection against the senseless brutalities of a war in which he had been a defiantly unwilling participant. As a drama of fate that evokes the physical and psychic traumas of war, Janschka's *Act I* is as universal as Calderón's play in its broadest implications. Yet it is also a very personal drama, the subject of which is the confrontation between the self and the creative instinct.

The violence of Janschka's imagery would imply that he, like Lehmden and Hausner, perceived the female principle of artistic creativity as a threat to the preservation of the ego. Although not explicitly self-inflicted, the gash on his right wrist is a wound usually associated with suicidal tendencies. According to Freud, such self-destructive impulses are manifested when the ego turns against itself the hostility directed toward a narcissistic object-choice (Freud, 1915–17, pp. 251–52). As in Lehmden's *Pair,* Janschka's self-reflective object-choice is his wife, who embodies the unconscious level of his own personality. For Janschka, the power of the unconscious was such that he actually altered his facial features to resemble those of Henriette Zettner, whose shaven head is reflected in the mirror he holds before him. At the point where the torsos of the two figures merge in the act of physical love, the jagged edges of the mirror have inflicted another wound. This masochistic fusion of the erotic and destructive instincts was a recurrent theme in the works of the Surrealists, for whom sexual violence symbolized the mythical struggle between male and female (Chadwick, 1975, pp. 46–56). Janschka's *Self-Portrait* is similar to Surrealist prototypes in that the unresolved conflict between the ego and the unconscious can be interpreted as a model for the struggle inherent in creating a work of art. As the artist confronts the negative female personification of his unconscious, a card game is in progress on his conscious, cerebral level. There, in a kind of skit within *Act I,* Hans Holbein, Albrecht Dürer, and Rembrandt van Rijn gamble for Janschka's artistic allegiances. The tendrils that emerge from his toes are not yet planted in terra firma, but the graphic precision of his imagery and the presence of the Northern masters leave little doubt that the disciplined forces of the ego will shape the outcome of this pictorial play of self-discovery.

Fig. 5. Kurt Steinwendner, *Temptation of Anthony,* 1946. Pencil on paper. Whereabouts unknown.

Kurt Steinwendner's *Temptation of Anthony,* 1946 (fig. 5), follows in the tradition of artists like Martin Schongauer, Bosch, and Félicien Rops, each of whom interpreted the tortures of Anthony according to his own tormented vision of Hell. Against the backdrop of a geometric grid framed by ominous black fenestrations borrowed from the painted architecture of Giorgio De Chirico and Carlo Carrá, the artist-martyr endures the agonies of bisection. Like the machines that invaded the pictures of the Metaphysical school and subsequently the art of post–World War I Germany, Steinwendner's instrument of torture is bereft of the ironic humor that informs Marcel Duchamp's and Francis Picabia's concept of the machine as metaphor. In combination with the stylized figure type and the sterile anonymity of the architecture, the precisely drawn cogwheels and chains convey a sense of alienation that recalls the drawings of Grosz and Schlichter. For the artists of the New Objectivity, modern technology did not have the positive connotations of vitality or functional efficiency. In Germany of the 1920s Grosz and Schlichter equated the products of industrial progress with the capitalists' exploitation of an increasingly dehumanized society. Had Steinwendner been a committed social satirist, he might have reacted similarly to the machines that churned for the capital gains of all those industrialists who tacitly supported Hitler's National Socialism. But he was less concerned with the fate of the masses than with his own

dilemma as an artist, and his *Temptation of Anthony* is the externalization of a self-centered conflict rather than sardonic social commentary.

The serpent enshrined in the upper left-hand corner of Steinwendner's visionary, International Style cityscape suggests that the artist was tempted by the efficiency and facility with which the clean lines of geometry could mask the aesthetic void created by the destructive forces of the war. Indeed, his later works show that he was eventually seduced by a functionalist aesthetic. In 1946, however, he felt estranged from anything that represented modernity. Seeking to fill the void, he turned to the past. Drawing on plates 5 and 7 of Andreas Vesalius's *De Humani Corpus Fabrica,* Book II, Steinwendner portrayed himself in the *Temptation of Anthony* as the heroic guardian of the past. Vestiges of the past are also evident in the diamond-patterned grid that recalls the marble pavements and revetments of Renaissance cathedrals. Bound by the 20th century and at the same time reacting against it, Steinwendner was quite literally torn between the past and the present, a victim of his conflicting allegiances to the figurative and decorative traditions of the Italian Renaissance and the geometric abstractions of the 20th century.

Like the drawings of Janschka and Steinwendner, Ernst Fuchs's *Resurrected* 1956 (fig. 6) is an homage to the past. Careful scrutiny of the painting reveals that it could only be the work of an artist familiar with the Surrealists' self-conscious manipulation of imagery. At first glance, however, it is a seamless conflation of imagery, figure types, and stylistic vocabulary assimilated from the masters of the Italian and Northern Renaissance. One readily apparent quotation is the setting, which was borrowed from Piero della Francesca's San Sepolcro *Resurrection* and repainted in the manner of Matthias Grünewald. Fuchs's startling self-portrait as the resurrected Christ was cloned from the figure types of Antonello da Messina, Rogier van der Weyden, and Albrecht Dürer. Fuchs was drawn to the masters of the 15th and 16th centuries by his need to establish a sense of identity in terms of historical continuity. At the same time he was attracted to Surrealism as a means of exploring what Breton called "the inner model" (Breton, 1945, p. 24). The artist's skillful integration of motifs from the past on the one hand and the principles of Surrealism on the other can be seen as an aesthetic parallel of his attempt to reconcile a conflicting image of self as Christian and Jew. His personal sense of dualism, inherited from a Jewish father and a Roman Catholic mother, was exacerbated by both World War II and the Israeli War of Liberation. In his autobiography Fuchs recalled being ostracized as "the red-headed Judas of Ottakring," the working-class district of Vienna where he lived with his family until his father was forced by the Nazis to flee Austria (Fuchs, 1979, p. 28). Although the Israeli war of 1947 heightened the consciousness of his Jewish heritage, his self-professed "longing for order and salvation" eventually culminated in his conversion to Catholicism (Fuchs, 1979, p. 133). Fuchs

arrived at the decision to embrace the Catholic faith during a period of meditative solitude in the United States, the final stop on a pilgrimage of escape and self-discovery that took him from Vienna to Paris in 1948 and finally to California. It was there that he painted *Resurrected,* an intensely personal expression of his spiritual and artistic identities.

Fuchs's conversion to Christianity imposed a new sense of order on his life as well as his art. Many of his early paintings portray his personal crisis of identity against the chaotic panorama of a global crisis. In *Resurrected* he combined an ordered composition with a complex iconographical program on the theme of the

Fig. 6. Ernst Fuchs, *Resurrected,* 1956. Watercolor and gouache on paper. Private collection. Photo: K. Scherb.

transition from the Old Testament order to the new Christian era. The iconography of Fuchs's version of the Resurrection differs from dozens of prototypes in its numerous references to the Judaic origins of Christianity. The common monotheistic heritage of the two faiths is revealed in details such as the star of David and the cross, both of which embellish the open sarcophagus and the Eyckian crown of heaven, and most significantly in the transfiguration of Moses into Christ. On the left side of the painting, behind the horned figure of Moses from the Book of Deuteronomy, is a skull with the conical headdress worn by Jewish high priests. This curious image points to an obscure tradition that is fundamental to the arguments set forth in Freud's *Moses and Monotheism*. Freud cited a tradition that began in the 8th century B.C. to support his claim that the Jews murdered Moses in an act of revolt against the "yoke of the Law." The Jews' remorse, Freud conjectured, provided the stimulus for the hope of redemption through a second Messiah. Christ could thus be recognized as Moses resurrected, the "substitute and successor" of the first Messiah (Freud, 1939, pp. 36, 89–90). In taking on the persona of Christ as the reincarnation of the murdered Moses, Fuchs resolved the conflict over his dualistic heritage and created an integrated self-image, one that binds his spiritual identity to his vocation as an artist. *Resurrected,* with its synthesis of Christian and Judaic symbolism, is an affirmation of Fuchs's messianic goal of communicating, through painting, what he perceived as "the historically decisive connections" between Christians and Jews (Fuchs, 1979, p. 137).

David Bakan has speculated that in fabricating the heretical fantasies that underlie *Moses and Monotheism,* Freud was willfully committing a "Sabbatian act of apostasy" (Bakan, 1958, p. 148). Bakan's reference to Sabbatianism and the Jewish mystical tradi-tion is equally applicable to Arik (Erich) Brauer's *False Messiah,* 1959 (fig. 7). Unlike Fuchs, Steinwendner, or Hausner, Brauer eschewed identification with a figurehead from the mainstream of the Judeo-Christian tradition. In *The False Messiah* he submerged his individual identity into a personification of cabalistic beliefs. The figure of the false messiah hovers in contemplative isolation above a vividly colored landscape. The tumultuous setting teems with Boschian aberrations, which, in conjunction with the title of the picture, may be interpreted as the anthropomorphic symbols of aberrant behavior. Although Brauer has claimed that a deeply rooted identification with Judaism informs all of his work (Brauer, 1979, p. 16), he is not a scholar of obscure Judaica. It can be assumed, therefore, that the apostate savior in *The False Messiah* is Sabbatai Sevi, the most notorious cult figure of the messianic movement in Judaism. In 1648 Sabbatai dared to utter the mystical name of God, thus giving himself messianic stature and fulfilling the prophecy of the Cabala. To escape death at the hands of the sultan of the Ottoman Empire, he expediently converted to Islam. Seeking a rationale for his heresy, Sabbatai's followers claimed that his renunciation of Judaism was a supreme act of self-

Fig. 7. Arik Brauer, *The False Messiah,* 1959. Oil on wood panel. Private collection.

sacrifice motivated by a desire to restore cosmic harmony in assuming the Jews' historical condition of exile (Scholem, 1946, pp. 287–88; 1973, pp. 1–102).

As Gershom Scholem documented in his studies of Jewish mysticism, Sabbatianism arose at a time when Jews were acutely aware of the contradiction inherent in their sense of inner, spiritual salvation and the brutal realities of religious persecution (Scholem, 1973, pp. 687–93; 1971, 78–86). For adherents to Sabbatianism, the idea of salvation through sacrificial self-condemnation offered a means of resolving the dualism experienced by Jews in the course of their long, troubled history. Brauer's emerging consciousness of his Jewish heritage occurred during yet another terrible chapter in the history of Judaism. A self-proclaimed "painter of Jews" (Brauer, 1979, p. 16), Brauer would later create an allegorical language with which he could portray the persecution of the Jewish people. *1944,* one of seven pictures in a series painted just after the Yom Kippur War, evokes the horrors of the Nazi concentration camps. In *The False Messiah* and in other early works that deal more obliquely with the persecution that he had experienced in Nazi-occupied Vienna, Brauer shrouded specificity of time and place with a veil of mysticism.

The paradoxical tenets of Sabbatianism offered him intellectual and spiritual justification for an appalling reality that had no rational explanation. Scholem has shown that the religious and moral nihilism advocated by the heretical mystics throughout history has proved to be an indirect expression of an urge toward reform and regeneration (Scholem, 1946, p. 299). Brauer's identification with the false messiah should be seen in the same context.

Like virtually all of the works of the Vienna school, the examples discussed above are similar to Surrealist works of the 1930s in that they are characterized by a conscious manipulation of imagery and stylistic traditions. What distinguishes the Fantastic Realists from the first generation of Surrealists is that their works rarely contain figures and objects arbitrarily juxtaposed for the sake of provocative novelty. Since the imagery is consistent with the ideological motivations behind each picture, the works of the Vienna school generally pose no insurmountably puzzling anomalies of interpretation. They are iconographically decipherable because the confluence of autobiography, sociopolitical history, and familiar quotations from the history of art provide accessible points of reference. This does not imply that the paintings of the Vienna school are devoid of what Sir Ernst Gombrich described as the "complex relationship between private and public meaning in 20th-century art" (Gombrich, 1963, p. 30). With few exceptions, self-portraits are the most personal form of artistic expression. Yet even in their self-portraits the Fantastic Realists revealed intimate meanings in the context of a public message. For a public stunned by the realization that established tradition was all too vulnerable to the ravages of conventional and atomic warfare, the painters of the Vienna school attempted to restore a sense of continuity between past and present. In doing so, they revived an idea expressed earlier in the 20th century by Alberto Savinio, composer and theorist of the Metaphysical school. "Memory," Savinio wrote, "is our Culture" (cited in Clair, 1981, 32).

Notes

I would like to express gratitude to Steven Levine of Bryn Mawr College and Fritz Janschka for offering constructive criticism of this essay. Thanks are also due to Heribert Hutter and Hubert Pfoch for their indispensable help in securing documentation and photographs.

1 Since the name Vienna school of Fantastic Realism was not self-imposed by a united group of artists with professed common goals, there is some question about which painters constitute the founding members. The first published survey of the Vienna school (Schmied, 1964) excludes Janschka, who has lived in the United States since 1949, and Steinwendner, who disassociated himself from the group in 1962 and changed his name to Curt Stenvert. This study will address works of the seven

artists listed in Muschik's more comprehensive survey, which includes a summary of the earlier publications in which he coined the name of the school and a general discussion of works by founders and followers (Muschik, 1974).

2 Exceptions include Comini, 1978, and Oesterreicher-Mollwo, 1979.

3 Biographical facts, selected articles by Gütersloh, and an excellent catalogue raisonné are contained in Hutter, 1977.

4 Although the painters of the Vienna school did read selected works of Freud and Jung, they absorbed from their cultural milieu as much as, if not more than they acquired from reading. For a survey of the influence of Freud on Austrian arts and letters, see Spector, 1972, pp. 192–94.

5 In 1981 the Museum of the 20th Century in Vienna held a retrospective exhibition of works by artists who participated in the Art Club exhibitions between 1947 and 1960. For documentation, see Breicha, 1981.

6 Because the painters of the Vienna school were not students of Freudian and Jungian theory, they often used the terminology of the two schools interchangeably. It is therefore not unusual that Hausner would apply the Jungian concept of the anima and an essay by Freud to the same painting.

7 See also Jung, 1932, p. 140, on the union of the "light and dark anima."

8 See in particular Böhme, 1909 [1682]. For a succinct exposition of Böhme's thoughts on the androgynous nature of Adam, see also Martensen, 1855, pp. 233–50.

9 As Schmied noted, the spirit of Hutter's pictures is closer to Offenbach than to E. T. A. Hoffmann, whose *Tales* served as the basis of Offenbach's libretto (Schmied, 1964, p. 43). Given the theatrical quality of many of Hutter's paintings, it is not surprising that he has been commissioned to design for the theater, most notably sets and costumes for a production of Mozart's *Magic Flute*.

References

Aragon, L. (1942). *Les Yeux d'Elsa*. Paris: Editions Pierre Seghers.

———. (1963). *Le Fou d'Elsa*. Paris: Gallimard.

Bakan, D. (1958). *Sigmund Freud and the Jewish Mystical Tradition*. Princeton: Van Nostrand.

Béguin, A. (1938). "L'Androgyne." *Minotaure* 11 (spring): 10–13, 66.

Böhme, J. (1909 [1682]). *The Threefold Life of Man*. Trans. J. Sparrow. London: Watkins.

Brauer, A. (1979). "Brauer on Brauer." In *Brauer Retrospective*. Exh. cat. Glarus/Switzerland: Goldregen AG for Jewish Museum, New York City.

Breicha, O., ed. (1981). *Der Art Club in Österreich*. Exh. cat. Vienna: Jugend und Volk.

Breton, A. (1945). *Surréalisme et la peinture*. New York: Bretano's.

Chadwick, W. (1975). "Eros or Thanatos: The Surrealist Cult of Love Reexamined." *Artform,* 14(Nov.): 46–56.

Clair, J. (1981). "Metafisica et Unheimlichkeit." In *Les Réalismes, 1919–1933*. Exh. cat. Paris: Le Centre Pompidou.

Comini, A. (1978). *The Fantastic Art of Vienna*. New York: Ballantine.

Freud, S. (1910). *Leonardo da Vinci and a Memory of His Childhood.*
Standard Edition, 11:3–137.
_____. (1914). "On Narcissism." *Standard Edition*, 14:73–102.
_____. (1915–17). "Mourning and Melancholia." *Standard Edition,*
14:243–258.
_____. (1923). "The Ego and the Id." *Standard Edition,* 19:12–59.
_____. (1939). "Moses and Monotheism." *Standard Edition*, 23:1–137.
Fuchs, E. (1979). *Ernst Fuchs.* Trans. S. Wilkins. New York: Abrams.
Gombrich, E. H. (1963). "Psycho-Analysis and the History of Art."
Meditations on a Hobby Horse and Other Essays on the Theory of Art, pp.
30–44. London: Phaidon. Delivered as the Ernest Jones Lecture to
the British Psycho-Analytical Society, Nov., 1953.
Hausner, R. (1974). *Rudolf Hausner: Adam.* Stuttgart: Belser.
Hocke, G. R. (1974). "Hausner als Medium: Zu neuen Methoden der
Kunstinterpretation." In *Rudolf Hausner: Adam,* pp. 113–24. Stuttgart:
Belser.
Hutter, H., ed. (1977). *A. P. Gütersloh: Beispiele.* Vienna: Jugend und
Volk.
Hutter, W. (1965). "Eine Welt der Rätsel und des Eros." In *Wolfgang
Hutter, Werkverzeichnis.* Dortmund: Harenberg Kommunikation, 1983.
Originally published in *Die Wiener Schule des phantastischen Realismus.*
Exh. cat. Hanover: Kestner.
Jean, M. (1967). *The History of Surrealist Painting.* Trans. S. W. Taylor.
New York: Grove Press.
Jung, C. G. (1928). "The Relations between the Ego and the Uncon-
scious." *Collected Works of C. G. Jung,* vol. 2. Trans. R. F. C. Hull. 2d
ed. rev. Princeton, NJ: Princeton University Press, 1966.
_____. (1932). "Picasso" *Collected Works of C. G. Jung,* vol. 15. Trans. R.
F. C. Hull. 2d ed. rev. Princeton, NJ: Princeton University Press,
1966.
_____. (1946). "The Psychology of Transference." *Collected Works of C.
G. Jung,* vol. 16. Trans. R. F. C. Hull. 2d ed. rev. Princeton, NJ:
Princeton University Press, 1966.
Knott, R. (1975). "The Myth of the Androgyne." *Artforum,* 14(Nov.):
38–45.
Martensen, H. (1855). *Jacob Böhme: His Life and Teaching/Studies in
Theosophy.* Trans. R. R. Evans. London: Hodder & Stoughton.
Mayr, H. (1979). *Rudolf Hausner.* Vienna, n.p.
Muschik, J. (1974). *Die Wiener Schule des phantastischen Realismus.* Vien-
na: Jugend und Volk.
Oesterreicher-Mollwo, M. (1979). *Surrealism and Dadaism.* Oxford: Phai-
don Press.
Rank, O. (1932). *Art and Artist.* Trans. C. F. Atkinson. New York:
Knopf.
Sandler, I. (1970). *The Triumph of American Painting: A History of
Abstract Expressionism.* New York: Praeger.
Schmied, W. (1964). *Malerei des phantastischen Realismus: Die Wiener
Schule.* Vienna: Forum.
Scholem, G. (1946). *Major Trends in Jewish Mysticism.* New York:
Schocken.
_____. (1971). *The Messianic Idea in Judaism.* New York: Schocken.
_____. (1973). *Sabbatai Sevi, the Mystical Messiah, 1626–1676.* Prince-
ton, NJ: Princeton University Press.
Spector, J. J. (1972). *The Aesthetics of Freud.* New York: McGraw-Hill.
Trilling, L. (1955). *Freud and the Crisis of our Culture.* Boston: Beacon
Press.

Avigdor W. G.
Posèq, Ph.D.

Tumarkin and the Feminine Archetype

This essay presents a personal interpretation of the universal
feminine archetype in a work by a contemporary Israeli artist,
Igael Tumarkin's life-size statue of *Salomé* (fig. 1). Since
I propose to discuss the work of art rather than the
subconscious motivations of its author, I shall adopt the ico-
nographic method, confronting the sculpture with its presumed
visual and literary sources, referring to the artist's own comments
as supporting evidence. The composite figure represents a nude
woman whose head, distinguished by a beak-like nose, has a hand-
drill attached at the side. The members were cast from moulds
formed on the body of a live model. A truncated right hand
covers the *mons veneris* while in the left hand she holds a spherical
helmet of an astronaut containing a life-cast male mask. The
casting method that Tumarkin employed in this work was however
not used to achieve a lifelike imitation of Nature but to obtain
shells of anatomic members, which were reassembled to achieve a
subtle interplay of concave and convex forms. The artist informs
me[1] that he drew his inspiration from French funerary sculpture,
especially from a life-size *transí* statue attributed to Ligier Richier
on the tomb of René de Chalon in the church of St. Pierre in Bar-
le-Duc, which shows the deceased offering his heart to God, while
his putrefying flesh and skin fall off his bones, revealing the
cadaver's inner hollow (fig. 2).[2] Tumarkin adopted the effect in
the partly transparent female body, most notably in her right hand
which reveals the inner armature. Although he claims that he was
mainly interested in "the interpenetration of human form by

285

Fig. 1. I. Tumarkin,
Salomé, 1967. Bronze
cast assemblage. Col-
lection of the artist.

extraneous objects which maintain their identity," he also speaks
of his work in terms of an "intellectual conscious fetishism, or
even a masochistic [self-]mockery." This clearly implies that the
figure's significance calls for some clarification.

The title of the work suggests that its subject matter was drawn
from the New Testament accounts of the martyrdom of Saint
John the Baptist, whose severed head was offered by Herod to
Salomé as a reward for her dancing (Matt. 14:10–11, Mark 6:21–
23). The story provided the subject of several romantic versions,
the best-known being the short play by Oscar Wilde, who elabo-
rated the episode by a vivid representation of Salome's lust for
Saint John and added a description of the seven veils that
enhanced the erotic fascination of her performance. The ico-
nographic tradition established in the Renaissance portrayed the
Herodian princess as a beautiful and richly attired lady bearing the
Baptist's head on a charger;[3] a typical example may be seen in one
of the numerous portraits of Salomé by Lucas Cranach the Elder
(fig. 232 in Friedlander and Rosenberg, 1978). Tumarkin took
liberties with the artistic tradition not only by showing Salomé
naked but also by rendering her body so as to give it a withered
effect, making her look like a hag emerging from a painting by
Hans Baldung Grien.

Fig. 2. L. Richier(?),
René de Chalons,
1547. Marble. Bar-le-
Duc, Church of St.
Pierre. Photo: Foto
Marbourg/Art Re-
source, New York.

Tumarkin's reinterpretation of the biblical theme is by no
means exceptional. Sixteenth- and seventeenth-century artists
sometimes also endowed Salomé with a special meaning, depicting
themselves in the guise of her victim. These macabre self-portraits
have close parallels in contemporary depictions of Judith bearing
the head of Holofernes, Yael with the head of Sisera, and David
with the head of Goliath, which in turn have a pagan counterpart
in Perseus with the head of Medusa (Friedman, 1984, p. 165, figs.
71, 85). This artistic fashion is usually explained by the humanistic
concept of love, which saw in the lover a victim of the beloved
(Panofsky, 1939, pp. 218–20), but it was probably also related to
the contemporary interest in the myth of Orpheus, the classic
paradigm of all artists, who was dismembered by the Thracian
maenads.[4] An antique (1st century A.D.) relief showing a frenzied
maenad brandishing the head of Orpheus which was perhaps a
model of the Renaissance portraits of Judith (pl. 34 in Saxl, 1957,
p. 328), may also be seen as a prototype of Tumarkin's *Salomé.*
The artist's awareness of the iconographic affinity between the
pagan and the biblical figures is shown by the fact that his statue
combines the impression made by Benvenuto Cellini's *Perseus* (pl.
70 in Pope-Hennessy, 1963, 3:70) with that of Caravaggio's
triumphant David with the head of Goliath (fig. 3), to whom
Caravaggio lent his own features (Hibbard, 1983, pp. 262–67).

Fig. 3. Caravaggio, *David with the Head of Goliath,* c. 1609–10. Oil on canvas. Rome, Galleria Borghese.

Tumarkin endorsed the latter's precedent, incorporating a mask cast from his own face in the Baptist's decapitated head, but he transformed the round charger, which is the Baptist's attribute, into the spherical helmet of an astronaut, implying an analogy between the martyred artist and the tragic heroes of progress who sometimes pay with their own lives for the pursuit of their vocation.[5]

The gesture with which *Salomé* brandishes the head of her victim is compromised by the other hand which she holds in front of her womb, in a gesture similar to that typifying a Roman copy of the *Cnidian Aphrodite* usually referred to as the *Cnidian Venus* (fig. 4). *Salomé*'s posture was apparently the result of a revision since Tumarkin's preparatory sketch shows her covering herself with her left hand and holding John's head in the right (fig. 5; Tumarkin, 1970, p. 75). The sketch may have been inspired by another ancient statue, the *Venus Pudica,* who holds her left hand in front of her mons veneris while with the right she points to her breast. The conventional meaning of this posture as an allusion to the goddess' modesty was established only in the fourteenth century when it was adopted by Giovanni Pisano in the person- ification of a Cardinal Virtue[6] but in antiquity the pose was probably understood as an allusion to bearing and lactation and indicated the role of the goddess as *Venus Genetrix,* the classic patroness of fertility.[7] By giving her the Venus posture, Tumarkin indicated that his *Salomé* is related to the feminine archetype.[8]

The fact that *Salomé* holds her bloodstained trophy in her left hand suggests a deliberate reversal of the pose shown in the preliminary sketch (persisting also in an early version of the statue, which this writer was privileged to see in Tumarkin's studio).[9] The reversal is probably related to the artist's own left-handedness, which makes him very sensitive not only to the physical difference between left and right, but also to their conventional implications.[10] The latter are especially pronounced in the Jewish tradition, which associates the left *(smol)* with the satanic domain of Sammael and regards the left hand as a maleficent omen of death. (Löwinger, 1916, 47 and passim; see also Scholem, 1941, p. 239). Considering that Tumarkin's figure was modelled upon Richier's funerary statue, *Salomé* may even be seen as a personification of death. The exhange of the heart, which René de Chalon offers to God for the artist's self-portrait, and which Salome brandishes in her left hand, defines her as a tragic *femme fatale*. Her destructive power is implied by the truncation of the right hand, which associates her with the maternity theme.

The conceptual dichotomy of Tumarkin's statue may be compared to that of a late medieval personification of the synagogue in a fifteenth-century Swiss drawing (fig. 6). The nude *Synagogue* who like Tumarkin's *Salomé* clearly acknowledges the impact of antique representations of Venus, is juxtaposed to a fully dressed personification of the Church; between the two allegorical figures is a Tree of Knowledge, which is also the Tree of Life bearing two kinds of fruit: the branches over *Ecclesia* bear a crop of sanctified wafers (the Holy Host) some of which she is offering to an assembly of church dignitaries, while the branches shading *Synagogue* sprout a poisonous kind of fruit, its deadly character indicated by a skull similar to that which she is offering to a group of Jews. The gesture of *Synagogue,* obviously inspired by depictions of the biblical Eve offering the fruit of sin (which were often also derived from the *Venus Pudica*) associates her with humanity's sinful mother, but the bunch of grapes—the traditional symbol of life *(vita)*—which she holds in front of her womb also indicates that she is the primordial life-giver. The Swiss illustration is included in Erich Neumann's study of the artistic manifestations of the archetypal great mother who in her double capacity as the maternal goddess of nature and the terrible goddess of death, is the patroness of fate (1955, pp. 226–39; see also Neumann, 1954, chap. 2). Neumann was one of the foremost adherents of Carl Gustav Jung's theory of the collective archetypes, which the creative unconscious of the individual shares with ancient myths,[11] which in turn paved the way for the recognition of archetype motifs not only in dreams and in spontaneous primitive creations but also in major works of art (Neumann, 1959*b*, 1954; Abell, 1957, p. 46). Neumann's richly illustrated survey of the multiform artistic expressions of the great mother archetype and his study of the archetype motifs in the work of Henry Moore (Neumann, 1959*a*) aroused much interest among Israeli intellectuals in the sixties (the author settled in Tel-Aviv after he was expelled from

Fig. 4. *Cnidian Venus,* Roman copy after a Greek original of the 4th century B.C. Vatican, Museo Pio Clementino. Photo: Art Resource, New York.

Nazi Germany). The association of the expressive dichotomy of Tumarkin's *Salomé* with Neumann's concept of the ambivalent feminine archetype is especially explicit in the figure's monstrous physiognomy. The evil expression of her wide-open eye reminds one of the mythic Gorgon who transfixed her adversaries with her piercing glare[12] (this aspect of the legend is perhaps alluded to by the hand drill welded to *Salomé*'s head), but the masklike face bears a distinct resemblance to Neumann's illustration of a beak-nosed Phoenician figurine of Astarte(?)[13] a goddess who embodied the positive aspect of the feminine archetype.[14]

The affinity of Tumarkin's statue with the Canaanite goddess of maternity is also suggested by the fact that in a survey of his work Tumarkin (1970, p. 82), placed the picture of his *Salomé* on the same page as the photographs of another sculpture of his, representing *Ashtoreth* (Astarte) [fig. 7]. While *Salomé* is shown as a cutout image set on the blank page, which confers upon her the effect of timelessness, *Ashtoreth's* background of modernistic architecture, together with the machine parts incorporated in her body (suggesting the influence of African "fetishes") imply a survival of the maternal archetype, even in the age of human robots. The headless and armless torso of the Canaanite deity also reminds one of the fragmentary statues of Venus, who was her classical

Fig. 5. Tumarkin,
A sketch for *Salomé*,
1967. Pen drawing.
Collection of the
artist.

counterpart, but she is distinguished by a cavity in her belly into
which Tumarkin inserted an effigy cast from his own face.

The hollow in the goddess' belly was apparently inspired by the
abdominal scarifications that typify the ancestral and charm figures
of the Bakongo (Congo), into which magical substances were
inserted,[15] but it may also be related to one of the skeletal statues
from the workshop of Ligier Richier, which served as Tumarkin's
models for the interplay of convex and concave human forms (fig.
56 in Cohen, 1973, pp. 111–12). The implicit ambiguity of
Ashtoreth's attribute conforms with Erich Neumann's interpreta-
tion of similar hollows in the female figures of Henry Moore as
archetypal symbols of the Great Mother, whose deadly womb is
also the womb of rebirth (Neumann, 1959, p. 134). Tumarkin's
choice of the womblike cavern as the Canaanite goddess' attribute
also conforms with the biblical use of her name as a metaphor of
fertility (Primer, 1965, pp. 27: 264). For instance, in the descrip-
tion of the blessings the Lord will bestow upon those who observe
his Law, Moses says: "He will love thee and multiply thee, he will
also bless the fruit of thy womb" (in Hebrew, *Ashtoreth-tzonkha*,
rendered in the English authorized version as "the flock of thy
sheep" [Deut. 7:13] the word *ashtoreth* being understood as a
rhetorical allusion to the fertility of beasts and as a synonym for

292

Fig. 6. *The Tree of Knowledge with the Synagogue and Ecclesia,* Swiss 15th century drawing. In Hist. Helvetica X. 50, f. 127. Bern. Staat-und Hochschulbibliothek.

the womb). The artist's self-portrait in Astarte's womb suggests that he adopted the Semitic deity as his ideal mother and that he claims her heritage as his own.

The personal message conveyed by the goddess' statue encourages one to look for an autobiographical significance also in the *Salomé.* Assuming that *Ashtoreth* represents the chosen parentage of the artist, one may infer that the figure of Salomé, who as we have already said is also a personification of motherhood, represents the mother figure whom Tumarkin rejected by the symbolic act of placing his effigy in the Canaanite goddess' womb.

The autobiographic implications of Tumarkin's beak-nosed *Salomé* bring to mind the famous psychoanalytic study of Leonardo da Vinci, in which Freud (1910, pp. 88–90) related certain motifs in the artist's work to an entry in his diary about a childhood daydream of a bird which encroached upon him in his cradle. Identifying the bird as a vulture, Freud associated Leonardo's fantasy with the vulture-headed Egyptian goddess Mut, whose name not only has a phonetic similarity with the German word *Mutter,* (mother), but also meant mother in Egyptian. In view of

Fig. 7. I. Tumarkin,
Ashtoreth, 1967.
Bronze-cast and col-
ored assemblage.
Collection of the
artist.

the ancient belief in the vulture's capacity for parthenogenetic
reproduction and of the fact that in the hieroglyphic symbolism of
the Renaissance the vulture was identified as an emblem of
motherhood,[16] Freud recognized a mother image in Leonardo's
bird fantasy and interpreted the dream as a reminiscence of a
traumatic childhood experience of mother love, which had a
decisive impact on the mature artist's personality. Freud's in-
terpretation provoked an intense polemic in the course of which it
was noted not only that he mistranslated the Italian text, which
refers to a kite (*nibbio*) rather than a vulture, but also that in
medieval Christian ideology the vulture was sometimes also en-
dowed with a completely different meaning.[17] The Greek Fathers,
especially Saint Basil the Great, endorsed the ancient Egyptian
myth of the bird's supposed virgin maternity, which they associ-
ated with the Immaculate Conception,[18] but later authors ascribed
to it demonic qualities. For instance, in the 12th century Peter the

Venerable in his treatise "On Miracles" wrote about the moral tribulations of a pious monk who was tempted in his bed by the devil in the form of a vulture.[19] Moreover, since the bird feeds on cadavers, in antiquity it was often associated with the realm of death.[20] Thus if Leonardo's daydream is interpreted as a symbolic mother image, it should probably be understood as a subconscious reflection of the ambivalent maternal archetype, who is both the life-giver and the goddess of death.[21]

An interpretation of the subconscious symbolism of Tumarkin's statue *Salomé*, which like Leonardo's daydream is endowed with an ambivalent symbolism, would require a Freudian analyst, but a student of iconography accustomed to explain images by written texts is tempted to associate the figure with an autobiographical note in which Tumarkin describes the circumstances of his childhood. Referring to the fact that his father was German, he reports a deep resentment toward his mother, who after being expelled from Nazi Germany settled in a Tel-Aviv suburb and in order to protect her child from the ostracism of the Jewish community concealed his father's identity from him. The traumatic discovery of the deceit was a decisive factor in Tumarkin's attitude toward his mother, whose deception he could never forgive.[22] Assuming that the mature artist spontaneously, or perhaps subconsciously, associated Salomé's sacrifice of her beloved with his mother's attempt to obliterate the memory of his father, one is inclined to perceive the special personal significance of Tumarkin's statue. The fact that the artist cast himself in the role of Salomé's victim suggests that he not only identified with his father but also with the Christian martyr who represents his father's creed.[23] The severed head may thus allude to the artist's feeling that his mother not only deprived him of his father but also of his father's cultural heritage.

Tumarkin's simultaneous discovery that the man whom his mother later married was not his biological parent and that his true father, who had repudiated him, belonged to a nation engaged in the total destruction of the people whom he had been brought up to regard as his own, must have caused tremendous psychic havoc, which persisted in the artist's maturity. I know of no psychological study of a similar case, but some insight may perhaps be gathered from clinical studies of the effect of a traumatic childhood loss on adult creative activity which is believed to arise at least in some cases, as a response to unresolved narcissistic injuries experienced in early childhood (Niederland, 1967, p. 33). It has been observed that preadolescent children's inability to accept the finality of bereavement fosters fantasies of the return of the departed parent, which may precipitate imaginary bargains with fate where the child's behavior (either exemplary in "goodness" and achievement, or impulsive, destructive, and aggressive) implies a covert attempt to coerce a restitution of the loss. The child's rage, and all manner of hostile feelings originally directed toward the parent who has "abandoned" him, may sometimes be projected outward, often toward the other

parent, and the child may turn himself into "a living and dying reproach." The adaptive behavior may also involve the child's emotional identification with the absent parent and a subconscious wish to take his place. All these conflicting tendencies result in "a psychic splitting, a division between wish and knowledge, which persists in later life, giving rise to an intense experience of dualisms of near and far, present and absent, lost and inalienable, living and dead, and in a mode of consciousness in which the opposites coexist and the past is ever alive." (M. Wolfenstein, quoted in Spitz, 1984, pp. 91–104). Tumarkin's childhood trauma may have stimulated a similar chain of psychic ambiguities, which in his adult life he constantly seeks to resolve in his artistic creativity. The remarkable confluence of emotional motivations and time honored iconographic motifs that merge in the figure of *Salomé* allow one to contend that, like Leonardo's bird fantasy, the beak-nosed statue bears the impact of a traumatic childhood experience which in Tumarkin's case also became a major factor in the formation of a creative personality.

Notes

This paper was presented in Hebrew at the Annual Assembly of the Society for Jewish Art, dedicated to the theme of "The Image of the Woman in Jewish Art," Jerusalem, April 27–28, 1986.

1 This information was contained in a letter written by the artist in response to a draft of this paper.
2 Ligier Richier (1500?–1567) was one of the foremost sculptors in the service of the Dukes of Lorraine. The remarkable effigy of René de Chalon, who fell in the battle of St. Dizier on July 15, 1544, was carved in accordance with his will which supposedly specified that he should be shown "as he shall appear three years after his death." The grimness of the representation must have been much appreciated, since Richier's workshop later produced several versions of the figure. For a discussion of the general context of such funerary statues see Panofsky (n.d., p. 79 and passim) and Cohen (1973, pp. 177 ff, fig. 416).
3 See Reau (1955–57, 2, pt. 1:432–35) and Keller (1975). On the evolution of the iconographic motif, see also Combs-Stuebe (1966–67, pp. 1–17).
4 Ovid, *Metamorphoses* 9:1–85. The cult of Orpheus' head is referred to in Philostratus, *Heroica,* 5:704 and in Lucian's *Against the Unlearned,* 2 and in the *Life of Apollonius of Tyana,* 4:14.
5 A photograph of an astronaut is included in Tumarkin's book as one of the sources of his inspiration. The spherical helmet also appears in several of his other works, including the *Astronaut* (1970, pp. 80, 98, 103, and passim). The artist's emotional identification with the tragic destiny of the astronauts is implied in his *Portrait of the Artist as a Young Astronaut,* which shows a child hovering over a female body (1970, p. 102).

6 For a discussion of the evolution of the pose of the *Cnidian Venus* into that of the *Venus Pudica,* see Clark (1964, pp. 81–7). He identifies the Pisano figure (p. 89) as an allegory of "Temperance or Chastity", but to Ayrton, she represented "Temperance" (1963, fig. 273). This identification was endorsed by Mellini (1970, fig. 267), but Panofsky described her as "Prudence" (1970, p. 201).

7 The origins of the gesture may be traced to an antique relief from Istria which shows a young woman giving birth with both hands while nourishing a child at her breast. See Neumann (1955, p. 137, fig. 22). The gesture of Venus' left hand persists even in statues showing a different pose of the right hand, i.e., the 2nd century A.D. *Venus Felix,* illustrated in Pogany-Balás (1980, p. 55, fig. 197).

8 In the letter referred to in n.1 above, Tumarkin observed that *"Salomé* is not unlike a glamorous but anonymous dummy, an archetype of woman as (sex) object. The expressionless eyes, the beak nose and sensuous mouth, combined with the somewhat stereotyped pose, suggest that she is both a (passive) instrument and a vamp."

9 Salomé's gesture was obviously adopted from that of Cellini's *Perseus,* who, like Caravaggio's *David* holds a sword in his right hand; this is also true of the maenad which may have served as a model for the Renaissance representations of Judith.

10 See Hertz (1909, pp. 553–80). On the cultural symbolism of hands in antiquity, see Frothingham (1917, p. 60) and Cabrol and Leclercq (1907, p. 53).

11 In Jung (1964, pp. 20–103; 1968a 9: ; 1968b 75–113); see also Jacobi (1959, passim).

12 Ovid, *Metamorphoses,* 4:798–802. On Gorgon's archetype symbolism see Neumann (1955, p. 23).

13 See Neumann (1955, fig. 14); on the cult of Astarte (also called Ashtoreth and Ashtart) as the goddess of fertility see s.v. "Ashtart" in: Hasting's *Encyclopedia of Religion and Ethics* (New York, 1910) 2:114 and 3:182 and, on the Phoenician cult of Ashtart, 9:892.

14 Neumann (1955, pp. 52, 268 ff.). Tumarkin might have also been familiar with the bird-headed figures in Jewish manuscript illustrations; see Narkiss (1983, pp. 49–62) and with the somewhat similar images in ancient American art; see Wilson (1983, pp. 6–18).

15 See Bascom (1973, p. 136, fig. 93). I owe this reference to Tumarkin, see above, n 1.

16 Mut was a mother goddess whose name signified "mother." Since the vulture was an emblem of maternity, the goddess was represented as vulture-headed and the vulture was the hieroglyph of her name. See "Egyptian Religion" trans. from Larousse, *Mythologie Generale (New York, 1965),* p. 93. See also Hastings' *Encyclopedia of Religion and Ethics* New York: 1910), 5:245. Mut was also associated with the Egyptian goddess Net, who was a personification of the eternal life-principle and a prototype of parthenogenesis; see Budge (1904, 1:451). The late antique text that was the source of the hieroglyphic science of the Renaissance says, "When they [the Egyptians] mean mother . . . they draw a vulture." Horapollo, *Hieroglyphica,* 1:11. See also Spector (1972, p. 59).

17 For this controversy, see Schapiro (1955–56, pp. 3–8; 1956, pp. 147–8) and Eissler (1960, pp. 13–25).

18 J. R. Migne, ed. *Patrologia cursus completus: series graeca,* (Paris, 1844–66), 7:6 and 29:180, A, B. The Egyptian legend is also alluded to by Origen and Gregorios Pisides, who may have been familiar with Horapollo's *Hieroglyphica.* See Klausner (1976, 9:457, s. v. "Geier").

19 J. R. Migne, ed. *Patrologiae cursus completus: series latina* (Paris, 1854–64) 129:877. See also Mâle (1947, pp. 357–86).

20 The vulture was also a symbol of the Egyptian goddess Nekkbet, who devoured corpses and watched over the dead in the underworld; see Neumann (1955, p. 164).

21 The error in translation does not necessarily invalidate Freud's interpretation, since the bird need not have been a vulture; see Ellis (1910, pp. 522–23), Kris (1952, p. 16, n. 6), and Neumann (1959, pp. 64 ff). 64 ff).

22 Tumarkin (1981, pp. 13–15; in Hebrew). In the letter cited in n. 1 above, Tumarkin wrote, "Like Leonardo I felt completely estranged from my mother and detached from my stepfather from the age of 12."

23 The motif of the severed head occurs in Tumarkin's work in different versions, among which the most important is the *Portrait of the Artist as a Holy Martyr;* see Tumarkin (1970, p. 59) and also Posèq (1987), pp. 323–330.)

References

Abell, W. (1957). *The Collective Dream in Art.* New York: Schocken.

Ayrton, M. (1963). *Giovanni Pisano.* London: Thames & Hudson, 1969.

Bascom, W. (1973). *African Art in Cultural Perspective.* New York: Norton.

Blunt, A. (1982). *Art and Architecture in France, 1500–1700.* Harmondsworth: Penguin.

Budge, E. A. W. (1904). *The Gods of the Egyptians.* London: Methuen.

Cabrol, F., and H. Leclercq (1907). *Dictionnaire d'archéolgie chrétienne et de liturgie.* Paris: Letonzey et Ané, 1907–53.

Clark, K. (1956). *The Nude.* Harmondsworth: Penguin, 1964.

Cohen, K. (1973). *Metamorphosis of a Death Symbol: The Transi Tomb in the Late Middle Ages and the Renaissance.* Berkeley: University of California Press.

Combs-Stuebe, I. (1966–67). "The *Johannesschüssel* from Reliquary to Narrative to Andachtsbild." *Marsyas,* 13:117.

Ellis, H. (1910). A Review of S. Freud, "Eine Kindheitserrinerung des Leonardo da Vinci." *Journal of Mental Science,* 56:59–137.

Eissler, K. R. (1961). *Leonardo da Vinci: Psychological Notes on the Enigma.* New York: International Universities Press.

Freud, S. (1910). "Leonardo da Vinci and a Memory of His Childhood." S. E., 11:59–138.

Friedlaender, W. (1955). *Caravaggio Studies* New York: Schocken, 1969.

Friedlander, M. & J. Rosenberg. (1978). *Les peintures de Lucas Cranach.* Paris: Flammarion.

Friedman, M. (1984). *Bilder zum Bibel.* Vienna: Gondröm.

Frothingham, A. L. (1917). "Ancient Orientation Unveiled." *American Journal of Archeology,* 21:60.

Hertz, R. (1909). "La pre-eminence de la main droite." *Revue philosophique,* 68:553–80.

Hibbard, H. (1983). *Caravaggio.* New York: Harper.

298 Jacobi, J. (1959). *Complex, Archetype, Symbol in the Psychology of C. G. Jung.* New York: Pantheon.

Jung, C. G. (1964). "Approaching the Unconscious." *Man and His Symbols,* pp. 20–103. London: Aldus, 1972.

———. (1968*a*). "Archetype and the Collective Unconscious." *Collected Works of C. G. Jung,* vol. 9. London: Routledge & Kegan Paul.

———. (1968*b*). "Psychological Aspects of the Mother Archetype." *Collected Works of C. G. Jung,* vol. 9. London: Routledge & Kegan Paul.

Keller, H. L. (1975). "Johannes der Taufer." *Reclam's Lexikon der Heiligen und der biblischen Gestalten.* Stuttgart: Philipp Reclam, Jun.

Klauser, T., ed. (1976). *Reallexikon für Antike und Christentum,* 9:457. Stuttgart: Hiersmenn.

Kris, E. (1952). *Psychoanalytic Explorations in Art,* New York: Schocken, 1964.

Löwinger, A. (1916). "Rechts und Links in Bibel und Tradition der Juden." *Mitteilungen zum jüdische Volkskunde,* 2:47.

Mâle, E. (1928). *L'Art religieux du XIIe siècle en France.* Paris: Colin, 1947.

Narkiss, B. (1983). "On the Zoocephalic Phenomenon in Medieval Ashkenazi Manuscripts," *Norms and Variations: Essays in Honour of Moshe Barasch.* Jerusalem: Magnes Press.

Neumann, E. (1954). *The Origins and History of Consciousness,* I, New York: Harper Torchbooks, 1962.

———. (1955). *The Great Mother.* Princeton, NJ: Princeton University Press, 1972.

———. (1959*a*). *The Archetype World of Henry Moore.* New York: Harper & Row, 1965.

———. (1959*b*). *Art and the Creative Unconscious.* New York: Harper & Row.

Niederland, W. G. (1967). "Clinical Aspects of Creativity." *American Imago,* 24:33.

Panofsky, E. (1939). "The Neoplatonic Movement and Michelangelo." *Studies in Iconology,* pp. 171–230. New York: Harper & Row, 1972.

———. (1965). *Renaissance and Ranascences in Western Art.* London: Paladin, 1970.

———. (n.d.). *Tomb Sculpture.* New York: Abrams.

Pogány-Balás, E. (1980). *The Influence of Rome's Antique Monumental Sculpture on the Great Masterpieces of the Renaissance.* Budapest: Akadémiai Kiadó.

Pope-Hennessy, J. (1963). *Italian High Renaissance and Baroque Sculpture.* London: Phaidon.

Posèq, A. W. G. (1987), "Five Allegorical Self-Portraits of Igael Tumarkin," *Jewish Art,* 12/13: 320–336.

Reau, L. (1955–57). *Iconographie de l'art chrétien.* Paris: Presses Universitaires.

Richter, G. M. A. (1959). *Handbook of Greek Art.* London: Phaidon Press, 1963.

Saxl, F. (1957). "Warburg's Visit to New Mexico." *Lectures.* London: Warburg Institute.

Schapiro, M. (1955–56). "Two Slips of Leonardo and a Slip of Freud." *Psychoanalysis,* 2:3–8.

———. (1956). "Leonardo and Freud." *Journal of the History of Ideas,* 17:147–48.

299 Scholem, G. (1941). *Major Trends in Jewish Mysticism.* New York: Schocken, 1961.

Spector, J. J. (1972). *The Aesthetics of Freud.* New York: McGraw-Hill.

Spitz, E. Handler (1984). "Toward the Separation of Memory and Hope. Applications of Psychoanalysis to Art in the Writings of Martha Wolfenstein." *Hillside Journal of Clinical Psychology,* 6:91–104.

Tumarkin, I. (1970). *Tumarkin by Tumarkin.* Jerusalem: American Paper Mills.

————. (1981). *Tumarkin, I.* Givatim: Masada (in Hebrew).

Wilson, L. A. (1983). "A Possible Interpretation of the Bird-Man Figure Found on Objects Associated with the Southern Cult of the Southeastern United States, A.D. 1200–1350." *Phoebus,* 3:6–18.

Section Four | **Book Review**

Frank Galuszka,
M.F.A.

Review of James Lord, *Giacometti: A Biography.* New York: Farrar, Strauss, Giroux, 1983.

In a moment of truth Alberto Giacometti broke with the program of the Surrealist group, when he announced that he felt it necessary to work from life. André Breton cajoled and debated, for Giacometti was too valuable a talent to lose. But the sculptor's mind was made up. Breton cursed his defection by arranging for Giacometti's ostracism by members of the Surrealist movement.

Giacometti's was not a simple exchange of one style for another or a backsliding into academicism. As a Surrealist he had composed and executed works that funneled feelings into ideas, that engineered autobiography into intelligent and witty provocations. He enjoyed success in communicating his anxiety and ambition to an astute and appreciative audience. Yet in his heart, Giacometti was not a Surrealist. The fantasy forms of Surrealism, for all their apparent uniqueness, seemed impersonal and superficial.

He would abandon the riches of Surrealism and cultural progress for the poverty of a search for what might not be found. He would become both the Percival and the St. Francis of modern art. All he wanted to do, he claimed, was make work that was like what he saw. What he "saw" was far from objective. His vision, it seems, penetrated appearances. It was hard to define. For over a decade his quest showed meager results. A few tiny sculptures a year, each a lonely bit of substance in space, "shrunken" from Giacometti's larger scaled intentions. But in the late 1940s his effort began to produce fulfilling results, and his characteristic attenuated figures and stark portraits rose in harvest after harvest until his death in 1966.

Giacometti spent the war years in his home country of Switzerland in a frozen little studio in a cheap hotel. His dry period was painfully underway, but his persistence, if not his faith, was strengthening. He pored over Cézanne, copying his work and meditating on his career. His drawings were to show the effect of Cézanne most directly, revealing a honing search for interlocking forms that equalize positive and negative space without defeating the visual facts in the process.

His paintings were to be primarily portraits. These also are indebted to Cézanne, especially to paintings like his portrait of Vollard and his *Woman with a Coffeemaker*. In Giacometti's case, the space dominates the sitter. Brushstrokes informally coordinate symmetrical features. In the late work the head itself exists as a coagulation of matter that seems to have shrunken from something larger. They would seem as fossilized as the sculptures if not for the suggestion of moisture the gloss of paint conveys. Images like a 1962 portrait of his wife Annette are both invigorating and frightening. The wide-eyed stare of the sitter is in such contrast to the face of its possessor that the gaze and the physical body antagonize one another. It is like the ardor of insanity, like the unreasoning fear of a reanimated corpse. This conflict between substance and being enlivens and tortures Giacometti's work.

Giacometti considered his works failures. This was neither true nor false humility—it was pride. The same man considered himself the best sculptor and painter of his time. To him, failure had a status that raised it above success. For all success is, necessarily, delusion.

In spite of his high estimation of his own paintings, he is remembered mainly as a sculptor. His sculptures are images of isolated existence. Thinness or smallness gives them power. When confronted by an accurately proportioned, life-size figure, the human viewer graciously shares his natural space with the sculpture. Actual and aesthetic space blend. Miniatures defy this mutuality, declaring private knowledge of the space that encircles them. They miniaturize the space around themselves, creating magic islands of separate reality in the world. Where the two realities meet cannot be seen. It can perhaps be *felt* by the viewer. Giacometti's miniatures stand on pedestals scaled for portrait busts. As the space around each sculpture shrinks, the pedestals become immense, unseating the viewer's sense of scale. These figures are also effaced, their details lost, their form somewhat attenuated. Each then is like a sculptural version of a painted figure seen in perspectival distance, for the remoteness portrayed by perspective not only reduces size but removes details and neutralizes color. In painting, perspective continues the impression of natural space onto a surface by means of illusion. But what are we to make of its three-dimensional counterpart setting up a simultaneous existence within the fully dimensional length and breadth of nature? It is like a glimpse into another dimension, an ordinarily unseen sphere. What is remote is here, close at hand.

As each figure generates the space around itself, it manufactures its own isolation. Yet, it can be reappropriated into the natural world: the aesthetic space can be violated, the object can be simply touched. This dual existence functions as a metaphor for emotional isolation: physical contact is possible but genuine communication is not.

In some works of the late 1940s Giacometti placed several bronze figures of similar scale on a single pedestal or platform. Whether a woman lined up beside others in a recollected brothel or a man among others walking across a town plaza, each is self-absorbed. While the spatial vibrations between figures are sufficient to knit them into communal space, compositional devices forbid further connection. Unlike the rhythmic curves that unify baroque figure groups, Giacometti's straight lines separate and divide. Parallel and intersecting lines of force suggest enclosing geometric frameworks, recalling the actual frameworks of some of his Surrealist constructions and his habit of sketching a border within the edges of his paintings.

In the stylistic "solution" of Giacometti's late work, ideas, subconscious forces, and physical matter meet in a unique way. The mystery of his mature works is perplexity over their obvious features. After having been so small, why are they suddenly so large? Why are these figures so skinny? So bumpy? Why are their feet so big?

The thinness and the sudden increase in size are connected. While in Switzerland during the war, Giacometti was separated from his brother Diego, who, in Paris, had served as Alberto's studio assistant. As such, he exerted influence, though how much is hard to say. It is significant that Diego built armatures for his brother's sculpture. Alone in Geneva, Alberto must have made his own armatures. The appearance of some works of this period as well as Giacometti's own comments suggest that these sculptures had slight armatures or perhaps even no underlying metal structurals at all. Given the sculptor's preference for a simple pocket knife as a tool, it is not surprising that these tiny figures often turned in the artist's hand rather than on a traditional sculpture stand. It is worth considering that, given the absence of a rigid core and the subtractive nature of the work, reduction of size is the path of least resistance. Moreover, this working situation focused the artist's attention so intensely on his subject that it is likely that he worked entranced for long periods without stepping back to view his work from afar. Falling out of such a trance the artist is naturally surprised when he sees his work suddenly in a larger context.

These circumstances contributed to the formal outcome in his period of small sculptures. Likewise, the larger, mature works occur in circumstances of their own. Primary, of course, was Giacometti's expressed desire to make larger works. This was confirmed by dealer Pierre Matisse's advice that he do just that. Beyond what persuasive force Diego offered, he also constructed

the armatures for this new, larger work. These armatures were, by necessity, of heavy gauge wire or welded metal rods. Such things could be shortened only with considerable difficulty were the sculptures to "shrink" in stature again. It seems that Giacometti accepted these armatures as "given" and worked inward only, making them skinny, but leaving them tall.

Giacometti's urge to subtract, reduce, pare down has to be accepted as irresistible. So is his urge to disturb surface. The backgrounds of his paintings are not blank. They are empty, but their emptiness is afflicted by marks and washes that suggest a unique emptiness. Neither pristine infinity nor wild abyss, it is uncertainty, gray and unsettling, like a bad day, a mirror of anxiety. His tiny sculptures are not polished bright. Nicks and scrapes adorn them. There is always a special quality to the surface activity, peculiar to Giacometti. As his sculpture enlarged, residual surface phenomena no longer sufficed. Surface had to be created that was appropriate to scale. This takes the form of irregular lumps, dents, and undulations, all suitably pitted. It looks like the result of a natural process—like coral growth, bark, or volcanic rock—and *it is*. It is the record of the touches of the sculptor's hands, of his fingers and thumbs, squeezing, poking, smearing, and pinching plaster or clay into place.

As the contours of Giacometti's figures swell and recede, the eye of the viewer slips and loses its place. It shifts from point to point until the sculpture, though plaster or bronze, seems to flicker and tremble. Other independent-minded artists of his period have come up with comparable results. Morandi's contours are similarly wavy, as if seen through rising heat. They also vibrate, like Giacometti's. And, as in Giacometti, this vibration is not "supernatural" in character, but natural, familiar, and pervasive. De Kooning, who described himself as a "slipping glimpser," acknowledged the artist-viewer's instability as a factor in intense visual experience. His wobbly figures slide from side to side, leaving facial features hanging like images sustained by memory. These artists, at some point in their careers, were drawn from the center of the collective enterprise of modernism to its edges in order to seek something personally compelling in visual experience. What they "saw" and sought independently was not academicism or the past rehashed, but a peculiarly modern insight into appearances, an apprehension of a kind of "reality" within.

James Lord's biography *Giacometti* is a labor of love. His personal acquaintance with the artist and with figures of his milieu give this book authority and a vigorous life of its own. Over twenty years or more Lord's interest in Giacometti has been growing. What once may have been enthusiasm has become passion. He is personally involved. He has opinions. While revealing the facts, he shades them, trying to minimize the artist's personal shortcomings, which are many, and often serious. He casts some of Giacometti's contemporaries, notably Picasso and Balthus, as heav-

ies, on moral grounds. This comparison led Lord to construct a scathing spinoff in the form of a short biography, "Balthus: The Curious Case of the Count de Rola" (*The New Criterion,* [December 1983]).

Like Picasso and Balthus, Giacometti created quite a bit of psychic wreckage among his family and friends. Lord uses Giacometti's "genius" to excuse him, as if the presumably non-genius reader will be automatically cowed. As Lord condemns the others, the reader must wonder why they are not awarded a moral waiver on the same grounds. But Lord finds Giacometti *superior,* even to Picasso. Giacometti believed this himself, declaring: "Picasso is certainly very gifted, but his works are only objects." Giacometti's rise to prominence admittedly coincides with Picasso's decline. And Giacometti's achievement of this period outstrips Picasso's. But, career for career, Picasso's imperial prodigiousness outweighs Giacometti's holy quest in nearly everyone's imagination. The ultimate value of both artists' works are affected by the endurance of respective well-developed mystiques. So far both artists have been protected by these mystiques from damaging criticism.

With the exception of Breton's complaints, Giacometti has received general critical support, much of it from existentialists such as Sartre, Genet, and Beckett. Their endorsement is based on their perception of something sympathetic to their views in Giacometti's life and work. Lord repeatedly notes that Giacometti did not consider his painting and sculpture a visual equivalent of existentialist philosophy or an illustration or enactment of existentialist views. Yet the appreciation of Giacometti is still tied up in existentialism, and, as the philosophy looks dated, the same fate hovers over the work. Lord's persistent reminder does an important service to the sculptor in beginning to break up this critical log jam.

Compared to Giacometti's austerity in life and art, Lord's style is ironically luxuriant. It is smooth, gossipy, and manipulative. Too rich and indirect for fast reading, *Giacometti* rewards care with pleasure and caution with insight into masked phrases. The people in this book sometimes subtly step through a looking glass to become *characters,* as the author claims knowledge of the unknowable. He tells what people are *thinking* while they are kissing each other or while they are driving around the Italian countryside. He baits us by scattering psychological tidbits that eventually add up like clues in a mystery. This is good craftmanship, even art perhaps, but while the research is exhaustive and impeccable, it is a trap for James Lord. He is caught between loyalty and scholarship. Lord's struggle with this dilemma gives *Giacometti* a rare poignancy.

As scholarship *Giacometti* is rendered, by the biographer's intrusions, predigested, already cast in a well-considered context. This context is so massive that it endows the book with a gravity that prevents fresh and individual perspectives from forming in

the reader's mind. Personal ideas rise up from this book with difficulty. More often than not they are destined simply to fall back in.

Giacometti succeeds best as art. This may not have been Lord's intention, but it is a tribute to Giacometti that Lord's involvement with the sculptor's life has led the author to be a participant in a freer creative arena. It serves Giacometti, too, not so much as a source of information, but as a vehicle for contemplation of this great artist's life and work.

Laurie Wilson,
Ph.D.

Review of James Lord, *Giacometti: A Biography.* New York: Farrar, Strauss, Giroux, 1983.

For many viewers the art of Alberto Giacometti symbolizes the existential anguish of the Second World War and the modern era which followed in its wake. In their quivering slenderness his characteristic standing figures evoke the predicament of mankind in the nuclear age—life at the vulnerable edge of nothingness. These sensitive and elegantly worked figures convey both the fragility and resilience of the human race. Though battered, they endure erect and undefeated. Giacometti's ability to capture the contemporary dilemma through these great figurative pieces commanded the attention of public and critics alike. He achieved great renown during his own lifetime and lived to see both his figurative work and his earlier Surrealist sculptures enshrined in art history. His complete integrity and unswerving devotion to his work also made him a model for many younger contemporary artists.

It is not surprising, then, that this monumental figure should inspire an intensive biographical effort on the part of his friend and admirer, James Lord, a writer who knew Giacometti for more than 15 years, who had already written two monographs on him, and who spent more than 30 years of research to produce this book. Lord has gathered a storehouse of anecdotal biographical material about the artist and with this book makes it available for future study.

If it has become a truism that every biography is in a very real sense an autobiography, this cliché must nonetheless be repeated if one is to weigh Lord's achievements as a biographer accurately.

The book has aroused controversy since its publication and a recent advertisement placed in the *New York Review of Books* (February 26, 1987, p. 33) by 41 internationally known friends and admirers of the artist is a public letter of protest about the biography. They charged that the book is a "wildly distorted portrayal"of Giacometti's personality that depreciates his image and reputation. To the psychologically attuned reviewer, however, the case appears more complex, and the positive assessments of his subject that result from Lord's overidealization of Giacometti seem at least as significant as any negative impressions the biography may have promoted. Perhaps only after additional evidence comes to light and Giacometti's life is reassessed by other biographers will it be possible to evaluate more objectively the successes and failures of Lord's effort. However, both as a seriously conceived and executed work and as a fascinating narrative, the book deserves serious consideration.

Lord's biography presents Giacometti as a tormented man who successfully transformed his private afflictions into great public works that permit—even force—his viewers to adopt his private vision and echo his private anguish. Attentive to the intimate details of his subject's psychic life as well as to his externally observable experiences, Lord creates a portrait of a man who possessed not only strikingly admirable traits, but disagreeable and sadistic tendencies as well. Often, however, the author refrains from evaluating or interpreting the significance of the less attractive aspects of Giacometti's personality for his art, as well as the art itself. The ambiguity created by Lord's combination of revalations and reticence may be the root of the book's principal weakness as well as the source of the mixed reception with which this biography has been greeted. Had the author adopted a more open, objective stance, carefully sorting fact from speculation, history from interpretation, he might have diverted some of this negative response. Rather than distancing himself from his subject in this manner, Lord often seems to have overidentified with the artist, at least with the Giacometti of his personal vision. Lord's ambivalence about exploring the implications of his subject's experiences for his art, as well as the author's identification with the artist is suggested by comments like the following: "He needed to reveal himself, to show what he was and why, but always in such a way that full understanding was deferred, one revelation calling for another, ad infinitum. Creativity is an alternative to the conflicts which cause nightmares. The same mechanism which in dreams governs the elaboration of our strongest though most carefully concealed desires, desires often repugnant to consciousness, also governs the elaboration of works of art." (p. 278).

Just as Giacometti concealed while revealing, forbidding his public real admission to his inner world, so his biographer uses metaphors, muddled language, and denial to glide past the apposite moment for clear interpretation, leaving his reader with an ambiguous picture of the artist himself, as well as of the rela-

tionship between the biographer and his subject. For example, though he presents data about Giacometti's alleged lies and betrayals, Lord often dismisses the implications of such behavior with remarks like "Genius has its own rules." He sometimes shows similar blind spots in evaluating the emotional impact of certain key Giacometti sculptures. Thus, when Lord describes the highly disturbing early bronze, *Woman with Her Throat Cut* (1932), as elegant, intellectual, and aesthetic, a representation of violence which "could not conceivably arouse horror" (p. 139), he seems to deny the real impact of this work as well as the true complexity of the artist's achievement.

The existence of other blind spots of this type may underlie the author's ability to characterize Giacometti's early life as "happy" and "harmonious" while simultaneously describing aspects of the artist's childhood that scarcely seem consistent with such an evaluation. Alberto was the eldest son and first of four children born to Annetta and Giovanni Giacometti. His father, a moderately successful painter, came from a family of prominent Swiss artists. The biography portrays Giacometti's father as a genial, mild-mannered, and generous man, and the artist's mother by contrast, as a domineering, seductive woman. Lord states that by the age of 18 Alberto was artistically more mature than his father and suggests that his mother was more gratified by her son's artistic prowess than that of her husband. Judging from early photographs that show mother and son gazing intently at each other, and the lifelong attachment which they maintained despite geographical distance, we can presume that an extremely strong bond between Annetta and Alberto had been present since childhood.

Despite the supposed serenity of his early life, sometime between the ages of four and seven, Giacometti developed crippling fetishistic rituals. His family remembered that before he could climb into bed and relax enough to fall asleep, Alberto felt compelled to carry out prolonged arrangements and rearrangements of his shoes and socks stored at the side of his bed. This behavior was accompanied by a recurring fantasy of rapine and murder, a waking dream that paradoxically soothed its young creator, permitting him at last to fall asleep. According to the artist's own later reconstruction, this barely disguised violent oedipal fantasy features the dreamer as principal actor. First he kills two men, one a terrified 17-year-old youth and the other garbed in shining armor. Later he disrobes, rapes, and slowly kills a 32-year-old black-clad woman and her daughter, the latter dressed in floating white veils.

In reporting this story Lord questioned neither the accuracy of Giacometti's retroactive recollection, nor the propitious timing of this reconstruction, provided for a Surrealist publication at the height of that movement so fascinated with the relationship between dreams, erotic and sadistic fantasies, and the creative act (Giacometti, 1933, pp. 44–45; Lord mistranslates the word *daughter* from Giacometti's original text into *young girl*).

To add to young Giacometti's problems, at age 17 he suffered a severe case of mumps, followed by an acutely painful attack of orchitis that left him sterile for life. At about the time of this traumatic illness, Giacometti fell in love with a handsome younger boy who attended the same boarding school. Lord believes that this relationship, which unfolded in an intensely repressive atmosphere in which homoerotic attachments were unacceptable, placed the future artist in an intolerable dilemma. He resolved his quandry by running home to his family, as he would later flee other painful situations as an adult.

According to Lord's reconstruction, this crucial event engendered in the artist a profound mistrust of emotional entanglements and may also have played a major role in the decision, made soon after, to dedicate his life to art. Such an identification with his artist father, Lord implies, proved far more ego syntonic to the artist than his earlier homosexual longings.

A statement by Giacometti himself suggests, rather, that both his decision to become an artist *and* his lifelong obsession with failure were intimately related to the traumatic effects of his sterility: "I thought nothing was impossible for me. That feeling lasted until I was seventeen or eighteen years old. Then I suddenly realized that I could do absolutely nothing, and I asked myself the reason. I decided to work to find out why" (Hohl, 1971, p. 231). Interestingly enough, Lord makes no attempt to explore the implications of this statement or even report it in the biography, although it implies that the artist had an almost conscious awareness of the connection between his illness at age 17, his vocation, and his recurring feelings of artistic impotence.

Critics who oppose psychologically oriented biographies might well question what relevance exploring the significance of such recollection of early experiences and feeling states might have for evaluating the oeuvre of a major artist whose achievements must stand or fall on their own merits. Lord partially defuses such objections by attempting to weave together elements of the artist's psychic life and his artistic career. For example, the biography vividly describes the multiple ways in which Giacometti's compulsion to engage in ritualistic behavior hampered his productivity, for he could neither work nor sleep when he failed to arrive at a completely satisfactory organization of the saucers, cigarettes, and pencils that he kept on his work table, or the socks and shoes that he stored by the side of his bed at night. Despite Lord's awareness of how crippling such rituals must have been, he describes with almost reverential awe the artist's titanic struggles against his continuous urge to destroy his emerging sculptures before he could complete them. Even when he was working optimally, Giacometti often felt compelled to do and undo the same work endlessly, and it was not at all unusual for him to make as many as 30 or 40 revisions of a piece in progress during a single day. At the crucial moment, his brother Diego (who acted as the artist's assistant and technical factotum for much of his working life), would wrest the figure away to cast it in plaster before Giacometti could reduce it to crumbs of clay.

Lord's veneration of Giacometti's inhibitions and battles with destruction should be understood within the context of the intellectual atmosphere of the times. Knowledge of Giacometti's friendship with Sartre and Beckett no doubt colors the writing of most authors on the artist including that of Lord.

Unfortunately some of the impact of Lord's carefully chosen evidence is lost because he does not draw a comprehensive interpretive picture and opens himself to charges of making pseudo-Freudian interpretations. Instead, the significance of certain behavioral patterns of his subject is rationalized away, suggesting a parallel ambivalence about self-knowledge existing both in the biographer and his subject.

Giacometti's fascination with failure remained in effect thoughout his life, and he never learned to tolerate many of the usual trappings of success, even when his own renown made its impact inescapable. He consciously admired Derain, whom he perceived as a failed artist and felt still more deeply attracted to Cézanne because he identified with that master's successful struggle against the same demon.

The sadistic character that permeated the artist's childhood fetishistic fantasies also found its expression in the art of his maturity. This character is evident in *Woman with Her Throat Cut* (1932), mentioned above, but seems more pronounced in the images that thematically tie man to woman as exemplified in *The Couple* (1929) (fig. 1). Here the essence of the relationship between male and female is the threat of an exciting but excruciatingly painful sexual intimacy. These works demonstrate how effectively Giacometti could transform his apparent underlying violent fantasies into haunting works of art. Echoes of this same sadistic quality persist even in his post-Surrealist production, when he developed his signature style of attenuated figures. These sculpted men and women with their life-defying thinness reminded their first audiences of the survivors of the Holocaust.

The sadistic fantasies operative in Giacometti's creative life also colored his actual relationships with women. Although he always overidealized his mother and treated her deferentially, aside from the easy intimacy he maintained lifelong with prostitutes, most other women in his life fared less well. For example, as a young adult, Giacometti was involved in a prolonged, but unconsummated, relationship with his cousin, Bianca; he once demonstrated his sadistic mastery over her by carving his initials in her arm with a knife! The biographical account of the artist's entire courtship and marriage to his wife, Annette, chronicles a tale of virtually unremitting torment and humiliation that ranged from forcing her to submit to material deprivations despite his considerable financial success to humiliating her before others. In one incident of the latter type, Giacometti publicly screamed out at his wife that he had married her only because her given name, Annette, was the same as his mother's.

The close genetic connection between Giacometti's sadistic fantasies and his foot fetish likewise remained operative throughout his life, sometimes revealing itself in bizarre artistic choices.

For instance, while he was still an art student, he defied his teachers during a life class by insisting on drawing only the foot of a particularly voluptuous model. Later, during a trip made in the company of his beloved Bianca, he burst into her hotel room one night when she was in a state of déshabillé and demanded that she pose for him. Ignoring the allure of her half-nude body, he drew only her feet. Later he seems to have shifted his preoccupation to his own feet. At least, his first test of his future wife's love was to ask her to purchase some Swiss shoes and send them to him in Paris, only to discard them immediately as totally unsuitable.

Soon thereafter, Giacometti injured his foot in an accident. In later years, this injury acquired mythic proportions for him, becoming the focus of hypochondriacal complaints and the rationalization for using a cane as a kind of third leg. In view of his overwhelming preoccupation with feet, one can hardly ignore the importance of the outsize feet with which he endowed so many of his bronze figures. It seems notable, too, that although he occasionally depicted men in movement, Giacometti's women stand stock still. Sometimes the artist did not even give them feet; instead their lower limbs merge with the pedestals, and they stand seemingly entrapped, resigned to obey their maker slavishly or risk his destructive wrath.

In summary, though Lord's biography has many defects, it also presents a rich, suggestive account of the career of an artist whose psyche simultaneously inspired and crippled his production. At the precipice between being and nothingness, Giacometti's vibrant figures stand as sentinels, arresting our imagination and attesting to a great artist's ability to transform his private traumas into brilliantly memorable works of art.

Notes

1 Giacometti, A. (1933). "Hier, sables mouvants." *Le Surrealisme au Service de la Revolution.* 5 (May): 44–45.
2 Hohl, R. (1971). *Alberto Giacometti.* New York: Harry Abrams.